VAN DYCK

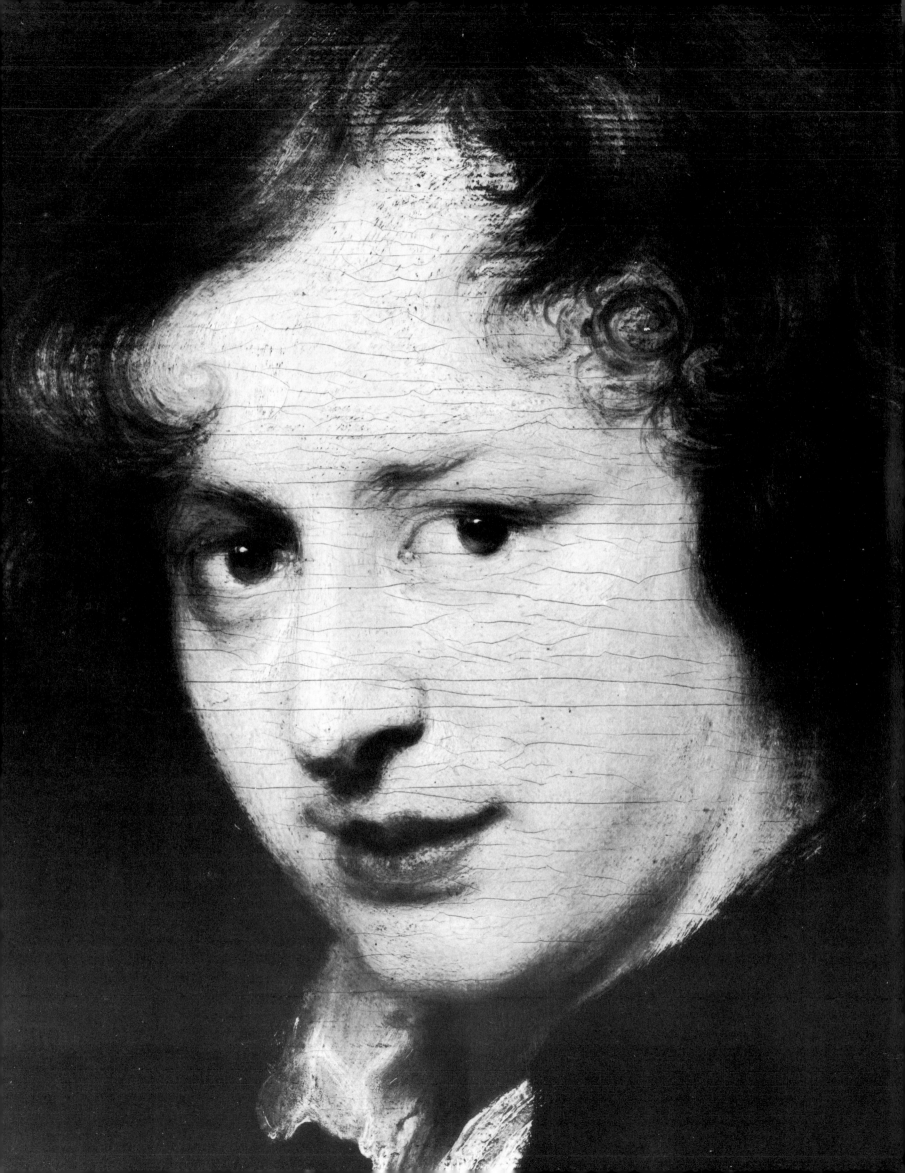

VAN DYCK

Christopher Brown

PHAIDON · OXFORD

Phaidon Press Limited, Littlegate House, St Ebbe's Street, Oxford OX1 1SQ

First published 1982
© Phaidon Press Limited 1982

British Library Cataloguing in Publication Data

Brown, Christopher
 Van Dyck.
1. Dyck, *Sir* Anthony van
 I. Title
 759.9493 ND638.V/
 ISBN 0-7148-2211-6

Monophoto composition in Garamond by Filmtype Services Limited, Scarborough,
North Yorkshire.

Printed in Great Britain by Fakenham Press, Fakenham, Norfolk.

Frontispiece. Van Dyck. *Self-Portrait. c.* 1617–18. (Detail of Plate 42)

Contents

To My Parents

Preface

Sir Anthony van Dyck created the image of the doomed court of Charles I which we immediately recognize today. The King as melancholy knight is his creation, as are Charles's languid, richly-dressed courtiers. Titian was the idol of both King and painter, and in Van Dyck Charles, the greatest patron and collector ever to grace the throne of Britain, saw the Venetian artist reborn. By tempting Van Dyck to London on terms which were unprecedented in the history of royal patronage, the King brought painting in England, which had scarcely been touched by the Renaissance, into the mainstream of the European Baroque.

Van Dyck settled in London in 1632, and proceeded to transform portraiture in England. The work of Lely and Gainsborough, Reynolds and Lawrence would have been unthinkable without his example. His effect on painting in the places in which he had worked before coming to England was no less dramatic. He inspired a generation of imitators in Genoa, and from his native Antwerp his influence and reputation spread throughout the Netherlands. His portraits of the Genoese, Flemish and English aristocracy are among the greatest triumphs of Baroque painting. In his equestrian portraits he was capable of immense grandeur; in his portraits of children, of great tenderness; and in his religious paintings, of profound spiritual feeling.

The last comprehensive study of the life and work of Van Dyck to be published in English appeared in 1900. Its author, Sir Lionel Cust, then Director of the National Portrait Gallery in London, was able to reap the rich harvest of the archival research of William Carpenter (published in 1844) and of the two important studies of the artist by Michiels and Guiffrey, which had both appeared in Paris in 1882. Cust outlined the circumstances of Van Dyck's life and discussed individual paintings and groups of paintings at length and often with great sensitivity. He was happiest when dealing with Van Dyck's English portraits, clearly his first love, and in writing on that part of Van Dyck's work I have been much indebted to his account. However, although he wrote so revealingly about particular paintings, the Victorian Director found certain aspects of the personality of the Baroque painter unsettling. Van Dyck was highly strung, temperamental and extravagant, and claimed the prodigy's right to be wilful, arrogant and haughty. He was not learned as the humanist painters of the Renaissance were; in fact, he was uninterested in classical culture and was intensely religious in the emotionally charged way of the Counter-Reformation. Cust was often out of sympathy with the man and this affected his consideration of Van Dyck's work, in particular his religious paintings. Indeed, unable to account for certain traits in Van Dyck's personality, he wrote of the 'feminine' side of his nature, by which

he meant to encompass his piety, emotionalism, vanity and volatility. I have referred to those aspects of Van Dyck's character that Cust found distasteful for I believe that Van Dyck's precociousness, religiosity, and love of court life all had a significant influence on the type of pictures he painted and the way in which he painted them. I have also set out to counter Cust's bias towards Van Dyck's English period by devoting relatively more space to his years in Flanders and Italy.

Just as Cust was able to benefit from the work of his immediate predecessors, so I have been able to take advantage, in writing this book, of numerous important studies on individual aspects of Van Dyck's work that have appeared since 1900. In particular, I should like to mention those of Horst Vey and Sir Oliver Millar, which have contributed enormously to our understanding of Van Dyck and the world in which he lived.

C.B.
London, 1982

1 The Young Van Dyck

In the Academy of Fine Arts in Vienna there is a remarkably accomplished self-portrait of Anthony van Dyck painted when he was about sixteen (Plate 2). The handsome, sensitive face with large eyes, long nose and full lips is framed by an unruly mass of curly hair. The boy's glance, over his right shoulder, is direct and self-assured. The collar of his shirt is indicated by a single bold stroke of white paint, applied with a deftness and confidence extraordinary in so youthful a painter. Such consummate technical assurance – and, one might add, such personal self-confidence – is a consistent feature of Van Dyck's work. For him the process of learning to paint, so gradual and so painful even for some of the greatest artists, was apparently effortless: he was quite simply a prodigy, a naturally gifted painter.

Anthony van Dyck was born in Antwerp, the seventh child and second son of a prosperous merchant, on 22 March 1599. His father Frans traded in silk, linen, wool and other fabrics between his native Antwerp and Paris, Cologne and London. After the death of his first wife he had married Maria Cuypers, Anthony's mother, in 1589. They occupied an imposing house known as the *Berendans* (The Bear Dance), just off the Grootmarkt in the very heart of the city. It had been purchased by Frans's father, from whom he had inherited both house and business. The family was a tightly-knit and pious one. In later life Anthony was particularly close to two of his sisters, Susanna and Isabella, both of whom entered a convent in Antwerp, and to his younger brother Theodoor, who became a priest. Their father was president of an important lay confraternity, the Confraternity of the Holy Sacrament, which had its own chapel in Antwerp Cathedral. These confraternities served both a religious and a social function, and Frans's position is evidence not only of his piety and public-spiritedness, but also of his high standing within the city's business community.

There was nothing in his father's family background to suggest that the young Anthony would make painting his career. His mother, however, who died when he was only eight years old, was a member of a family which may have included painters – there are a number of artists named Cuypers recorded on the membership rolls (*liggeren*) of the Antwerp painters' guild between 1575 and 1610. A certain artistic link is provided by the marriage of a relative of Anthony's mother, Paulina Cuypers, to the painter Jan Snellincx. Many of the city's artists were related by the intermarriage of the Snellincx, Brueghel, de Jode and de Wael families, all dynasties of painters and engravers. In 1600 the Brueghel dynasty was headed by the two sons of Pieter Bruegel the Elder – Pieter the Younger, who made a successful career by none too skilfully repeating his father's compositions,

and the far more talented Jan the Elder, who developed his father's approach to landscape in an entirely original manner. Jan's wife was Elizabeth de Wael, daughter of the painter Jan de Wael and sister of Lucas and Cornelis de Wael, both painters and dealers who settled in Genoa and were to be Van Dyck's hosts in that city. Jan de Wael's wife was a daughter of the engraver Gerard de Jode and de Jode's sister Helena had been Jan Snellincx's first wife.

It may have been this family connection with the almost incestuous world of Antwerp artists which caused the young Van Dyck to be marked out at an early age for a career as a painter. In 1609 the Dean of the artists' Guild of St Luke in Antwerp was Hendrick van Balen, and among the apprentices inscribed in the guild in that year was the ten-year-old Anthony van Dyck, entered by Van Balen himself. On the same day another *leerjonger*, Jooys Soeterman, was inscribed in the guild register as a pupil of Willem de Vos. As Justus Sustermans he was to be a very successful portraitist in the service of the Grand Duke of Tuscany (at whose court in Florence Van Dyck was to meet him again) and Marie de Médicis. A fellow-pupil of Van Dyck in the studio of Hendrick van Balen was Jan Brueghel the Younger, a close friend of Van Dyck throughout his early years.

Hendrick van Balen was a successful figure painter in a conservative Italianate tradition. He was a native of Antwerp, but his master is unknown. (Van Mander says he was a pupil of 'Adam van Oort' and this has been taken to refer to Adam van Noort, who was however a contemporary of Van Balen, not a member of an older generation.) Van Balen had lived in Italy for ten years after entering the guild as a master in 1593. There he studied Raphael and Michelangelo and returned home to paint idealized human figures in a manner which was a pale reflection of the Roman High Renaissance. He collaborated with landscape painters in mythological and historical scenes; the most distinguished of them was Jan Brueghel the Elder, the father of his pupil. Brueghel painted the landscape and Van Balen the figures in such small-scale mythological scenes as *Pan and Syrinx* (Plate 1).

Although Van Balen had no discernible influence on Van Dyck's earliest known paintings (or, for that matter, on his mature style) it was in his Antwerp studio that Van Dyck learnt the basic skills of his craft. As a young apprentice he would have had to grind pigments and prepare oak panels and canvases with gesso and other priming. He must have eventually progressed from such menial tasks to drawing from casts of antique statuary and from prints after Italian and Netherlandish paintings. No doubt Van Balen also had painted copies of both Italian and Flemish paintings in his studio which the young apprentices would copy. From simple copying apprentices graduated to painting the least important areas – drapery, distant landscape, and so on – in the pictures taking shape in the studio. Finally they would be allowed to work more or less independently in their master's manner and he would add the finishing touches.

Van Dyck was ten when he joined Van Balen. In 1615, when he was fifteen or sixteen, he is said to have already been established as an independent painter. This is most unusual, since the general practice in Antwerp was for apprentices to remain in their master's studio until they themselves entered the guild, which in Van Dyck's case was in February 1618. The evidence for Van Dyck's precocious independent activity is provided in the proceedings of a court case in 1660, which concerned the authenticity of paintings said to have been made by Van Dyck at this time. The thirteen paintings, which represented Christ and the Apostles, had been purchased by a certain Canon François Hillewerve on the advice of Jan Brueghel the Younger who told the court that he had been a close friend of Van Dyck during his early years in Antwerp. Hillewerve was claiming against the vendor, Pierre Meulewels, that they were not the work of Van Dyck. Two

1. Hendrick van Balen (*c.* 1575–1632). *Pan and Syrinx*. *c.* 1608. Copper, 25 × 19.4 cm. London, National Gallery.
Van Balen, an Italianate figure painter, frequently collaborated with other Antwerp artists who supplied the landscapes or the still-life in his pictures. Among his collaborators were Joos de Momper the Younger and Jan Brueghel the Elder and his son Jan Brueghel the Younger. In this small painting on copper it is difficult to be sure of the identity of Van Balen's colleague. The style of the landscape is similar to that of Jan Brueghel the Elder, but the execution is too leaden and it must be by one of his many followers or imitators. The picture has been dated to the years just before Van Dyck entered Van Balen's studio.

2. *Self-Portrait*. *c.* 1615. Panel, 25.8 × 19.5 cm. Vienna, Academy of Fine Arts.
This is Van Dyck's earliest self-portrait, painted when he was only about sixteen. He is said to have been already established as an independent painter by this time, but such an early end to his apprenticeship with Van Balen would have been most unusual. However, as this self-portrait reveals, there can be no doubt of his precocious skill as a painter.

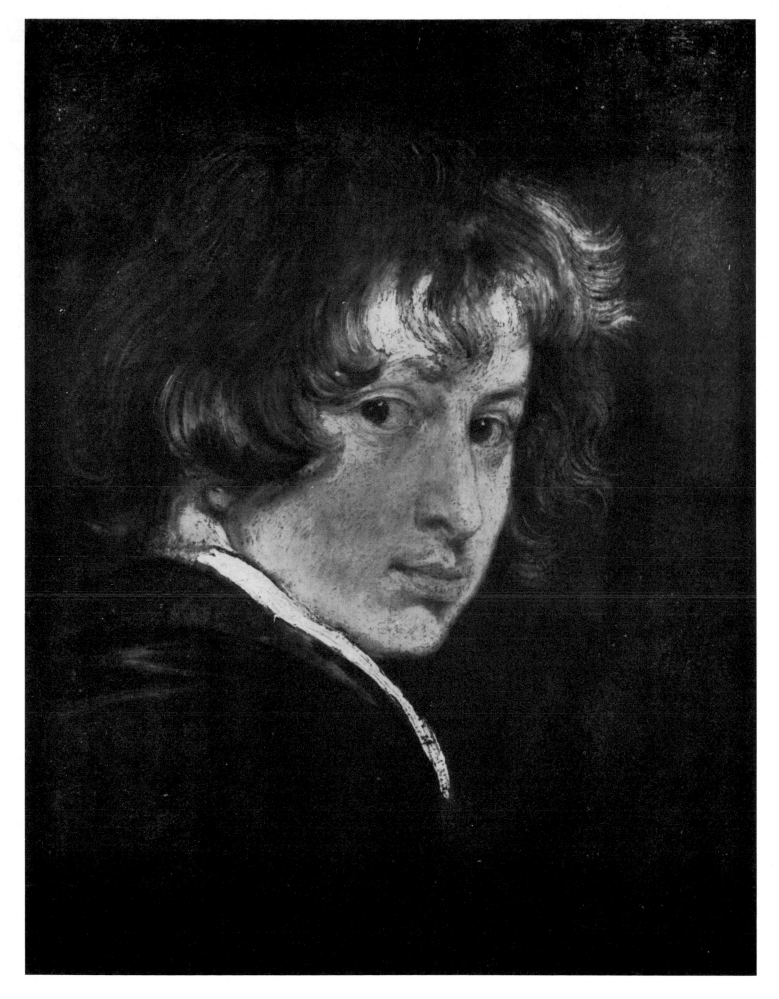

painters, Herman Servaes and Justus van Egmont, testified that they had painted the pictures, which had then been merely retouched by Van Dyck. On the other hand an old man, Willem Verhagen, stated that he had commissioned the pictures from Van Dyck 44 or 45 years before and that he had seen Van Dyck at work on them. Verhagen claimed that the panels had been admired in his house by many artists, including Rubens. Nevertheless, other painters, notably the aged Jacob Jordaens, testified on Hillewerve's behalf that the paintings were copies.

This case provides our only real knowledge, apart from a number of surviving paintings, of Van Dyck's earliest years as a painter; however, the evidence is contradictory. It is important to remember that the case was brought to court half a century after the events it concerned and that much turned on the memory of a very old man. However, a few relatively secure facts do emerge. At a very early age – in 1615 or 1616 if Verhagen is to be believed – Van Dyck set up an independent studio in a house in Antwerp known as the *Dom van Keulen* (the Cathedral of Cologne). Servaes and Van Egmont were also working there, apparently as his assistants. Servaes was two years younger than Van Dyck and Justus van Egmont gave his date of birth as 1601. Among the pictures painted by Van Dyck at this time was a series of thirteen panels representing Christ and the Apostles.

In 1616 Van Dyck, with his father's consent, took action against the guardian who administered the estate of his grandmother; why this should have been necessary and how the case turned out is unknown. The next firm date, after his entry into Van Balen's studio, that is of significance in tracing the painter's early career is 11 February 1618, when he was received as a master into the Guild of St Luke. Four days after this Van Dyck's father acknowledged his son's coming of age. The next we hear of him is two years later, in the contract drawn up between Peter Paul Rubens and the Rector of the Jesuit Church in Antwerp. Van Dyck was the only assistant to be mentioned by name in Rubens' undertaking to provide the ceiling paintings for the Church.

As has been stated already, it would have been most unusual for a young Flemish painter to have left his master's studio three or four years before he entered the guild as a master. Entry into the guild was required before a painter could sell his work in any Netherlandish town, although it is difficult to know how stringently this regulation was enforced in Antwerp. Rubens had not only remained in the studio of his master Otto van Veen until he entered the guild but had then continued there for two more years, working as an assistant. It is possible, therefore, that after fifty years had elapsed Verhagen's memory was at fault and that Van Dyck was not quite the prodigy that his testimony suggests. It may be that the *Dom van Keulen* period was 1618–1620, after Van Dyck had entered the guild but before he went to join Rubens' workshop as the senior assistant on the Jesuit Church project. Van Dyck's earliest dated paintings that survive are from 1618.

It is clear from the 1660 court proceedings, however they are interpreted, that among Van Dyck's very earliest works was a series of panels showing Christ and the Apostles. A number of extant paintings have been identified with these. The arguments are complex – at least three possible series have been suggested – but the most likely candidates for the set sold to Hillewerve are the paintings which today hang in the castle at Aschaffenburg. If these are Hillewerve's set, then he was right in his claim, for although they bear the brand of the city of Antwerp on the back, they are the work of copyists or imitators of Van Dyck. The originals are scattered throughout the world in museums and private collections; the largest group is at Althorp House in Northamptonshire, where there are five

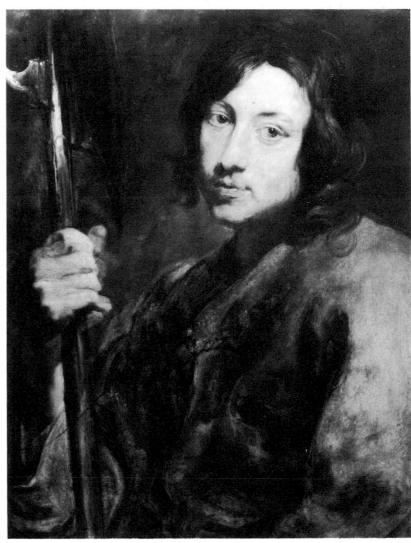

3. *St Simon. c.* 1618. Panel, 64 × 48 cm. Althorp House, Northamptonshire, Collection of the Earl Spencer.

4 (Right). *St Matthew. c.* 1618. Panel, 64 × 48 cm. Althorp House, Northamptonshire, Collection of the Earl Spencer.

We know from documents that a series of panels showing Christ and the Apostles was among Van Dyck's earliest works. There are a number of surviving contenders, and it is quite possible that Van Dyck painted more than one series, but among the very best are five paintings of single Apostles at Althorp. Each saint is shown in half-length, carrying his attribute. The series displays the strong influence of Rubens and reveals none of the precise handling of Van Balen.

Apostles (Plates 3, 4). The inspiration for a series of this type came from Rubens, who in about 1610 had painted busts of Christ and the Apostles for Philip IV of Spain's chief minister, the Duke of Lerma. Van Dyck would have seen studio replicas of that series in Antwerp and he modelled his own on them. In both series each Apostle is strongly characterized. Van Dyck emphasizes the forceful, idealized features with a strong fall of light from the top left and each Apostle holds his particular attribute – St Peter his keys, St Bartholomew the knife with which he was flayed, St Andrew the wooden cross upon which he was martyred, St John the Evangelist his chalice, and so on. Christ carries his cross and displays the wounds in his side and left hand. The garments are simplified in order not to distract attention from the faces, hands and attributes; the draperies are broadly painted with richly coloured highlights and deep shadows. The faces themselves are boldly described while the hair and beards are more carefully indicated, with individual strands and curls drawn in with a fine brush.

In the Christ and the Apostles series, as in the rest of Van Dyck's early work, the paramount influence is not that of his teacher Van Balen, but of Rubens, who after his return from Italy in 1608 had soon established himself as the leading painter of religious subjects in the city. The years of Van Dyck's apprenticeship were exciting ones for a young artist in Antwerp because it was at this time that Rubens burst upon the city's artistic scene with a series of altarpieces of startling originality.

Van Dyck and Rubens

Peter Paul Rubens, born in 1577, received his early training in the Antwerp studio of Adam van Noort, a classicizing figure painter and portraitist in the tradition of the city's leading Italianate painter of the sixteenth century, Frans Floris. In 1596 Rubens left Van Noort and went to work with Otto van Veen. Van Veen had travelled to Italy and absorbed the styles of Raphael and Michelangelo, painting stiff, provincial adaptations of their work on his return. He was a learned humanist, a fervent Catholic and a loyalist who had close connections with the court of the Spanish regents in Brussels. In these respects Rubens' personality and career were to echo those of Van Veen. Rubens entered the Antwerp guild as a master in 1598 but remained for two further years in Van Veen's studio, assisting in the preparations for the triumphal entry of the new Spanish governors, the Archdukes Albert and Isabella, into Antwerp in 1599. On this occasion the city was decorated with lavish and elaborate temporary architecture – arches and screens – which in allegorical fashion welcomed the Archdukes and at the same time called attention to Antwerp's sad economic plight, which had been brought about by the continuing war with the northern provinces.

In 1600, the year after the Archdukes entered Antwerp, Rubens set off for Italy. In crossing the Alps he was following a century-old tradition according to which Netherlandish artists, among them both of Rubens' own teachers, completed their training with a stay in Italy. Soon after his arrival there Rubens entered the service of the Gonzaga Duke of Mantua. He received disappointingly few artistic commissions from Vincenzo, but the Duke, recognizing the young man's diplomatic skills, entrusted him with a mission to the King of Spain in 1603. Later Rubens spent several years in Rome, where he obtained, 'against the claims of all the best painters of Rome', as he wrote himself, a major commission – the altarpiece for the High Altar of the Chiesa Nuova, which was the name given to S. Maria in Vallicella, the church of the Oratorians. His first version was unsuccessful because, as he wrote, 'The light falls so uniformly on it that one can hardly discern the figures, or enjoy the beauty of the colouring and the delicacy of the heads and draperies, which I executed with great care, from nature, and completely successfully, according to the judgement of all.' (Plate 5.) During the summer of 1608 Rubens worked on a replacement: instead of a single altarpiece with the figures of six saints and a representation of the Madonna della Vallicella in a restricted format, he painted three separate pictures, on slate to avoid the dazzle of reflected light, with the saints moved to the two side paintings. With this arrangement the composition was not so cramped. The Madonna della Vallicella, an image of the Virgin believed to possess the miraculous power to staunch bleeding, was shown supported by *putti* and adored by angels in the central painting. On the left St Gregory in a richly decorated chasuble, his papal tiara held by an angel, is flanked by Sts Maurus and Papianus, in armour, crowned with wreaths by flying angels and holding palms of martyrdom. On the right hand of the altar, St Domitilla, wearing a crown in her braided hair, stands between Sts Nereus and Achilleus. All three carry palms and are crowned with floral wreaths by flying angels. The three paintings make up a magnificent *ensemble*: the compositions are spacious and well-integrated, the handling fluid and assured. It is a measure of the value of his years in Italy to the young Rubens that he had progressed from tentative, Flemish interpretations of Raphaelesque designs such as the *Adam and Eve*, which is today in the Rubenshuis in Antwerp, to the successful completion of a large-scale Italian altarpiece, one of the most sought-after commissions in early seventeenth-century Rome.

Very soon after completing the Chiesa Nuova altarpiece Rubens returned to Antwerp. His sudden departure from Rome was prompted by the news of the serious illness of his mother and in the letter which he wrote to the secretary of the Duke of Mantua explaining his haste, he promised to return to Italy and to the Duke's service as soon as he could. In fact Rubens was never to return to Italy. Sadly, despite his speed, the dash to his mother's bedside was in vain. By the time he arrived in Antwerp she had been buried in the church of the abbey of St Michel. In the chapel in which she was buried Rubens erected an altar on which he placed the first version of the Chiesa Nuova altarpiece which, despite energetic salesmanship, he had been unable to dispose of to the Duke of Mantua; it was consecrated on Michaelmas Day, 1610. This altarpiece was one of the first of Rubens' works to be shown in a prominent position in Antwerp and it must have been studied with the greatest interest by the young Van Dyck. Rubens had employed the familiar High Renaissance formula of the *sacra conversazione* – saints grouped in adoration around or beneath the Virgin and Child, close to and yet apparently oblivious of one another. The arrangement had been used by both Raphael and Titian and in this particular case Rubens' model was Titian's *Virgin and Child in Glory with Six Saints* which he had seen in the Church of the Frari in Venice. (Today it hangs in the Vatican Museum.) Rubens' profound debt to the Antique is also clear – the figure of St Papianus, the second from the left, is based on the famous statue of Mars Ultor, now in the Capitoline Museum in Rome.

Rubens' return to Flanders in 1608 came at a moment when it seemed that the nightmare of war and suffering through which the country had passed might be coming to an end. Forty years earlier the Netherlandish provinces of the great Habsburg empire had rebelled against their ruler Philip II of Spain. The causes, religious and economic as well as political, were complex, and the first political events of the Revolt were accompanied by an outbreak of iconoclasm in 1566. Beginning with isolated acts of destruction of religious images in the country, the movement gathered force until in August it reached Antwerp, where it exploded into a protracted orgy of violence. The iconoclasts' enthusiasm may have been fired by political or economic motives – the frustration of the politically powerless and the economically under-privileged – but the justification was religious: Calvinist revulsion against the cult of saints and the use of images. Stained glass windows, sculpture and painted altarpieces were destroyed and the general dislocation encouraged widespread looting and wanton violence.

Following the outbreak of the Revolt and the iconoclastic fury, Philip despatched a powerful army, which under the vigorous generalship of the Duke of Alva had dispersed the rebel armies by 1568. Nevertheless, the spirit of defiance was kept alive by a fleet of armed ships manned by Calvinists known as the Sea Beggars, and by the House of Orange. The Revolt which Philip must have thought easily crushed had repercussions which were to cripple the Spanish Empire for eighty long and bitter years and to end at last in humiliating defeat.

Antwerp, which in the first half of the sixteenth century had been a rich and rapidly expanding commercial city, went into a slow but steady decline as its position as the economic heart of the Netherlands was usurped by Amsterdam, capital of the province of Holland. Alva used Antwerp as the base for his operations against the rebels; after the mutiny of the Spanish troops garrisoned there in 1576, however, the city became a strong supporter of the rebel cause. It was not until 1585, after a siege of over a year, that the city was in Spanish hands again. Thereafter Antwerp was a Spanish stronghold, even in the darkest days of the Eighty Years' War. After its reconquest Antwerp revived but never regained its former pre-eminence.

5. Peter Paul Rubens (1577–1640). *The Madonna della Vallicella*. 1607. Canvas, 477 × 288 cm. Grenoble, Musée des Beaux-Arts.
This is the first, rejected, version of the Chiesa Nuova altarpiece. Having failed to sell the painting to the Duke of Mantua, Rubens took it back with him to Antwerp in 1608 and placed it above his mother's tomb in the Abbey Church of St Michel. It was removed by the Napoleonic armies, exhibited in the Louvre and subsequently placed in the museum in Grenoble. When the contents of the Musée Napoleon were returned to their owners, this altarpiece remained in Grenoble.

In 1608 an end to the war seemed in sight. Just before his death in 1598, Philip II had decreed that although Spain and the rest of his Empire were to pass directly to his son Philip III, the Netherlands were to be the dowry of his daughter Isabella, who was to marry her cousin Albert. An experienced administrator, Albert had been governor-general in Brussels since 1595. The marriage took place in May 1599 and the Archdukes, as they were known, entered Brussels as sovereign rulers in September. Their independence of Spain was not absolute: they needed Spanish consent to make war or peace, and there were Spanish garrisons which took their orders directly from Madrid in all the principal towns of Flanders. However, Albert and Isabella did have considerable freedom of action, and achieved, in the eyes of their subjects, a measure of independence from Spain. Albert's first action on his return to Brussels after his marriage was to re-open peace talks with the Dutch, though it was not until 1607 that, at his instigation, an informal truce was arranged between Flanders and the United Provinces. The subsequent negotiations between the two sides were lengthy and complex, bedevilled by Spanish intransigence and Dutch suspicion, and it was two years before a formal truce was declared, in April 1609. It was to last only twelve years, but at the time it seemed to be the first step towards a permanent peace.

Unfortunately, the truce did not bring about the hoped-for economic revival of Antwerp. A fascinating glimpse of the city during the years of the truce is contained in a letter written by Sir Dudley Carleton, who passed through on his way to take up his appointment as British Ambassador in The Hague in September 1616: '... we came to Antwerp, which I must confess exceeds any [town] I ever saw anywhere else for the beauty and uniformity of its buildings, height and largeness of streets, and strength and fairness of the ramparts. ... I must tell you the state of this town in a word so as you take it literally, *magna civitas magna solitudo*, for in the whole time we spent there I could never set my eyes in the whole length of a street upon 40 persons at once; I never met coach nor saw man on horseback; none of our company (though both were workdays) saw one pennyworth of ware either in shops or in streets bought or sold. Two walking peddlers and one ballad-seller will carry as much on their backs at once as was in that royal exchange either above or below. . . . In many places grass grows in the streets, yet (that which is rare in such solitariness) the buildings are all kept in perfect reparation. Their condition is much worse (which may seem strange) since the truce than it was before, and the whole country of Brabant was suitable to this town, *splendida paupertas*, fair and miserable.'

In 1609, however, the truce created a mood of great optimism in Flanders. Rubens was one of a number of idealistic young men – others were his elder brother Philip and his friend Jean Richardot the Younger – who saw a chance to rebuild their war-torn country. 'When he returned to Flanders', the earliest life of Rubens records, 'his fame had already spread far and wide, and the Archdukes Albert and Isabella, who wished to be painted by him, appointed him court painter and bound him by chains of gold lest he return to Italy, whither the high prices paid for his pictures might attract him.' The chains of gold were literal rather than figurative – Rubens received a gold chain with a gold medal depicting the Archdukes shortly after his appointment as court painter, an appointment which Van Dyck was also to receive after his own return from Italy. The terms on which Rubens was engaged by the Archdukes were generous: he received the sum of 500 florins a year and, apart from the Archdukes' portraits, he was paid separately for any paintings commissioned by his royal patrons. His position exempted him from taxes as well as from various obligations (such as the need to register his pupils) imposed on members of the guild of St Luke and he was not required to move from Antwerp to the court in Brussels.

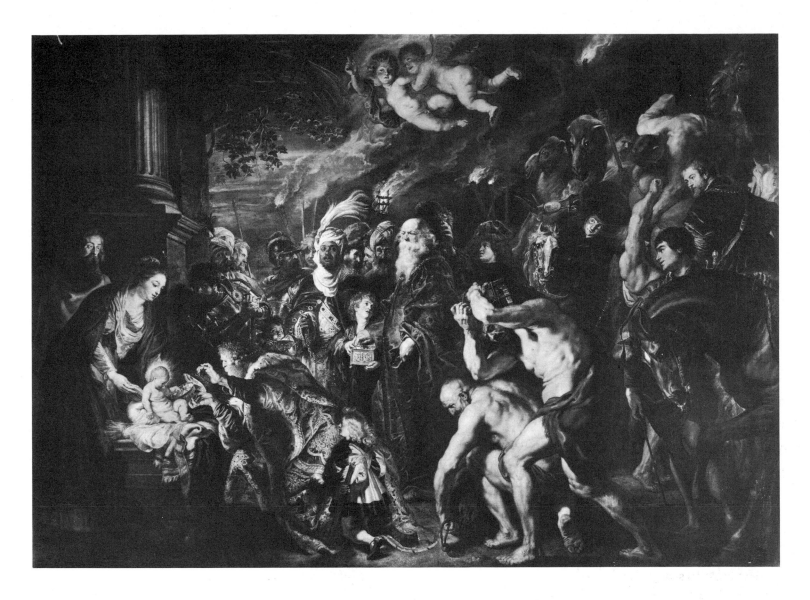

6. Rubens. *The Adoration of the Kings*. 1609. Canvas, 346 × 488 cm. Madrid, Prado. Painted for the *Statenkamer* in the Town Hall of Antwerp, it was presented by the city burgomasters to the Spanish ambassador, Rodrigo de Calderon, in 1612. It subsequently entered the collection of King Philip IV of Spain. When Rubens was in Madrid in 1628/9 he reworked parts of the canvas and added a large section on the right hand side, which includes a prominent self-portrait.

One of Rubens' very first commissions after his return from Italy was for a large-scale *Adoration of the Kings*, to be placed in the *Statenkamer* in Cornelis Floris's great Town Hall at Antwerp. He created a vivid, crowded scene, richly coloured and full of movement (Plate 6). Individual figures were taken from the small cabinet paintings of Adam Elsheimer, the German painter whom he had known in Rome, and reproduced in near life-size. The prominent location of the *Adoration of the Kings* drew attention to its young artist and Van Dyck, accustomed to the small-scale, timid, and over-elaborate compositions of Van Balen, must have found Rubens' strong, broad strokes of colour and his flashes of light amid darkness breathtaking.

In the following year Rubens began the first of two monumental altarpieces which made his reputation in Antwerp – *The Raising of the Cross* for the Church of St Walburga. This commission was apparently secured for him by Cornelis van der Geest, a churchwarden of St Walburga's and one of the church's principal benefactors. He later became an important patron of Van Dyck. The *Raising* (Plate 7) was probably finished by late 1611 and soon afterwards was placed on the principal altar of the church. The altar was approached by nineteen steps and the position of the altarpiece, towering above the nave, was particularly dramatic. The central panel depicts the Raising of the Cross; the landscape background and, to a lesser extent, the figure groups, extend to the wings and so the triptych forms a unified composition. On the left wing are the Virgin and St John with a group

of grieving women and children and on the right Roman officers and the two thieves being prepared for execution. On the reverse of the wings are the figures of four saints who were especially venerated in Flanders: on the left, Sts Amandus and Walburga, and on the right, Sts Eligius and Catherine. They recall the standing saints of the Chiesa Nuova altarpiece.

The second great altarpiece was *The Descent from the Cross* (Plate 9), the commission for which Rubens was offered in March 1611 when he was still at work on *The Raising*. The contract was signed in September and exactly a year later the central panel left Rubens' studio to be installed above the Harquebusiers' altar in the transept of Antwerp Cathedral. The wings were not in place until March 1614 and the altar was consecrated in July. Unlike the *Raising*, the central panel was sharply differentiated from the two wings – on the left, *The Visitation* and on the right, *The Presentation in the Temple*. When closed, the outer wings showed St Christopher, the Christ-Bearer, and it is the theme of Christ-bearing that unifies the subjects of the various parts of the triptych.

It is useful to outline Rubens' working method in creating these altarpieces because Van Dyck adopted his procedures – though with significant variations – in his own religious paintings. Rubens' first task was to work out the general composition of the altarpiece by means of preliminary drawings. None survives for the *Raising*, but the idea for the design of the central panel of the *Descent* can be seen for the first time in a drawing in the Hermitage (Plate 8). This, in a Latin

7. Rubens. *The Raising of the Cross*. 1610–11. Panel, 462 × 341 cm. (central panel); 462 × 150 cm. (side panels). Antwerp, Cathedral.
The great triptych of the *Raising*, painted for the Church of St Walburga, is now to be seen in the crossing of Antwerp Cathedral beside the *Descent*.

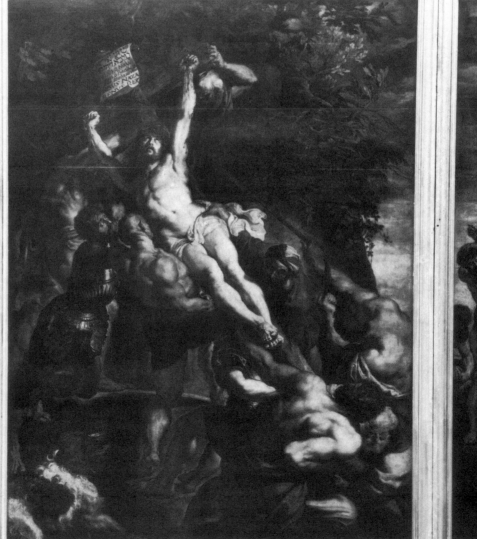

8. Rubens. *The Descent from the Cross*. 1611.
Pen and wash, 43.7 × 38 cm. Leningrad,
Hermitage.

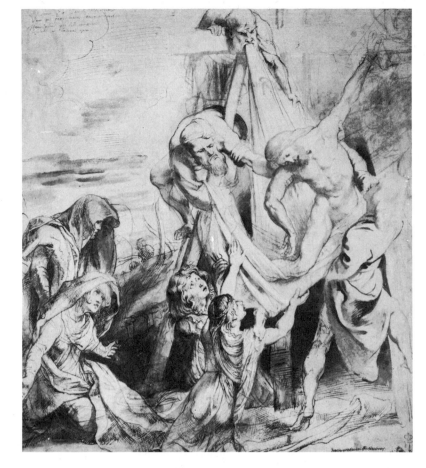

9. Rubens. *The Descent from the Cross*.
1611–14. Panel, 420 × 310 cm. (central
panel); 420 × 150 cm. (side panels). Antwerp,
Cathedral.
Painted just after the *Raising*, the triptych of
the *Descent* was in place in the Cathedral by
March 1614.

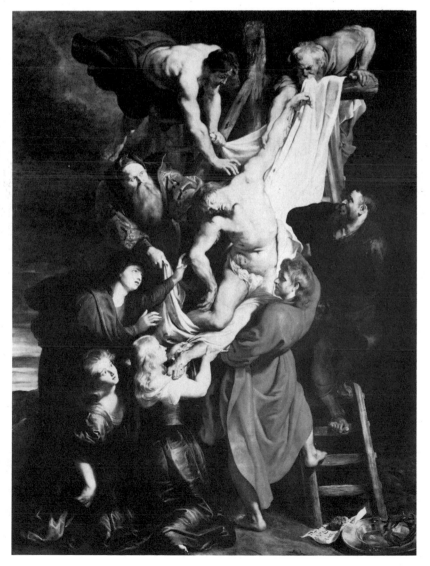

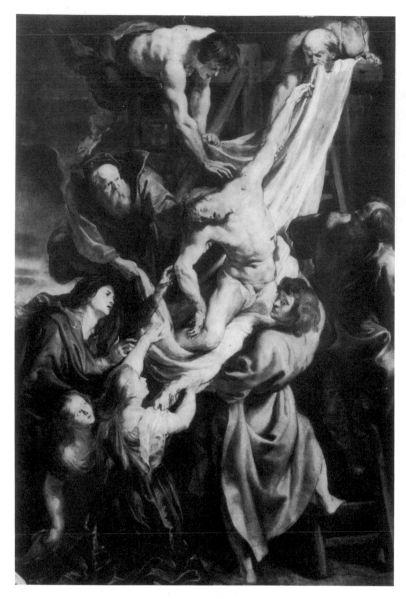

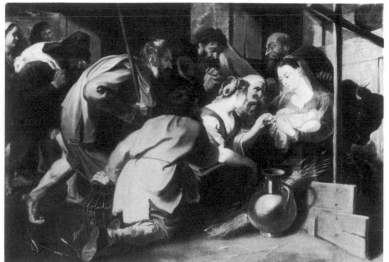

10. Rubens. *The Descent from the Cross*. 1611. Panel, 114 × 76 cm. London, Courtauld Institute Galleries.
This is the oil *modello* for the central panel of the triptych of *The Descent from the Cross*. Such *modelli* would be shown to the patrons – in this case, the officials of the Antwerp guild of Harquebusiers – before the final contract for the altarpiece was signed.

11. *The Adoration of the Shepherds*.
c. 1616–18. Canvas, 111 × 161 cm. London, Courtauld Institute Galleries.
As often happens with Van Dyck's early paintings, there is a second, slightly larger, version of this composition, in this case at Potsdam.

inscription in Rubens' own hand, acknowledges that the two figures on ladders lowering the body of Christ are taken from a fresco of the same subject by Daniele da Volterra, a pupil of Michelangelo, in S. Trinita dei Monti in Rome. The next stage was the painting of a *modello*, a small-scale coloured oil sketch which the artist showed to his patrons for their approval before the contract was signed. An oil sketch of this kind was an Italian convention – used, for example, by Tintoretto and Barocci – which Rubens had adopted. *Modelli* for both altarpieces survive: the principal elements of the final composition are all present, but some minor changes (such as the position of Mary Magdalen's left hand in the *Descent*; Plate 10) were made by Rubens as the altarpieces were taking shape on the panels. After the *modello*, Rubens made drawings from the life for individual figures: for these he posed models in the studio. There are, for instance, several surviving drawings in black chalk for the figure of the crucified Christ in the *Raising*. Finally, he began to paint the huge oak panels themselves, having first drawn the outlines of the composition on them in charcoal. After the completion and installation of the finished work Rubens, who was very conscious of the commercial possibilities of the graphic media, commissioned Lucas Vorsterman to engrave both compositions. The *Descent* was engraved in 1620 but soon afterwards Vorsterman, a difficult, neurotic though prodigiously gifted artist, fell out with Rubens and it was not until 1638 that Hans Witdoeck engraved the *Raising*, with a posthumous

dedication to Cornelis van der Geest 'the best of men and my oldest friend, who, since my youth, has been my never-failing patron, and whose whole life showed a love and admiration of painting'. These prints were widely distributed outside Antwerp: not only did they make money for Rubens but they also acted as advertisements to potential patrons and exerted a profound influence on contemporary painters. Rembrandt's *Descent from the Cross*, for example, painted in about 1635 for Prince Frederik Henry of Orange, clearly reflects his study of Vorsterman's print after Rubens' altarpiece.

The two great altarpieces, which effected a virtual revolution in painting in Antwerp and which made a deep impression on the young Van Dyck, have been said to illustrate two different aspects of Rubens' art, the 'Baroque' and the 'Classical'. This is unduly simplistic, but it is true that the two are organized on different principles: the *Raising*, with its highly dramatic, diagonal composition, forcefully illustrates an action which is still going on, while the *Descent*, although the action taking place within it is not complete, appears to catch a quiet moment suspended in time. Some of these qualities of drama and repose Rubens derived from the sources he drew upon, although he has entirely absorbed them within his own idiom. Tintoretto's *Raising of the Cross* in the Scuola di San Rocco in Venice is an important prototype for Rubens' treatment of the subject, but he was also aware of a classical sarcophagus relief (representing the Raising of a Herm of Dionysus) from which he took both the general scheme of the composition and a number of specific elements. In the *Descent* Rubens also refers to the Antique: the body of Christ echoes that of Laocoon in the Hellenistic group which since its discovery in Rome in 1506 had been greatly admired for its representation of pathos and suffering and which Rubens had carefully copied during his stay in the city. The *St Christopher* reveals his study of the Farnese *Hercules* which he had also seen in Rome. In the *Raising* and the *Descent*, with their profound absorption of Antique and High Renaissance elements into an entirely original interpretation of the events of the Passion, Rubens is seen at one of the first great creative moments of his remarkable career. Even works like the Chiesa Nuova altarpiece can be viewed as part of an extended apprenticeship when placed beside the two Antwerp altarpieces, in which the painter is speaking for the first time with true, individual authority.

Van Dyck cannot have failed to be excited by Rubens' reinvigoration of the largely derivative tradition of painting in Antwerp. His apprenticeship with Van Balen formally ended with his entry into the Guild of St Luke as a master in February 1618, but as has been seen, it is possible that he had been working as an independent painter for some time previously. There can be no doubt that in the years immediately before his entry into the guild Van Dyck was moving further and further into the orbit of Rubens: his work at this time shows no trace of Van Balen's tight, intricate and small-scale style, but is heavily influenced by Rubens' broad, bold and powerful manner. A painting which shows Van Dyck labouring with uncharacteristic clumsiness to emulate Rubens' style is *The Adoration of the Shepherds* (Plate 11). The viewer can sense the young painter, whose precocious skill is evident in areas like the heads of the shepherds, struggling to compose on a large scale and to abandon the meticulous technique in which he had been trained in favour of a far looser and freer application of paint and definition of forms.

Very soon after his entry into the guild Van Dyck was to learn to paint in this manner from the master himself. In a letter of May 1618 Rubens wrote that 'I have made some cartoons [for tapestries] which are very sumptuous at the request of some Genoese gentlemen; they are now being worked.' These cartoons, the

subject of which Rubens identified as 'the history of Decius Mus the Roman consul who devoted himself to the victory of the Roman people . . .', were almost certainly made for the Pallavicini family. Today they are in the collection of the Prince of Liechtenstein at Vaduz (Plate 12). There are eight cartoons from which the tapestries were woven: six tell the story of the heroic Roman consul who, prompted by a dream, sacrificed his life in battle for the sake of victory. In the Life of Van Dyck which is included in his *Lives of the Artists*, published in Rome in 1672, Giovanni Pietro Bellori states that these cartoons were painted by Van Dyck. Bellori is on the whole a reliable source. Much of his information came, he tells us, from Sir Kenelm Digby, a close friend of Van Dyck during his years in England, who was in Rome in the mid-1640s. Bellori's statement is apparently confirmed by the deathbed testimony of the painter Gonzales Coques, who declared in 1682 that he owned 'certain pictures of Decius, painted by Van Dyck after sketches by Rubens'. Coques' paintings can almost certainly be traced to the Prince of Liechtenstein's Palace of Cleves in the eighteenth century.

The invention in the Decius Mus series is Rubens' own: after the initial draw-ings, he painted small oil sketches and then larger detailed *modelli* (Plate 13) from which the full-scale cartoons would be made. The cartoons, painted on canvas in oils, are the same size as the finished tapestries and served to guide the weavers. The enlargement of the compositions of Rubens' oil sketches into the tapestry cartoons provided an ideal opportunity for Van Dyck to study and perfect Rubens' technique. The cartoons would presumably have taken shape in the studio under the master's eye. It was Rubens' usual practice to go over tapestry cartoons with his own hand before they left the studio, and he probably did so in this case. However, the cartoons are largely the work of Van Dyck. The tentativeness which can be detected in *The Adoration of the Shepherds* has quite

12. *The Death of Decius Mus.* 1618–20. Canvas, 288 × 519 cm. Vaduz, Collection of the Prince of Liechtenstein.
According to Bellori in his life of Van Dyck, the cartoons for the tapestry series showing scenes from the life of the Roman consul Decius Mus were painted by Van Dyck from Rubens' *modelli*. Van Dyck was in Rubens' studio at the time work was under way on the series (*c.* 1618–20), and the cartoons possess a vigour of execution that suggests the young Van Dyck.

13. Rubens. *Decius Mus relating his Dream*.
1618–20. Panel, 80.7 × 84.5 cm. Washington
D.C., National, Gallery of Art.
One of Rubens' oil *modelli* for the *Decius
Mus* tapestries.

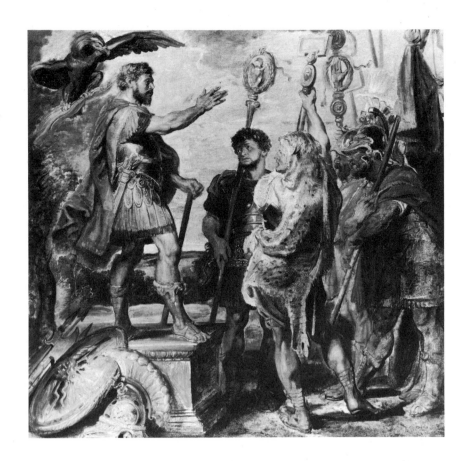

disappeared: under Rubens' direction, Van Dyck painted with bold strokes of a heavily-laden brush while at the same time supplying sufficient detail for the weavers to follow.

Subjects from Roman history were especially close to Rubens' heart: he was well read in the story of Rome, had a great admiration for the Roman state and, as we know from his correspondence, possessed an extensive knowledge of Roman dress and domestic utensils. In the Decius Mus series he combined archaeological exactitude with the vivid imaginative power of a historical novelist. His immense knowledge is evident in the carefully observed detail in *The Burial of Decius Mus*, for example, and yet the scene is a lively recreation of a historical event.

The Decoration of the Jesuit Church in Antwerp

Following the successful completion of the Decius Mus cartoons, Van Dyck was invited to join Rubens on the greatest ecclesiastical project in Flanders – the decoration of the Jesuit Church in Antwerp, which was then being built. The Jesuits were closely associated with the Counter-Reformation movement, the Catholic revival which laid stress on just those elements of dogma and worship which had been so strenuously attacked by the leaders of the Reformation, the importance of ritual and of the cults of the Virgin and the saints. The Jesuit College of Antwerp had been established in 1562 but was subsequently expelled from the city by the Protestants and did not return until 1585 with the conquering army of Alessandro Farnese. During the reign of the Archdukes, the Jesuit College was one of the most important intellectual and artistic centres in Antwerp. It was during the reign of Jacobus Tirinus as superior that the new church, the first to be dedicated to the founder of the Order, St Ignatius Loyola, who was canonized in 1622, rose to become the most splendid ecclesiastical building in

Flanders. The form chosen by the architect, Pieter Huyssens, a member of the Society, was that of an early Christian basilica, a decisive break with the Gothic style, which had lingered on lifelessly in The Netherlands. The decision was applauded by Rubens, who wrote in his treatise *Palazzi di Genova*, published in 1622: 'We can see that the style of architecture called barbaric or Gothic is gradually waning and disappearing in these parts; and that a few admirable minds are introducing the true harmony of that other style which follows the rules of the ancient Greeks and Romans, to the great splendour and beautification of our country; as may be seen in the famous temples recently erected by the venerable Society of Jesus in the cities of Brussels and Antwerp.'

The façade of the Jesuit Church in Antwerp, with its coupled pilasters, scroll-shaped buttresses, and niches for statuary, is based on the Gesù in Rome, the first church of the Order. The plan is a simple basilica with side aisles and three apses, but the interior elevation presented some notable innovations: the nave, instead of being roofed with traditional Gothic rib-vaulting, was covered with a wooden tunnel vault *all'antica*, decorated with gilt coffering and rosettes. The aisles were in two storeys and divided from the nave by a double arcade, the marble columns above being of the Ionic, and those below of the Tuscan order. Both the aisles and the galleries, or tribunes, had flat ceilings and it was here, in the ceilings of the aisles, and directly above, in the ceilings of the galleries, that Rubens' great sequence of thirty-nine paintings was placed.

By the time he signed the contract for the ceiling paintings, Rubens had already delivered two great altarpieces for the High Altar, *The Miracle of St Ignatius Loyola* and the *Miracle of St Francis Xavier*, which were to be displayed alternately. The formal contract for the ceiling paintings, which must have been planned early on since the flat ceilings were evidently intended to receive paintings, was drawn up on 29 March 1620. By its terms Rubens undertook to finish the thirty-nine paintings in less than a year: for each picture he promised to provide a small sketch (*teekeninge in't cleyne*) from which the full-scale paintings would be made by his assistants. Rubens himself would add the finishing touches as necessary. Attached to the contract is a list of the titles of the ceiling paintings. On the lower level there were to be sixteen saints; on the upper, biblical subjects, including nine scenes from the life of Christ with their Old Testament prototypes. In the contract only one of Rubens' assistants is mentioned by name, Anthony van Dyck; this gives us a measure of the unique position he occupied in the studio. In addition, the Jesuit Principal was 'to commission from Sr Van Dyck at a suitable time a painting for the aforementioned four side altars'. Apparently the suitable time never came, for Van Dyck seems never to have painted these altarpieces.

An unusual feature of the commission for the Jesuit Church ceilings within Rubens' work is the almost complete absence of preliminary drawings. Even allowing for the sketches having been lost, it is most unusual for Rubens that only two drawings for the ceiling paintings are known. It seems likely, therefore, that Rubens drew the designs directly onto small prepared oak panels. In these grisaille sketches, or *bozzetti*, the design was first drawn in black chalk and then gone over in brown oil paint, lightened with touches of white. The *bozzetti*, some of which survive (*The Flight of St Barbara* is in the Ashmolean Museum, Oxford), he then worked up into the coloured oil sketches or *modelli* which are referred to in the contract. Rubens' *modelli* were especially prized by his contemporaries, and indeed have continued to be so by collectors since his death, for *la gran prontezza e la furia del pennello* which Bellori praised so highly in his life of the artist. A particularly fluent and colourful example is the *Esther before Ahasuerus* (Plate 14), which, together with three other *modelli* for the Jesuit Church, is today in the

14. Rubens. *Esther before Ahasuerus. c.* 1620.
Panel, 48.8 × 47 cm. London, Courtauld
Institute Galleries.
Rubens' *modello* for one of the ceiling
paintings in the Jesuit Church. His principal
inspiration was Veronese.

Courtauld Institute Galleries in London. The system of ceiling decoration in the Jesuit Church, with canvases set within wooden compartments, is Venetian in origin, as is the extent of the foreshortening, which assumes an angle of vision of about 45 degrees. There are reminiscences of Titian's ceilings for S. Spirito in Isola (now in S. Maria della Salute), Tintoretto's decorations in the Scuola di San Rocco and in the Ducal Palace, but above all it was Veronese's ceiling in S. Sebastiano which was Rubens' inspiration. Here he had found the dramatic *da sotto in sù* effect which he employed so remarkably in the *Esther and Ahasuerus*. It was from the *modelli* that Van Dyck worked in painting the ceiling pictures themselves. The *modelli* are not squared up (that is, there is no grid of lines on them in order to assist in reproducing them on a larger scale) and so he must have painted by eye or else made intermediary drawings, though no such drawings survive.

Sadly, our knowledge of the appearance of the Jesuit Church ceilings depends on the *modelli*, the woodcuts made after them by Christoffel Jegher under Rubens' supervision and a set of early copies. On 18 July 1718 the Church was struck by lightning and the roof caught fire. The marble pillars of the nave collapsed, bringing down the side aisles. The façade was spared, as were the lateral chapels of St Ignatius and the Virgin Mary, the east end with its fine tower and, remarkably, the choir, with its two great altarpieces by Rubens. However, the Church's greatest glory, the thirty-nine ceiling paintings designed by Rubens and executed by Van Dyck and other assistants of the master, were destroyed.

While working on the Decius Mus and the Jesuit Church projects, Van Dyck would have been in Rubens' studio, which the artist had designed and had built adjoining his house on the Vaartstraat, just off Antwerp's central square, the Meir. There is a fascinating and vivid account of Rubens' studio at just this moment written by a Danish doctor, Otto Sperling, who visited Antwerp in 1621. The description is written in the third person:

> He visited the celebrated painter Rubens, and found the great artist at work. While still painting, he was having Tacitus read aloud to him, and was dictating a letter. When we kept silence so as not to disturb him with our talk, he himself began to talk to us, while still continuing to work, to listen to the reading and

15. *The Stigmatization of St Francis*. Black chalk with white highlights and brown wash, 51.8 × 35.2 cm. Paris, Louvre (Cabinet des Dessins).
This is one of a group of drawings after paintings by Rubens which are said to have been made by Van Dyck to guide the engraver. For this purpose they had to be precisely detailed and cannot therefore be usefully compared to his other early drawings, most of which are rough working sketches.

to dictate the letter, answering our questions and thus displaying his astonishing powers. After that he told one of his servants to show us over every part of his splendid house, in which we were shown the Greek and Roman antiquities, which he possessed in great quantity. We saw there also a large hall which had no windows but was lit through an opening in the ceiling [this was on the floor above the large studio]. In this hall were a number of young painters, all at work on different pictures, for which Rubens had made the drawings in chalks, indicating the tones here and there, which Rubens would afterwards finish himself. This work would then pass for a Rubens and so it was that he amassed an unheard-of fortune and was loaded with presents and jewels by princes and kings. About this time a new Church for the Jesuits was being built in Antwerp, and for this he executed innumerable paintings, some intended to cover the ceilings, others to adorn the walls and altars, which brought him in considerable sums. When we had seen everything, we returned to him, thanked him politely and took our leave.

According to Bellori, another of Van Dyck's duties in Rubens' studio was to make detailed drawings of the master's compositions which would then be given to the engravers for them to work from. In particular Bellori mentions an engraving of *The Battle of the Amazons*, and this is one of the subjects of prints currently being made after his paintings that are listed by Rubens in a letter of January 1619.

He returned to the question of engravings after his paintings in a letter of June 1622 when he apologized to his correspondent, Peter van Veen in The Hague, explaining that the delay in sending the prints had been caused by the engraver, who can be identified as Lucas Vorsterman, having had a mental breakdown. There are eight drawings in the Louvre that are copies after Rubens' paintings prepared as models for the use of engravers and these highly-finished black chalk drawings with brown wash and white highlights have been attributed to Van Dyck (Plate 15). None of them represents *The Battle of the Amazons*. It is very hard to be certain about the authorship of these sheets, although they were presumably made in Rubens' studio under the master's direction at the time when Van Dyck was there. Rubens himself probably touched them up, adding the white highlights. They are quite different from Van Dyck's other early drawings, which are for the most part rough, schematic working sketches. There is, however, some similarity with Van Dyck's technique when he came to make prints himself. Whether or not these particular drawings are by Van Dyck, the drawings he made for Rubens would have been of this type – precise in detail and with forms which in the paintings were created by colour tones here rendered by purely linear means.

Van Dyck as an Independent Painter

During these years, from the time he left Van Balen's studio until the completion of the Jesuit Church ceilings – that is, from about 1618 until 1620 – Van Dyck also painted a number of independent pictures. From his uncertain assimilation of Rubens' style in the *Adoration of the Shepherds* he very quickly progressed to paintings like the Brussels *Drunken Silenus* (Plate 17), which, although it is based on a Rubens composition and (as far as can be judged beneath the discoloured varnish) uses a Rubens palette, is already quite recognizable as the work of the young Van Dyck. This is distinguished, as will be shown, by a particularly scintillating technique, a boldness of composition and, when compared to Rubens, a lack of solidity and three-dimensionality in the forms. If the Brussels *Silenus* is compared to the Dresden version of the subject (Plate 18), painted by Van Dyck about two years later (around 1620), all these features of his art can be

16. Rubens and his studio. *Drunken Silenus*. *c*. 1620. Canvas, 133.5 × 197 cm. London, National Gallery.
There are a number of versions of this composition produced in Rubens' studio (the earliest seems to date from *c*. 1615). The foliage and fruit are by Frans Snyders and it has been suggested that Van Dyck was the artist of the figures. They possess, however, little of his scintillating surface treatment.

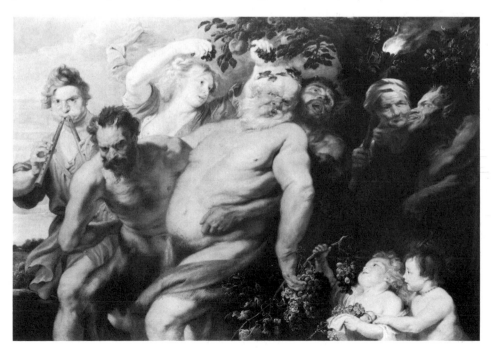

27

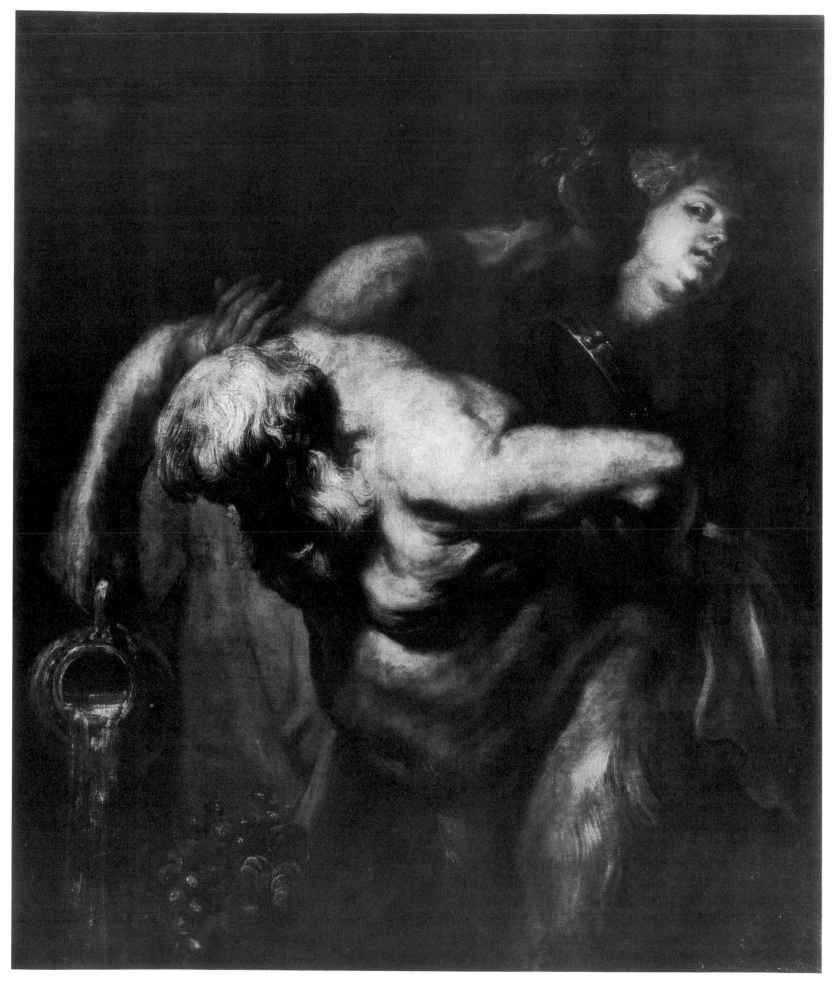

17. *Drunken Silenus. c.*1618. Canvas, 133 × 109 cm. Brussels, Musées Royaux des Beaux-Arts.
The picture is based on a composition by Rubens, yet when compared to Rubens' painting it reveals a lack of solidity and three-dimensionality in the forms that is characteristic of the young Van Dyck.

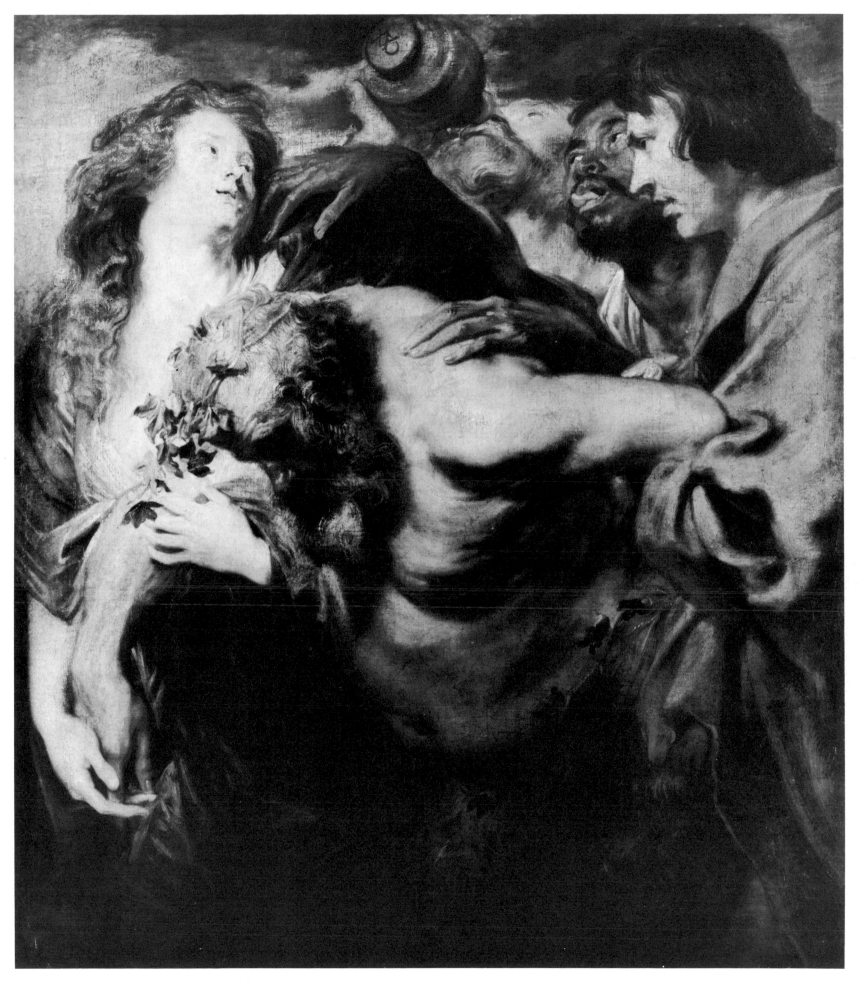

18. *Drunken Silenus. c.* 1620. Canvas, 107 × 91.5 cm. Inscribed on the bottom of the jug with the monogram AVD. Dresden, Gemäldegalerie.

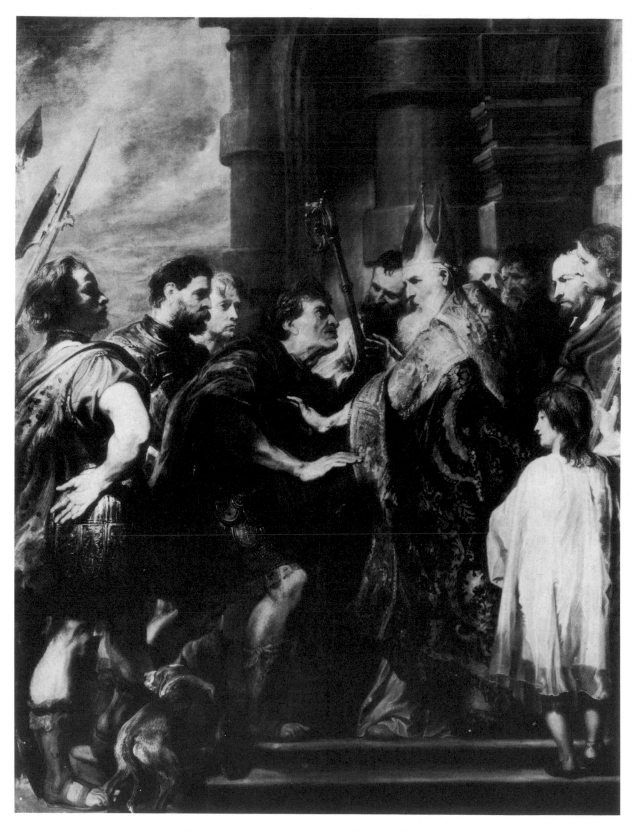

seen to have developed further: the technique is even freer and more assured, the palette has lightened and certain forms (in particular, the hand laid on Silenus's back) are suggested rather than described, while areas like the hair and beard of Silenus contain detailed brushwork. In Rubens' versions (for example, the studio painting in the National Gallery, London; Plate 16) the forms are far more substantial, almost tangible: there is a solidity of flesh that is absent from Van Dyck. This difference is very clear if Van Dyck's free copy of Rubens' *Emperor Theodosius refused Entry into Milan Cathedral* (Plate 19) is compared with the original

19. *Emperor Theodosius refused Entry into Milan Cathedral*. Canvas, 149 × 113.2 cm. London, National Gallery.
St Ambrose, Archbishop of Milan from AD 374, is said to have refused to allow Theodosius into the Cathedral because of the Emperor's massacre of the inhabitants of Thessalonica. This is a free copy by Van Dyck of Rubens' painting, which is now in Vienna. The head second from the right is said to be that of Nicolaes Rockox.

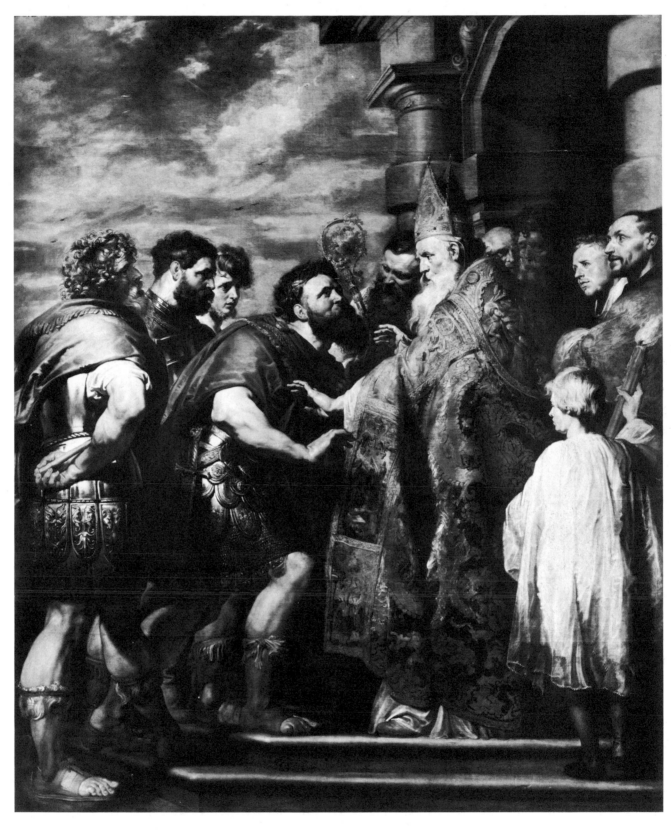

20. Rubens. *Emperor Theodosius refused Entry into Milan Cathedral*. Canvas, 362 × 246 cm. Vienna, Kunsthistorisches Museum.
It has been suggested that although the design of this composition is by Rubens, it was carried out by Van Dyck. In fact, the traditional attribution to Rubens himself is correct as a comparison with Van Dyck's free copy (Plate 19) makes clear.

in Vienna (Plate 20). In Rubens' painting the figures have weight and substance. Saint Ambrose, we feel, is capable of physically preventing Theodosius from entering the Cathedral. In Van Dyck's treatment, however, the encounter has lost that physical sense and the refusal has become an elegant ritual, at the centre of which is the delicate pattern made by the tapering fingers of the Emperor's and the Archbishop's hands. In Rubens' painting, Ambrose's cope is both weighty and elaborately patterned: in Van Dyck's, its thread of gold shimmers and appears to float on the very surface of the canvas.

A further valuable comparison in an attempt to define Van Dyck's early style can be made between his and Rubens' versions of the subject of *Samson and Delilah* (Plates 21, 22). Rubens painted the subject in about 1610, soon after his return from Italy, probably for Nicolaes Rockox, burgomaster of Antwerp. It is a highly-charged erotic painting, full of Italian memories. Rubens' study of the Antique and of Michelangelo is clearly reflected in Samson's superbly muscled back and arm; Michelangelo's *Notte*, which Rubens had drawn, inspired the pose of Delilah, and the use of three distinct light sources recalls Caravaggio and, perhaps even more strongly, Elsheimer. Yet there is no doubt that the painter had found his own quite individual artistic personality – the monumental composition, the profound characterization of Delilah, whose face and whose gesture with her left hand convey both triumph and pity, the rich application of paint (especially in the area of the central figures), the choice of a highly dramatic moment in the story, the unashamed eroticism – all these would continue to be features of Rubens' art. Rubens chose to illustrate the point in the narrative when one of the Philistines nervously begins to cut Samson's hair, in which the hero's strength lay, while he sleeps in Delilah's lap, exhausted after making love. The

21. Rubens. *Samson and Delilah. c.* 1610–12. Panel, 185 × 205 cm. London, National Gallery.
Painted probably for Nicolaes Rockox, the wealthy merchant and burgomaster of Antwerp whom Rubens described as 'my friend and patron' in a letter of May 1611.

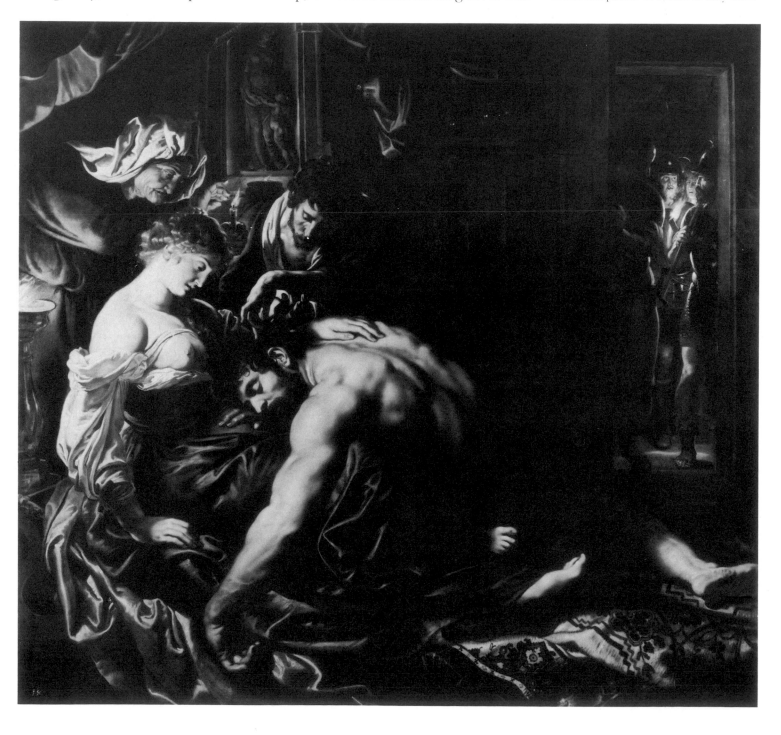

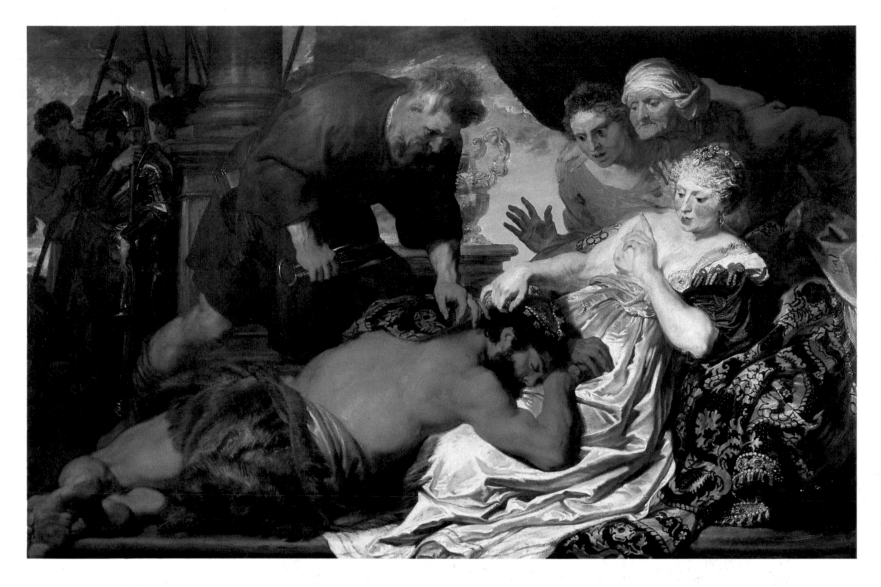

22. *Samson and Delilah. c.* 1620. Canvas,
149 × 229 cm. London, Dulwich College
Picture Gallery.

23. *Samson and Delilah. c.* 1620. Pen and
black chalk, 15.8 × 23.4 cm. Berlin-Dahlem,
Kupferstichkabinett.

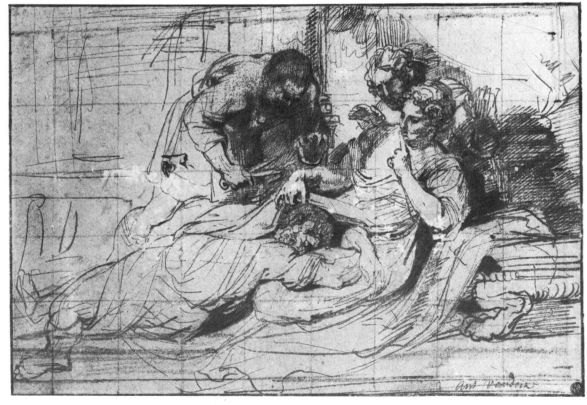

whole atmosphere is heightened by the room's deep shadows, while the dimly lit statuette of Venus and Cupid adds poignancy to Samson's downfall. The elderly woman does not appear in earlier representations of the subject, yet her presence here is entirely appropriate. She is a procuress. The Book of Judges suggests that Delilah was 'an harlot': Rubens had, as usual, read the text with care.

Van Dyck painted the subject almost ten years later, in about 1620, and his design depends on Jacob Matham's print after Rubens' *Samson and Delilah*. Samson's position in Delilah's lap, the Philistine bending over the sleeping hero with his scissors in hand, the presence of the procuress, the low bed – these and many other details confirm that the Rubens was Van Dyck's source. Van Dyck's treatment of the subject, however, has little of Rubens' psychological subtlety. Delilah is merely apprehensive in case Samson should wake, while the younger of the two figures behind her reacts to the sight of the vulnerable sleeping hero with outstretched arms, the most conventional of gestures employed to register surprise. The procuress strains forward to see Samson while the face of the Philistine who is about to cut his hair is obscured and his actions are simply businesslike. Even more striking is the change of location. Van Dyck has moved the scene from Rubens' richly appointed room, with its flickering shadows, to an outdoor terrace. The blue sky can be clearly seen between the Philistine and the group of women, while the Philistine army cowers behind a massive pillar. This setting not only contradicts the story, it also undermines its credibility. Van Dyck places the scene within a building which makes little architectural sense (what function, for instance, does the column serve?) and, most importantly of all, this setting has the effect of dissipating much of the tension of the moment. The comparison also points up those features of Van Dyck's style in about 1620 which have been touched upon before – the fluidity of his brushwork, the light palette, the insubstantiality of the figures and the detailed treatment of areas like hair and, here, the brocade in the right hand corner. What is quite remarkable about Van Dyck's painting (the work, it must be remembered, of a 20-year-old) is his extraordinary and apparently effortless facility in the depiction of textures. The dark skin of Samson's back, the rich satin of Delilah's dress and her delicate, fair skin – all these differing and deliberately contrasted textures he depicts convincingly and with great economy of brushwork. A few carefully placed strokes of a brush lightly loaded with paint are enough to conjure up skin, satin or velvet brocade.

It is worth pursuing the comparison between these paintings a little further, because an examination of the preparatory works for them reveals an unexpected difference between the methods of the two painters. In the case of Rubens' picture, we can trace its evolution from pen drawing to coloured oil *modello* and finished panel, a sequence already seen in the two great Antwerp altarpieces of the same years. For Van Dyck's painting only two preparatory drawings, both in pen and wash, are known. The first, which was destroyed during the last war, showed the composition in reverse and Samson in a different pose: it was closer to Rubens' painting than is Van Dyck's finished composition. A second drawing, in Berlin (Plate 23), is more truly a preparatory drawing for the Dulwich painting. It contains all the principal elements with the exception of the procuress. It is even squared up for transfer to the canvas. Van Dyck was making a pen drawing serve the same function as an oil *modello* in Rubens' creative process. He adhered to this method of working for the rest of his life: for the most part he carried out his compositional changes on paper and did not often paint *modelli*.

Van Dyck's working procedures can be studied in a number of projects from this time. One was the painting of *Christ crowned with Thorns* formerly in the Kaiser Friedrich Museum in Berlin but later destroyed (Plate 24). A second version of

24. *Christ crowned with Thorns. c.* 1620. Panel, 262 × 214 cm. Destroyed, formerly Berlin, Kaiser Friedrich Museum.
This major work from Van Dyck's early years in Antwerp was destroyed during the Second World War.

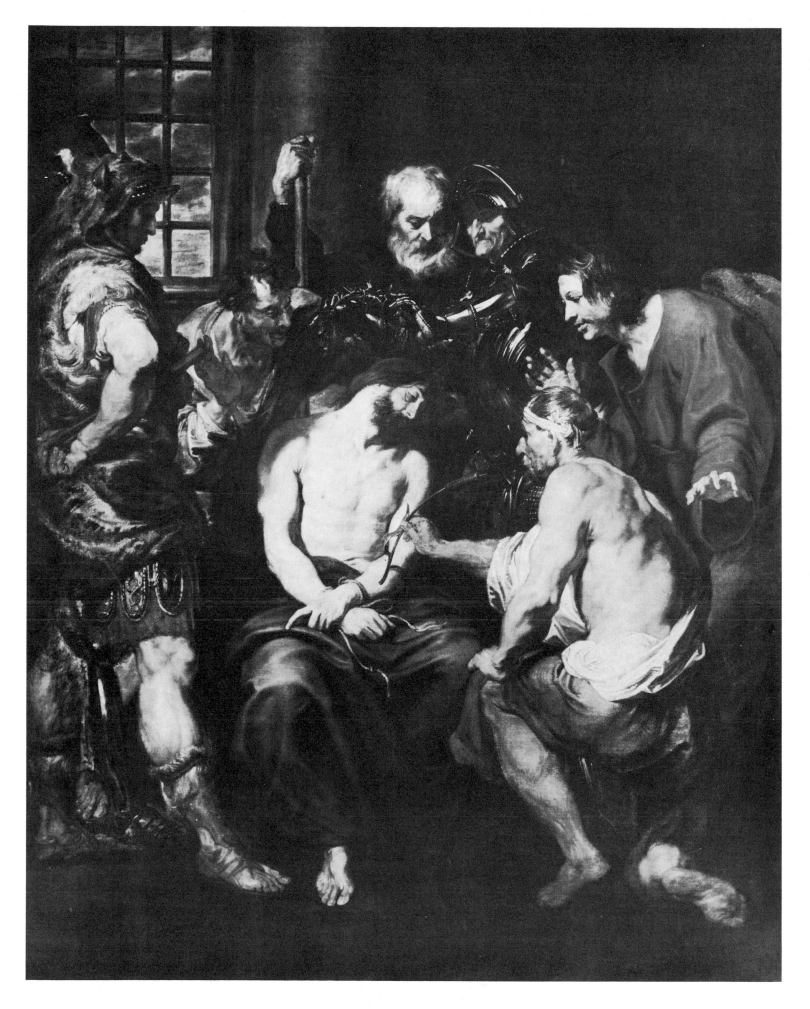

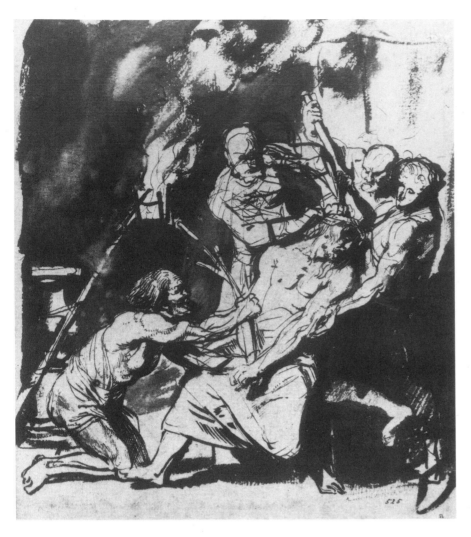

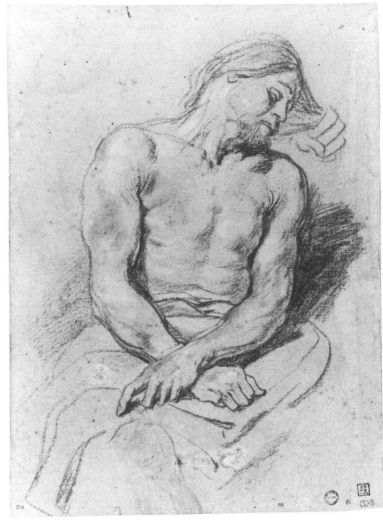

this composition is in the Prado (Plate 27). Seven drawings for these two paintings survive. The first in the sequence, in which Van Dyck gradually develops the final composition, is vigorously drawn in pen and wash (Plate 25). A heavy line of strong wash divides the sheet, confining the figure group to the lower right-hand half. Van Dyck's starting point may well have been a Rubens drawing which uses a similar strong diagonal and which itself is indebted to Titian's famous treatment of the subject which was then in S. Maria della Grazie in Milan (today it hangs in the Louvre). The next two drawings in Van Dyck's sequence – in Amsterdam and Paris – are far more balanced in their composition, with figures placed on each side of the seated Christ. These drawings contain considerable detail – the costumes and the architectural settings are carefully described – but Van Dyck's ideas are not yet fixed. Alterations in pen show figures being moved from one side to the other or abandoned altogether, and gestures being altered or discarded. It is at this point – as can be seen in drawings in Rotterdam and Oxford (Plate 26) – that Van Dyck posed models in the studio for individual figures: a kneeling man seen from the back, the chest and arms of the mocked Christ and a right hand holding a spear. Finally there is a carefully elaborated drawing in pen and wash with all the principal figures in place (Louvre), the equivalent of Rubens' *modello*. There may have been a further drawing, which showed the scene with the left-hand figure group (which is in the Berlin version but not in the Prado painting) removed and the cell window in its place, but it is equally likely that Van Dyck made this important change while at work on the canvas itself. It serves the compositional function of placing the actions within

25 (Left). *Christ crowned with Thorns.* Pen and wash, 24 × 20.9 cm. London, Victoria and Albert Museum.

26. *Christ mocked.* Black chalk, 37 × 27 cm. Oxford, Ashmolean Museum.
A study from a model posed in the studio for the figure of Christ in *Christ crowned with Thorns* (Plate 24). On the *verso* is a drawing for the arm of the man holding a spear in the same painting.

27. *Christ crowned with Thorns. c.* 1620. Canvas, 223 × 196 cm. Madrid, Prado.
A second version of this subject painted by Van Dyck soon after the picture formerly in Berlin (Plate 24). The demand for Van Dyck's work at this time seems to have been such that he often painted more than one version of important compositions.

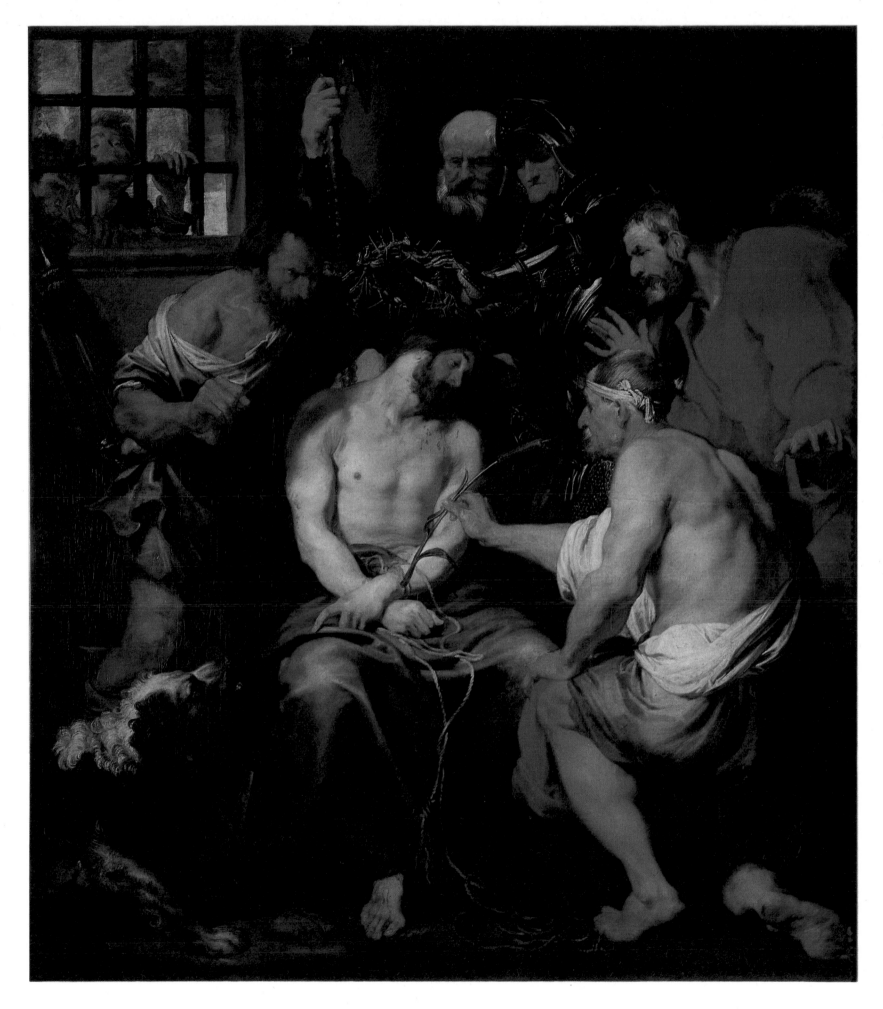

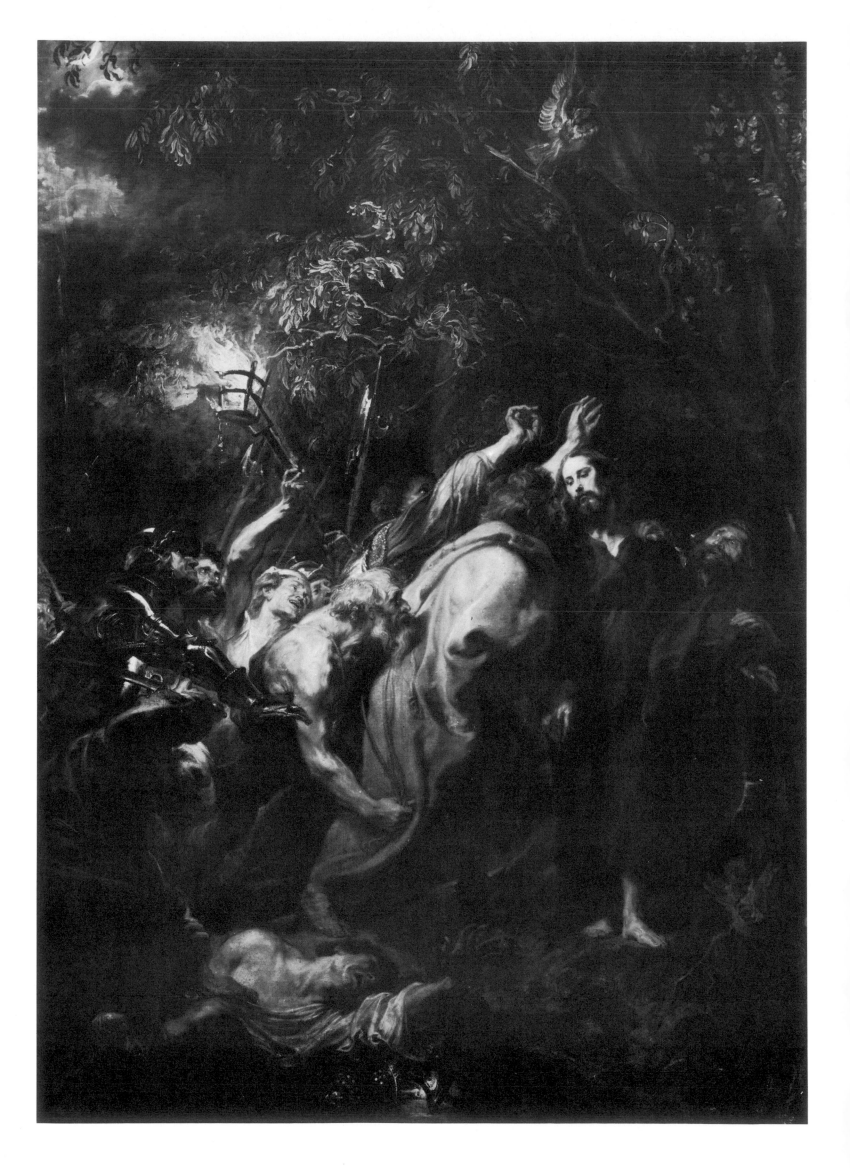

28 (Left). *The Betrayal of Christ. c.* 1618–20.
Canvas, 344 × 249 cm. Madrid, Prado.

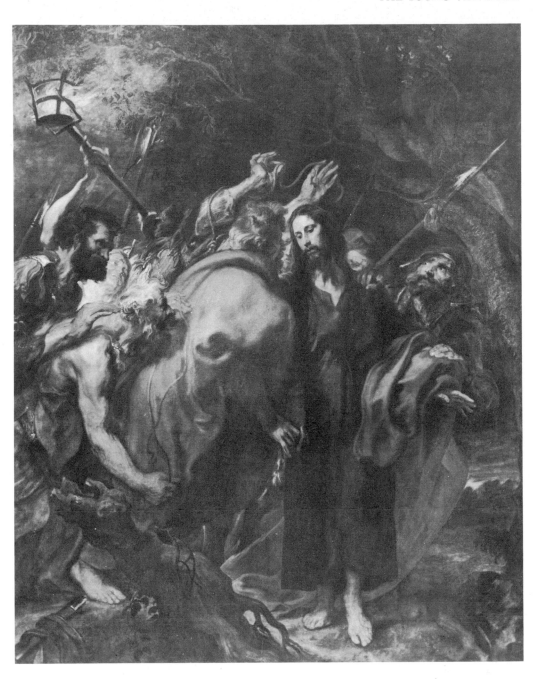

29. *The Betrayal of Christ. c.* 1618–20.
Canvas, 274 × 222 cm. Corsham Court,
Wiltshire, Collection of Lord Methuen.

a properly defined architectural setting as well as emphasizing the all too human
curiosity which Christ's fate aroused in the Jews.

In the case of *The Betrayal of Christ* Van Dyck painted three versions: they are
now in Madrid (Plate 28), Minneapolis, and in the collection of Lord Methuen
at Corsham Court (Plate 29). All are by Van Dyck himself and are important
evidence of both his facility and his success. The Minneapolis painting in par-
ticular was rapidly executed with sweeping brushstrokes and little concern for
detail. As with *Christ Crowned with Thorns*, the preparatory drawings can be
arranged in a sequence which shows Van Dyck moving from general com-
positional layout (with frequent use of dark washes) to more detailed com-
positional drawings via individual figure studies (in this case only one survives
— for Malchus), to elaborate sheets which contain all the major features of the
finished scheme. The final drawing is squared up for transfer to the canvas.
Unlike *Christ Crowned*, there are a number of compositional drawings for groups
of figures in the *Betrayal* – for example, St Peter and Malchus.

Although there can be no doubt that Van Dyck was rapidly establishing
himself as a successful painter of religious subjects in the years around 1620,

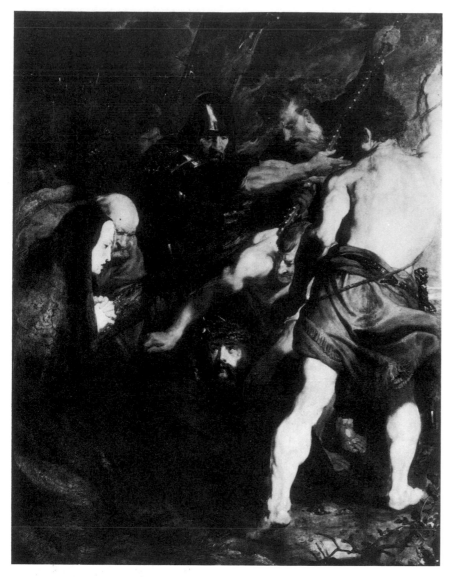

30. *Christ Carrying the Cross. c.* 1617/18.
Canvas, 211 × 162 cm. Antwerp, Sint
Pauluskerk.
One of a series of 15 paintings showing the
Mysteries of the Rosary commissioned by
the Antwerp Dominicans from the city's
leading artists in about 1617/18. Van Dyck's
painting hung alongside pictures by
Rubens, Jordaens, Cornelis de Vos,
Hendrick van Balen and others.

details of his commissions are known in very few cases. *Christ carrying the Cross*
(Plate 30) was painted for the church of the Antwerp Dominicans, which is now
St Paul's. It was one of a series of fifteen paintings representing the Mysteries of
the Rosary commissioned by the Order. Among the other artists who contributed
to the series were Rubens, Jacob Jordaens (who was six years Van Dyck's senior
and a master in the guild since 1615), Cornelis de Vos (who was fourteen years
older than Van Dyck and a master since 1608) and Van Dyck's master, Hendrick
van Balen. Rubens' painting has an inscription on the frame dating it to 1617 and
it is generally believed (the relevant document is undated) that the series was
painted in 1617-18. If this is the case, Van Dyck's inclusion among the leading
painters of Antwerp is a clear indication of his reputation, despite the fact that he
was still only in his late teens. His painting is very Rubensesque not only in mood,
colour and compositional scheme, but also in the inclusion of figures on a heroic
scale, like the half-naked man on the right. Of the technical skill of the young
painter there can be no doubt, but the composition is crowded and the action
confused. Figures which are extraneous to the scene, like the man on the right,
are obtrusive: they distract the viewer's attention from the central drama of
Christ's suffering glance at his mother. Once again, a series of drawings for the
painting survives. They display the now familiar sequence of bold compositional
drawing, more detailed compositional drawing, studies from the life and *modello*
drawing squared up for transfer.

Van Dyck's painting of *St Martin dividing his Cloak* still hangs above the high altar of the church of Saventhem, for which it was commissioned by the lord of the manor. There is an old tradition that this painting and a now destroyed *Holy Family* for the same church date from the few months Van Dyck spent in Flanders in 1621 between his return from England and his departure for Italy. Once again Rubens' influence is paramount, not only in the general scheme, but also in particular figures like the muscular beggars (for whom there are fine black chalk drawings from studio models). The composition is far more successful than that of *Christ carrying the Cross*: Van Dyck has resisted the temptation to pack the painting with figures and the line described by St Martin and his mount is especially graceful. The horse's stance and St Martin's pose were taken by Van Dyck from a figure in a woodcut by Domenico delle Grecche after a design by Titian, *The Submersion of Pharaoh's Army in the Red Sea*. Van Dyck may well have seen the print in Rubens' collection. He made a drawing of this particular area of the large multi-sheet woodcut in his Italian Sketchbook (today in the British

31. *St Martin dividing his Cloak. c.* 1620/1. Canvas, 257.8 × 242.6 cm. Windsor Castle, Royal Collection.
A second, larger, version of the painting commissioned for the parish church of Saventhem (near Brussels) and traditionally said to have been painted by Van Dyck in 1621, shortly before his departure for Italy.

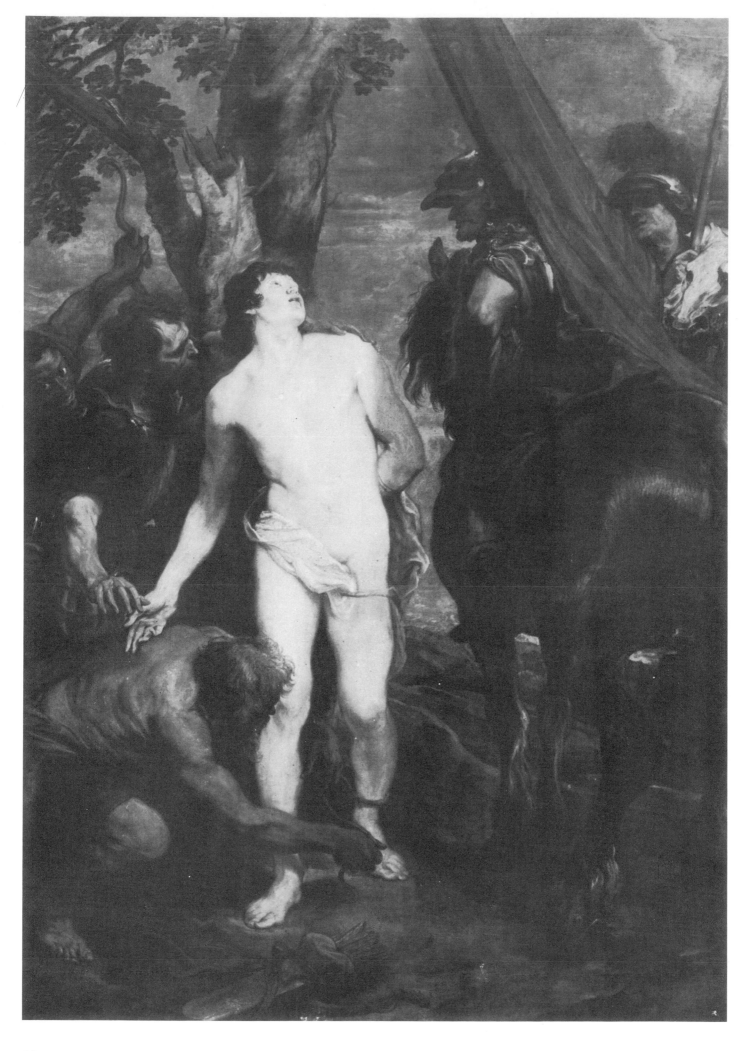

42

32. *The Martyrdom of St Sebastian*. Canvas, 226 × 160 cm. Edinburgh, National Gallery of Scotland.
The X-rays of this painting show that it began as a replica of the picture now in the Louvre but that after much of the design had been laid in, Van Dyck made substantial alterations to the poses of the figures. This second design was then worked up in a larger version now in Munich. The Edinburgh painting was bought from the daughters of the Marchese Constantino Balbi in Genoa in 1830.

33. *The Entry of Christ into Jerusalem*. Canvas, 151 × 228 cm. Indianapolis, Museum of Art.
A preparatory drawing (which survives in a copy) reveals that at first Van Dyck intended a more spacious composition.

Museum), which raises the possibility that the Sketchbook was first used in Antwerp prior to Van Dyck's departure for the south. He painted a second version of the *St Martin* (today in the Royal Collection at Windsor Castle; Plate 31). Multiple versions of major compositions are a feature of Van Dyck's work during these years and an eloquent testimony of the demand for his paintings. Some subjects he often repeated, as if obsessed by them. Particularly striking in this regard is the *Martyrdom of St Sebastian*, of which there are three extant versions, all slightly different. The earliest treatment would seem to be the painting now in the Louvre, in which the left hand of the saint, who looks directly at the spectator, is being bound. In the larger canvas in Edinburgh (Plate 32) Sebastian's right hand is about to be bound and the saint looks upward to the right – not, as it may seem at first, at the soldiers on horseback, but towards heaven. This pose is taken from Titian's *St Sebastian*; there was, interestingly, a copy in the Earl of Arundel's collection, which Van Dyck certainly visited during his first stay in England in 1620-1. The Edinburgh painting has been X-rayed and shows radical changes made while it was on the artist's easel. Such changes make it clear that Van Dyck undertook major alterations even in the final stages of an important painting. Although, as has been seen, it is possible to establish a careful sequence of preparatory drawings, it sometimes happens that even the most detailed, squared-up drawing differs from the final painting in a number of important respects. Van Dyck would restlessly recast the composition while working on it. This process can be observed in canvases less complex than the *St Sebastian* – in the various different but closely related versions of the single figure of *St Jerome*, for example.

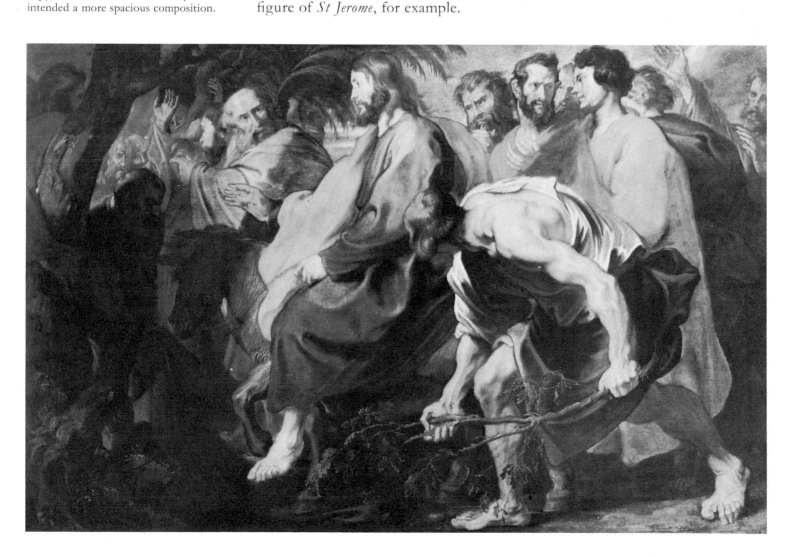

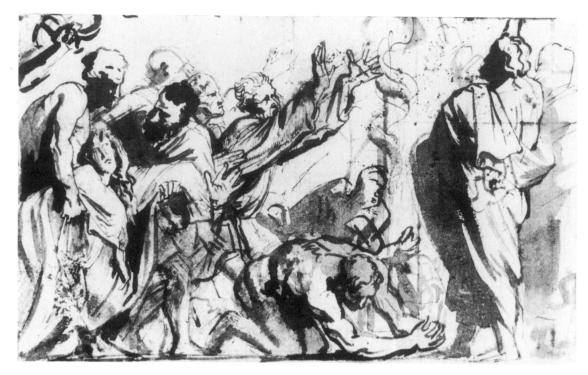

34. *Moses and the Brazen Serpent*. Pen and wash, 12.1 × 19.2 cm. Chatsworth, Collection of the Duke of Devonshire. A typically sketchy compositional drawing for the Prado painting (Plate 36). In the picture Van Dyck followed the drawing in the placing of the principal figures but reversed the direction of the composition.

35. *The Mystic Marriage of St Catherine*. Canvas, 121 × 173 cm. Madrid, Prado. The position of the Christ Child on the Madonna's knee is strongly reminiscent of Titian.

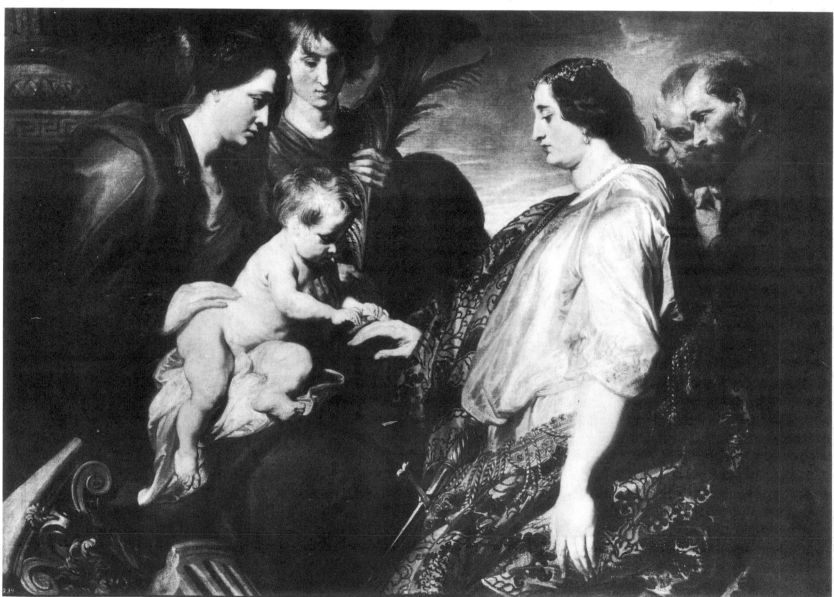

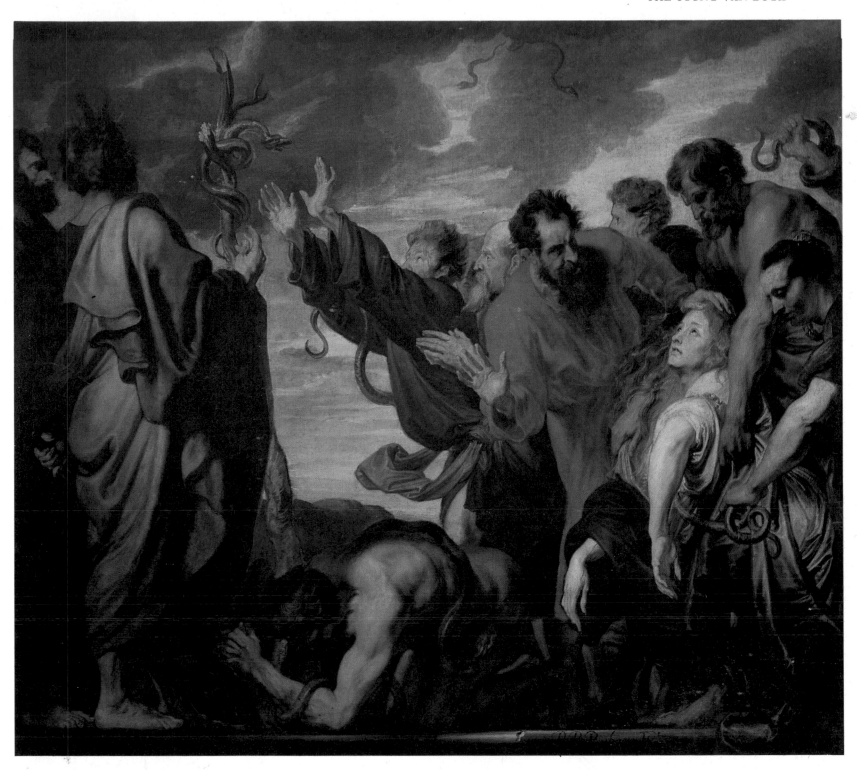

36. *Moses and the Brazen Serpent*. Canvas, 205 × 235 cm. Madrid, Prado.

Other major religious paintings include *The Entry of Christ into Jerusalem*, *The Mystic Marriage of St Catherine*, and *Moses and the Brazen Serpent* (Plates 33-6), all of which are intensely Rubensian in their inspiration but equally are evidence of the growing confidence and ambition of the young painter.

In addition to this hectic activity as a history painter, Van Dyck had also begun to paint the type of pictures on which, justly or unjustly, the greatest part of his contemporary and posthumous reputation was to be based – portraits. In seventeenth-century hierarchies of genres of painting constructed by Italian, French and Netherlandish theorists, portraiture occupied a lowly position – it called, it was said, for little exercise of the artist's imagination – and many painters of the period thought of themselves as history painters (for history, which included religious and mythological subjects and scenes from classical history, was

45

the highest category) who painted portraits merely from economic necessity. There seems little doubt that Rembrandt, for example, thought of himself in this way. Rubens rarely painted portraits, except for the very grandest patrons and for friends and acquaintances. Although, as we shall see, Van Dyck hankered after commissions for large-scale decorative schemes of historical subjects, he held no such disdain for portraiture. He had little time for theorizing about painting; his work rarely possesses the iconographical complexity of Rubens' 'sublime inventions'. Van Dyck simply recognized and exploited his remarkable talent for a type of painting that was lucrative and always in demand.

Van Dyck's first dated portraits – a woman now in the Liechtenstein collection and a man and a woman, presumably a married couple, both now in Dresden – are from 1618. The poses are stiff and formal, and the formats – three-quarter and half-length – conventional. Although the young painter confidently handles the faces, heads, ruffs and lace, there is little in these portraits to suggest that Van Dyck was to bring about far-reaching changes in the development of European portraiture. They are conventional exercises in the traditional style of the Antwerp school; in 1618 the leading practitioner of this type of portrait was Cornelis de Vos. In those portraits he painted before his departure for Italy, Van Dyck strained the tired formulas of Antwerp portrait painting to their absolute limits but never entirely abandoned them. In a *Portrait of a Man* (Brussels), which is dated 1619, he varied the conventional format by employing the device of an artificial oval to frame the bust portrait and in this way concentrated the viewer's attention on the features of the face. The portrait of Rubens' friend and patron Cornelis van der Geest, painted in about 1620, is undoubtedly the masterpiece of Van Dyck's early portrait style (Plate 37). He used a traditional format, a close-up of the face framed by the ruff, but the portrait is distinguished by the intense vivacity of the features. Van Dyck has animated Van der Geest's face by the skilful use of delicate brushstrokes and highlights. The touches of white in the corners of the eyes brilliantly suggest moistness. Van der Geest was an important collector and a key figure in the art world of Antwerp whom Van Dyck was anxious to please.

Equally masterful are the magnificent pair of three-quarter-length portraits of Frans Snyders, the animal and still-life painter who collaborated with Rubens, and his wife Margaretha de Vos (Plates 38, 39). The viewer's eye is immediately drawn to the vividly rendered head of Snyders with his intense, deep-set eyes, long bony nose, and prominent cheekbones. He stands on a terrace, beyond which the landscape can be glimpsed though it is largely obscured by a rich purple curtain cascading from the top edge of the picture. Snyders is sombrely dressed in blue and black with startlingly white lace at collar and cuffs. His long, elegant hands – such hands were to become almost a hallmark of Van Dyck's portraits – rest on a chairback, from which hangs his broad-brimmed black hat. The effect of the portrait is of studied casualness, of carefully posed relaxation. There is nothing whatsoever to tell us that this distinguished and prosperous Antwerp citizen made his living wielding a paintbrush. The head of Margaretha is far less arresting, and there is something almost pedantic in the care Van Dyck has expended on the richly embroidered detail of her stomacher. In this portrait the eye is drawn to the top left-hand corner. Almost as if challenging the skill of her husband, who painted still lifes in which dewdrops can be seen on the petals, Van Dyck has conjured up a vase of flowers with a few deft strokes of yellow, blue, purple, and green. The vase is given its shape and its translucency with skilfully placed white highlights.

Suffer the little Children to come unto Me (Plate 40) is a history painting-cum-family

37. *Cornelis van der Geest*. c. 1620. Panel, 37.5 × 32.5 cm. London, National Gallery. Van der Geest (1575–1638) was a successful Antwerp spice merchant and an important patron of the arts. He was influential in securing the commission for *The Raising of the Cross* (Plate 7) for Rubens who called Van der Geest 'my never-failing patron'. The extent of his impressive collection of sixteenth- and seventeenth-century Flemish painting can be seen in a painting by Willem van Haecht (Antwerp, Rubenshuis) which records the visit of the Archduke Albert and the Archduchess Isabella to Van der Geest's house in 1615. The walls are crammed with paintings by Quentin Massys as well as by contemporaries including Rubens, Snyders and Jan Brueghel the Elder.

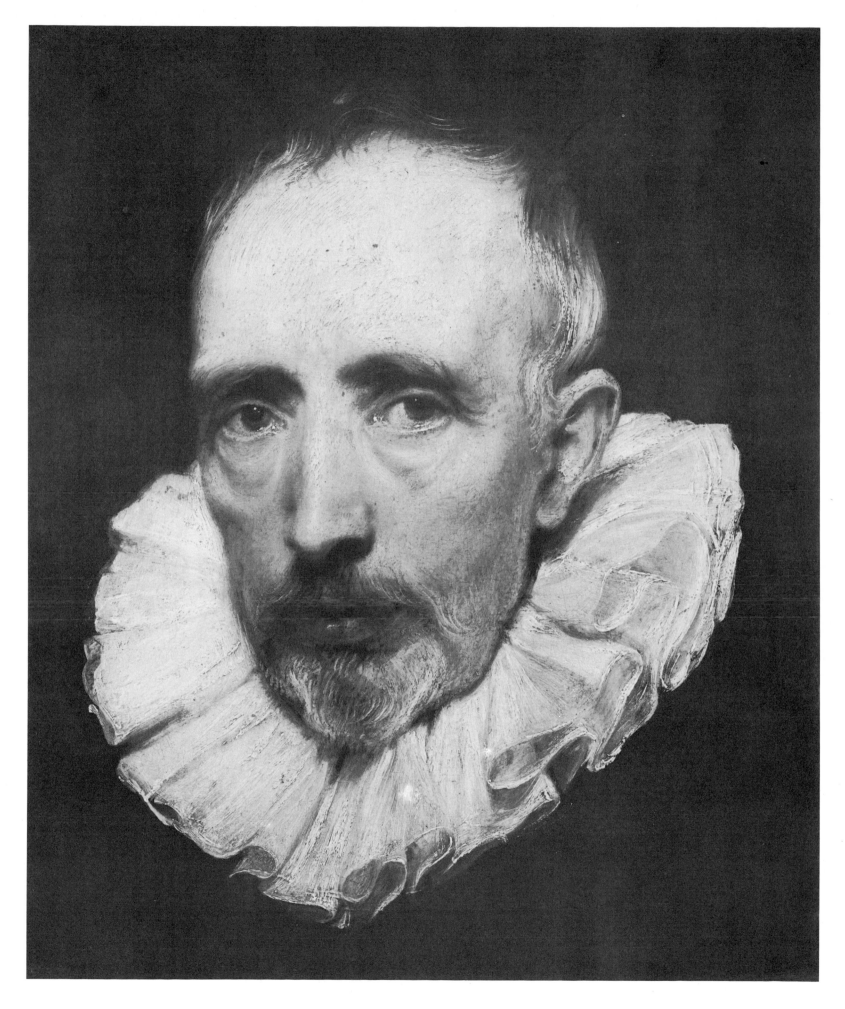

39. *Margaretha de Vos*. Canvas, 130.7 × 99.3 cm. New York, Frick Collection.
Margaretha de Vos was the wife of Frans Snyders.

38. *Frans Snyders*. Canvas, 142.5 × 105.4 cm. New York, Frick Collection.
A native of Antwerp, Snyders (1579–1657) had trained in the studio of Pieter Brueghel the Younger. He entered the painters' guild as a master in 1602 and soon after set off for Italy. On the recommendation of Jan Brueghel the Elder, he received the patronage of Cardinal Borromeo in Milan. He was back in Antwerp by 1609 and two years later, on 23 October 1611, married Margaretha de Vos, sister of the painters Cornelis and Paul. Snyders specialized in the painting of animals, hunts and still-life. He collaborated closely with Rubens, who named him as one of his executors, and with other figure painters in Antwerp. Among his patrons were Philip IV of Spain and the Archduke Leopold Wilhelm. Van Dyck etched the portrait of Snyders for the *Iconography* himself.

portrait. There can be no doubt that the mother, father and four children on the right are meant as portraits (though not of Rubens and his family as has recently been suggested), and the painting was probably commissioned to mark the occasion of the first communion of the boy who bends his head to be blessed. By comparison, the figures of Christ, who is seen in strict profile, and the three Apostles are clearly taken from Van Dyck's already familiar repertory of noble, strongly characterized heads. These two distinct halves of the painting – the worlds of the New Testament and of contemporary Antwerp – are linked with great effectiveness by Christ's dignified gesture of blessing.

Van Dyck painted a number of more conventional family portraits during the years immediately before his departure for Italy. The finest is in the Hermitage in Leningrad (Plate 41). As in the history paintings of this time, he felt no need to establish a convincing impression of depth; the mother, father and child, whose outlines are very close to the edges of the canvas, are shown in so shallow a space that they seem to be on the point of falling out of the picture. The odd angle of the chairback in the lower left-hand corner contributes to the sense of instability in the composition. And yet this quite deliberate effect of spatial uncertainty lends an immediacy and liveliness to the group. The momentary turn of the child's head to look towards his father (who may be the landscape painter Jan Wildens) and the sparkling treatment of lace and satin add to this effect. The heads of the young parents are superbly modelled, while the child's pose and the position of the two heads serve to bind the composition together.

Bellori recounts that Rubens encouraged Van Dyck to concentrate on portraiture. Later commentators have suggested that Rubens did this because he

40. *Suffer the Little Children to Come unto Me.* Canvas, 134 × 198 cm. Ottawa, National Gallery of Canada.
This painting is first recorded in 1759 when it is described in the collection of the Duke of Marlborough at Blenheim Palace: it was said to be by 'a scholar of Rubens'. The attribution to Van Dyck was made by Bode in 1887 and has not been seriously questioned. The picture remained at Blenheim until the sale of the greater part of the collection of paintings at Christie's in 1886.

41. *Family Portrait*. Canvas, 113.5 × 93.5 cm. Leningrad, Hermitage.

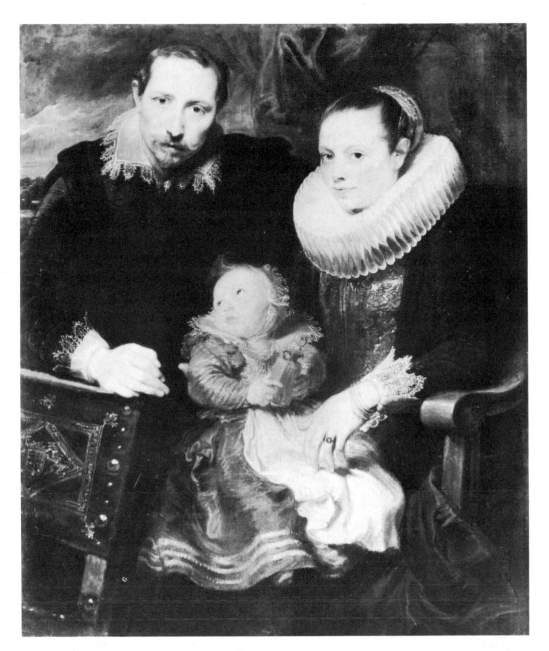

sensed competition from Van Dyck the history painter. Not only does this seem quite out of character for Rubens, but judging by the portraits of Cornelis van der Geest and Frans Snyders there can be no doubt of Van Dyck's quite exceptional gifts as a portraitist, which Rubens recognized. It might be thought that by his own intensely serious and intellectually strenuous standards Rubens considered that Van Dyck was not by nature suited for history painting on a grand scale, but this is contradicted by Rubens' own testimony. In a letter to Dudley Carleton he recommended an *Achilles* 'fatto del meglior mi discepolo', by whom he meant Van Dyck, and in the inventory of his collection taken after his death there are nine paintings by Van Dyck, all of them history paintings. They include a *Betrayal of Christ* (the painting that is today in the Prado, which was bought at the sale of Rubens' effects for Philip IV), a *Mocking of Christ*, a *Jupiter and Antiope*, and no fewer than four *St Jeromes*.

During the course of his career Van Dyck painted a series of self-portraits, not as many as Rembrandt, but far more than Rubens or Jordaens, for example. In Rembrandt's case these have been considered to be evidence of painful self-examination, in Van Dyck's of simple vanity. There is, as will be seen, evidence to suggest that Van Dyck was vain; certainly, there can be little doubt that he was

acutely conscious both of his appearance and of the image that he presented to the world. However, the difference in the attitudes detected in Rembrandt's and Van Dyck's fondness for self-portraiture simply points up how facile such explanations are. It is fruitless to speculate seriously about Van Dyck's reasons for so frequently choosing himself as a model.

The earliest self-portrait has already been mentioned: it is the painting in the Vienna Academy which shows the face of an alert teenager (Plate 2). The portrait of the same boy in Fort Worth, which has been thought to be a self-portrait, is in fact a portrait by Rubens of his young assistant. The *Self-Portrait* in Munich (Plate 42) shows the artist at the age of 18 or 19, while those in New York (Plate 43) and Leningrad were painted in 1620 or 1621. It is striking that the self-portraits grow larger in size and in format – increasing from face to half-length to three-quarter length – which is a reflection of the artist's increasing self-confidence and skill as a portrait painter. In this sequence of paintings Van Dyck's application of paint to the canvas becomes progressively thinner and freer, his pose increasingly self-conscious and his dress richer. All this documents his development from precocious apprentice to self-confident master painter.

Van Dyck's first visit to England

It is hardly surprising that Rubens' gifted young assistant began to attract attention. Francesco Vercellini, the Venetian secretary of the great English collector the Earl of Arundel, travelled with the Countess on her journey to Italy in 1620. On 17 June he wrote to his master from Antwerp. The letter describes in detail Lady Arundel's sitting to Rubens for the life-size portrait which is now in Munich. Vercellini adds, 'Van Dyck is still with Signor Rubens and his works are hardly less esteemed than those of his master. He is a young man of 21 years, his father and mother very rich, living in this town, so that it will be difficult to get him to leave these parts, especially since he sees the good fortune that attends Rubens.' The use of the word 'still' suggests that Arundel had previously shown an interest in Van Dyck, and despite Vercellini's opinion, Van Dyck was tempted to England later that year, presumably to enter Arundel's service. We know this from a letter written on 25 November 1620, by Tobie Mathew, an Englishman then living in Antwerp and involved in the acquisition of works of art for James I as well as for Arundel. Addressing Sir Dudley Carleton, British ambassador in The Hague, Mathew wrote: 'Your Lordship will have heard how Van Dyke his [Rubens'] famous *allievo* [pupil] is gone into England, and that the King has given him a pension of £100 per annum.' Mathew's news is confirmed by an entry in the royal accounts which records a payment on 26 February 1621 to 'Anthony Vandike the some of one hundred pounds by way of reward for speciall service by him performed for his Majesty'.

Thomas Howard, 2nd Earl of Arundel, was one of the leading collectors of his day. Horace Walpole was later to call him 'the father of *virtù* in England'. He had been born into an ancient Catholic family, many of whose estates had been confiscated by Queen Elizabeth. His father, Philip Howard, spent much of his life in the Tower, imprisoned on an unsubstantiated charge of treason. He died there in 1595. Thomas Howard, however, was welcomed at the court of James I and confirmed in his titles of Arundel and Surrey. As Earl of Arundel, he assumed the position of premier Earl of England. Howard consolidated his position by his marriage in 1606 to a wealthy heiress, Aletheia Talbot, whose fortune enabled him to buy back many of his family lands and cut an impressive figure at court. In the year of his marriage he was one of the principal performers in Ben Jonson's

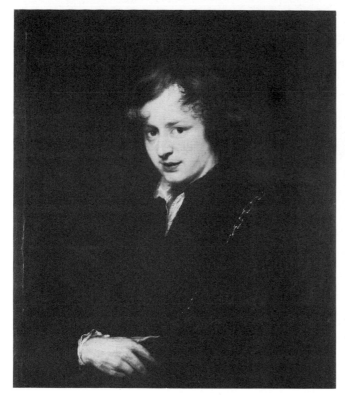

42. *Self-Portrait. c.* 1617–18. Canvas, 81 × 69 cm. Munich, Alte Pinakothek.

43. (Right). *Self-Portrait. c.* 1621. Canvas, 119.4 × 87 cm. New York, The Metropolitan Museum of Art.

masque *Hymenaei*, staged to celebrate the marriage of his cousin to the Earl of Essex. Arundel was particularly drawn to the cultivated and highly sophisticated circle around Henry, Prince of Wales. He seems to have been an artistic mentor to the Prince, whose tastes were in their turn influential on those of his younger brother Charles, later King Charles I.

Arundel was profoundly conscious of his distinguished ancestry: he was an aristocrat rather than a courtier, a figure of gravity and probity at the frivolous and corrupt court of James I. He was a severe and aloof man who preferred intellectual discussion to the drunken feasting and constant hunting enjoyed by the King. Nevertheless, James continued to favour Arundel. In 1616 he was admitted to the Privy Council and restored to the office of Earl Marshal, which carried with it the responsibility for all Court ceremonial, in preparation for the installation of Prince Charles as Prince of Wales in November (Prince Henry had died in 1612). At Christmas that year the Earl, whose stoical cast of mind, opposed to religious factionalism, became more pronounced as he grew older, took Holy Communion in the Royal Chapel, a public declaration of his allegiance to the Church of England. In the same year Lady Arundel's father, the Earl of Shrewsbury, died, and her inheritance enabled her husband to expand his collection rapidly. He snapped up a consignment of Venetian paintings intended for the disgraced Earl of Somerset and intensified his pursuit of antique statues, inscriptions and manuscripts. When Rubens was in England in 1629 he expressed his astonishment at the riches of the collection: he described the Earl as 'one of the four evangelists and a great upholder of our art'. According to an inventory taken after the Countess's death in Amsterdam in 1655, there were about six hundred paintings: the collection was dominated by the Venetians and Holbein. There were 36 Titians, 19 Tintorettos, 17 Veroneses, 16 Giorgiones, 12 Raphaels, 11 Correggios, 5 Leonardos, and no fewer than 43 Holbeins. Arundel also had a large collection of Old Master drawings. From contemporary accounts it is clear that he was a discerning and knowledgeable collector, unlike courtiers such as Somerset who seem merely to have been following a fashionable trend.

At the houses which bore his name in London and Sussex, Arundel gathered about him scholars and artists. The philosopher and antiquarian Franciscus Junius from Heidelberg served as his librarian and wrote a famous study of

classical painting, *De Pictura Veterum* (published in 1637), while in Arundel's household. The Earl's friend, John Selden, catalogued his remarkable collection of antique marbles in the *Marmora Arundelliana* of 1628. Henry Peacham, author of the *Compleat Gentleman*, Sir Henry Spelman, the Church historian, the mathematician William Oughtred and the physician William Harvey were among those who enjoyed Arundel's patronage. Among the artists was Daniel Mytens, born in Delft in about 1590, who had moved from The Hague to London at Arundel's request by 1618. He worked for both Arundel and the royal family until his return to Holland in the early 1630s. During his stay in England Mytens made Netherlandish ideas of portraiture familiar and so prepared the ground for Van Dyck's triumphant return to London in 1632. He painted Arundel sitting in the first-floor sculpture gallery designed by Inigo Jones at Arundel House in the Strand (Plate 140), with a liveliness and three-dimensionality entirely lacking in earlier portraiture in England. If, for example, this portrait is compared to one attributed to the mysterious William Larkin which was painted only a few years before, Mytens' ability to place his figure within a credible space becomes clear. The Larkin, though elegant and colourful and full of visually exciting detail, lacks any real sense of perspective or depth.

Another Netherlandish portrait painter, Paul van Somer, had moved to London by 1616. In the following year he painted a portrait of the Queen, Anne of Denmark (Plate 139). Van Somer worked for members of the royal family and the court – documents tell us this, few paintings survive – until the summer of 1620 when he fell ill. He died early in the following year. It has been suggested – and it does not seem unlikely – that Van Dyck was called to England to replace Van Somer in the royal service. And yet it also seems likely that with such good prospects in Antwerp there must have been some very special incentive to tempt Van Dyck to cross the Channel. Was the prospect of a large-scale decorative undertaking such as he had worked on with Rubens held out to him? Could he have been persuaded by the offer of a commission for a tapestry series to be woven

44. *Thomas Howard, Earl of Arundel.* 1620/1. Canvas, 113 × 80 cm. Washington D.C., Private Collection.
This portrait of the 35-year old Earl (1585–1646), painted during Van Dyck's brief stay in England in 1620/1, was said to have been given by the sitter to his great rival (both as a statesman and a collector), the Duke of Buckingham. Sold abroad with much of the Duke's collection, it was subsequently in the Orleans Gallery and returned to England when Philippe Egalité's paintings were bought by the Duke of Sutherland and others in 1792.

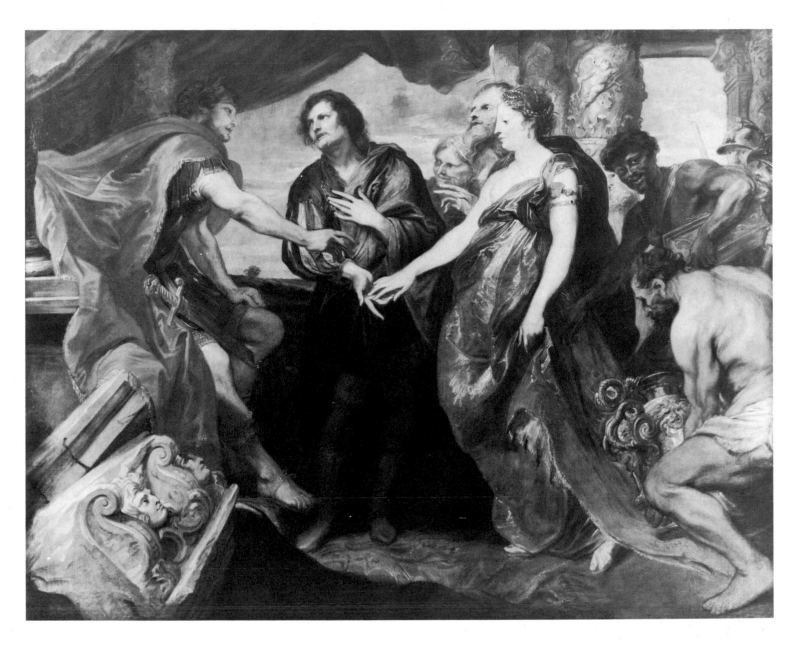

45. *The Continence of Scipio*. 1620/1. Canvas, 183 × 232 cm. Oxford, Christ Church Picture Gallery.
The influence of Veronese is paramount. Van Dyck no doubt studied the important collection of paintings by the Venetian artist that had been assembled by the Duke of Buckingham at York House. They had been purchased, probably in Antwerp, from the collection of Charles de Croy, Duc d'Aarschot.

The painting shows the restoration of a captured Spanish woman to her fiancé by the victorious Roman general Scipio Africanus. Rubens had painted the subject about five years before and his design (which today only survives in an engraving by Schelte à Bolswert) was Van Dyck's starting-point.

at the royal tapestry works at Mortlake, which had been set up in 1619, for example?

Of Van Dyck's work in the years around 1620 it is hard to know which paintings were made during what proved to be a short stay in England. Although employed in the service of the court, there are no surviving portraits of James I or his Queen or of any other members of the royal family. Only two paintings can indisputably be said to have been executed in this country. They are the *Portrait of Arundel* and *The Continence of Scipio* (Plates 44, 45). The 35-year-old Arundel is shown in half-length, holding in his left hand the Order of the Garter, which he had received in 1611. He wears characteristically sober dress. Clarendon, who was no friend of Arundel, wrote of him that

it cannot be denied that he had in his person, in his aspect and countenance, the appearance of a great man, which he preserved in his gait, and motion. He wore and affected a Habit very different from that of the time, such as men had only beheld in the Pictures of the most considerable Men; all which drew the eyes of most, and the reverence of many toward him, as the Image, and Representative of the Primitive Nobility, and Native Gravity of the Nobles, when they had been most Venerable.

Behind Arundel are a parapet, a curtain and a landscape, portrait devices which Van Dyck had adopted from Titian and Tintoretto. They are not obtrusive, neither overwhelming the sitter (as the red curtains of some contemporary Flemish portraits did) nor pushing him forward. Van Dyck was to paint Arundel, with and without members of his family, many times during his second stay in England, culminating in the superb portrait of the Earl with his grandson (Plate 215). It is said that this first portrait of Arundel was given by the Earl to his great political rival, the Duke of Buckingham, and that it was included in the sale of Buckingham's goods abroad. Whatever the truth of this, there is no doubt that Buckingham took a great interest in Van Dyck; it was probably he who commissioned the *Continence of Scipio* from the young Flemish painter. The picture can be identified with an entry in the inventory of the Duke's London residence, York House: 'Vandyke – One great Piece being Scipio.' The fragment of an antique frieze introduced so deliberately into the lower left hand corner of the painting has been identified with a second-century Roman provincial relief from Syria which was unearthed on the former site of Arundel House in London and which today is in the Museum of London. After Buckingham's assassination in 1628, Arundel had purchased many antiquities from his large and important collection. Buckingham must have asked Van Dyck to introduce the relief into the painting: its prominent, unusual position suggests a patron's request rather than the artist's inspiration. Buckingham also had a rich collection of paintings, to which he was to add when he went to Spain in 1623 with the young Prince of Wales, who was trying, unsuccessfully, to secure the hand of the Infanta in marriage. The Duke, like Arundel, was a particular enthusiast of Venetian painting of the sixteenth century. At York House Van Dyck could have seen paintings by Titian, Tintoretto and Veronese. The study of Veronese, in particular, is evident in the *Continence of Scipio*: the frieze-like arrangement of the figures, the treatment of drapery, the elongated figures, all reflect Van Dyck's interest in the Venetian. The main elements of the composition come from a treatment of the subject by Rubens: in his painting, destroyed in the nineteenth century and known only in the form of an engraving by Schelte à Bolswert, Rubens had used a horizontal format with fluted columns placed in the background and a drapery suspended behind Scipio. Van Dyck's preparatory drawings show how he took this composition and reworked it. It may have been Buckingham, a keen collector of Rubens' work, who suggested to Van Dyck that he model his composition on Rubens'. The comparison reveals once again that Van Dyck differs from Rubens in the scintillating surface of his paintings, the way in which figures, objects and architecture are all suggested rather than described. It seems that the subject had a particular significance for the Duke of Buckingham. In May 1620 he had eloped with Catherine Manners, daughter of the Catholic Earl of Rutland, and married her against her parents' wishes. The court was scandalized, but in time the King, showing the same wisdom and generosity as Scipio, approved the marriage and permitted the young couple to rejoin his inner circle. The central figure of the bridegroom is intended as a portrait of the Duke, who, according to Sir John Oglander, was 'one of the handsomest men in the whole world'.

In England Van Dyck would have seen – for the first time in his life – important collections of Italian High Renaissance paintings. The houses of Arundel and Buckingham were lined with Venetian and Roman pictures, and James and Anne of Denmark, though to a far lesser extent than their son, assembled an interesting group of Italian paintings. They all collected – and indeed competed for – antique marbles, but in these Van Dyck had little more than a polite interest. However,

46. *Nicolaes Rockox. c.* 1621. Canvas, 122 × 117 cm. Leningrad, Hermitage. Rockox, nine times burgomaster of Antwerp, was an important collector and patron of the arts. He probably commissioned, for example, the *Samson and Delilah* (Plate 21) from Rubens soon after the artist's return from Italy. His house in Antwerp has recently been restored and opened to the public as a museum, although sadly few of his major works of art are still in place.

the sight of canvases by much-admired Italian painters fired Van Dyck's enthusiasm to follow in the footsteps of both his master Van Balen and his mentor Rubens and complete his artistic education with a stay in Italy. Arundel, who himself made two extended trips to Italy (one in the company of his architect Inigo Jones), realized the importance of such a visit for a young painter. On 28 February 1621, only two days after the payment of £100 'for speciall service by him performed for his Majesty', the following entry appears in the register of the Privy Council: 'A passe for Anthonie van Dyck gent his Ma^ties Servaunt to travaile for 8 months he having obtained his Ma^ties leave in that behalf as was sygnified by the E. of Arundel.' Van Dyck left London for Antwerp soon afterwards, but rather than set out immediately for Italy, his eventual destination, he remained in his native city until October, that is, for eight months. It has been generally supposed that in staying on in Antwerp Van Dyck reneged on the terms of his royal pass. However, it is equally likely that the pass was granted to him for the purpose of a stay in Antwerp. Soon after his arrival in Italy at the end of 1621 he joined the Countess of Arundel in Venice, which suggests that he still considered himself to be in the service, if not of the King, then of his Earl Marshal, Arundel.

Van Dyck spent the months from March until October 1621 in Antwerp. It is impossible to date paintings to this short period on stylistic grounds alone, but it does seem likely that two outstanding portraits were painted just before his departure for Italy. The *Portrait of Nicolaes Rockox* (Plate 46) shows the

47. *Isabella Brant. c.* 1621. Canvas,
153 × 120 cm. Washington D.C., National
Gallery of Art.
Rubens married Isabella Brant (1591–1626)
in 1609. She bore him a daughter (who died
in 1623) and two sons, Albert and Nicholas.

48. Rubens. *Isabella Brant. c.* 1622. Black, red
and white chalk, and pen and ink, lightly
washed, 38.1 × 29.2 cm. London, British
Museum.

burgomaster of Antwerp seated and in three-quarter length against a background
of columns and curtain, beneath which the tower of the Town Hall can be
glimpsed. On the table on which Rockox rests his left hand there is an antique
marble head and a small bronze, which refer to his activities as a collector, and
a book which represents his extensive library. The face and head have the same
vitality as in the portrait of that other great Antwerp collector and patron of the
arts, Cornelis van der Geest, but in the portrait of Rockox Van Dyck adopts a far
more ambitious format. He had taken it from Rubens, who showed his Italian
sitters against a similar imposing backdrop. At about the same time as he painted
Rockox in a Rubensian composition, Van Dyck portrayed Rubens' wife, Isabella
Brant, against the background of the great stone screen which the painter had
erected across the courtyard that separated his house and his studio (Plate 47).
Van Dyck had to rearrange the architecture in order to show Isabella as if she were
sitting just inside a doorway of the house with the screen behind her on the left.
It is a superbly accomplished design for a 22-year-old painter. A comparison of
her head with a drawing by Rubens (Plate 48) will show Van Dyck's tendency,

which was increasingly evident during his career, to stress the bone structure beneath the flesh, and so to make the faces of many of his sitters seem to conform to an 'aristocratic' type. The large eyes, high cheekbones, long nose and small chin are all emphasized, while the fullness of the face, which is evident in Rubens' drawing, is deliberately reduced. With precocious ease Van Dyck evokes the differing textures – satin, lace, velvet, ostrich feathers, pearls, jewellery and flowers – in a few unerringly placed brushstrokes.

It is an attractive romantic notion, though one which has no historical foundation, that Van Dyck, just before he left for Italy, painted Isabella Brant as a parting present for Rubens.

2 The Italian Years and the Influence of Titian: 1621–1627

Van Dyck left Antwerp for Italy in the first days of October 1621. He was accompanied by Giovanni Battista Nani, a Venetian friend of Rubens. The two men travelled via Brussels to Genoa, where they arrived late in November. Van Dyck went to stay with two friends from Antwerp, the brothers Cornelis and Lucas de Wael, both painters, engravers and art dealers, who had settled in the city. Throughout the six years of his stay in Italy, Genoa, and in particular the house of the de Wael brothers at the far end of the Via Nuova (now the Via Garibaldi) with its magnificent view over the gulf of Genoa, was to be his base. To thank them for their hospitality, Van Dyck painted the brothers in a marvellously inventive and lively double portrait just before he left Italy (Plates 49, 50). The contrasted poses, dress and expressions make for one of Van Dyck's most relaxed and informal Italian portraits.

Genoa had made a deep and lasting impression on Rubens twenty years earlier, although during his Italian years he had lived principally in Mantua and Rome. The opulent architecture of its palaces and the elegance and wealth of its aristocracy had overwhelmed the young Rubens. He received portrait commissions from the Genoese aristocracy and created a new and particularly graceful form of portraiture, which was to be the starting-point for Van Dyck's own portraits of the nobles of Genoa.

Van Dyck's movements during his years in Italy can be reconstructed, at least in outline, with the help of an eighteenth-century manuscript life of the painter which is now in the Bibliothèque du Louvre in Paris. Written in French, it is said to be the work of the Flemish antiquarian, J.F.M. Michel. Its importance lies in the fact that the author had access to letters, which are now lost, written by Van Dyck's host in Genoa, Cornelis de Wael, to his fellow-Fleming, Lucas van Uffelen, who lived in Venice, in which the painter's movements are often mentioned. It provides by far the most detailed account of Van Dyck's Italian years.

Having spent his first winter in Genoa, Van Dyck travelled by sea to Civitavecchia and thence to Rome in February 1622. He was still in the city in August but soon afterwards went to Venice, where, in the late summer, he joined the entourage of the Countess of Arundel. Lady Arundel had left England in June 1620 with the chief purpose of visiting her two sons, who were studying at the University of Padua. She had travelled, as we have seen, via Antwerp, where her portrait had been painted by Rubens. Having arrived in Venice late in 1620, she established herself in considerable splendour in the Palazzo Mocenigo on the Grand Canal and also rented a villa at Dolo on the Brenta canal, strategically placed between Padua and Venice. Lady Arundel shared her husband's keen

interest in painters and painting, and one of her many contacts with the artistic life of Venice is of particular interest in view of Van Dyck's enormous admiration for the work of Titian. In 1622 Tizianello, son of the great painter's cousin and assistant Marco Vecellio, dedicated the life of Titian that bore his name – *Breve Compendio della Vita del famoso Titiano Vecellio da Cadore* – to Lady Arundel. It is an intriguing possibility that Van Dyck's guide to Venice was related to the Venetian artist whom he admired above all others. It is of interest too that Lord Arundel's secretary, Francesco Vercellini, who accompanied Lady Arundel on her travels, had been commissioned by her husband to buy paintings in Venice, and it may be that Van Dyck helped him in this task.

However, paintings to be taken back to England were not uppermost in the thoughts of Lady Arundel and her suite in the summer of 1621, for this was the time of the Foscarini affair. Antonio Foscarini, who had been Venetian ambassador in London, was denounced to the Council of Ten and accused of betraying State secrets. He was arrested, tried secretly and strangled in prison. Rumours circulated in the city that some of the meetings at which Foscarini had passed on information to hostile foreign powers had taken place at Lady Arundel's *palazzo*. Sir Henry Wootton, the English ambassador, advised her not to return from Dolo to Venice in the summer of 1622, but to go back to England rather than risk banishment by the Senate. Wootton had misjudged Bess of Hardwick's granddaughter. Lady Arundel immediately set off for Venice and demanded an official denial of the rumours and after an investigation she received it. Foscarini was posthumously rehabilitated and given a state burial. Vercellini was sent back to England to explain to the Earl what had happened.

It was against this stormy background that Van Dyck explored Venice for the first time, recording paintings by Titian, Tintoretto and Veronese in his Italian Sketchbook. This Sketchbook, which is now in the British Museum, is the most important artistic document of his Italian years. Lady Arundel left Venice in November 1622 with Van Dyck in her party. He had only been in the city a little over two months. She travelled to Mantua, where Van Dyck is said to have painted Duke Ferdinand and where he explored the great Gonzaga collection, about which he would have heard so much from Rubens. During this visit the Grand Chancellor, Alessandro Striggi, approached the Countess about the possible sale of paintings from Mantua. The treasures of the Gonzaga were eventually to come to London, where Van Dyck was able to study them afresh, but it was not until they had been the subject of a decade of hard bargaining and bitter wrangling that they finally entered Charles I's astonishing collection.

Their next stop was Milan and then Turin, which they reached by late January 1623. In Turin Van Dyck painted Duke Charles Emmanuel and his two sons, the princes of Piedmont and Carignan. In March Lady Arundel left Turin for Genoa and at the end of the summer sailed to Marseilles on her way home to England.

Van Dyck left Lady Arundel's party to make his way to Rome. He first spent several weeks in Florence, where he painted Lorenzo de Medici, the brother of Duke Cosimo II, and then settled in Rome for eight months, from March until October or November 1623. This was his second visit – he had spent some months in the city in the spring and summer of the previous year – and it was to be his longest stay. For most Netherlandish painters, Rubens among them, Rome, which Carel van Mander in 1604 had called 'the capital of Pictura's schools', was the city which above all others in Italy they wished to visit. It was the capital city of Christendom and of the antique world; it contained great private collections of paintings and antiquities in addition to churches decorated with Renaissance and contemporary altarpieces and frescoes. Rubens had been fascinated by the

49. *Lucas and Cornelis de Wael*. Canvas, 120 × 100 cm. Rome, Capitoline Museum. Lucas stands while his brother is seated. They had moved from their native Antwerp to Genoa where they worked as painters, engravers and art dealers. Cornelis was the leader of the Flemish community in Genoa and the brothers' house on the Via Nuova was Van Dyck's base during his years in Italy.

50. Detail of Plate 49.

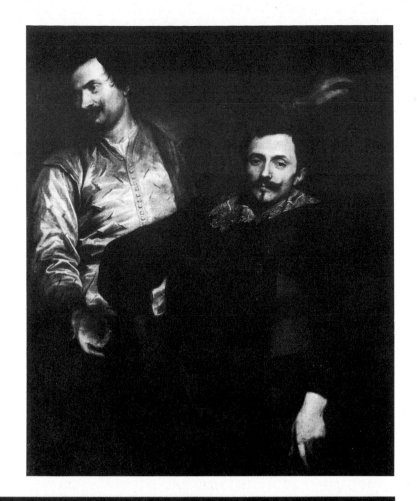

city, endlessly copying after the Antique and after Renaissance masters as well as working on his own altarpieces for the city's churches. Van Dyck's reaction to Rome was quite unlike Rubens': he was uninterested in the Antique (there is only one drawing after the Antique in the entire Italian Sketchbook), he had no desire (Bellori tells us) to fraternize with the community of Netherlandish artists in the town and he secured no major church commissions. In October or November he went back to Genoa for the winter and, as far as we know, never visited Rome again.

In the spring of 1624 Van Dyck travelled, presumably by sea, from Genoa to Sicily. He painted the Viceroy Emmanuele Filiberto, Prince of Savoy, in a superb three-quarter-length portrait (Plate 71) in the Dulwich College Picture Gallery, and carried out an important commission for the Oratory of the Rosary in Palermo. In September he left Sicily because of plague and once more returned to Genoa for the winter.

In the summer of 1625 Van Dyck visited southern France: in July he is said to have been in Marseilles. Otherwise we know little of his movements in 1625, 1626 and 1627, but he would seem to have spent much of this time in Genoa, where he enjoyed great success as a portraitist to the aristocracy. In September 1627 Van Dyck's sister died in Antwerp and it was probably this news that caused him to return home. On 8 March in the following year he drew up a will, the first document recording his presence in the city.

For Netherlandish artists throughout the sixteenth and seventeenth centuries a visit to Italy was a usual part of training. Once their apprenticeship was completed and they had been accepted into the guild as masters, they would set off across the Alps and then travel the length of the peninsula, sketching what they saw. Van Dyck was no exception: during his first four years in Italy he travelled extensively. However, as a precocious artist, whose style was already formed to a quite remarkable extent, he was very selective, taking from Italy only what he wanted and not – like Rubens and many others – exposing himself to a very wide range of visual experience.

The Italian Sketchbook permits us to study Van Dyck's reactions to Italy closely. While in the studios of Hendrick van Balen and Rubens, he had been constantly impressed by the greatness of Italian Renaissance painting. He would have studied it in the form of drawn copies, painted copies, engravings and sometimes originals – Rubens, in particular, had built up an important collection of Italian paintings. Van Dyck had also seen the great collections of Jacobean England, but when he finally arrived in Italy, he was not only able to study originals in previously undreamt-of quantity, but also those types of large scale Italian painting which could not be seen at all in the north, the frescoes and the huge decorative schemes.

Van Dyck did not use his Sketchbook consecutively and so we cannot follow him around Italy by simply turning its pages. Also, it is difficult to date particular pages precisely because he made two visits to Rome and spent so much time in Genoa. As far as can be judged, he seems to have used the Sketchbook principally between his arrival in Rome in February 1622 and his departure from Sicily in September 1624.

Sir Robert Shirley, an Englishman in the service of the Shah of Persia, and his wife, a Circassian noblewoman, were in Rome on a diplomatic mission to Pope Gregory XV between 22 July and 29 August 1622, during Van Dyck's first stay in the city. He made detailed drawings of them in the Sketchbook – the standing portrait of Shirley is inscribed by Van Dyck *Ambasciatore di Persia in Roma* (Plate 51) – for the pair of painted portraits which are now at Petworth House in Sussex

(Plates 52–4). The drawings are simply to record pose and costume: there are colour notes for Shirley's cape. We find a second drawing of Shirley closer to the final pose, on the next page, and also a group of sketches of turbaned heads, presumably members of his entourage. These are the only drawings for commissioned portraits in the Sketchbook. The Shirleys were ideal subjects for Van Dyck, for they chose to be painted in rich and colourful Persian court dress. Sir Robert wears a turban, a patterned tunic with red silk bows and over his shoulder a magnificent cloth-of-gold cape embroidered with Oriental figures. This exotic costume is set off by a deep red curtain, which falls behind him from the top right-hand corner of the canvas. Lady Shirley is seated on a cushion, wearing an elaborately patterned and jewelled cloth-of-gold dress with a matching headdress, a jewelled tiara and a black feather. She is shown against a landscape background; the tower is intended to suggest Rome. Beneath her feet is a Persian carpet. The painting of the costumes is masterly: with daringly free brushstrokes Van Dyck suggests the rich materials – the shimmer of gold thread, the sparkle of jewels, the glow of the carpet and the velvet cushions.

51. *Sir Robert Shirley.* 1622. Drawing from the Italian Sketchbook, pen, 20.1 × 14.6 cm. London, British Museum.

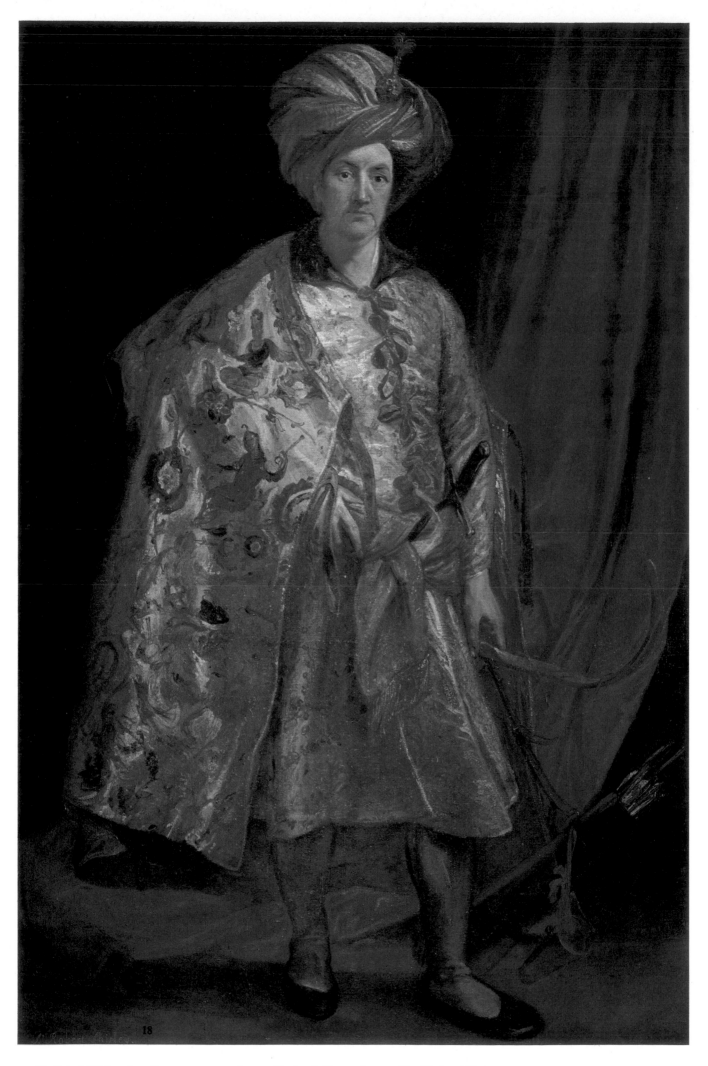

18

52. *Sir Robert Shirley*. 1622. Canvas, 197.5 × 138.7 cm. Petworth House, Sussex, The National Trust.

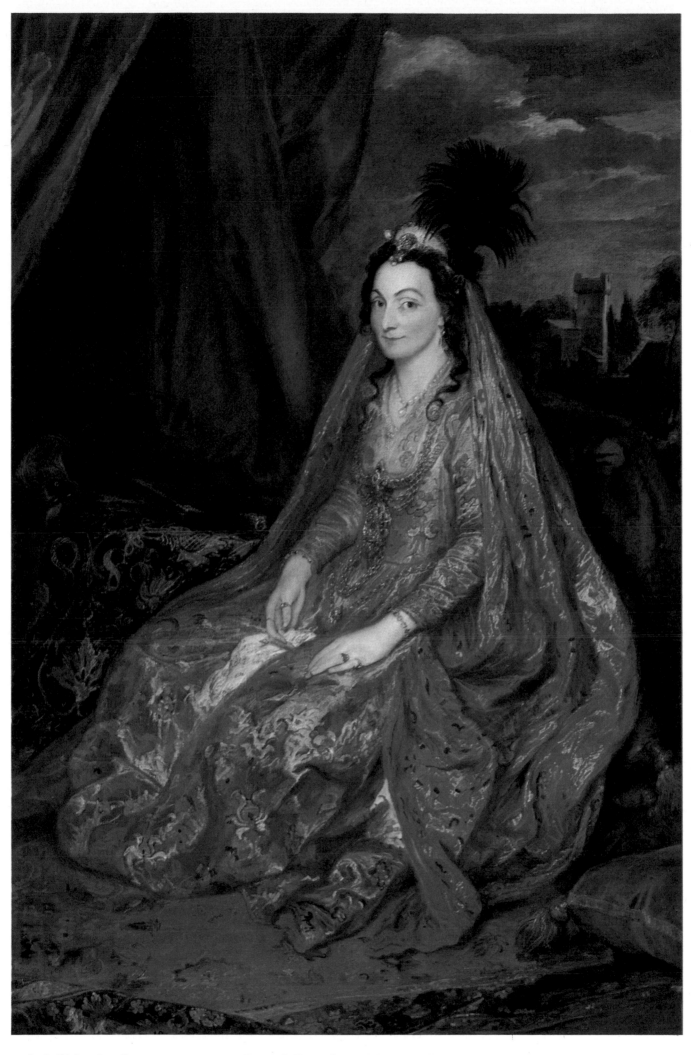

53. *Lady Shirley.* 1622. Canvas, 197.5 × 138.7 cm. Petworth House, Sussex, The National Trust.

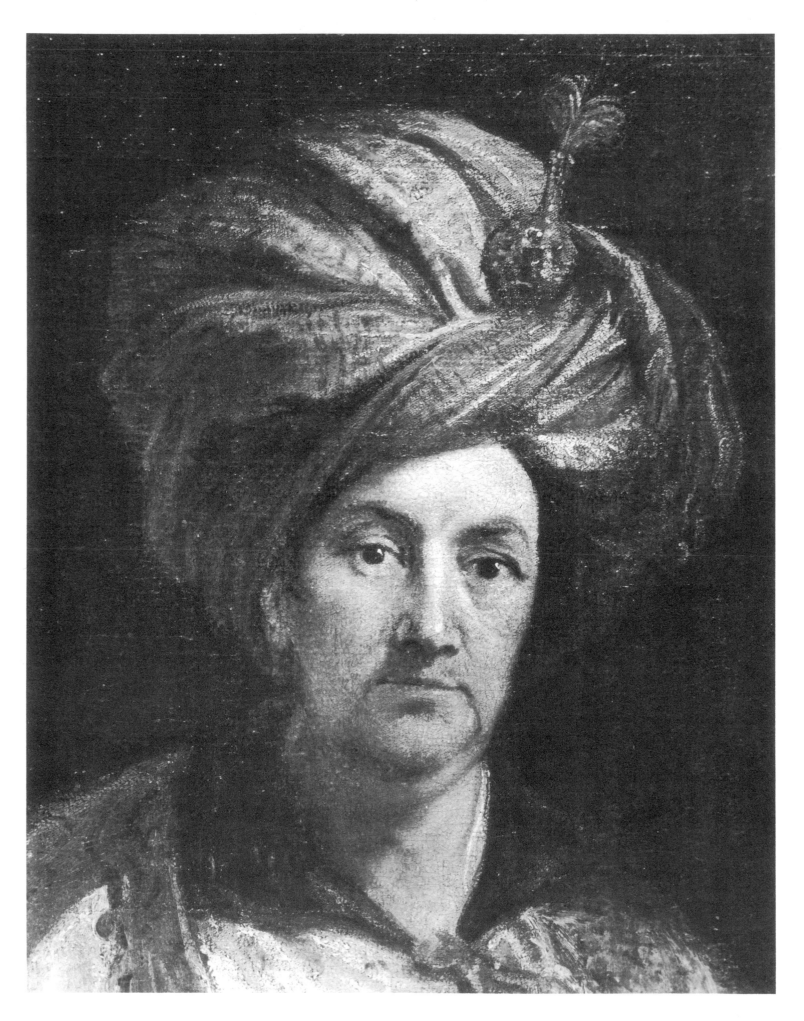

55. *Titian's 'The Andrians'*. 1622/3. Drawing from the Italian Sketchbook. London, British Museum.
Van Dyck's original black chalk drawing has been gone over in pen by a later, coarser hand.

56 (Right). *Titian's Blindfolding of Cupid'*. 1622. Drawing from the Italian Sketchbook. London, British Museum.

While in Rome, either on this visit or in the summer of 1623, Van Dyck sketched constantly. His principal interest was in the Venetians, and above all, Titian. He drew Titian's *Andrians*, which was in the Palazzo Ludovisi (Plate 55). Its composition was to haunt Van Dyck: he returned to it a decade later when he painted the story of Amaryllis and Mirtillo from Guarini's play *Il Pastor Fido*. In that picture (Plate 126), in Gothenburg, Van Dyck shows himself to be the true heir of the great Venetian, so close is he in spirit to Titian. He also sketched St John the Baptist from *The Holy Family with St John*, now in the National Gallery, London, but then in the collection of Cardinal Pietro Aldobrandini, and painted a copy of the picture (his copy is today in the Kunsthistorisches Museum in Vienna). In the Villa Borghese he drew Titian's *Sacred and Profane Love* and *Blindfolding of Cupid* (Plate 56), still amongst its greatest treasures. Not only has he made a colour note of the hanging above Venus in the latter, he has also written, with an arrow pointing at Diana's breast – '*quel admirabil petto*' (what a wonderful breast). He also painted a copy of this picture: in a 1644 inventory of his possessions, under the heading 'copies after Titian by Van Dyck', is *Una fictione poetica di tre Donne e due cupidetti*.

As we may expect, Van Dyck also studied Titian's portraits. Towards the back of the Sketchbook is a group of pages devoted to copies of portraits, among them Titian's portrait of Ranuccio Farnese, which Van Dyck saw in the Palazzo Farnese in Rome, and the *Portrait of a Man* by Moroni, which was believed in the seventeenth century to be by Titian and was known as 'Titian's Schoolmaster'. It was recorded in the Borghese collection in Rome in the eighteenth century and was presumably there when Van Dyck was in the city. His interest is concentrated in the man's pose and in the shadow thrown across his doublet. On the verso of that page is a copy in pen and wash of Titian's *Pope Paul III and his Nephews, Ottavio and Alessandro Farnese* (Plate 57), which hung in the Palazzo Farnese when Van Dyck was in Rome and is now in the Capodimonte Museum in Naples. Van Dyck was not concerned to delineate the individual heads, but rather to record the

54. Detail of Plate 52.

intense psychological drama which the three men play out. He was later to specialize in the double (and very occasionally the triple) portrait, and owed much of his ability to convey psychological nuance to his study of portrait groups by Titian and Raphael.

In Rome Van Dyck copied Raphael's *Disputa* fresco in the Vatican: his nervous pen strokes enlivened Raphael's figures, replacing their monumentality with a hectic energy. He also copied pictures by contemporaries: a page inscribed *da Cento*, the hometown of Guercino, contains a bold pen sketch of *The Magdalen at the Tomb of Christ with Two Angels* (Plate 58). Now in the Vatican Museum, Guercino's picture was painted in 1623 for the high altar of the now destroyed church of S. Maria delle Convertite in Rome. In 1623, the year of Van Dyck's second visit to Rome, the altarpiece was the very latest work by this rising star and as such attracted a great deal of attention. He also sketched Annibale Carracci's *Christ Mocked*, which was then in the Palazzo Farnese (today it hangs in the Pinacoteca at Bologna). Below the Carracci is a drawing of Titian's famous painting of the same subject, now in the Louvre, but at the time hanging in the Cappella Corona in S. Maria delle Grazie in Milan. Within the Sketchbook he grouped his drawings by subject. It is the sketchbook of a working painter, not of an antiquarian. He can be seen studying the ways in which the great painters of both past and present had solved particular problems and interpreted particular subjects, with a view to treating these subjects himself.

One of the most striking aspects of the Italian Sketchbook is the virtual absence

57 (Left). *Titian's 'Pope Paul III and his Nephews, Ottavio and Alessandro Farnese'.* 1622/3. Drawing from the Italian Sketchbook. London, British Museum. At just the moment when this portrait was being painted, in 1546, the Pope's overambitious 'nephew' (in fact his grandson) Ottavio, seen here obsequiously bending towards him, was plotting with the old man's enemies. By contrast Cardinal Alessandro Farnese, a great churchman and patron of the arts, stands to the left, removed from the intense psychological drama acted out in front of him and providing a foil to it.

58. *Guercino's 'The Magdalen at the tomb of Christ with two angels'.* 1623. Drawing from the Italian Sketchbook. London, British Museum.

59. *Diogenes.* 1622/3. Drawing from the Italian Sketchbook. London, British Museum.
The only drawing after antique statuary in the 200 pages of copies and sketches that make up the Italian Sketchbook.

of drawings after the Antique. This lack of interest in classical marbles is most unusual among Netherlandish painters who went to Italy. For these artists, from Jan Gossaert (who was in Rome in 1508) to Rubens and beyond, the works of Antiquity were one of the principal reasons for a journey to Italy. Steeped in an Italian-derived theory of art which maintained the primacy of classical art, they enthusiastically drew as many of the surviving sculptural and architectural monuments as they could. This, of course, greatly added to the importance of Rome on their itineraries. Most made extended visits to Rome and not only drew in the Forum, but also managed to insinuate themselves into the great private collections of antiquities. Van Dyck was markedly different. He had introductions to all these collections – he drew Renaissance and contemporary paintings in some of them – but he had no interest in sketching the marbles. The solitary drawing in the Sketchbook after antique sculpture is of a statue of the philosopher Diogenes, which is now in the Louvre (Plate 59). Van Dyck saw and sketched it in the Villa Borghese. It is a delicate study in pen and wash; the artist's principal interest is in the fall of light and the shadow it casts in the folds of the toga. It is quite different from Rubens' drawings after the Antique: in his drawings of the Laocoon, for example, Rubens was anxious to record every detail in the group, every bend in the limbs and every straining muscle. He was fascinated by classical sculpture, being an antiquarian and a collector as well as a painter; he even wrote a treatise – *De Imitatione Statuarum* – on the importance of the study of antique statuary for painters.

60. *The Aldobrandini Marriage.* 1622/3.
Drawing from the Italian Sketchbook.
London, British Museum.
This drawing of the Hellenistic fresco, now in the Vatican, is spread across two pages of the Sketchbook. Van Dyck has noted, in Italian, 'Seen in the garden of the Aldobrandini. Painted in ancient fresco' and, below, 'Wedding of the ancient Romans'.

Van Dyck's lack of interest in the Antique confirms an interesting remark about him made by Joachim van Sandrart in his *Teutsche Akademie* (1675): 'The rules of painting held in esteem in that town [Rome], the academies, that is to say studies made in a group after the antique or after Raphael, or other serious studies, did not interest him and it is for this reason that after a short time he returned to Genoa.' Certainly it was most unusual for a Flemish painter to spend as little time in Rome as Van Dyck did during his long residence in Italy. He preferred the society of Genoese aristocrats to that of the Netherlandish painters, who formed a large and sometimes raucous community in Rome. Bellori tells us that Van Dyck offended them with his haughty manner and his grand, courtly style of life: he was known as *il pittore cavalieresco*.

While antique statuary held little fascination for Van Dyck, his attention was caught on a visit to the Villa Aldobrandini at Magnanapoli by the Hellenistic fresco known as *The Aldobrandini Marriage*. At the top of a double page of figures drawn from the fresco (Plate 60) he wrote *si vede nel giardino di Aldobrandini dipinto in fresco antico* and beneath *sposalitio di gli Romani antichi*. The fresco had been discovered in 1606 and was housed in one of the many pavilions in the gardens of the Aldobrandini villa until its removal to the Vatican, where it is today. It is said to be a copy of a work by Aëtion, a contemporary of Alexander the Great, and to show the preparations for the marriage of Alexander and Roxana. Van Dyck's interest in the fresco was not at all archaeological. He was not concerned to have a true and detailed record of it: it was the striking pose and gesture that he chose to record, and he also made a number of colour notes.

During his time in Rome, Van Dyck made some drawings from the life. Above a group of figures of richly-dressed Roman ladies (Plate 61) is the inscription: '*nel giorno di S.Margritta in ciesa di essa*' (on St Margaret's Day, in the church of the same name). The church is S. Margherita in Trastevere, and the saint's day is 20 June. Van Dyck has shown the wealthy women of Rome on their way to church and chatting while on their knees at prayer. One woman has turned round and registers mock indignation at the young artist sketching her.

While he was in Rome, Van Dyck received a commission for two paintings

from Cardinal Guido Bentivoglio, who had been Papal Legate in Flanders until 1617. One was a *Crucifixion* which today cannot be identified. The second was the superb full-length portrait of the Cardinal which now hangs in the Pitti Palace in Florence (Plates 63, 64). For this prince of the Church Van Dyck painted his finest portrait to date. The Cardinal's alert features, turned towards the right and illuminated by a strong fall of light, dominate the composition, but perhaps the most remarkable aspect of this portrait is the rendering of his scarlet and white robes. The scarlet silk and the white lace shimmer, seeming almost to have a life of their own and creating an intense visual excitement. The effect is like that of a rich jewel which changes colour as it is turned in the hand. The English painter Jonathan Richardson the Younger saw the painting early in the eighteenth century, and a few years later he wrote:

> I never saw anything like it. I look'd upon it two Hours, and came back twenty times to look upon it again. He sits in an Elbow Chair with one of his Elbows upon the Arm of the Chair and his Hand (the most Beautiful and Graceful in the World) falls carelessly in his Lap by the other, which most unaffectedly gathers up his Rochet, which is painted Beautifully, but keeps down so as not to break the Harmony. His Face has a Force beyond anything I ever saw, and a Wisdom and Solidity as great as Raffaele's but vastly more Gentile. Indeed it must be confess'd the Difference of the Subjects contributes something to this Advantage on the side of Van Dyck. The Colouring is true Flesh and Blood, Bright, and Transparent; Raffaele's is of a Brown Tinct and something Thick, at least compared with this. His Scarlet is very Rich and Clear, but serves nevertheless to set off the Face, 'tis so well manag'd. The Picture is enrich'd with things lying upon the Table, which unite with the Cardinal's Robes, and Flesh, and make together the most pleasing Harmony imagineable.

No visitor to the Pitti can fail to share Richardson's enthusiasm.

61. *Roman Ladies at Prayer in the Church of S. Margherita in Trastevere.* 1622/3. Drawing from the Italian Sketchbook. London, British Museum.
Van Dyck has noted that he made this sketch on St Margaret's day, 20 June. He was in Rome on that day in both 1622 and 1623.

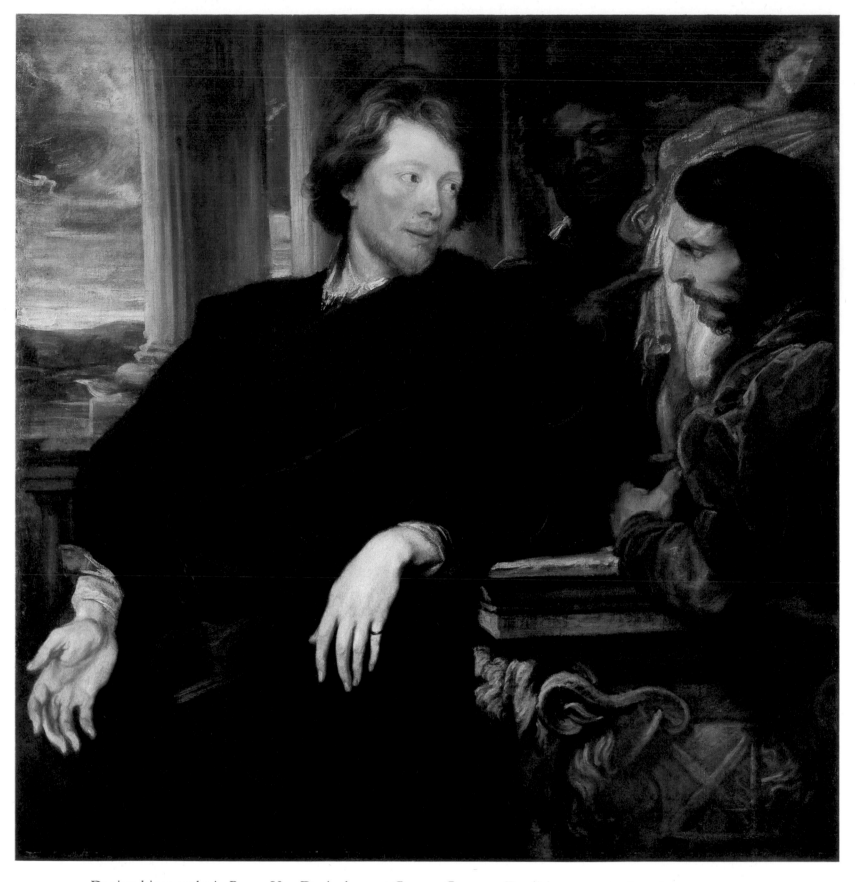

During his months in Rome Van Dyck also met George Gage, an Englishman on the lookout for works of art. He was later to be one of Charles I's most effective agents in the building up of his great collection. Van Dyck painted Gage characteristically examining a small statuette being offered to him, presumably for purchase (Plate 62). Gage's relaxed, even casual pose contrasts with the formality of Bentivoglio's. Van Dyck was content to sketch in the sky, landscape and architecture, though he took very considerable care to incorporate Gage's coat of arms cleverly into the parapet on which he leans. The broad style suits the

62. *George Gage examining a Statuette*. Canvas, 115 × 113.5 cm. London, National Gallery. The arms carved on the ledge on which the sitter leans are those of the Gage family, whose crest is the ram's head, and identify him as George Gage (*c.* 1592–1638), a diplomat and agent of Charles I. It is likely that Gage and Van Dyck met in Rome in 1622 or 1623 and that Gage sat to the painter then.

74

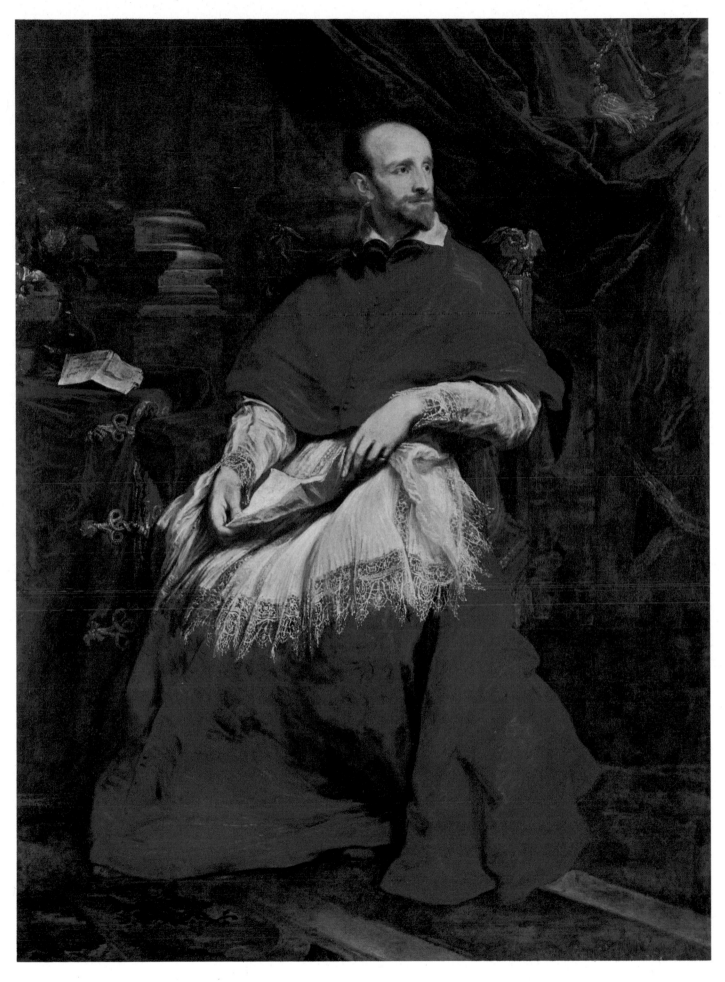

63. *Cardinal Bentivoglio.* 1622/3. Canvas, 196 × 145 cm. Florence, Pitti Palace.

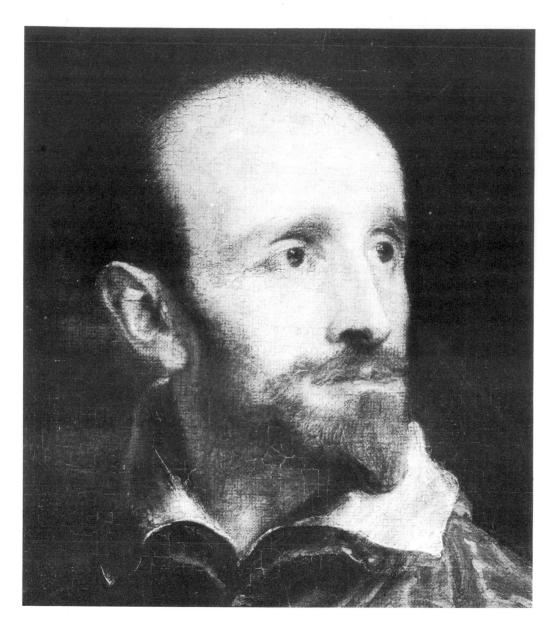

subject; it enables Van Dyck to convey the sense of a moment – the proffering of the statuette – being frozen. In the face of the earnest entreaties of the vendors Gage registers interest but, like a skilful poker player, is careful not to appear too enthusiastic. The serious haggling is yet to come.

Although, as seems entirely in accord with our knowledge of Van Dyck's personality, he did not join the Netherlandish artists' societies in Rome, he did meet a number of fellow Northern artists during his stays there. He painted, for example, a half-length portrait of the Flemish sculptor Frans Duquesnoy, holding the small head of a satyr (Plate 66). He also painted a half-length of the German sculptor Georg Petel (a friend of Rubens who specialized in small-scale ivory statuettes), though in this case he gave no hint of his sitter's occupation. Petel's hands are almost entirely concealed by the bold sweep of his cloak; he glances up to the left, his face caught in a strong fall of light. The face is modelled with a vivacity of expression equal to that in Van Dyck's head of Frans Snyders. A third half-length portrait is said to show the Parisian engraver Jean Leclerc, whom he would have met in Rome, probably in 1623.

From Rome Van Dyck went on to Venice, where he scoured the city for the work of Titian: in the Sketchbook he drew the *Annunciation* in the Scuola di S. Rocco, where it still hangs; the Pesaro altarpiece and the *Assunta*, both in S. Maria

65. *Venetian scenes*. Drawing from the Italian Sketchbook. London, British Museum.

66. *Frans Duquesnoy*. Canvas, 77.5 × 61 cm. Brussels, Musées Royaux des Beaux-Arts. The Flemish sculptor Duquesnoy (1594–1643), a native of Brussels, settled in Rome in 1618 and remained there until 1643. He died on his way to Paris to take up the position of Court Sculptor.

dei Frari; the *Madonna and Child* from a fresco then in the Chapel of S. Niccolò in the Ducal Palace; the *Pentecost* which hung above the high altar of S. Spirito in Isola (now in S. Maria della Salute); and many others. He also made drawn copies after Paolo Veronese, notably a ceiling painting in the Ca' Pisani; the *Allegories of Love*, now in the National Gallery, London; and ceiling paintings in the Ducal Palace. There are also sketches of paintings by Giorgione, Pordenone, and Sebastiano del Piombo which he saw in Venice. The *Carrying of the Cross* by Sebastiano, copied by Van Dyck in bold pen and wash, was probably the painting recorded soon afterwards in the Arundel Collection and may therefore have been one of the pictures bought by Vercellini in Venice. The treatment is cursory; Van Dyck's interest, once again, is in the fall of the light and the shadow that it creates. The inscription confirms this: '*questo lume e il più ciaro*' (this highlight is the brightest).

Just as he had done in Rome, Van Dyck also sketched from the life in Venice. The two ladies at the top of a sheet of studies of figures glimpsed in the streets of the city are deliberately contrasted (Plate 65): the one on the left, heavily veiled,

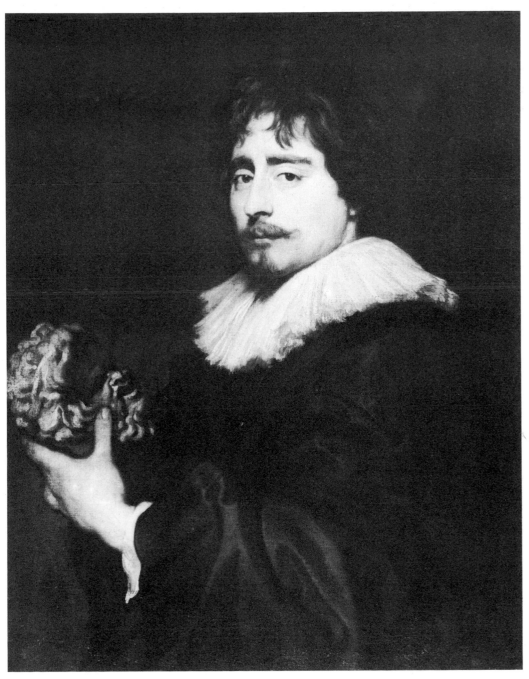

is inscribed *'cortisana de venetia'*, while the lady on the right is a *'donna ordinaria'*. (Dürer too, while in Venice, had been struck by the appearance of the courtesans and made drawings of them.) Beneath the courtesan is a *'citella'*, an old woman. To her right is a water-carrier and further to the right a gondolier, shown in three-quarter length, a vivid study of a figure in action. On the facing page is a bearded man in a skull-cap and a long robe, perhaps a Venetian senator, and a group of three men in conversation.

While in Venice Van Dyck met and painted Cornelis de Wael's friend and correspondent, the Antwerp merchant and shipowner Lucas van Uffelen, who had been established in the city for some six years. There are two surviving portraits of Van Uffelen by Van Dyck, one in Braunschweig and the other, which is among the finest of all his Italian portraits, in the Metropolitan Museum, New York (Plate 67). In the latter picture Van Uffelen is shown rising from his chair, compasses in hand, looking over his right shoulder. The table in front of him is draped with a rich Turkish carpet, on which are strewn a sheet of drawings, a flute, the bow of a viola da gamba, a globe, and an antique sculpted head, all of which refer to his wide range of interests. Van Uffelen's face is alert, strongly individual, and highly intelligent. His pose, supporting himself on his right hand, is tense, almost impatient. It suggests a man of action, eager to get on, unwilling to sit still even for the portraitist. This sense of the capture of a fleeting moment is an essential aspect not just of Van Dyck's portraits, but of Baroque portraiture as a whole. Van Uffelen amassed an important collection of Italian paintings and sculptures which he took back to Amsterdam, where he died in 1637. It was dispersed in two sales, in 1637 and 1639: Rembrandt was among those who attended the second sale in April 1639. He sketched Raphael's *Baldassare Castiglione*, one of the treasures of the collection, which also included a painting purporting to be a self-portrait of Titian and his mistress. This grotesque and clumsy composition, which is now thought to be an early-seventeenth-century pastiche of Titian, had caught Van Dyck's eye when he was looking at Van Uffelen's collection in Venice, and he drew it in the Italian Sketchbook. He also etched it with an effusive dedication to its owner: *Al molto illustre magnifico et osseruandis^mo Sig^r il Sig^r Luca van Uffel, in segno d'affectione et inclinatione amoreuole, como patrone et singularis^mo amico suo dedicato il vero ritratto del unico Titiano. Ant. Van Dyck.*

Van Dyck continued to use the Sketchbook as he travelled in the winter of 1622 and 1623. At the back of the book is a list of places in which he had seen *le cose di Titiano* (no other artist is mentioned): they include Rome, Ancona, Reggio, Parma, Milan and Venice. Individual private collections are also listed: noteworthy among them are the *palazzo del motcenigo al duolo*, Lady Arundel's summer palace on the Brenta canal, the *palazzo delli foscari in strada di padua*, the Villa Malcontenta, also on the Brenta, and the *casa de danielo nys*. (Nijs was the shady merchant and art dealer who acted for Charles I in his purchase of the Gonzaga collection.)

In the spring of 1624 Van Dyck went to Sicily at the invitation of the Viceroy Emmanuele Filiberto of Savoy, taking his Sketchbook with him. The presence of a wealthy Genoese community in Palermo must have made him hope for generous patronage. On the second page of the Sketchbook, beneath his signature – *Antonio van Dyck* – he noted the name of a doctor in Palermo, Don Fabricio Valguernero. Perhaps he had been warned about plague on the island; and in fact, a severe outbreak eventually curtailed his stay. It first broke out in Palermo in mid-May, and in the months that followed thousands died. However, on 14 July an event occurred which gave hope to the Sicilians and employment to Van Dyck – the discovery of the remains of St Rosalie, the patron saint of the

67. *Lucas van Uffelen*. Canvas, 124.5 × 101 cm. New York, The Metropolitan Museum of Art.

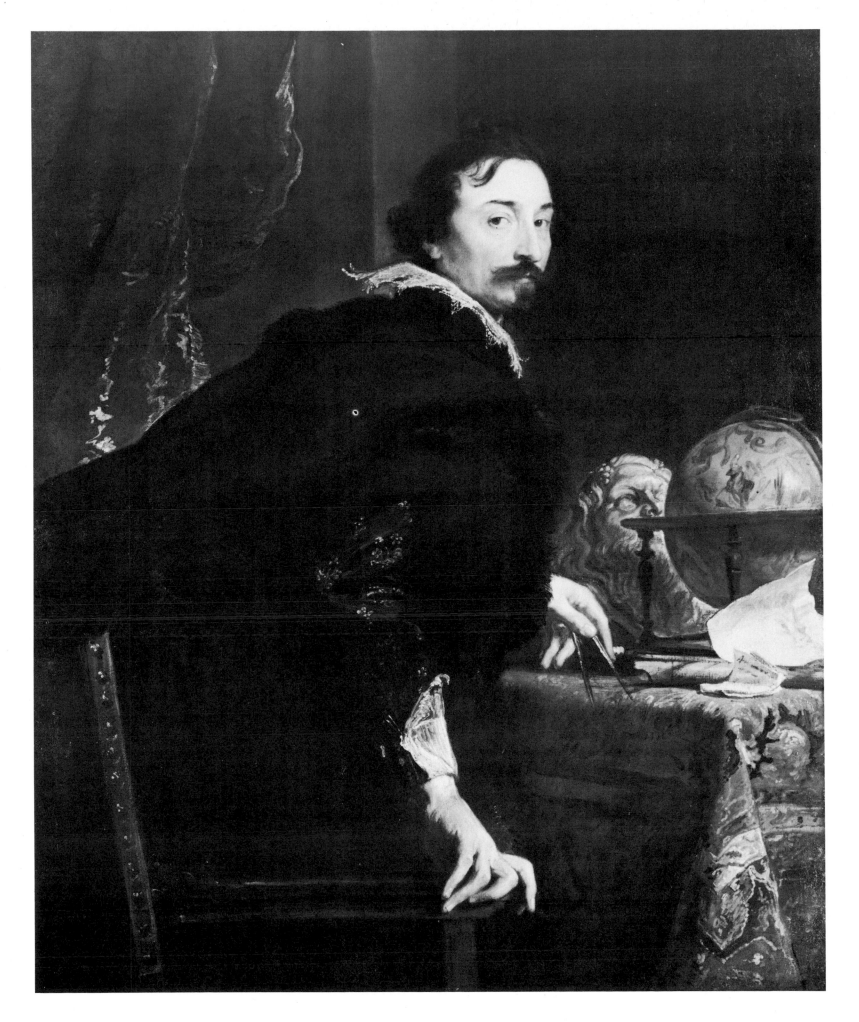

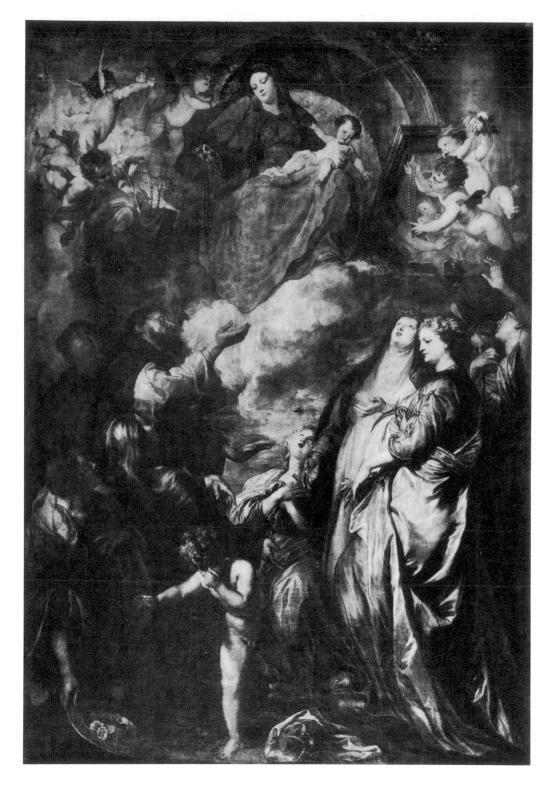

68. *The Madonna of the Rosary*. 1624–7.
Canvas, 397 × 278 cm. Palermo, Oratorio del
Rosario.
Van Dyck's most important religious
commission during his Italian years, this
large altarpiece was completed in Genoa
and not installed in the Oratory in Palermo
until 1628, by which time the painter was
back in Antwerp.

city of Palermo, in the grotto of Monte Pellegrino. St Rosalie, the daughter of a
nobleman at the court of King Roger of Sicily, rejected offers of marriage and
withdrew to Monte Pellegrino above the city, to devote herself to prayer and
solitary meditation. Churches were dedicated to her in the thirteenth century but
her cult subsequently declined until the discovery of her relics in 1624, when the
people of Palermo turned to her as an intercessor in time of plague. Van Dyck
was commissioned to paint a number of pictures showing the saint, of which the
most important was his extremely ambitious altarpiece, *The Madonna of the Rosary*,
for the Oratorio del Rosario in Palermo, where it still hangs (Plate 68). The
composition is a traditional Italian one – the Virgin and Child in glory, adored
by two groups of full-length saints. St Rosalie, a tall figure shown in near-profile,
is prominent in the right hand group. The plague is referred to by the boy who,
holding his nose against the stench of death, rushes out of the painting – a

dramatic device which Van Dyck had taken from Caravaggio. Titian, however, is the dominant influence: the massing of the figures, the saints' arms raised in adoration, the clouds separating the altarpiece into two levels – all these elements echo his Venetian altarpieces. Van Dyck may also have had in mind Rubens' first Chiesa Nuova altarpiece, which he had seen and marvelled at in Antwerp and which itself was influenced by Rubens' study of Titian. The large-scale Italianate altarpiece was an idiom in which Van Dyck felt entirely at ease: to it he brought his exquisite sense of colour (the silvery greys and blues are particularly effective), his fluent painting of textures, and the elegant, attenuated figures of his saints. St Rosalie in the *Madonna of the Rosary* could be the sister of St Catherine in the *Mystic Marriage of St Catherine* or the bride in the *Continence of Scipio*. Van Dyck succeeds in binding together the two halves of the painting with a flowing, upward movement. The altarpiece was still unfinished when he left Palermo in September 1624 in order to escape the plague that continued to rage there. He took the canvas back to Genoa with him and completed it there in 1627; it was set in place in Palermo in the spring of 1628.

For the Oratorio del Rosario altarpiece Van Dyck used a traditional Italian composition, but for his other paintings of St Rosalie he had no direct Italian prototypes to follow, for the saint had rarely been represented before. It was Van Dyck who established the iconography of St Rosalie. He painted two compositions: in one the saint is kneeling, eyes raised to heaven, interceding for the inhabitants of Palermo; the other shows her being borne up to heaven by angels. There are at least three examples of the first type (Houston; Apsley House (Plate 69); Ponce, Puerto Rico). St Rosalie is by her cave; she wears monastic robes and places her left hand on her breast while her right hand points to the city of Palermo beneath her. In two versions she is being crowned by angels. Rather than

69. *Saint Rosalie.* c. 1624. Canvas, 114 × 84 cm. London, Apsley House, Wellington Museum.

70 (Right). *Saint Rosalie borne up to Heaven.* c. 1624. Canvas, 100.3 × 74.4 cm. New York, The Metropolitan Museum of Art.

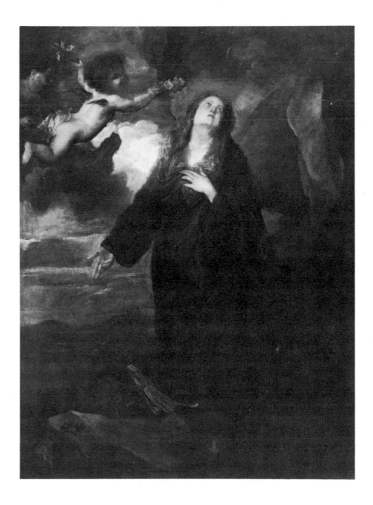

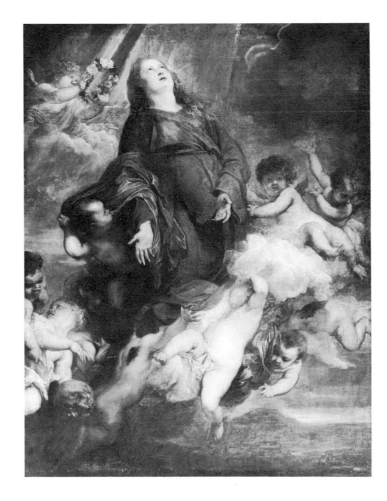

create an entirely original composition for St Rosalie, Van Dyck had recourse to a painting of a single saint by Guido Reni, which he then adapted for his own purposes. His source was Reni's *St Francis in Ecstasy*, which was painted for the Church of S. Filippo Neri in Naples. Although there are no drawings after Reni in the Italian Sketchbook, while he was in Italy Van Dyck certainly responded to Reni's refined and emotional religious paintings. He used Reni's seated *St John the Baptist* (now in the Musée des Beaux-Arts, Nantes), for example, as the model for his own painting of the Baptist. He may have seen the *St Francis* in Reni's studio in Rome in the summer of 1622 or on a later visit to Naples. In the *St Rosalie* he elongates the saint's figure and refines her expressive hands; he takes pleasure in her long rippling hair and enjoys the over-elaborate folds of her habit. In the Ponce version he includes an accurate view of Palermo, a topographical detail rarely found in his work.

For *St Rosalie borne up to Heaven* (Plate 70) a long-established iconographic formula existed in the subject of the Assumption of the Virgin, which Van Dyck readily adopted. Indeed, when he later came to paint his own *Assumption of the Virgin* (the Metropolitan Museum) he used a composition very close to that of the *St Rosalie*. Once again, the emphasis is on intercession; even as the saint ascends to heaven, her elegant hands with their characteristically long, tapering fingers gesture towards the stricken city below.

Van Dyck painted one outstanding portrait during his stay in Palermo – the three-quarter-length of the Viceroy Emmanuele Filiberto, Prince of Savoy, in armour (Plate 71). As with the portrait of Cardinal Bentivoglio, it combines his remarkable gift for the depiction of materials – here gold-inlaid armour, lace, and the plumes of the helmet – with a strongly characterized head. It is painted from dark to light, as are most of his Italian portraits; that is, Van Dyck adopted the Italian procedure of priming the canvas with a dark ground and laying the light pigments over it. The usual Flemish practice was the reverse.

While he was in Palermo, Van Dyck paid a visit to the elderly woman painter Sophonisba Anguissola. Born and trained in Cremona, she had achieved great contemporary fame as a portraitist; Baldinucci, in his *Lives of the Artists*, calls her the equal of Titian. In 1559 she went to the court in Madrid as a lady-in-waiting and painted Philip II's courtiers. By 1584 she was living in Genoa with her second husband, Orazio Lomellini, who owned extensive properties in Sicily. Sophonisba finally settled in Palermo. She died there in November 1625, and was buried in the church of her husband's community, S. Giorgio dei Genovesi. Van Dyck may have secured the introduction through the Lomellini family, whose group portrait he painted soon afterwards in Genoa; he must have been fascinated to meet this legendary portrait painter, the last survivor of an earlier generation, who had the added interest of being a woman working in a traditionally male profession.

Sophonisba must have held the painter spell-bound as she told of Philip II and his courtiers. He drew her portrait in the Italian Sketchbook (Plate 72) and round the drawing made notes (in Italian) on their meeting: 'Portrait of Signora Sophonisba, done from the life in Palermo in the year 1624, on 12 July, her age being 96 years, still having her memory with her brain most alert, very courteous and although through great age she has lost her sight, she would all the same delight in putting pictures in front of her, and then by putting her nose to the picture, she was able to make out a little of it, and she took great pleasure in doing this. As I was making her portrait, she gave me many hints, such as not to take the light from too high, in case the shadows in the wrinkles of old age become too strong, and much other good advice, while she told me the events of her life,

71. *Emmanuele Filiberto, Prince of Savoy*. 1624. Canvas, 126 × 99.6 cm. London, Dulwich College Picture Gallery.
Emmanuele Filiberto (1588–1624) was the third son of Charles Emmanuel of Savoy. His career was spent in the service of Spain. He was a Knight of Malta and was created Prince of Oneglia in 1620. In 1621 he was appointed Viceroy of Sicily; he died in Palermo on 3 August 1624, a few months after this portrait was painted.

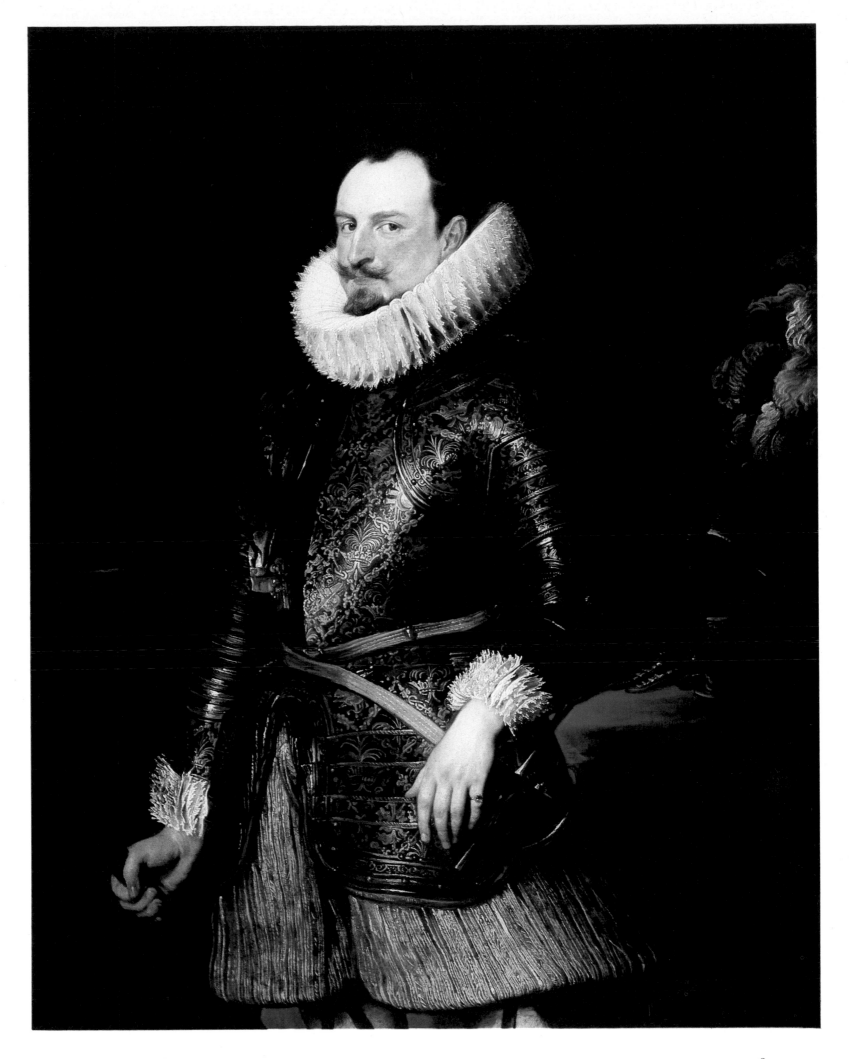

72. *Sophonisba Anguissola*. 1624. Drawing from the Italian Sketchbook. London, British Museum.

from which I came to know that she was a painter from nature and very skilled and that the greatest misfortune she had was that because of her failed eyesight she was no longer able to paint, although her hand was firm without any trace of a tremor.' From Van Dyck's account it is clear that he not only sketched Sophonisba, he also painted her portrait. This is apparently the painting formerly in the Nauta collection in Amsterdam; its present whereabouts are unknown. The old woman is seen in three-quarter length; she is bent over, wearing her widow's peak and a broad flat collar. Her right hand tightly grips the arm of the chair in which she sits. Sophonisba's own portraits belong to the North Italian realist tradition of Moroni and Moretto, and had little real influence on the development of Van Dyck's style. There are no surviving copies by him of any of them.

Van Dyck's eye for vivid incident and for the unusual did not desert him in Sicily; on one page, beside a drawing of a women wearing a tall hat, he has written *'una striga in Palermo'* (a witch in Palermo) (Plate 73). The next opening shows street scenes, also presumably in Palermo (Plate 74). On the left are actors and

acrobats, at the top of the page a monkey, and to the right, characters from the *Commedia dell'arte*, one playing an exaggeratedly long *chittarone*.

In September 1624 Van Dyck left Sicily for Genoa and apart from a trip to southern France in the following year, about which little is known, he seems to have spent most of his time there until his return to Antwerp in the winter of 1627. In the seventeenth century the ancient maritime republic of Genoa was ruled by an oligarchy, whose constituent families had frequently intermarried; it included the Spinola, Pallavicini, Grimaldi, Doria, Sauli, Cattanei, Giustiniani and Lomellini families. Their immense wealth was principally derived from banking; Genoese bankers lent throughout the world and the city had a truly cosmopolitan air. A number of Flemish painters had visited Genoa, among them Rubens and Frans Snyders, and the animal painter Jan Roos and Van Dyck's host Cornelis de Wael had both successfully settled in the city. De Wael seems to have been the unofficial leader of the Flemish community. The elegance and richness of Van Dyck's portrait style was ideally suited to the aristocrats of Genoa and after initial contacts had been established, presumably through Cornelis de Wael, Van Dyck was in constant demand. His portrait style owes much to that of Rubens' Genoese portraits. Rubens' *Portrait of Brigida Spinola Doria* (Plate 76) contains many of the features of Van Dyck's Genoese portraits – the Marchesa was shown full-length, standing in the open air against an elaborate architectural backdrop, the richness of her dress of silver thread trimmed with gold set off by a deep red drapery (which has no functional justification) cascading from the top right-hand corner of the painting. To this established formula Van Dyck brought his gift for the depiction of lace, satin and velvet, and his ability to flatter his sitters by elongating

73. *Street Scene in Palermo.* 1624. Drawing from the Italian Sketchbook. London, British Museum.

74 (Right). Detail from *Street Scene in Palermo.* 1624. Drawing from the Italian Sketchbook. London, British Museum.

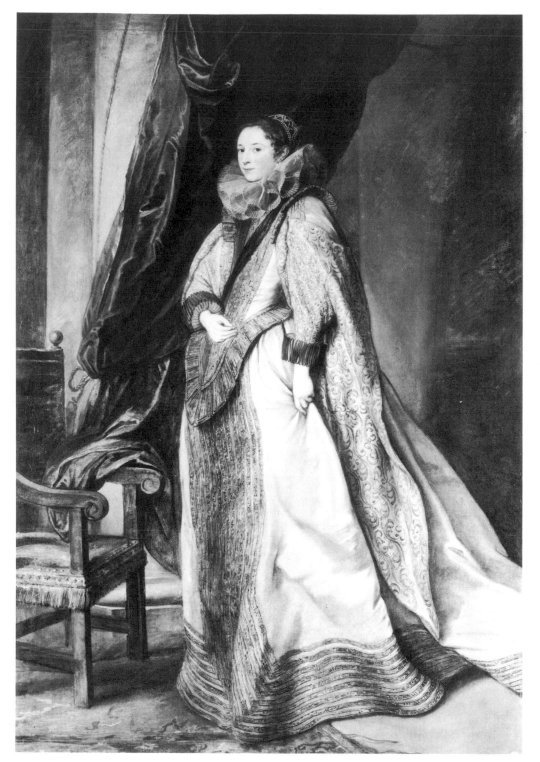

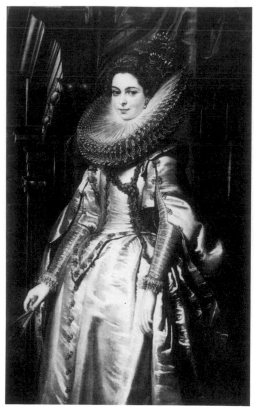

75 (Left). *Paola Adorno, Marchesa Brignole-Sale*. Canvas, 230.8 × 156.5 cm. New York, Frick Collection.

76. Rubens: *Marchesa Brigida Spinola Doria*. 1606. Canvas, 152.2 × 98.7 cm. New York, The Metropolitan Museum of Art. Judging from an early engraving and a preparatory drawing, this portrait was originally full-length and subsequently was reduced to its present dimensions. Apparently painted in Genoa in 1606, it is one of the finest of all Rubens' Italian portraits.

their figures and making them seem even more elegant and remote than they were in life. An idea of the demand for Van Dyck's work in Genoa and his industry during his years there can be gained from a guide book to the city which was published in 1780: in the *palazzi* and churches of Genoa there were said to be no fewer than ninety-nine paintings by Van Dyck, of which seventy-two were portraits.

A Genoese noblewoman who sat to Van Dyck at least three times was Paola Adorno, Marchesa Brignole-Sale. The first portrait would seem to be the one which is now in the Frick Collection (Plate 75). Shown in full-length, standing, she wears a white dress, trimmed with gold, with patterned sleeves and train. She has lace at her neck and wrists and wears a small cap decorated with pearls. Van

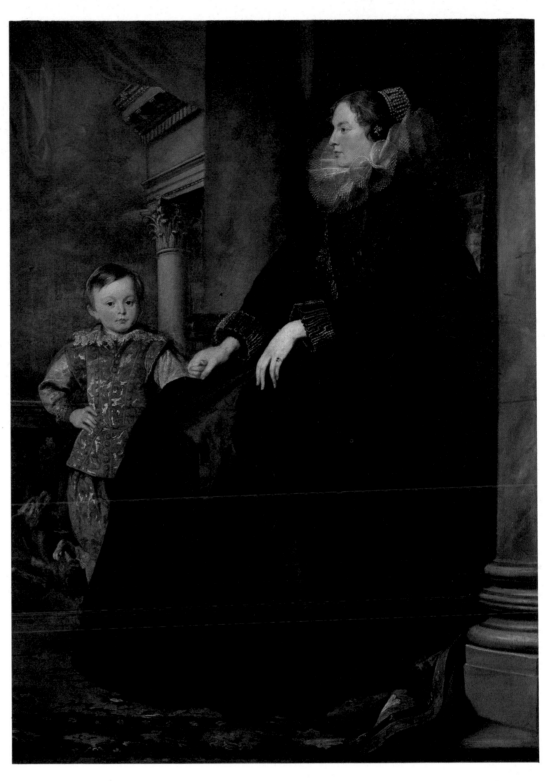

77. *Paola Adorno with her Son.* Canvas, 189.2 × 139.7 cm. Washington D.C., National Gallery of Art.

Dyck placed her against a plain (though palatial) architectural setting and set off her white and gold with a red curtain, which falls from the top centre edge of the canvas and drapes over the arm of a chair. The background is suggested, not described – Van Dyck's hasty brushstrokes can easily be made out – and is deliberately contrasted by the painter with the careful, even painstaking rendering of the figure of the Marchesa herself. Van Dyck painted her again in a portrait still in the Palazzo Rosso in Genoa, in which she stands on the terrace of her *palazzo*, a composition which follows Rubens' *Brigida Spinola Doria* very closely. On this occasion he has given greater substance to the architecture, the curtain and the chair, on which the Marchesa's pet parrot is perched. Her dress is darker, red and gold, again with lace at neck and wrists – and again she wears a small

pearl-encrusted cap. In a third portrait (Plate 77) Van Dyck shows the Marchesa seated, with her young son standing beside her, holding her right hand in his left. She is dressed in black and her face is in strict profile to the right. The boy wears a velvet brocade doublet and hose. The composition is statuesque yet tender, immensely dignified yet – in the boy's direct gaze and the clasp of hands – affectingly human. Van Dyck also painted a portrait of the Marchesa's husband, Anton Giulio Brignole-Sale, on horseback (Plate 78). The columns of the rider's *palazzo* and the near-obligatory red curtain are present, but any tendency towards formality is counteracted by Brignole-Sale's pose. Doffing his cap as he rides towards the spectator, he is relaxed and utterly natural. Van Dyck, as we know from Bellori, was an enthusiastic horseman himself, and, with Velazquez, he is the great Baroque master of the equestrian portrait. Rubens, in his *Portrait of a Prince of the Doria Family*, shows the horse rearing, an action he took from a manual of equestrianism, but Van Dyck is content to let the Marchese's horse walk. He used this equestrian pose again, in a portrait of his host in Genoa, Cornelis de Wael.

A particularly striking pair of Genoese portraits are of an elderly senator and

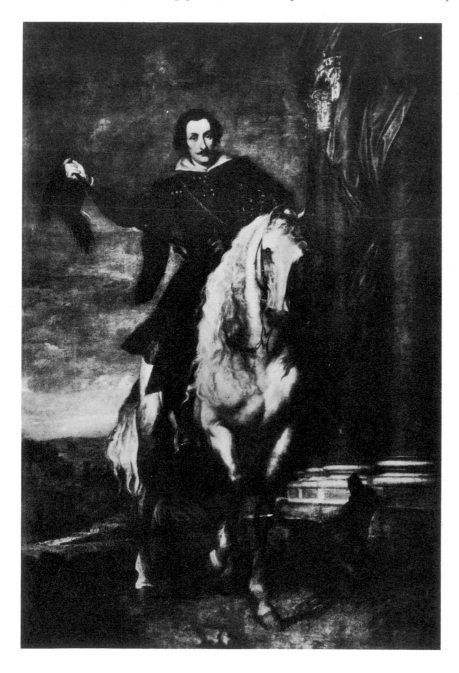

78. *Anton Giulio Brignole-Sale on Horseback*. Canvas, 288 × 201 cm. Genoa, Palazzo Rosso.
Brignole-Sale's trappings – horse, column, curtain – were chosen to emphasize his aristocratic status, and yet he had only shortly before bought this title, having made a fortune as a merchant.

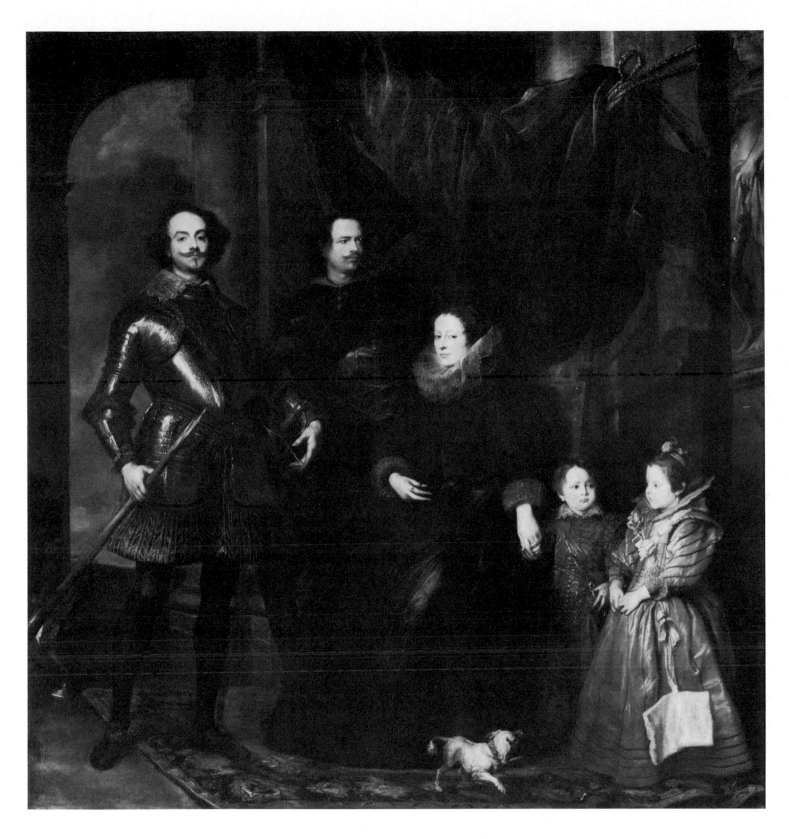

79. *The Lomellini Family*. Canvas,
269 × 254 cm. Edinburgh, National Gallery
of Scotland.
The Lomellini were one of the leading
families of Genoa. Sophonisba Anguissola
had married into the family, which had
extensive estates in Sicily. This portrait
group probably shows Giovanni Francesco,
son of Doge Giacomo Lomellini, with his
wife and two elder children, and his
brother. It was bought in Genoa in 1830 by
Andrew Wilson from Marchese Luigi
Lomellini.

his wife (Plates 80, 81). (When they were in the collection of Sir Robert Peel they
were admired by the portrait painter Sir Thomas Lawrence.) Both sitters are
shown full-length, seated, and dressed in black, relieved only by their ruffs. With
so few accessories to aid him, Van Dyck stresses the individuality of the two faces
– the determination and severity of the senator and the eroded beauty of his wife.
In the great Lomellini family portrait (Plate 79) Van Dyck makes the seated wife
the pivot of the composition: on her left are the two children, richly dressed in
red and gold; on her right is her husband, in armour and holding a broken staff,
with a second man, presumably his brother. A looped-up curtain, an arch, and,
glimpsed in the top right-hand corner, an antique statue of Venus (an allusion to
the couple's love) provide the backdrop.

80. *An Elderly Senator*. Canvas, 200 × 166 cm. Berlin-Dahlem, Gemäldegalerie.

81. *The Senator's Wife*. Canvas, 200 × 166 cm.
Berlin-Dahlem, Gemäldegalerie.
Plates 80 and 81 are a magnificent pair of
full-length portraits, bought for Sir Robert
Peel by the painter David Wilkie in Genoa
in 1828. They are recorded as hanging in
the Palazzo Raggio there in 1776.

82. *Elena Grimaldi, Marchesa Cattaneo, with a Negro Servant.* Canvas, 246 × 173 cm. Washington D.C., National Gallery of Art. She was the wife of the Marchese Nicola Cattaneo. With seven other pictures by Van Dyck (including Plates 83 and 84) this portrait was purchased from the Palazzo Cattaneo in Genoa in 1906.

83. *Filippo Cattaneo.* 1623. Canvas, 122 × 84 cm. Inscribed: Aº 1623. AET 4.7. Washington, D.C., National Gallery of Art. He was Elena Grimaldi's son.

84. *Clelia Cattaneo.* 1623. Canvas, 122 × 84 cm. Inscribed: Aº 1623 AET 1.3. Washington D.C., National Gallery of Art.

Another enthusiastic aristocratic patron of Van Dyck was the Marchesa Elena Grimaldi. He showed her in a superb full-length portrait, standing on the terrace of her palace, accompanied by a negro servant (Plate 82). The Marchesa is dressed entirely in black except for the red ruffs at her wrists and the hem of her richly embroidered underskirt. The red is picked up in the umbrella held by the servant to protect her delicate complexion from the strength of the sun. The Marchesa's face, with her large eyes, long nose, and small mouth, floats on a huge lace ruff, and her hair is taken up under a small, pearl-encrusted cap. The effect of the setting, with the Corinthian columns of her palace and the lush landscape beyond, the pose, and the restrained yet rich dress, is one of immense dignity and unassailable aristocratic privilege. The contrast between the freely drawn figure of the servant and the more detailed treatment of the Marchesa adds a visual excitement to the surface of the canvas, though at present that surface is overlaid with a heavy, discoloured layer of varnish. Van Dyck also painted portraits of the Marchesa's young children, Filippo and Clelia Cattaneo (Plates 83, 84). (The portraits are dated 1623, when Filippo was four and Clelia one and a quarter.) The children are dressed up in their best clothes and carefully posed – Filippo has his hand on his hip, aping his elders – and yet there is no trace of solemnity in the portraits. The faces of both children are dominated by their huge, dark eyes: Filippo stares boldly at the viewer, while Clelia, clutching a large apple, demurely

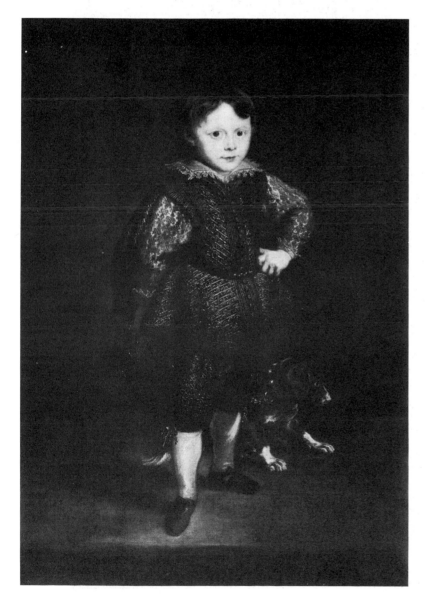
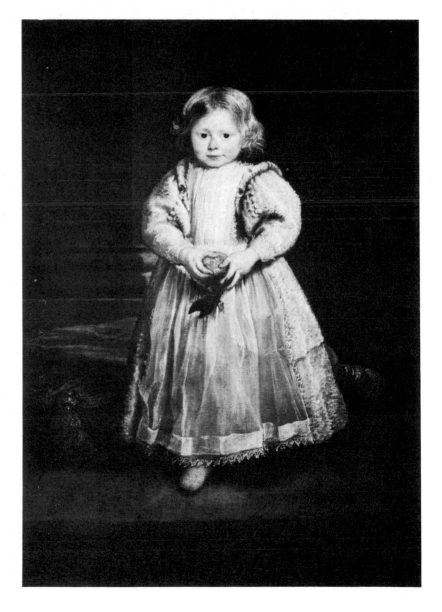

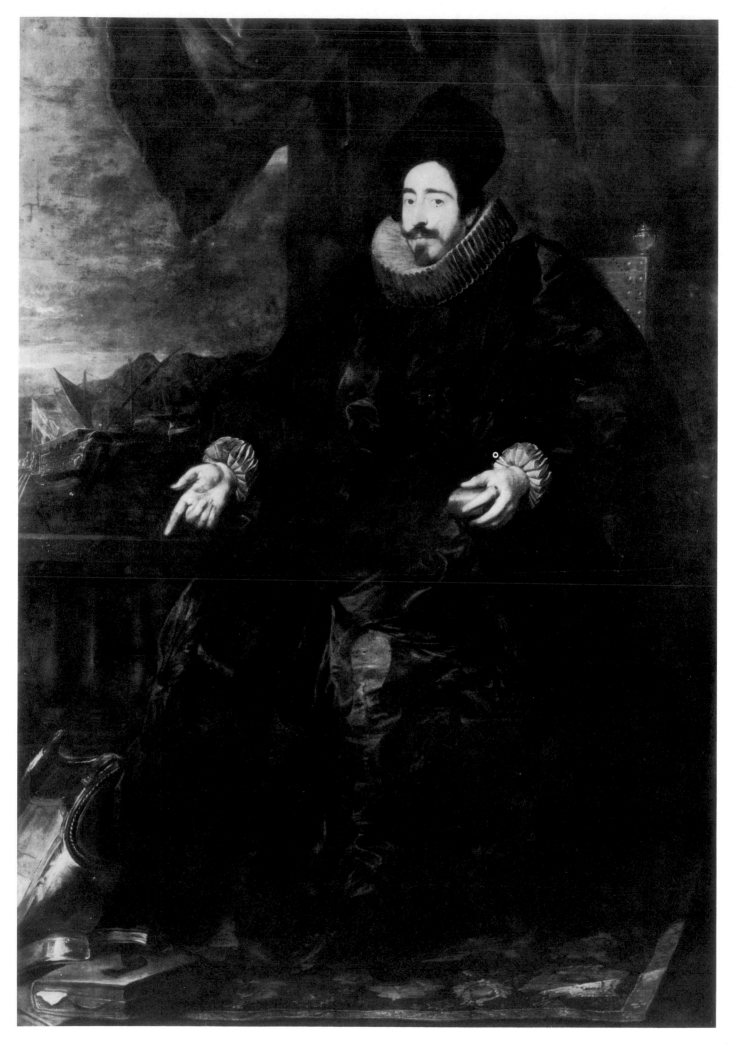

85. *Giovanni Vincenzo Imperiale.* 1626.
Canvas, 210 × 147 cm. Inscribed: Aº SAL
1626. AET SUAE 46. Brussels, Musées
Royaux des Beaux-Arts.
A three-quarter length portrait of Imperiale,
painted by Van Dyck in the previous year,
is in the National Gallery of Art,
Washington.

lowers her gaze. Filippo's puppy, which has just seen a cat or a mouse and is about to pounce, and the enormous gilt-tasselled velvet cushion behind Clelia counteract any suggestion of formality.

Three years later, in 1626, Van Dyck painted a severely formal portrait of Giovanni Vincenzo Imperiale, a procurator of the Genoese Republic and captain of its fleet, who in that year was 46 (Plate 85). Imperiale was the husband of the Marchesa Brigida Spinola Doria; he was an experienced diplomat, a man of letters and a vigorous patron of the arts. The full-length now in Brussels has all the necessary solemnity of an official state portrait. Imperiale wears his procurator's black robe and cap and points with his right hand to a breastplate and a pile of books, which stand for his responsibility for the defence of Genoa and the administration of its laws. In the background is a glimpse of the bay on which the city stands, with a warship flying the flag of the Republic.

By contrast, the Genoese goldsmith Puccio (Plate 86), who points towards a display of his work laid out on a rich red cloth, is posed casually, with his young son at his side. As in the portrait of Petel, the upper part of Puccio's sombrely-clad body is given interest by the sweep of his black cloak. However, it is the still-life elements of a gold ring, a string of pearls on a gold chain and gold ornaments that draw the eye. As with the vase of flowers in the portrait of Margaretha de Vos, Van Dyck has conjured up these jewels with dabs and slashes of pure pigment on the broadly woven canvas.

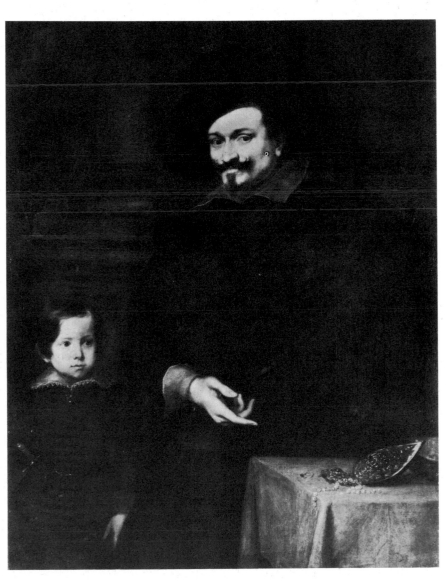

86. *The Genoese Goldsmith Puccio and his Son.*
Canvas, 129 × 99 cm. Genoa, Palazzo Rosso.

While it would strictly be untrue to say that Van Dyck evolved a new and especially effective type of portraiture in Genoa, for Rubens had provided prototypes for both the single and the equestrian portrait, there can be no doubt that the Genoese aristocracy found in him an ideal chronicler of their gilded lives. There was in his temperament a love of luxury, a merchant's son's fascination with aristocrats and courts, a Northerner's yearning for Southern extravagance, as well as a special sensitivity to the representation of the rich fabrics in which the Genoese clothed themselves. In the north such unashamedly conspicuous display would have been frowned upon; here it was *de rigueur* and Van Dyck applauded it.

In Genoa Van Dyck spawned imitators not only of his portrait style but also of his treatment of religious subjects. In the past their work has frequently been confused with his own. The best of the portraitists was Giovanni Bernardo Carbone, born in 1614 and therefore a generation younger than Van Dyck. He adopted the Flemish painter's style in a series of portraits, the earliest of which date from ten years after Van Dyck's departure from Genoa (Plate 88). Carbone never achieved Van Dyck's grandeur of composition or luminosity of colour. Van Dyck's influence also extended to the most distinguished artist working in Genoa in the years following his visit, Giovanni Benedetto Castiglione, who in his rare portraits adopts a Van Dyckian format and palette.

Van Dyck's religious paintings found resonances in the work of Giovanni Andrea Ansolo, Orazio de Ferrari, whose treatment of the subject of the *Ecce*

87. *The Four Ages of Man.* Canvas, 118 × 164 cm. Vicenza, Museo Civico. The subject may have been suggested to Van Dyck by Titian's painting (Sutherland Collection; on loan to the National Gallery of Scotland, Edinburgh), although the composition is quite different. The ungainly pose of the sleeping child is similar to drawings after Titian in the Italian Sketchbook.

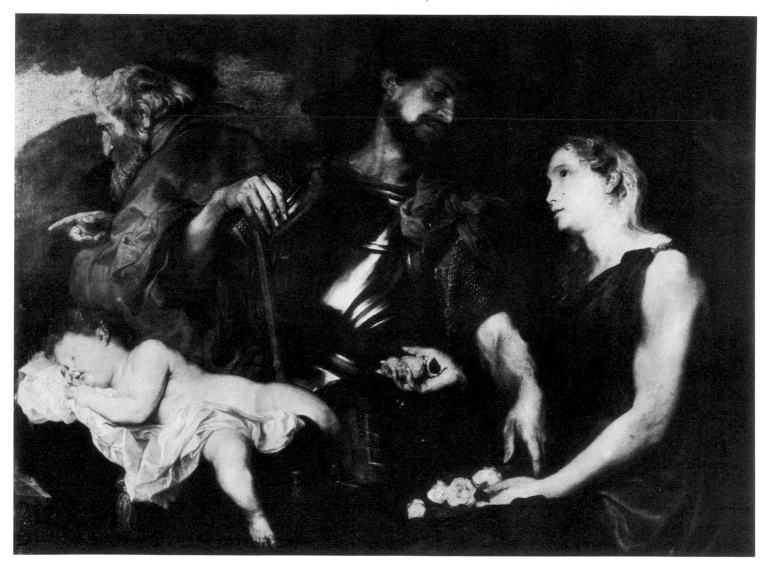

88. Giovanni Bernardo Carbone
(1614–1683). *Portrait of a Man.* Canvas,
122.6 × 97.2 cm. Indianapolis, Museum of
Art.

Homo echoes Van Dyck's, and Gioachino Assereto, whose *Mocking of Christ* in the
Palazzo Bianco in Genoa, painted in about 1640, also depends on Van Dyck. His
Italian heritage can also be traced in Palermo and Venice, where his paintings
could be seen by aspiring artists.

Van Dyck's years in Genoa were not devoted exclusively to portraiture. He
completed the altarpiece for the Oratorio del Rosario there; as late as April 1628
it was said in Genoa to have been *'nuovamente fatto'*. He painted a *Crucifixion* for
S. Michele di Pagana, a composition he later refined in several versions after his
return to Antwerp. His profound study of – indeed complete immersion in – the
work of Titian is especially evident in his religious paintings and in the remark-
able allegory, *The Four Ages of Man* (Plate 87). In that canvas the relationship
between the figures has a static quality – so unlike most of Van Dyck's history
paintings – which strongly recalls the young Titian at the time when he was close
to Giorgione. The delicate, light palette is also taken from Titian. Van Dyck uses
a coarsely woven Italian canvas, prepared with a warm ground, on which he lays
his colours sparingly. There is little modelling of the figures, which are described
in two dimensions only. The gestures are especially eloquent; they flow into one
another, hands crossing and intertwining in an elegant decorative pattern.

In *The Tribute Money* (Genoa, Palazzo Bianco) Van Dyck borrows once again
from Titian. Christ's questioners, eager to catch him out, press forward. The same
intensity, conveyed by a nervousness in the application of the paint, is present in

Susannah and the Elders (Plate 89), a subject which traditionally gave an artist the opportunity to paint the female nude. Van Dyck's treatment is remarkable for the drama he imparts to the scene. All three heads are strongly characterized and the gestures tell the story – Susannah, a terrified young girl, pulls her robe about her naked body while the elders warn of the consequences if she does not submit to their lust.

89. *Susannah and the Elders*. Canvas, 193 × 143 cm. Munich, Alte Pinakothek. The composition is based on a treatment of the subject by Tintoretto.

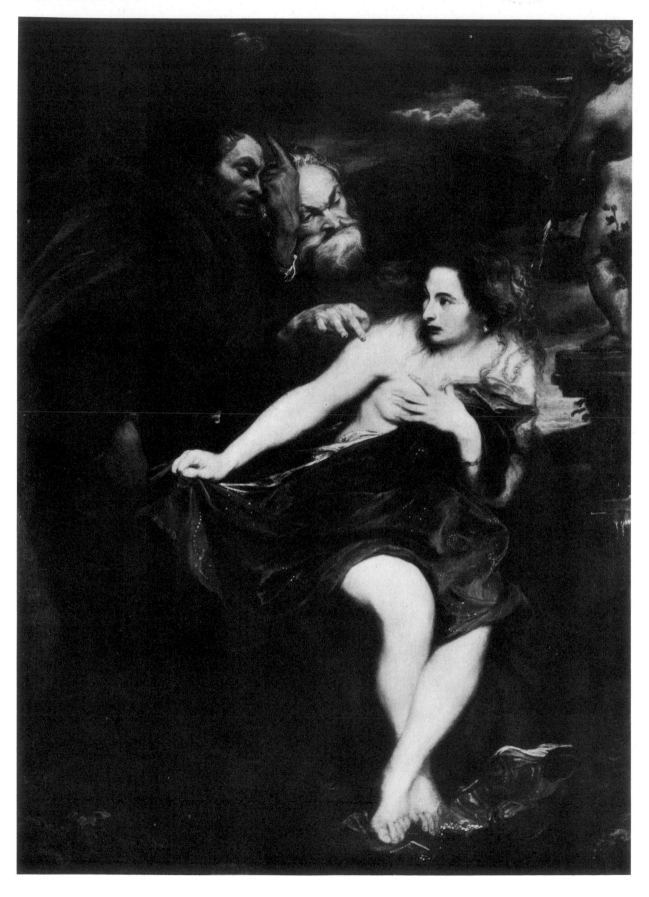

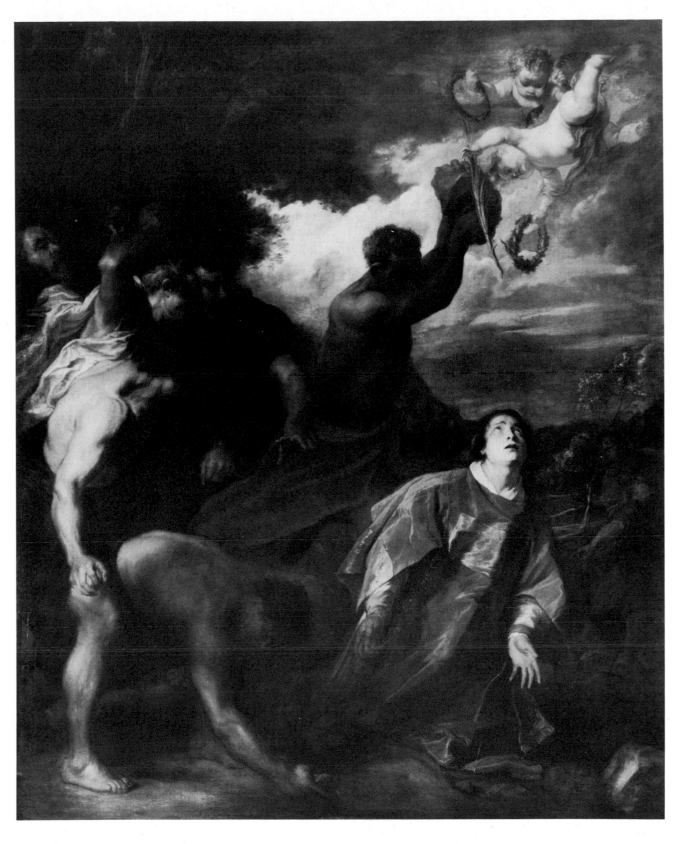

90. *The Stoning of St Stephen*. Canvas,
178 × 150 cm. Tatton Park, Cheshire, The
National Trust.
Unfortunately the early history of this
painting is unknown. It is said to have been
painted for the Spanish Church in Rome in
1623 but the date and the circumstances of
its removal to England have never been
established.

In the superb large altarpiece of *The Stoning of St Stephen* (Plate 90), said by Cust
to have been painted in 1623 for the Chiesa degli Spagnoli in Rome, Van Dyck's
study of Bolognese painting, notably of the Carracci, is evident in the com-
position. The technique, however, remains Venetian in inspiration; the picture
is freely painted on a dark ground. The figure of the saint is conventionally
idealized, but there is real violence, fanaticism and power in the figures of his
murderers.

In 1625 Van Dyck travelled to southern France. Little is known about the visit,
but he does seem to have called on the antiquarian Claude Fabri de Peiresc, the
friend and correspondent of Rubens, who lived in Aix-en-Provence.

3 The Antwerp Years: 1628-1632

Van Dyck arrived back in Antwerp soon after his sister Cornelia's death. She had been a beguine, a member of an order of nuns who take no vows, keeping the option of returning to the world, and was buried in the churchyard of the beguinage on 18 September 1627.

After his long absence there were pressing family matters to be attended to. Frans van Dyck, the painter's father, had died in 1622 and the division of the family property had been postponed because of Anthony's absence in Italy. However, in 1624 his eldest sister, Catharina, had married an Antwerp lawyer, Adriaen Diericx, and in order that the estate could be administered, Diericx made a submission to the city magistrates to the effect that Anthony van Dyck was of age, but was abroad and had instructed that his affairs be dealt with by the family in his absence; again, in December 1625, the family had to testify that Van Dyck was abroad. His return provided the opportunity to resolve outstanding business, and on 3 March 1628, now a man of property, he made a will. He was a 'painter, unmarried and in good health'. He asked to be buried in the churchyard of the beguines near his sister. He made two other sisters, Susanna and Isabella, both beguines, his heirs, and after their deaths his property was to be divided, with four fifths going to the poor of Antwerp and one fifth to the convent of S. Michel. There were a few other small legacies, including one to Tanneken van Nijen, an old servant of his father and himself. At the same time his sisters Susanna and Isabella made a will leaving their property to Anthony.

Lacking any extensive correspondence, such as we have from Rubens' hand, we must rely for our glimpses of Van Dyck's character on documents such as his will and on contemporary and near-contemporary accounts like those of Bellori and Soprani. In this Antwerp will there is clear evidence of Van Dyck's closeness to certain members of his family, in particular his two beguine sisters. As we shall see, this family affection is confirmed by later documents. There is no mention in the will of his eldest brother, Frans, or of Catharina, the sister married to an Antwerp lawyer. The youngest brother, Theodoor, was a priest and could not own property; nor could his sister Anna, a Faconite nun.

Van Dyck, like other members of his family, was of an intensely religious disposition. He was a devout Catholic throughout his life. The death of his sister Cornelia seems to have concentrated his mind on the condition of his soul and in the same year as he drew up his will he joined the Confraternity of Bachelors, a lay brotherhood which had been formed in Antwerp under the direction of the Jesuits. In the following year, 1629, the Confraternity acquired some relics of St Rosalie of Palermo and placed them in its chapel in the Jesuit Church. Van

Dyck painted a large Titianesque altarpiece, *The Virgin and Child with Sts Rosalie, Peter and Paul*, for the principal altar of the chapel, and in the next year painted a companion piece representing *The Mystic Marriage of the Blessed Herman Joseph* (Plates 92, 93). Particularly effective is the tender gesture of the angel who raises the kneeling Herman Joseph's right hand to touch the Virgin's hand. The focal point of the composition is the delicate arrangement of the three hands. The colours – the rose of the Virgin's robe, the gold and turquoise of the angel – are of a new refinement. They were colours Van Dyck had seen in Titian's 'Bacchanals', and are used again and again in the religious and mythological pictures he painted after his return from Italy. The two large canvases he painted for the Confraternity of Bachelors, and for which he received 300 and 150 guilders respectively, hung in the Jesuit Church until the suppression of the Order of 1776, when they were bought by the Empress Maria Theresa. They are now among the fine group of Van Dyck's paintings in the Kunsthistorisches Museum in Vienna. Following Rubens' practice, Van Dyck had both pictures engraved by Paulus Pontius.

Van Dyck returned from Italy with an already established reputation. He was appointed court painter to the Archduchess Isabella soon after his return, at an annual salary of 250 guilders, and was commissioned to paint the first of a number of portraits of her. Isabella's husband, the Archduke Albert, had died in 1621, the year in which the Twelve Years' Truce expired, and the widowed Archduchess had devoted herself to the Franciscan rule. She dressed in the simple habit of the Poor Clares – a black, grey and white robe with a black hood. In Van Dyck's portrait (Plate 91) she is shown in half-length, her hands clasped, the severity of her dress set off by a rich brocade curtain on the left. There are many other versions of this composition, some full-length; they were no doubt despatched as diplomatic gifts. Some are from Van Dyck's own hand; others are the work of assistants supervised by him.

91. *The Archduchess Isabella in the Habit of the Poor Clares. c.* 1628. Canvas, 109 × 89 cm. Vienna, Kunsthistorisches Museum.
The Archduchess devoted herself to the Franciscan rule after her husband's death in 1621. She appointed Van Dyck one of her court painters soon after his return from Italy.

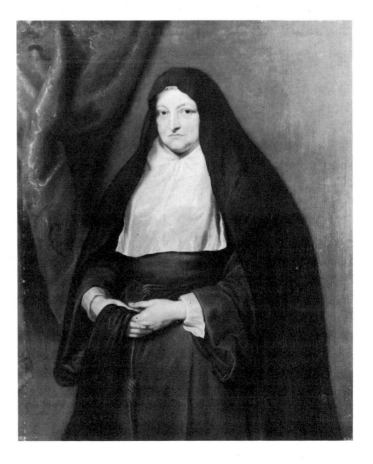

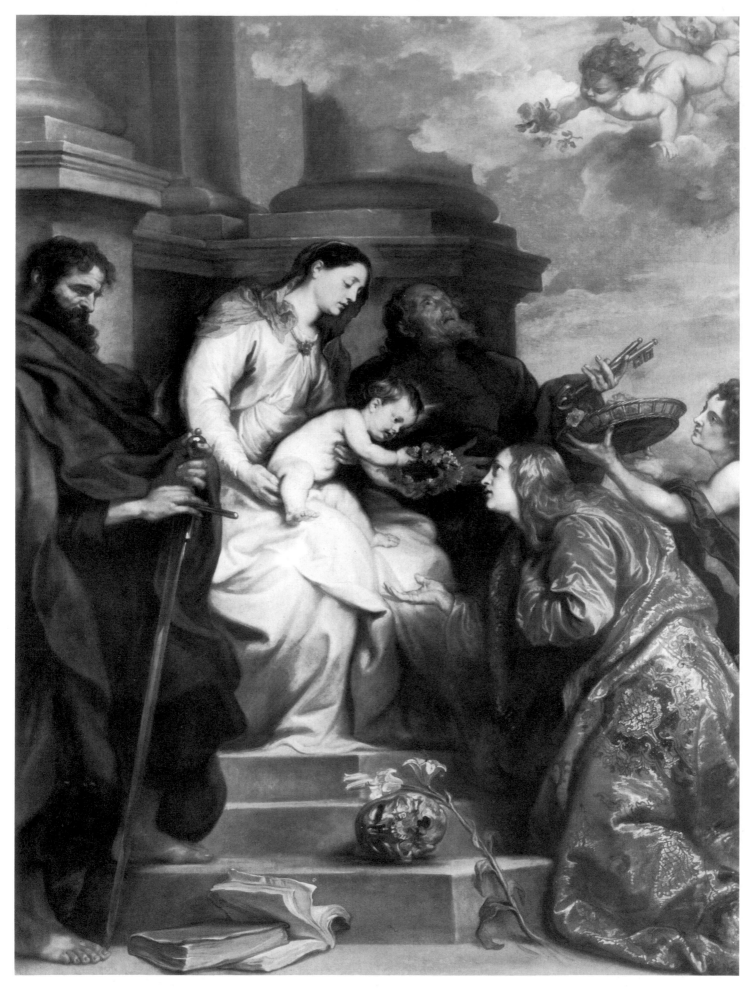

92. *The Virgin and Child with Saints Rosalie, Peter and Paul.* 1629. Canvas, 275 × 210 cm. Vienna, Kunsthistorisches Museum.

Van Dyck received the important commission for an altarpiece for the Chapel of the Confraternity of Bachelors in the Jesuit Church in Antwerp soon after his return from Italy. The Confraternity, of which the painter was a lay member, had acquired some relics of Saint Rosalie of Palermo and no doubt the fame of his altarpiece for the Oratorio del Rosario in Palermo had reached the north. It was a chance for Van Dyck to display his talents as a religious painter in a prominent location in his native town and in this way establish his reputation. He took special care with the commission and a year later was asked to provide a companion to it (Plate 93).

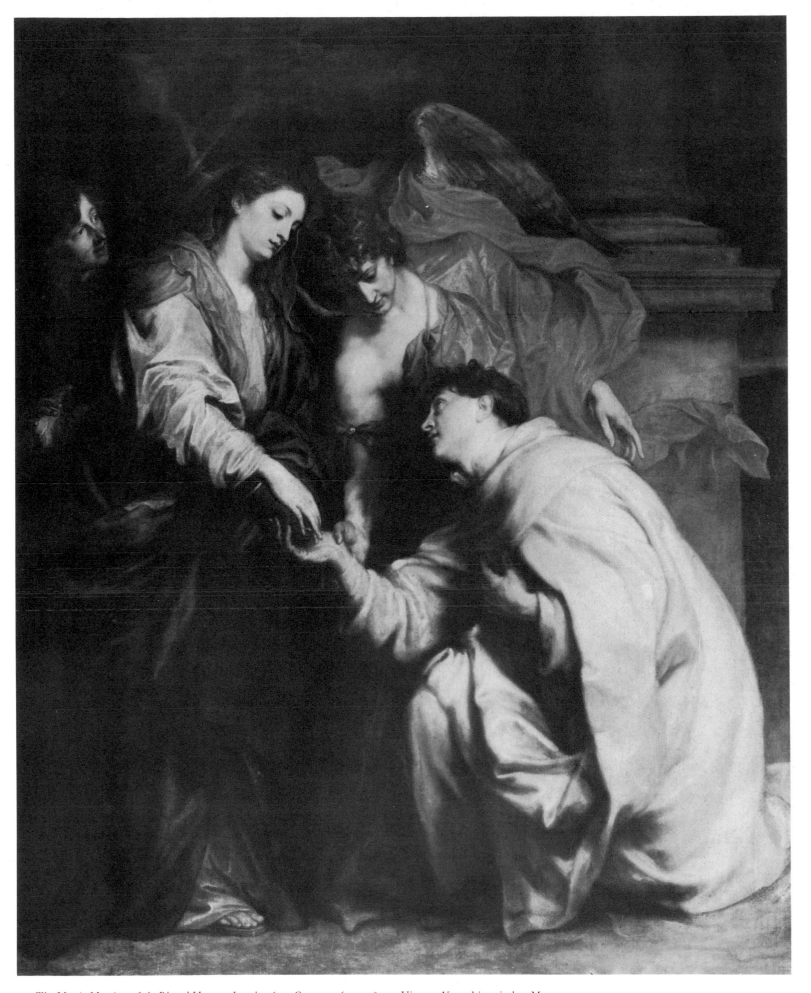

93. *The Mystic Marriage of the Blessed Herman Joseph.* 1630. Canvas, 160 × 128 cm. Vienna, Kunsthistorisches Museum.

Van Dyck was in great demand as a portraitist among members of Isabella's austere court. Chief among them was Hendrick van der Bergh, who had succeeded the Marquis of Spinola as commander of the Spanish forces in The Netherlands. The powerful, direct account of an experienced soldier in uniform is one of Van Dyck's most strongly characterized portraits (Plate 94). It lacks all the cosmetic devices of the Genoese portraits. The balding, middle-aged commander is shown against a rocky landscape with a distant view; there are no cascading curtains or imposing columns. The pose conveys determination and strength. Van Dyck painted many of the Italian and Spanish noblemen who commanded the army of Flanders or were involved in the administration of the province. Van der Bergh, who went over to the side of the rebels in 1629, was succeeded by a Spanish aristocrat, Francisco de Moncada, Marquis of Aytona, whose appointment by Philip IV was a mark of the King's intransigence and his unwillingness to enter into serious negotiations with the United Provinces. Van Dyck painted Aytona in about 1630, when he had assumed a senior position in

94. *Hendrick van der Bergh. c.* 1628. Canvas, 114 × 100 cm. Inscribed, lower left: A. VA. DYK. F. Madrid, Prado.

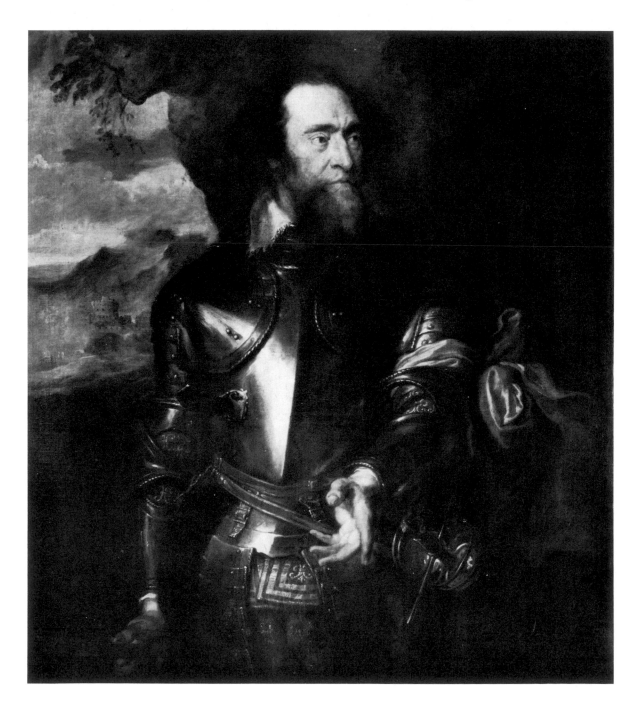

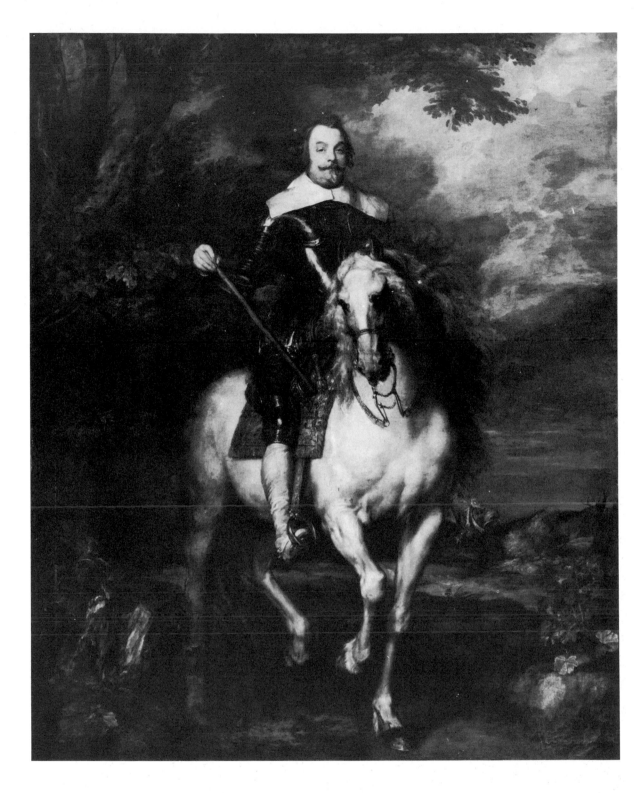

95. *Francisco de Moncada, Marquis of Aytona, on Horseback. c.* 1630. Canvas, 307 × 242 cm. Paris, Louvre.

the Regent's Council, in a superb life-size equestrian portrait (Plate 95). The conception of the portrait is quite different from that of the elegant and graceful Anton Giulio Brignole-Sale, who is relaxed and informal (Plate 78). Aytona is confidently seated astride his white horse with its flowing mane; the image is one of authority and command.

It was not only the foreigners at Isabella's court who flocked to Van Dyck's studio. Many members of the noble families of Flanders and Brabant — the Arenbergs, De Lignes, De Croys and Tassis — sat to him during these hectic years in Antwerp. Geneviève d'Urfé, Marquise du Havre, one of the De Croy family, was portrayed in a simple three-quarter length pose, and her stepdaughter, Marie Claire de Croy, was shown full-length with her small daughter. In 1630 Van Dyck

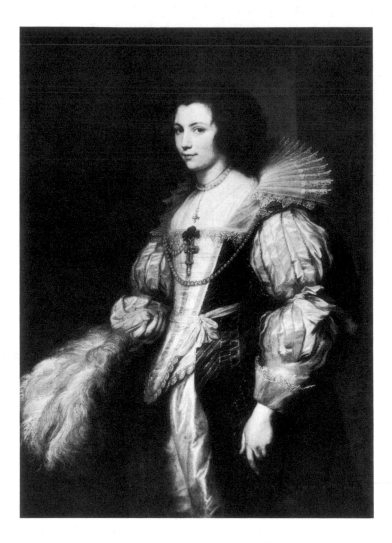

96. *Maria Luigia de Tassis*. Canvas, 129 × 93 cm. Vaduz, Collection of the Prince of Liechtenstein.

painted Anne Marie de Boisschot, wife of the Baron of Saventhem, who had commissioned the Saventhem *St Martin* from him. Perhaps the most outstanding portrait of this group is of Maria Luigia de Tassis (Plate 96). Shown in three-quarter length, in an elaborate dress of satin trimmed with fur and decorated with pearls, she holds an ostrich feather fan in her right hand. Van Dyck manages to convey both the delicacy of her features and the liveliness of her expression. He does not ignore or simplify the detail of her dress: the lace of her collar is intricately described while the gold-thread pattern of her over-skirt is rendered in bold, rapid strokes of a heavily-laden brush.

Two outstanding portraits of Flemish nobles are the full-lengths of Philippe le Roy, Seigneur de Ravels, and his wife Marie de Raet (Plates 97–101). The portrait of Le Roy is dated 1630, when he was 34; dressed simply in black and white, his height and aristocratic demeanour seem to be emphasized by the elegant greyhound, on whose head he rests his right hand. (There is a superb drawing in black chalk for the dog in the British Museum.) Especially striking are the piercing dark eyes within the gaunt, bony face. In the year after Van Dyck painted his portrait Le Roy married the 16-year-old Marie de Raet and he commissioned Van Dyck to paint her in a companion portrait. Though dressed in the rich, simply cut dress of a Flemish aristocrat's wife, Marie is still a child, and Van Dyck has poignantly captured her innocence and her apprehensiveness in the new role she has just begun to play. She is affectingly ill at ease in her lace and pearls and seems unsure how she should hold her black ostrich feather fan.

Van Dyck applied the same skill and care to the more soberly dressed citizens of Antwerp as he did to the aristocrats of Brussels. Dressed in simple clothes

97. Detail of Plate 98.

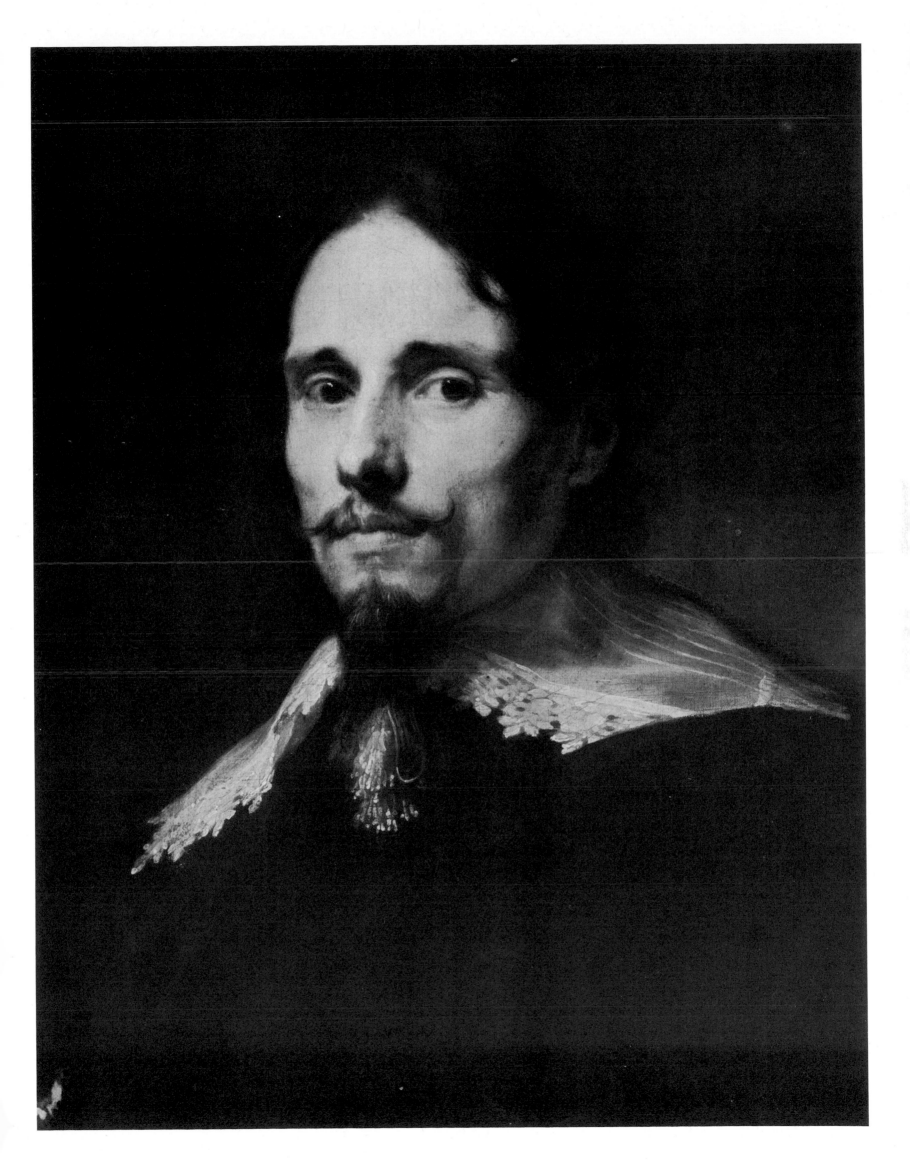

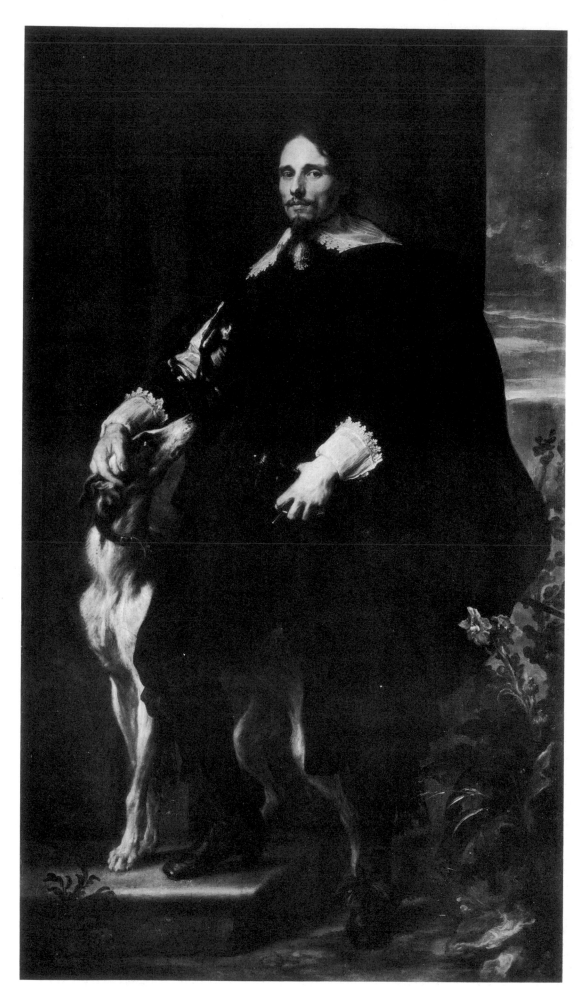

98. *Philippe le Roy, Seigneur de Ravels.* 1630.
Canvas, 215 × 123 cm. The portrait is inscribed:
VANDYCK. F.AETATIS SUAE 34 A° 1630.
London, Wallace Collection.

99. *Marie de Raet.* 1631. Canvas,
215 × 123 cm. The portrait is inscribed:
A.E.T. SUAE 16 A. 1631. London, Wallace
Collection.

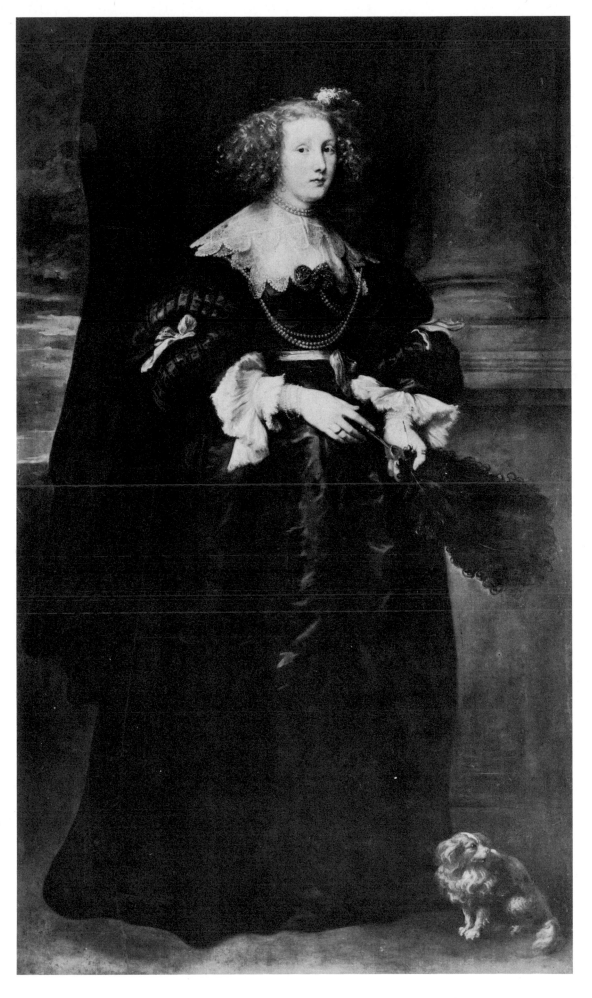

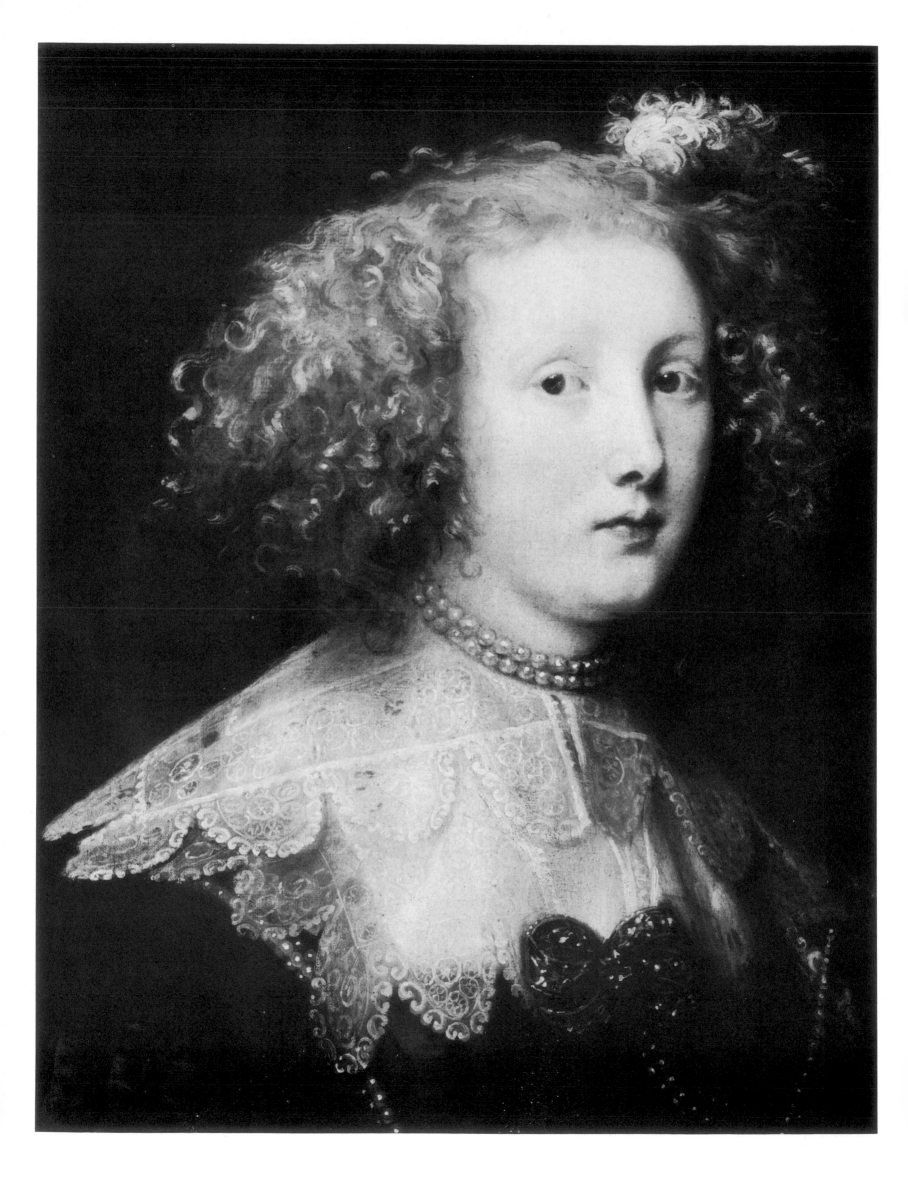

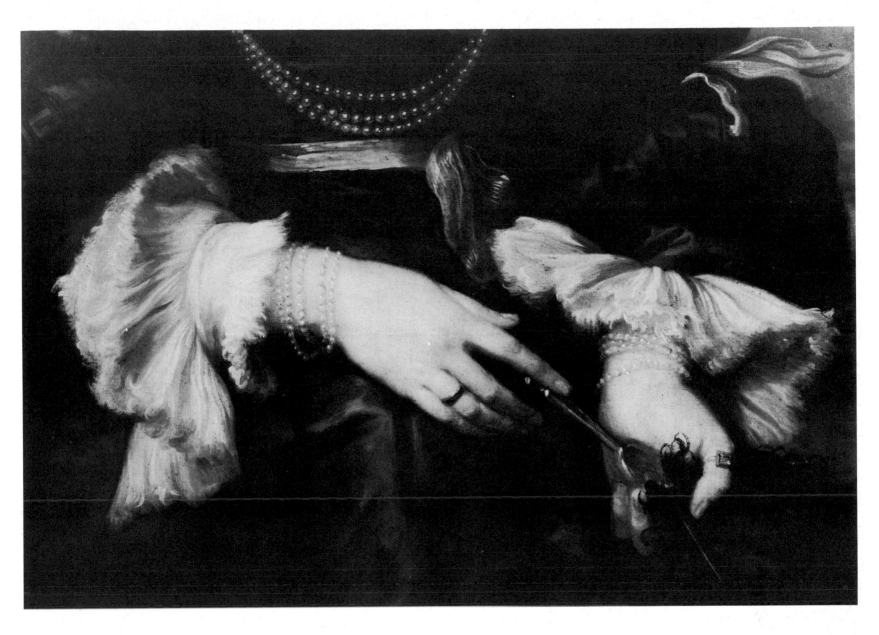

100. Detail of Plate 99.

101. Detail of Plate 99.

with flat wide collars – stiff, high ruffs having gone out of fashion except among the older generation – they too beat a path to the studio door of Antwerp's leading portrait painter. There are also less formal portraits from the years following Van Dyck's return from Italy, of friends or acquaintances – the engraver Karel de Mallery, the musician Henricus Liberti, the organist of Antwerp Cathedral, shown leaning against a pillar holding a sheet of music, and the striking seated portrait of the one-armed painter Martin Rijckaert in his fur-trimmed robe and cap (Plate 102). Van Dyck rarely introduced studio props into his portraits to denote the sitter's interests, but he made an exception – presumably at the sitter's request – in the portrait of the Jesuit father Jean-Charles de la Faille (Plate 103); he is shown with globe, sextant and dividers, which refer to his geographical studies, particularly of the Indies. Van Dyck included another fine still-life, this time of books, papers, an antique bust and a clock, in his Titianesque seated portrait of Aubert Lemoire, better known by his humanist name of Albertus Miraeus, librarian to the Archduke Albert, deacon of Antwerp Cathedral and friend of the great Stoic philosopher Justus Lipsius.

Van Dyck's splendidly animated portrait of François Langlois (Plate 104) was painted around 1630, presumably when the Frenchman was on a visit to Antwerp. Langlois, who was known as *Ciartres* after his native town of Chartres, was an

 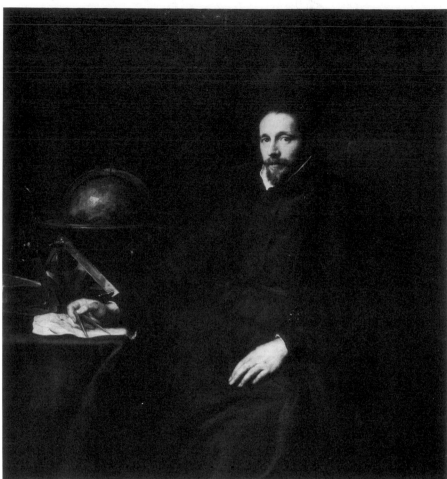

engraver, print publisher and art dealer based in Paris. He was also one of a network of agents in Europe used by Charles I, Arundel and Buckingham in the creation of their great art collections. Van Dyck has shown him as a *savoyard*, an itinerant shepherd-cum-musician, a familiar figure on the highways of France. This guise is an allusion to Langlois's musical talent: he plays a kind of bagpipes known as a *musette*, on which he was very skilled and which he occasionally played at court. The lively expression and casual pose were entirely appropriate to a man who had to live by his wits. Van Dyck met Langlois on a number of occasions and, we may judge from the portrait, found him sympathetic. There is an intimacy and an unrestrained good humour in the portrait which is relatively rare in Van Dyck's work; he usually maintains a respectful distance between sitter and spectator.

In the few years between his return from Italy in 1627 or 1628 and his departure for England in 1632, Van Dyck's production of portraits was truly prodigious. His technical facility was absolute: these delicate renderings of satin, lace, flesh and hair were conjured up on the canvas with complete fluency. For some of the portraits preparatory pencil drawings survive, but they rarely do more than describe the outlines of face and body. Most of the details of the composition were created directly on the canvas. In these years, however, Van Dyck did not only paint portraits. Although he enjoyed portraiture and found it lucrative, he maintained the ambition to establish a reputation as a history painter, and Rubens' absence from Antwerp in the years 1628-30 gave him the opportunities for which he yearned. Shortly after the Archduke Albert's death Rubens had become involved in diplomatic negotiations with the Dutch and the Spanish on behalf of his widow. The truce with the United Provinces on which so much hope had rested

102 (Left). *Martin Rijckaert*. Canvas, 148 × 113 cm. Madrid, Prado.
The landscape painter Martin Rijckaert belonged to a dynasty of Antwerp painters. Van Dyck included an engraving based on this portrait among the distinguished contemporary painters in *The Iconography*.

103. *Father Jean-Charles de la Faille*. 1629. Canvas, 130.8 × 118.5 cm. Inscribed: Aº 1629 AETATIS SUAE 32. Brussels, Musées Royaux des Beaux-Arts.

104. *François Langlois as a Savoyard*. Canvas, 104 × 84 cm. Collection of the Viscount Cowdray.

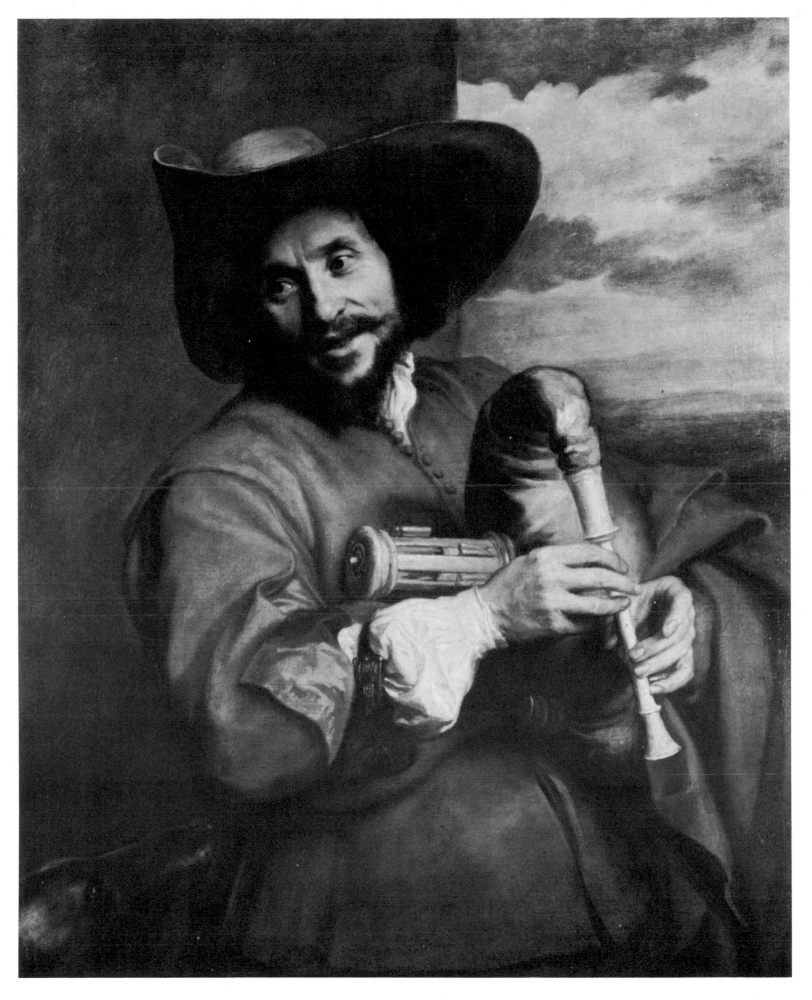

was over, but Prince Maurits of Orange, the Stadholder of Holland, secretly continued to discuss peace terms. Rubens was involved in these negotiations throughout the 1620s and in September 1628 he was summoned to Madrid by the Council of State. He spent the winter in Spain and in the summer of the following year went to England, the natural ally of the northern rebels; Spain and Flanders were eager for peace with Charles I. Rubens successfully negotiated the exchange of ambassadors who would treat for peace, and did not return from London until March 1630.

It has often been said that during these years Van Dyck received a number of important commissions which might otherwise have gone to Rubens and his studio, and there is some truth in this. There is at least one documented instance of a commission first offered to Rubens and then carried out by Van Dyck, presumably because Rubens was abroad. However, it is important to remember that before Rubens' departure Van Dyck had already established a significant reputation as a painter of large-scale religious works with his altarpiece of *The Vision of St Augustine* for the Augustijnerkerk in Antwerp (Plate 105). This huge painting, for which he received 600 guilders, was completed by June 1628, some months before Rubens left for Madrid. It was one of three paintings (the others were by Rubens and Jordaens) commissioned by the Augustinian friars to be placed over the altars of their church. They are all still in place. It was the only occasion on which Antwerp's three leading painters produced large works for the same building. (Ten years earlier they had all contributed small paintings to the series of *The Mysteries of the Rosary* for the Dominican Church.) Rubens' painting, for which he received 3,000 guilders, is the largest of the three. It shows the Madonna and Child adored by saints, and was placed above the high altar, which was dedicated to the Virgin and All Saints. Jordaens' *Martyrdom of Saint Apollonia* was placed above the altar at the end of the right-hand aisle, and Van Dyck's *Vision of St Augustine* stood above the altar in the left-hand aisle. St Augustine is shown, supported by angels, eyes heavenwards, experiencing a vision of the Trinity. The Trinity is represented by Christ, the Dove of the Holy Spirit, and the triangular symbol of God the Father, which bears his name, Jehovah, in Hebrew characters. Below are nine cherubs holding emblematic attributes. St Augustine describes in his *Confessions* a vision he saw at Ostia. He and his mother, St Monica, were talking about the mysteries of eternal life when they were transported into a state of ecstasy. The Trinity is not mentioned, but it was no doubt suggested to the Augustinians who devised the scheme for the altarpiece by a treatise St Augustine wrote on the subject. In Van Dyck's painting St Monica is shown kneeling on the left, with hands crossed. The monk on the right is presumably the donor of the altarpiece, Father Marinus Jansenius. There is a clear division in the painting between the saint and his companions on the one hand and the vision of the Trinity on the other, which recalls the division between the earthly and the heavenly in Titian's *Assunta*; and certain details, like the pointing finger of the angel on the right, also bring to mind the great altarpiece which Van Dyck had seen – and sketched – in the Church of the Frari in Venice. In *The Vision of St Augustine* the saint himself, eyes raised, body bent backwards, reveals Van Dyck's study of Guido Reni and the Bolognese. However, for all that such sources can be traced, the altarpiece is an original and entirely successful work within an Italianate tradition developed by Rubens. The figure of Augustine is heavy and vigorous – there is nothing of the ethereal quality of Raphael's *St Cecilia*, another distant ancestor of the composition – and the angels who support him are strong young men who look quite capable of sustaining his weight. St Augustine wears a rich, gold-embroidered cope over the black habit of the

105. *The Vision of St Augustine*. 1628. Canvas, 390 × 225 cm. Antwerp, Augustijnerkerk. There is an oil *modello* by Van Dyck for this composition in a private collection in Belgium.

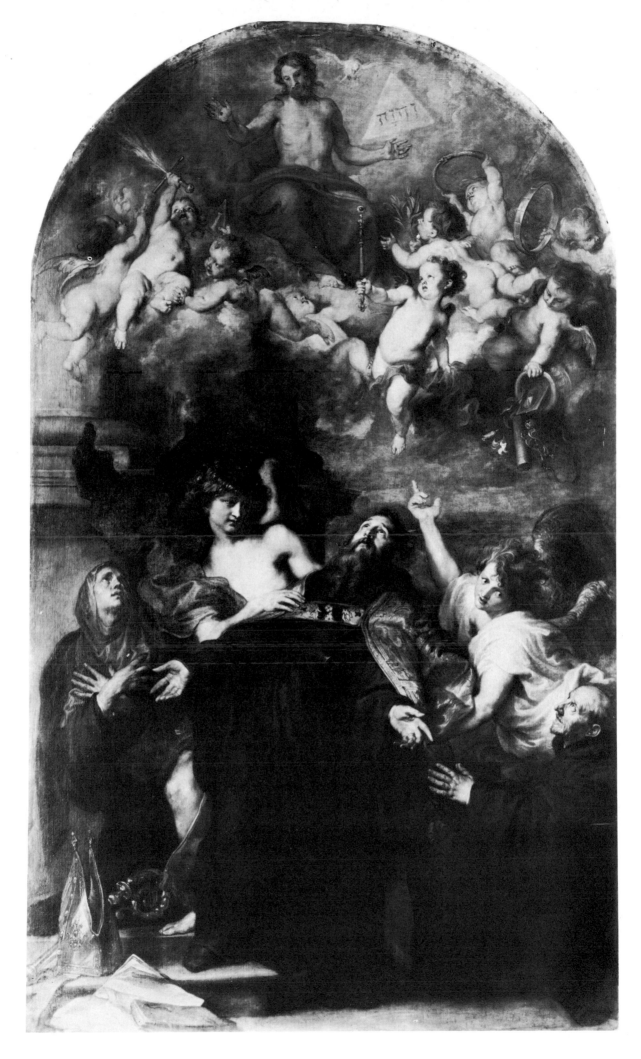

Augustinian monks. It has the effect of drawing the eye immediately to the central figure in the drama. As we should expect of Van Dyck, all three heads, those of Augustine, Monica and Father Jansenius, are strongly individual.

The grisaille oil sketch for Van Dyck's *St Augustine* altarpiece has recently been discovered. This is the *modello* which he showed to the Augustinian friars who had commissioned the work, and from which he worked. Such *modelli* are rare in Van Dyck's work; he usually preferred to develop his ideas on paper. On this occasion, however, the patron must have required him to submit a sketch in oils. It has all the energy and liveliness of his pen drawings: the forms are freely brushed in with forceful, broken lines and given highlights with dabs of lead white. The bodies of the *putti* and of Christ float above the clouds, which are indicated by strokes of white with spare black outlines. In transforming this sketch into the finished altarpiece Van Dyck made a number of changes: St Monica's position has been altered, St Augustine's mitre and crozier have been moved and the *putti* rearranged. However, all the main features of the finished composition are present in this sketch. The altarpiece was engraved by Pieter de Jode the Younger, with a dedication to the painter's sister, Susanna.

Jordaens, whose *Martyrdom of St Apollonia* was near Van Dyck's *St Augustine*, had not travelled to Italy to complete his training. Unlike Rubens and Van Dyck, the third member of the triumvirate who dominated Flemish painting in the first half of the seventeenth century was to spend his entire working life in Antwerp, though he undertook major commissions for the Queen of Sweden, the Prince of Orange, and the burgomasters of Amsterdam. Born in 1593, he was a pupil of Adam van Noort, whose daughter he married, and joined the guild in 1615. Although baptized a Catholic, Jordaens (like Van Noort) developed Protestant sympathies which he was only able to declare publicly after 1648. Like Van Dyck, he was powerfully influenced by Rubens and worked with him on a number of projects perhaps from as early as the mid 1620s, notably on the decorations for the entry of the Cardinal-Infante Ferdinand in 1635 and the Torre de la Parada paintings for Philip IV soon afterwards. Following Rubens' death, Balthasar Gerbier, who was then in Antwerp, described Jordaens as 'ye prime painter here'. He continued painting until shortly before his death in 1678.

The relationship between Van Dyck and Jordaens was one of two young painters, both under the spell of Rubens, exchanging ideas while developing their own quite independent styles. They each took different aspects of Rubens' manner, Jordaens choosing to emphasize the weight of his figures, his creamy flesh-tones and the deeper, darker end of his palette. Jordaens devoted himself almost exclusively to history, rarely painting portraits, though in the few he did paint – like the *Govaert van Surpele and his Wife* (Plate 106) – his style seems ideally suited to the solid, secure, and soberly dressed merchants of Antwerp. In Van Dyck's imagination they were transformed into elegant courtiers, but Jordaens was doubtless nearer the truth. In addition to his numerous religious and mythological paintings, Jordaens developed a type of large-scale genre scene, often illustrating a Flemish proverb, popular subject-matter of a kind which it is difficult to imagine being painted by Van Dyck.

At about the same time as Van Dyck was working on the Augustinian altarpiece, he was also developing his ideas on a subject which he was to represent no fewer than five times during these Antwerp years, the Crucifixion. He had treated the subject before – in the *Crucifixion with Sts Francis and Bernard and a Donor* for the church of S. Michele in Pagana, in Genoa – but these Antwerp pictures form a coherent group in which he explores the highly-charged emotive possibilities of the subject. The first version seems to be the painting now in the Musée des

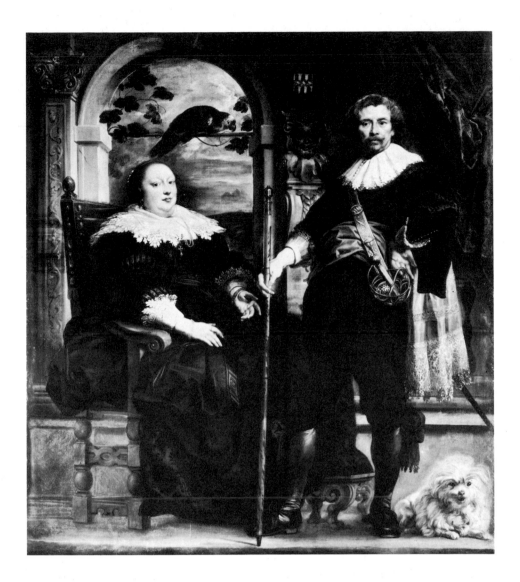

106. Jacob Jordaens (1593–1678). *Govaert van Surpele and his Wife, Catharina Coninckx.* c. 1636. Canvas, 213.3 × 189 cm. London, National Gallery.
Van Surpele (1593–1674) was three times burgomaster of his native town of Diest, between Brussels and Antwerp. This portrait was probably painted soon after his second marriage, in 1636, to Catharina Coninckx.

Beaux-Arts, Lille, which was painted for the Church of the Recollects there (Plate 108). The crucified Christ is adored by the Virgin, St John, and the Magdalen, who, dressed in rich brocade with her long hair loose, bends to kiss his feet. The second version appears to be the *Christ on the Cross between St Dominic and St Catherine of Siena* painted in 1629 for the Church of the Dominican nuns of Antwerp (Plate 107). The artist's father had died in their care and the Latin inscription on the stone at the foot of the Cross states that the picture represents the fulfilment of a deathbed promise made by his father, to provide an altarpiece for the church, painted by Van Dyck. The third version was commissioned for the Church of the Minorites in Mechelen by Jan van der Laen at a cost of 2,000 guilders. The crucified Christ is shown between the two thieves, mourned by the Virgin, the Magdalen and St John in a composition which strongly recalls Rubens' *Coup de Lance*, painted in 1629 or 1630 for the Church of the Recollects in Antwerp. When Sir Joshua Reynolds visited Mechelen in 1781 he thought the *Crucifixion* 'the most capital of all his works, in respect of the variety and the extensiveness of the design, and the judicious disposition of the whole. In the efforts which the thieves make to disengage themselves from the cross, he has successfully encountered the difficulty of the art; and the expression of grief and resignation in the Virgin is admirable.' Van Dyck's two other treatments of the subject are the painting in the Capuchin Church of Our Lady at Dendermonde, commissioned by Anton Triest, Bishop of Ghent (whose portrait he also painted), in which St Francis joins the group at the foot of the Cross, and the picture in the

Church of St Michel, Ghent, painted for the Sodality of the Holy Cross in 1629 or 1630, in which Longinus and a soldier carrying the vinegar-soaked sponge are included. Finally, there is a sixth picture, the *Raising of the Cross* painted in 1631 for the Cathedral of Our Lady at Courtrai, which is closely related to this group. In this series of *Crucifixions*, all painted within the space of two or three years, Van Dyck examined the reactions of the figures at the foot of the Cross. It is not surprising to find, therefore, that the preparatory drawings for this series of paintings concentrate on these figure groups. A double-sided sheet in the collection of the Ecole des Beaux-Arts, Paris, shows Van Dyck working out the figure relationships in the Lille painting. Purely working drawings in pen, they are nervous, hurried, and possess no calligraphic elegance. There are blots of ink and crossings-out on the sheet; here we come very close indeed to the mind of the artist at work. There is also a squared-up compositional drawing for the Lille picture in the British Museum and in the same museum a drawing from the life of the torso of Christ in the Dendermonde picture (Plates 109, 110). In all these paintings Van Dyck isolates the figure of the crucified Christ against a stormy sky in which there is an eclipsed sun. In this way he created one of the most effective dramatic images of the Baroque.

In addition to these altarpieces, Van Dyck also represented the crucified Christ alone, or with a single figure at the foot of the Cross (for example, St Francis in the painting in the Rijksmuseum), in a number of smaller canvases. Christ is always represented as a noble physical type with well-muscled chest, legs and arms. In some of the smaller versions Christ's head, with its unobtrusive halo, is

107 (Left). *Christ on the Cross between St Dominic and St Catherine of Siena.* 1629. Canvas, 314 × 245 cm. Inscribed: NE PATRIS SUI MANIBUS TERRA GRAVIS ESSET, HOC SAXUM CRUCI ADVOLVEBAT ET HUIC LOCO DONABAT ANTONIUS VAN DYCK. Antwerp, Koninklijk Museum voor Schone Kunsten. The Latin inscription at the foot of the Cross refers to Van Dyck's father's deathbed promise (in 1622) that his son would paint an altarpiece for the Dominican nuns of Antwerp on his return to the city. The painting hung in their church until the convent was suppressed in 1785.

108. *Christ on the Cross with the Virgin and St John the Evangelist.* Canvas, 400 × 217 cm. Lille, Musée des Beaux-Arts.

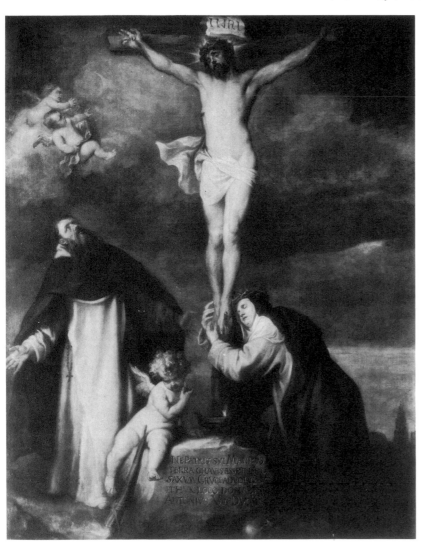

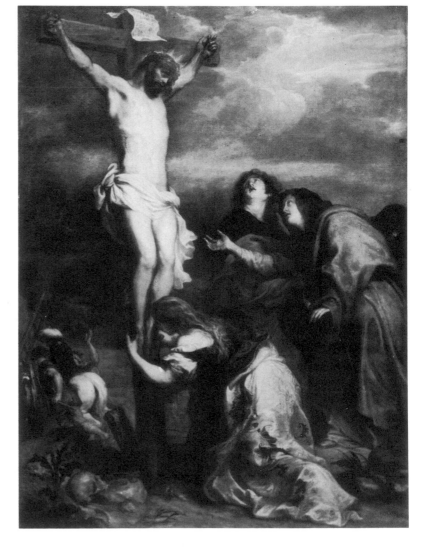

109. *The Crucifixion*. Pen and wash,
27.1 × 19.5 cm. London, British Museum.
A compositional drawing squared up for
transfer to canvas for the painting now in
the Musée des Beaux-Arts in Lille (Plate
108). While at work on the picture Van
Dyck reversed the figure group of St John
and the Virgin, moved the Roman soldiers
from right to left, and changed the angle of
the cross.

110. *Christ Crucified*. Black chalk with white
chalk highlights, 56.5 × 43.9 cm. London,
British Museum.
A drawing from a model posed in the
studio for the torso of Christ in *The
Crucifixion* in the Church of Our Lady,
Dendermonde.

turned to heaven and his eyes are raised so that it is largely the whites that are
visible; this is the moment at which Christ implored his Father, 'Why hast thou
forsaken me?' The key to the remarkable effectiveness of Van Dyck's various
treatments of the Crucifixion is the use of a low viewpoint, which enables him to
outline the figure of Christ against a cloudy, threatening sky. It is an intensely
emotional, unsettling image, whose unashamed manipulation of the strong feel-
ings it is capable of arousing characterized the art of the Counter-Reformation but
is too direct for some modern viewers.

The same religious emotionalism is evident in another image to which Van
Dyck returned again and again during these years, the Lamentation. The dead,
but perfect, body of Christ lies in his Mother's lap. She looks up to heaven, as if
showing God the Father his sacrificed son, while the Magdalen kisses Christ's left
hand and St John, grieving, brings a winding-cloth. The crown of thorns, the
nails and a bowl lie at Christ's feet. The first version of this intensely moving
image was painted in about 1629 for the high altar of the Beguinage in Antwerp.
There is an autograph replica of the painting in the Prado (Plate 111). For the
powerful treatment of the subject which was in Berlin but was destroyed during
the Second World War Van Dyck altered the position of Christ's body, further
emphasizing its weight in death. Here it is St John who supports the body, while
the Virgin reaches out her hands towards her son. She is comforted by the
Magdalen, who attempts to restrain her grief. Van Dyck also introduced a
weeping *putto* in the lower right-hand corner. He had this version engraved by
Paulus Pontius, with a dedication to his sister Anna.

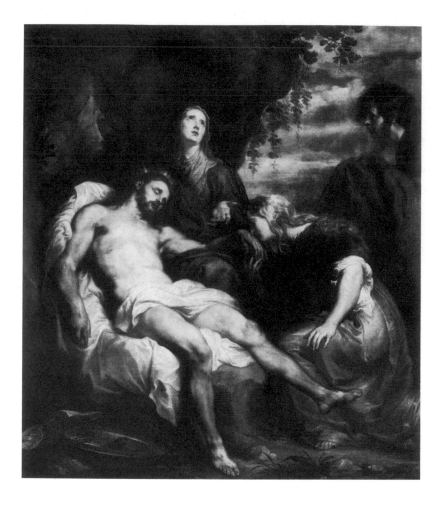

111. *The Lamentation*. Canvas, 114 × 100 cm.
Madrid, Prado.
The second version of this composition.
The original was painted in 1629 for the
high altar of the beguinage in Antwerp.

In Antwerp Van Dyck returned to a religious subject which he had painted on
a number of occasions in Italy, the Mocking of Christ. In his Italian Sketchbook
he made no fewer than five drawings, all copied from Titian, of Christ as Man of
Sorrows, with his hands bound in front of him. It is also known that in Italy he
acquired a painting by Titian of this subject for his own collection. In two
pictures, one of which is markedly sketchy in technique (London, Courtauld

112 (Left). *The Mocking of Christ*. Canvas,
101 × 78 cm. Birmingham, Barber Institute
of Fine Arts.

113. *The Mocking of Christ*. Canvas,
112 × 93 cm. Princeton, The Art Museum.

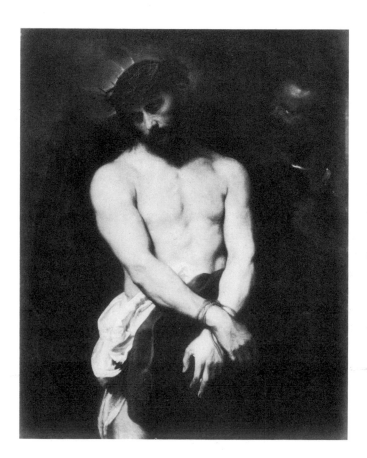

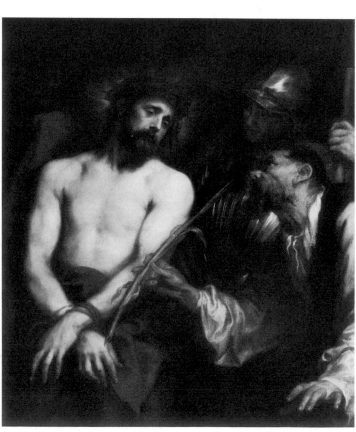

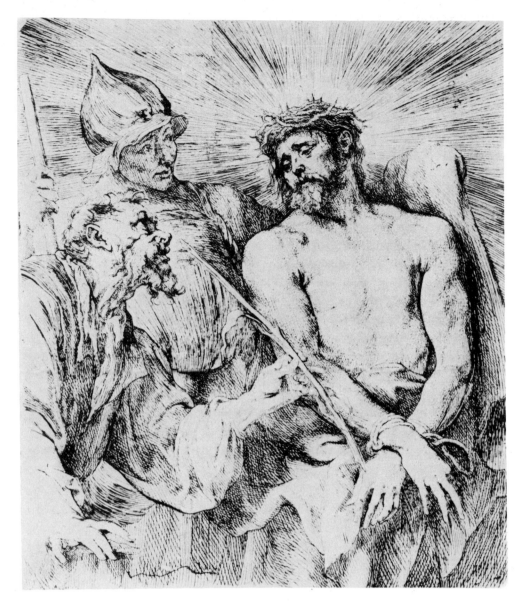

Institute Galleries) and the second an elaborately finished canvas now in the Barber Institute in Birmingham (Plate 112), Van Dyck rearranged the elements of Titian's various compositions. A comparison between the Barber picture, probably painted in Genoa in 1625 or 1626, and *The Mocking of Christ* now at Princeton (Plate 113), painted soon after Van Dyck's return to Antwerp, reveals the importance to Van Dyck of renewed contact with the art of Rubens. Both paintings are profoundly indebted to Titian in the fall of light and shade over the figure of Christ and in the muted colours. In the Princeton painting the treatment of the drapery of the man on the right and its delicate highlights are especially Venetian in character. However, the close grouping of the three figures and the eloquent gestures of the hands display Van Dyck's study of Rubens, notably of paintings such as the *Incredulity of Thomas* of 1613–15. Yet there is none of the three-dimensional solidity of Rubens' figures nor the almost tangible sense of dramatic action which characterizes Rubens' paintings of the earliest years of the second decade of the century. The mood of Van Dyck's painting is far more restrained, even reflective. Christ's face shows a dreamy acceptance of his fate rather than an intense reaction to the mockers' insults. The composition was etched by Van Dyck himself (Plate 114); it is his only etching of a religious subject. Here he handled the etching needle with all the fluency of a pencil, especially in his modelling of the chest and neck of Christ with dots and short criss-crossed lines. In the second and subsequent states the plate was heavily reworked by an engraver, probably Lucas Vorsterman, who created a tonal effect much closer to that of the original painting.

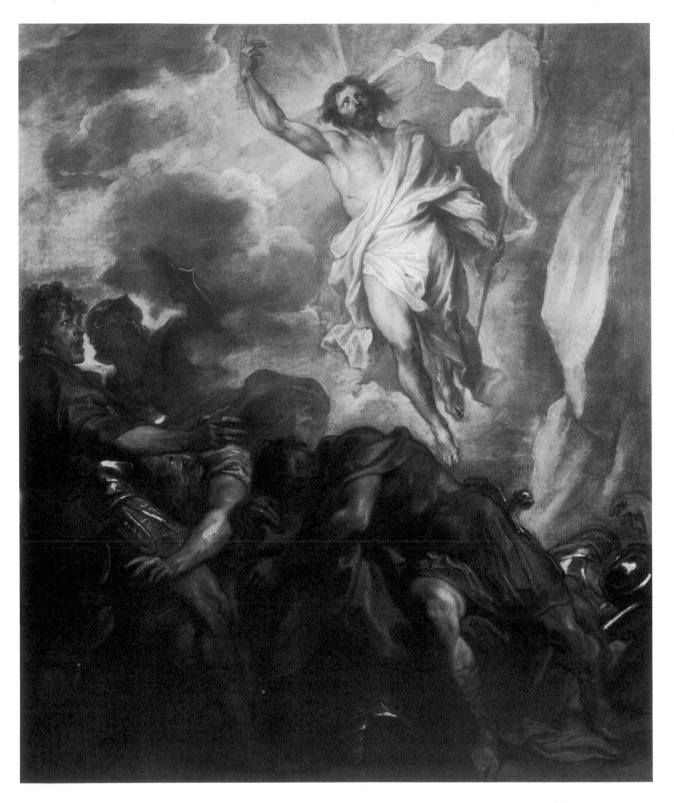

Another important religious painting of about this time (*c.* 1630-2) is *The Resurrection* (Plate 115). The composition closely follows (in reverse) Rubens' treatment of the subject, engraved by Theodoor Galle for the *Breviarium Romanum* of 1612–14 (Plate 116). As we have come to expect, Van Dyck's painting possesses little depth when compared to the engraving after Rubens, who, as we can see even in this restricted medium, manages to give his figures real solidity. Van Dyck's technique, however, is scintillating and characteristically assured.

Under the renewed influence of Rubens Van Dyck also developed a number of Virgin and Child and Holy Family compositions. He painted the Christ Child standing near a column, supported by his Mother, in a number of versions – in

115. *The Resurrection*. Canvas, 114×94.5 cm. Hartford, Wadsworth Atheneum.
The dependence of this composition on Rubens' treatment of this subject in the *Breviarium Romanum* (Plate 116) underlines the importance of Van Dyck's renewed contact with the art of Rubens after his return from Italy.

116. Theodoor Galle, after Rubens. *The Resurrection*. Engraving from the *Breviarium Romanum* (1612–14).

117. *Virgin and Child*. Canvas, 111.5 × 104 cm. London, Dulwich College Picture Gallery.

Munich, Cambridge and Dulwich (Plate 117). They are tender, though not sentimental, variations on themes by Titian and Rubens. The figure grouping and the use of gesture reveal Van Dyck's study of Rubens, while the delicate colours and sensitive rendering of textures are the heritage of his prolonged study of Titian. Van Dyck painted the Holy Family in a lively, intimate picture now in Vienna and in a restrained, thoroughly Titianesque version of the *Rest on the Flight into Egypt* in Munich (Plate 118). In the latter, which is painted in broad, bold, direct strokes, the landscape background is brushed in very lightly. The child sprawls sleeping across his young mother's lap while the elderly Joseph looks on. The beauty of Mary, the ungainly sleeping pose of Christ, and the gesture of Joseph, together

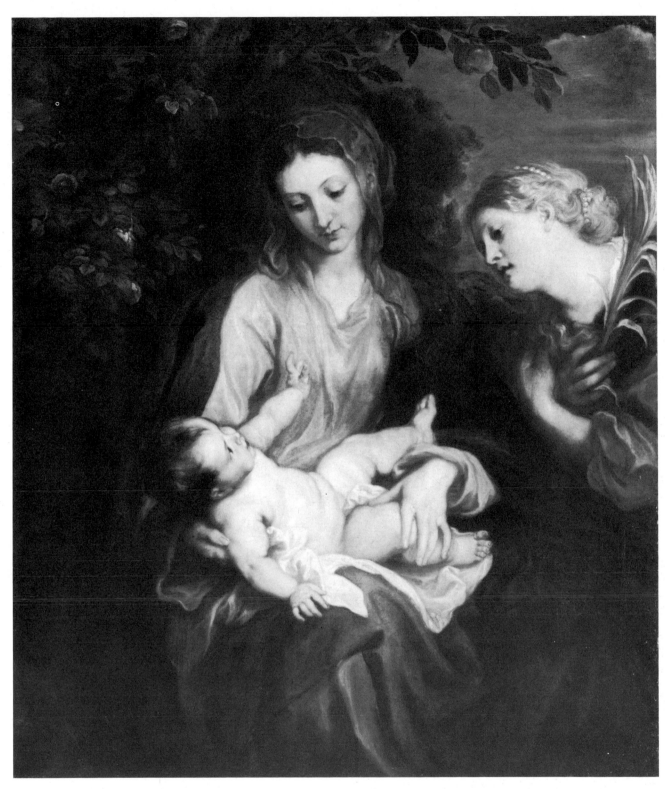

119. *The Virgin and Child with St Catherine*. Canvas, 112.1 × 94 cm. New York, The Metropolitan Museum of Art.

118. *The Rest on the Flight into Egypt*. Canvas, 134 × 115 cm. Munich. Alte Pinakothek.

with the delicate, muted colours and the immaculate technique, make this one of the most moving of Van Dyck's religious images. Though it dares to risk sentimentality it is not sentimental, but genuinely human and profoundly moving. The engraving of this painting by Schelte à Bolswert is dedicated, perhaps with a sense of its success on an emotional level, to Van Dyck's brother, Theodoor Walmannus, who had become a canon of the church of S. Michel in Antwerp. The mood is equally tender in the *Virgin and Child with St Catherine* in New York (Plate 119). Christ, lying in his mother's lap, raises his arm and looks up at her; the saint, holding the palm of martyrdom and modestly crossing her hands over her breast, gazes lovingly at the Child. The sweetness of her expression calls to mind the

madonnas and female saints of Correggio; Van Dyck could well have seen his *Mystic Marriage of St Catherine* in Rome. The thoughtful face of the Virgin has the same youth and grace as the Virgin in the Munich *Rest on the Flight*; the child's clumsy actions are equally well observed. In these paintings Van Dyck shows himself to be the heir of the great High Renaissance Italians, and of Titian in particular.

Titian was also Van Dyck's model in a number of paintings of literary and mythological subjects during these years. Van Dyck adopted both composition and palette from Titian's series of mythological paintings known as *poesie* for his magnificent, large-scale *Rinaldo and Armida* (Plate 136), which, bought for Charles I, must have convinced the King that Van Dyck was Titian reborn.

Although in the mythological paintings of these years Titian was the chief influence, Van Dyck evolved his own pictorial language. In *Venus at the Forge of Vulcan* (Plate 120) a *putto* assists Venus in donning a breastplate. The contrast between the metal and Venus's soft, pink flesh is excitingly effective, as is the pale colour of her skin, set off by a billowing pink satin wrap, next to the brown bodies of Vulcan and his assistant. Venus looks longingly at Vulcan, whose heart is about to be pierced by the arrow of Cupid who hovers above. On the right *putti* play mockingly with armour; one has his head stuck in a helmet, another is about to unsheath a sword. A second interpretation of this subject by Van Dyck is in the Louvre; here attention is focused exclusively on the three principal actors, Venus, Vulcan and Cupid, whose figures occupy the entire picture space. The magnificent half-naked figure of Venus is a triumph of the painting of the female nude. Similar in scale is *Time clipping the Wings of Love* (Plate 121) where the picture space is dominated by the single figure of Father Time. Van Dyck is masterly in his differentiation of the texture of hair, wings and flesh, and boldly contrasts the white body of the infant Cupid with Time's tanned, weatherbeaten skin.

120. *Venus at the Forge of Vulcan*. Canvas, 116.5 × 156 cm. Vienna, Kunsthistorisches Museum.
The story of Venus and Vulcan is told in the eighth Book of Virgil's Aeneid. A second treatment of this subject, the composition of which is different, is in the Louvre.

122. Detail of Plate 120.

123. Detail of Plate 120.

121. *Time clipping the Wings of Love*. Canvas, 175 × 110 cm. Paris, Musée Jacquemart-André.
An allegorical representation of the destruction of youth and beauty by the ravages of time.

Despite the hectic activity of these years, Van Dyck found time to travel. He made two trips to Holland, the first in 1628 and the second three years later. Although the two countries were still at war, the work of Flemish painters was eagerly sought after in the more cosmopolitan circles in Holland and nowhere more than at the court of Prince Frederik Henry of Orange and his consort Amalia van Solms in The Hague. Frederik Henry had been brought up at the courts of Paris and London and although by comparison his own court was modest, his taste was modelled on that of the rulers of France and England. His artistic adviser was Constantijn Huygens, a learned humanist who had served in the Dutch embassies in Venice and London and was at the centre of a cultivated group of cosmopolitan dilettanti in The Hague. In an autobiography written in about 1628 Huygens names Rubens as the contemporary artist whom he admires above all others; Rubens, he writes, is 'one of the wonders of the world'. It is hardly surprising, therefore, that Rubens' talented assistant, now established in Antwerp as a leading portraitist and history painter, should have been called to the court at The Hague. He painted portraits of Frederik Henry and Amalia van Solms, of which a number of replicas survive, presumably sent from The Hague as gifts. Especially impressive is the three-quarter-length of the Prince in armour, holding his commander's baton, with a plumed helmet beside him on a table, looking the very image of martial determination and authority. (Today it hangs in the Prado in Madrid; Plate 124. The fine companion piece of Amalia, in lace and satin set against a rich brocade hanging, was sold in London in 1973 but its present whereabouts are unknown.)

It was for the Prince and his consort that Van Dyck painted two of his finest treatments of literary subjects during these years. In order to depict the story of Amaryllis and Mirtillo from Guarini's play *Il Pastor Fido* (Plate 126) Van Dyck turned to his Italian Sketchbook, where he had drawn Titian's *Andrians*. The naked female figure on the right and the group in the left centre are taken directly from Titian, as is the general layout of the composition. In addition, Van Dyck adopts Titian's palette and his delicate, luminous manner of drapery painting. He also painted a *Rinaldo and Armida* for the Orange Court. It is described in a 1632 inventory of the Stadholder's palaces as *Mars and Venus*; the confusion is understandable, for Van Dyck has introduced elements from the story of the god of war and the goddess of love into the painting. He chose a different moment in Torquato Tasso's *Gerusalemme Liberata* from the one he had shown in the picture bought by Charles I. Rather than the sorceress Armida stumbling on the sleeping crusader, Van Dyck showed Carlo and Ubaldo discovering Rinaldo lying in her lap, bewitched by her beauty. He follows Tasso's text only loosely and yet he is very close in spirit to the Italian poet in this painting, which is sensual, romantic, and full of touches of visual wit, such as the *putto* trying on Armida's slipper in the bottom right-hand corner. Van Dyck, as we have seen, had little feeling for the classical world, and it is unlikely that he read the Latin and Greek authors with real pleasure or understanding as Rubens did. His modern Italian was, however, fluent, and Tasso, Ariosto and Guarini evoked a world with which he felt a profound sympathy. We may imagine that it was to these books that he turned to stimulate his imagination, rather than to Virgil or Tacitus. The *Rinaldo and Armida* painted for the Prince of Orange was engraved by Pieter de Jode the Younger, and Van Dyck himself painted the grisaille *modello* for the engraver to follow (Plate 125).

The House of Orange continued to collect the work of Van Dyck enthusiastically; an inventory taken at the time of Amalia van Solms's death lists, in addition to the paintings already mentioned, a *St Mary*, a *Thetis demanding Arms from Vulcan*

124. *Frederik Henry, Prince of Orange*. 1628. Canvas, 110 × 95 cm. Madrid, Prado.

125. *Rinaldo and Armida*. Panel 57 × 41.5 cm. London, National Gallery.
The grisaille *modello* for the engraving by Pieter de Jode the Younger after the large canvas painted for the Prince of Orange and today in the Louvre.

for Achilles, 'une grande pièce avec la représentation des portraits de la maison d'Angleterre', *Charity* and 'un jeune prince couvert d'un bonnet'. In other early Orange inventories there is a *Time clipping the Wings of Love*, an *Achilles on Scyros*, an *Allegory of Love* and a *School of Love*. Finally Bellori also describes two pictures painted for the House of Orange: 'a story from the Pastor Fido' (presumably the Gothenburg *Amaryllis and Mirtillo*) and a *Virgin and Child with Cherubs*.

Such enthusiasm for Van Dyck's work explains his second visit to The Hague in the winter of 1631/2, when he painted Huygens' portrait and the superb full-lengths of Prince Charles Louis and Prince Rupert, sons of Charles I's sister, Elizabeth of Bohemia, who was living in exile there (Plates 128, 129). It is said that the Prince of Orange tried to persuade Van Dyck to settle in The Hague as court painter, but despite his evident enjoyment of court life, their efforts were in vain. Only the far richer and more glamorous court of Charles I would tempt Van Dyck away from his successful career in Antwerp.

During these stays in Holland, Van Dyck must have visited the studios of fellow artists and it may have been such a visit that inspired the story told by Arnold Houbraken, in his lives of the Dutch artists, of Van Dyck's meeting with Frans Hals. Houbraken, writing in the first years of the eighteenth century, tells of the visit to Hals's studio of an elegantly, even foppishly dressed young man, whose appearance contrasted strongly with that of the slovenly Hals. He asked the great Haarlem artist to paint his portrait as quickly as he could. In half an hour Hals had painted a marvellous, freely drawn head. His visitor said that he would like to try to portray Hals in the same short space of time. Hals was astonished by the skill and speed of the stranger and, when the portrait was completed, said 'You are Van Dyck, for no one else could do that.' The story belongs to a familiar

126. *Amaryllis and Mirtillo.* 1628/31. Canvas, 123 × 137 cm. Gothenburg, Museum. For his treatment of this subject – the so-called kissing scene from Guarini's play *Il Pastor Fido* – Van Dyck turned to his drawing of Titian's *The Andrians* (Plate 55), which he had made in his Italian Sketchbook.

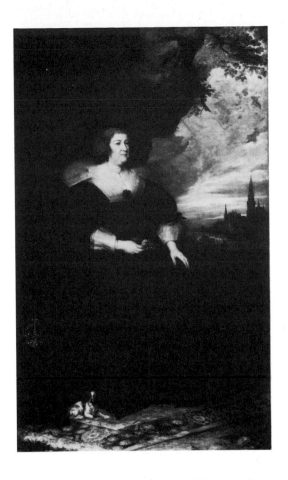

127. *Marie de Médicis*. 1631. Canvas,
246 × 148 cm. Bordeaux, Musée des Beaux
Arts.
This portrait was used by Paulus Pontius
for the engraving of the Queen Mother of
France which was included in *The
Iconography*.

type among lives of the artists, from Pliny onwards – one painter visits another
incognito and astonished him by his skill – but it is of particular interest because
of the at first surprising comparison made between the two painters, whose speed
of execution and broadly-brushed technique contemporaries found similar. The
similarities were superficial, but the story underlines Van Dyck's reputation for
extravagant dress and, more importantly, for quickness and deftness of hand.

In August 1631 the French Queen Mother, Marie de Médicis, fled from France
and sought refuge with the Archduchess Isabella in Flanders. She was in Antwerp
until October and as well as visiting Rubens, who had immortalized her in a series
of paintings in the Luxembourg Palace, she went to the studio of Van Dyck.
There, according to the account written by her secretary, Pierre de la Serre, she
saw 'le cabinet de Titien; Je veux dire tous les chefs d'Oeuvre de ce grand maistre'.
Van Dyck's superb collection of paintings by Titian had already been referred to
in a legal document of September 1630, signed by the artist with Rubens and
Seghers, and there also exists an inventory of Van Dyck's collection of paintings,
taken after his death, which confirms De la Serre's account: it lists seventeen
Titians, among them *The Vendramin Family* (now in the National Gallery in
London) and *Perseus and Andromeda* (Wallace Collection, London), and two paint-
ings by Tintoretto, three by Antonio Mor, three by Bassano, and portraits by
'various masters'. It was to these paintings – as well as to those he had drawn in
his Italian Sketchbook – that he returned again and again throughout his career
for ideas and inspiration.

Van Dyck painted Marie de Médicis's portrait more than once. De la Serre
praised one of these portraits at great length, comparing it to the Helena of
Apelles and placing Van Dyck on a par, as a portraitist, with Titian. A number
of versions, in full, three-quarter and bust-length, survive; among the best are the
seated full-length with the Queen's crown at her side, her dog at her feet and a
view of Antwerp in the background (Plate 127), and the three-quarter-length in
the collection of Lord Radnor at Longford Castle.

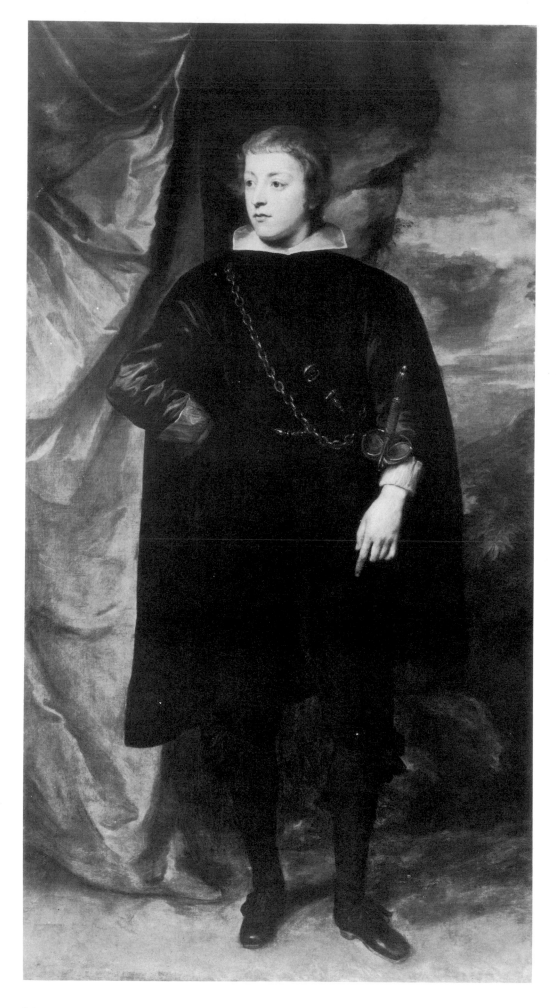

128. *Prince Charles Louis of the Palatinate.*
1631/2. Canvas 175 × 96.5 cm. Vienna,
Kunsthistorisches Museum.
Charles Louis was the second son of the
Elector Frederik and his wife Elizabeth,
daughter of James I of England. After the
couple's defeat by Catholic forces in
Bohemia they withdrew to The Netherlands
where they lived in exile in The Hague.
They were known, because of the brevity of
their reign in Bohemia, as the Winter King
and Queen. In 1629 their eldest son died
and Charles Louis succeeded as the Prince
Palatine. He became Elector on the death of
his father in 1632.

129. *Prince Rupert of the Palatinate.* 1631/2.
Canvas, 175 × 95 cm. Vienna,
Kunsthistorisches Museum.
Charles Louis' younger brother Rupert was
born in 1619. During the Civil War he led
the cavalry and later the navy of his uncle,
King Charles I, with notable success. The
two brothers were painted together by Van
Dyck in a superb double portrait (now in
the Louvre) executed in London in 1637.

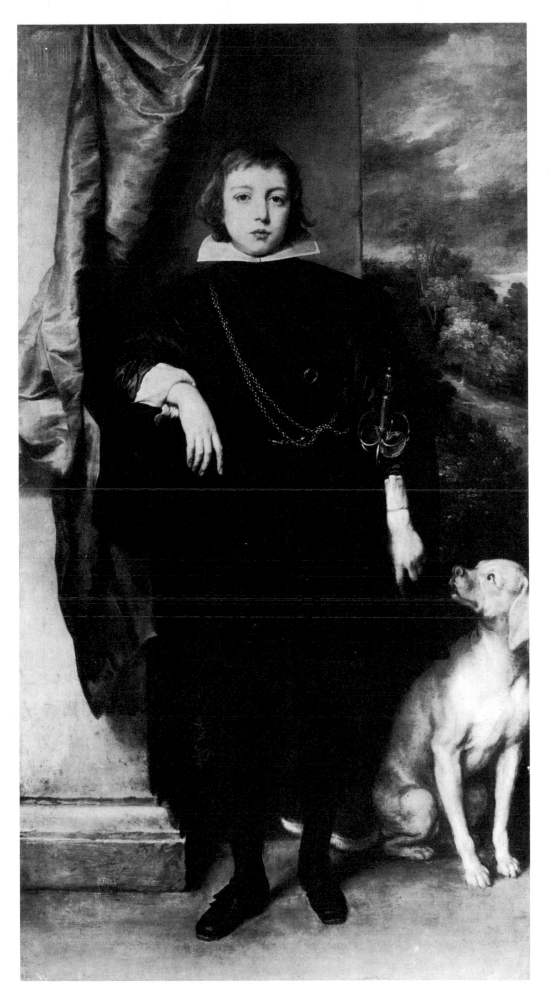

The Iconography

During these years in Antwerp Van Dyck began an ambitious project for a series of engraved portraits of his distinguished contemporaries, known as *The Iconography* (Plates 130–5). Following the example of Rubens' shrewd commercial practice, Van Dyck had commissioned engravings of a number of his larger religious paintings. Not only could these be sold at a profit, they were also a means of advertising his work. In Antwerp Rubens had trained a group of talented engravers to a very high standard of reproductive printmaking: they included Paulus Pontius, the Bolswert brothers, and Pieter de Jode the Younger. The most gifted of all was Lucas Vorsterman, who seems, however, to have been a volatile, unstable person; on 10 May, Van Dyck stood godfather to his daughter, who was christened Antonia, at her baptism in St George's Church. Subsequently Vorsterman worked closely with Van Dyck, engraving, for example, the *Lamentation* which Van Dyck painted for the Abbé Scaglia in 1634. Its dedication is to George Gage, the agent of Charles I, whom Van Dyck had met in Rome a decade earlier.

The idea of a series of engraved portraits of prominent contemporaries was not a new one: a collection of artists' portraits with inscriptions by the humanist Domenicus Lampsonius had been published by Hieronymus Cock in Antwerp in 1572. Van Dyck's project, however, was far more ambitious and was original in that all the portraits were to be the work of a single artist. There were to be three groups of portaits, the first of princes and military commanders, the second of statesmen and philosophers, and the third of artists and collectors. The last group was by far the largest, being fifty-two portraits out of a total of eighty; the first consisted of sixteen and the second of twelve. The publisher was to be Martin van den Emden; however, the three groups of portraits seem never to have been issued together as one complete publication. The enterprise may date from as early as 1628 and was still under way in 1636, as we know from a letter written by Van Dyck to Franciscus Junius, the Earl of Arundel's librarian, requesting an appropriate inscription for the engraved portrait of Sir Kenelm Digby.

Van Dyck made careful black chalk drawings of his subjects. In some cases these were taken from life, in others from his own painted portraits or those of other artists. For his portrait of the celebrated Flemish humanist Justus Lipsius, for example, Van Dyck seems to have used Rubens' portrait. Van Dyck's drawings, in which the head would be modelled in detail and the body merely sketched in, were transformed into grisaille oil sketches as a guide to the engraver. Some of these were painted by Van Dyck himself, others by assistants under his close supervision. Examples of Van Dyck's delicate black chalk drawings and of these studio grisailles survive. A number of different engravers were employed by him on this undertaking; for example, in the first group of princes and generals, two were engraved by Schelte à Bolswert, ten by Vorsterman, one by Pieter de Jode the Elder, two by Pieter de Jode the Younger, and one by Nicholas Lauwers. A number of the sitters – the Marqués of Leganes, Marie de Médicis, John, Count of Nassau, Thomas de Savoie-Carignan, and Spinola, for example – had already been painted by Van Dyck. For such subjects as the generals of the Thirty Years' War – Gustavus Adolphus, Wallenstein and Tilly – Van Dyck had to rely on the portraits of others. Among the second group (statesmen and philosophers), most had been painted by Van Dyck and some were well known to him – they included Caspar Gevartius, the Antwerp humanist; Albertus Miraeus; the Abbé Scaglia, who, after a diplomatic career in the service of the House of Savoy, had retired to Antwerp; Peiresc, Rubens' antiquarian correspondent, whom Van Dyck had

130. *Pieter Bruegel the Elder*. Engraving from *The Iconography*. *c*. 1628–*c*. 1636.

131. *Lucas Vorsterman*. Engraving from *The Iconography*.

132. *Jan de Wael*. Engraving from *The Iconography*.

133. *Gaspar de Crayer*. Panel, 24.4 × 19 cm. Drumlanrig Castle, Collection of the Duke of Buccleuch.
De Crayer (1584–1669) was a successful figure painter who worked for the court of the Spanish regents at Brussels and for a time in Madrid.

PETRVS BREVGEL
ANTVERPIÆ PICTOR RVRALIVM ACTIONVM.

Ant. van Dyck fecit aqua forti.

LVCAS VORSTERMANS
CALCOGRAPHVS ANTVERPIÆ IN GELDRIA NATVS.

15

Ant. van Dyck fecit aqua forti.

IOANNES DE WAEL
ANTVERPIÆ PICTOR HVMANARVM FIGVRARVM.

Ant. van Dyck fecit aqua forti. G. H.

135

sought out in southern France; Sir Kenelm Digby, whose portrait was engraved in London by Robert van der Voerst; and two portraits Van Dyck began to engrave himself, of Antonius Triest and Jan van der Wouwer. They were completed by Pieter de Jode the Younger and Paulus Pontius respectively. The third group includes the leading artists and collectors of the day – among the artists were Adriaen Brouwer, Gaspar de Crayer (Plate 133), Gerard Honthorst (whose portrait, as well as that of Cornelis Poelenburgh, Van Dyck drew on his trip to The Hague in 1631/2), Daniel Mytens, Rubens, Hendrick van Steenwyck, the architectural painter, Jan Wildens, Jacques Callot, Van Dyck himself, Orazio Gentileschi, Jan Lievens, Joos de Momper, Lucas van Uden, Jacob Jordaens, Michiel Mierevelt, Frans Francken, Inigo Jones and Simon Vouet. A number of these artists Van Dyck had met in Holland or England. The portrait of Mierevelt was engraved in his hometown of Delft by his son-in-law Willem Jacobsz. Delff; two others in the group were engraved in Holland by Willem Hondius; and the portraits of Inigo Jones, Simon Vouet and Robert van der Voerst were engraved by Van der Voerst in London. Nor were other engravers ignored: Paulus Pontius, Theodoor Galle, Pieter de Jode the Elder and Vorsterman (Plate 131) were all included. *The Iconography* thus provides a fascinating glimpse into the world of Van Dyck and his contemporaries.

It is not known how many of the plates were issued during Van Dyck's lifetime. After his death the original eighty plates were sold by Martin van den Emden to another Antwerp publisher, Gillis Hendricx; to these Hendricx added a further fifteen plates etched (but some only partially) by Van Dyck himself and six more by Schelte à Bolswert, de Jode, Pontius, and Vorsterman, to bring the total to a hundred. This edition was published in 1645 and was known as the *Centum Icones*. The portrait of Van Dyck, the head of which he had etched himself (Plate 134), was worked up as a title-page, with the addition of a pedestal bearing the Latin title, by the engraver J. Neeffs (Plate 135). Two further editions appeared later in the century and two more in the eighteenth century. The well-worn plates were subsequently purchased by the Print Room of the Louvre, where they remain today.

This was not Van Dyck's first excursion into the realm of printmaking. On the basis of a drawing in the Italian Sketchbook he had etched *Titian and his Mistress* (beside the drawing he had written '*Mors Titian*') with a dedication to Lucas van Uffelen. As has also already been mentioned, he etched, probably in 1630 (the date on the impression in the Albertina, Vienna), the *Mocking of Christ* which is now in Princeton. Both these plates show that his dexterity with pencil and brush apparently extended effortlessly to the etching needle. In the plates of the *Iconography* that he etched himself this mastery is confirmed. With a few strokes Van Dyck models the head, composes the features into a characteristic expression, and sketches in the upper half of the body. His own head is lively, his features caught in a momentary glance; in this case, however, and in some of the other heads etched by Van Dyck himself, reworking by later engravers has obscured much of the vivacity of the original. His portrait on the 1645 title-page has a worthy clumsiness and a portentousness which is a far cry from Van Dyck's own nervous turn of the head.

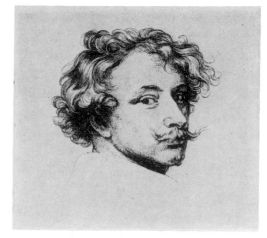

134. *Self-Portrait*. Etching, first state, from *The Iconography*. London, British Museum.

135. *Self-Portrait*.
Etching and Engraving, second state, from *The Iconography*. London, British Museum. The title-page of the *Centum Icones*, the edition of Van Dyck's *Iconography* published by Gillis Hendricx in 1645. Van Dyck's original etched plate was reworked by J. Neeffs.

4 Van Dyck at the Court of Charles I

The Household Accounts of Charles I for 23 March 1630 record an order to pay Endymion Porter, 'one of the Grooms of his Majestie's Bedchamber, the sum of £78 for one picture of the story of Rinaldo and Armida bought by him of Monsieur Vandick of Antwerp and delivered to his Majesty without accompt as per letter of privy seal 20 March 1629'. This was apparently Van Dyck's first direct contact with the English court since he had left London in February 1621. The sale of this picture was to prove a crucial event in his career because the enthusiasm it aroused may have caused Charles to tempt Van Dyck to London. This large painting (Plate 136), in the tradition of Titian's *poesie* and suffused with the rich colour of Veronese, seems to have been almost deliberately intended to appeal to a royal collector whose passion was for the Venetians. Charles recognized in Van Dyck the heir to Titian and there is in his patronage of him a conscious echo of the Emperor Charles V's employment of Titian.

The exact circumstances of Van Dyck's move to London early in 1632 are unknown. The Earl of Arundel no doubt strongly urged his case, and Nicholas Lanier, Master of the King's Music and an agent for Charles in his purchase of paintings on the Continent, had returned to England shortly before with the magnificent half-length portrait (Plate 137) which Van Dyck had painted of him in Antwerp. (According to Walpole, Lanier sat to Van Dyck for seven days.) The eighteenth-century antiquarian George Vertue says that it was Michel le Blon (whose portrait by Van Dyck is today in the Rijksmuseum, Amsterdam), in England as an agent of Queen Christina of Sweden, who recommended Van Dyck to Charles I. Marie de Médicis, delighted by her own portrait, may well have praised Van Dyck to her daughter, Queen Henrietta Maria, and the King himself may well have heard the painter praised by Rubens. It is recorded that during Rubens' visit to England the King preferred to discuss painting with him rather than politics. There were also other paintings by Van Dyck in England which Charles may have seen; a *Virgin and Child with St Catherine*, for example, was bought in Brussels in December 1631 by Balthasar Gerbier for the Lord Treasurer, Richard Weston.

Whatever the reason, and it was no doubt a combination of reasons, the royal invitation was issued, and in March 1632, according to a letter written to the King by Gerbier, Van Dyck was about to leave Brussels for England, carrying with him portraits of Marie de Médicis and the Archduchess Isabella as examples of his work.

The reasons for Van Dyck's acceptance are less hard to identify. He was, as we have seen, fascinated by courts and the aristocratic life. Bellori's account of him

in Italy, his travels there in the train of Lady Arundel, his pleasure in the company of the nobility of Genoa, his frequent visits to the courts of Brussels and The Hague, are all evidence of this. The reputation of Charles I and his passion for the visual arts must have been well known to Van Dyck; in a letter of 10 January 1625 Rubens had described Charles as 'the greatest amateur of paintings among the princes of the world'. Rubens' return to Antwerp and his resumption of his position as the city's leading painter may well have encouraged Van Dyck in his decision to cross the Channel.

Charles's accession in 1625 had brought about a great change at the English court; by 1632 it was very different from the court Van Dyck had known during his short stay a decade earlier. A vivid account of this transformation is given by a writer who was hostile to Charles, Lucy Hutchinson, in her memoirs of the life of her husband, the implacable Puritan Colonel John Hutchinson: 'The face of the Court was much chang'd on the change of the King, for King Charles was

136. *Rinaldo and Armida.* 1628/9. Canvas, 236.5 × 224 cm. Baltimore, Museum of Fine Arts.
The subject is taken from Canto 14 of Tasso's *Gerusalemme Liberata*. After the sale of Charles I's collection, the painting was owned by the Dukes of Newcastle.

137. *Nicholas Lanier*. 1630. Canvas, 111 × 87.6 cm. Vienna, Kunsthistorisches Museum.
In addition to holding the position of Master of the King's Music and to acting as an agent for Charles I in the creation of his remarkable collection, Lanier (1588–1666) was himself a painter, and a self-portrait hangs today in the Faculty of Music at Oxford University.

temperate and chaste and serious; so that the fooles and bawds, mimics and catamites of the former court grew out of fashion, and the nobility and the courtiers, who did not quite abandon their debaucheries, had yet that reverence to the King to retire into corners to practise them. Men of learning and ingenuity in all arts were in esteeme, and received encouragement from the king, who was a most excellent judge and a great lover of paintings, carvings, gravings and many other ingenuities less offensive than the bawdry and profane abusive wit which was the only exercise of the other court.' She adds, however, that for all his interest in the arts, 'this King was a worse encroacher upon the civil and spiritual liberties of his people by far than his father [James I]. He married a papist, a French lady of a haughty spirit, and a great wit and beauty, to whom he became a most uxorious husband. By this means the court was replenished with papists, and many who hoped to advance themselves by the change turned to that religion.'

At this court, presided over by the greatest patron and collector ever to occupy the throne of Britain, and by his French Catholic Queen, Van Dyck, one of the 'papists' of whom Lucy Hutchinson so disapproved, was employed on terms quite exceptional in the history of British royal patronage.

On 21 May 1632 a Privy Seal warrant was issued at Westminster to Edward Norgate, a miniaturist in the service of the Earl of Arundel, for 15 shillings a day 'for the dyett and lodging of Signior Antonio Van Dike and his servants; the same to begin from the first day of April last past to continue during the said Vandikes residence there'. The King took a personal interest in Van Dyck's arrival; he instructed his Secretary of State, Sir Francis Windebank, to 'speak with Inigo Jones concerning a house for Vandyck'. This may refer to apartments in the new Whitehall Palace, with which Jones was at that time occupied. In the event a house was found for Van Dyck at Blackfriars, on the river to facilitate royal and other visits, and just outside the boundaries of the city of London, so that he would not come within the jurisdiction of the Painters-Stainers' Company, the painters' guild, which was constantly petitioning against the presence of foreign artists in London. A summer residence was provided for him in the royal palace at Eltham in Kent, just south of London.

Soon after Van Dyck's arrival in England the King and Queen sat to him for the first of many portraits. On 5 July 1632 the painter was knighted at St James's Palace, being described as 'Sir Anthony Vandike, principalle Paynter in ordinary to their Majesties'. Less than a year later, on 20 April 1633, the Lord Chamberlain issued a warrant 'for a chain and medal of One Hundred and Ten Pounds value to be presented unto Sir Anthony Vandyck.' This was a gold chain with a medallion of the King, which Van Dyck is wearing in *Self-Portrait with a Sunflower* (Plate 150). The King granted the painter an annual pension of £200, to be paid quarterly, and in the warrant for its payment in 1633 instructions were given for it to be paid, 'any restraint formerly made by our late dear Father, or by us, for payment or allowance of Pensions and Annuities or any Declaration, Significa-tion, Allowance or Thing to the contrary in any wise notwithstanding'. This presumably referred to the pension paid to Van Dyck in 1620, which he forfeited by his failure to return to England.

Van Dyck was by no means the first foreign or indeed Netherlandish painter to be employed at the English court. In 1611 Charles's elder brother, Prince Henry, whose artistic tastes had a considerable influence on his own, had already attempted to persuade Michiel van Mierevelt, the great portrait painter of Delft, regarded at that time as 'the most excellent Painter of all the Low Countries', to enter his service. The young Prince Henry already employed Inigo Jones as well

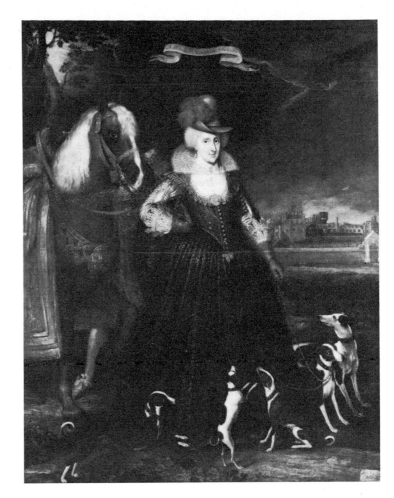

138. Robert Peake (d. 1619): *Prince Charles,
Duke of York. c.* 1610. Canvas,
127 × 85.7 cm. Edinburgh, Scottish National
Portrait Gallery.
Painted shortly before the death of Charles's
elder brother, Prince Henry, in 1612.

139. Paul van Somer (*c.* 1577–1622): *Queen
Anne of Denmark.* 1617. Canvas,
261.6 × 208.4 cm. Signed and dated 1617.
Windsor Castle, Royal Collection.
Van Somer has shown James I's Queen
against a background of her favourite palace
at Oatlands.

as a painter, a limner of pictures, a jeweller, and, as Keeper of his Cabinet Room,
the Dutchman Abraham van der Doort. Van der Doort later entered Charles's
employment and was responsible for the maintenance and cataloguing of his great
collection. On Prince Henry's early death in 1612 his collection and his cabinet
passed to Charles and on the death of their mother, Queen Anne of Denmark, five
years later, her important collection of paintings also passed to Charles. Charles
was encouraged in his enthusiasm for the visual arts by Arundel and by the Duke
of Buckingham, with whom the young Prince had travelled to Spain in 1623,
where he saw the great Habsburg collection, so rich in the work of the great
Renaissance painters of Venice.

The development of court portraiture in England in the early years of the
seventeenth century was rapid. Two-dimensional, icon-like Elizabethan portraits
were still being painted well into the reign of James I. In about 1610 the young
Prince Charles, then Duke of York, was painted by Robert Peake (Plate 138).
The subsequent revolution in portraiture brought about by Charles' discerning
patronage can be judged when this flat, ornate image is compared with Van
Dyck's portrait of the King on horseback, in which the full, lavish trappings of
the international Baroque style are employed to transform the physically un-
prepossessing monarch into a majestic, even romantic, vision of Kingship.

This revolution was not brought about by Van Dyck alone, though he was by
far the greatest portrait painter to serve Charles or his father. Paul van Somer,
born in Antwerp but working principally in Leiden and The Hague, had settled
in London by 1616. He died in January 1622 and so his working life in England
lasted only about five years. Few of his paintings survive, but in his 1617 portrait
of Queen Anne, Ben Jonson's 'Queen and Huntress Chaste and Fair', in riding
habit, with her horse, a Negro groom, and her greyhounds, against a backdrop
of Oatlands Palace (Plate 139), Van Somer brought a sense of contemporary
European portrait conventions to the artistically isolated and backward English

court. Compared to portraits by court artists like Peake, Gheeraerts or De Critz, there is in Van Somer's *Anne of Denmark* a sense of the third dimension, a placing of the figure in a credible, receding landscape, and also, although her costume is rendered in fine detail, the detail is incorporated within the overall aesthetic structure of the portrait.

Far more important than Van Somer in preparing the revolution which Van Dyck was to carry through was Daniel Mytens. Born in Delft, he had been a pupil of Mierevelt there. Subsequently he moved to The Hague and is next recorded in London in 1618. He is mentioned in a letter to the Earl of Arundel as 'your Lordship's painter'. The first royal payments to Mytens for portraits date from 1620, and some time after Van Somer's death he succeeded as court painter; payments for portraits of the King and Prince Charles begin in 1623. In the following year he was granted an annual pension of £50 – half of Van Dyck's in 1620 and a quarter of that granted him in 1632 – 'on condition he do not depart from the realm without a warrant from the King and Council'. On Charles's accession, Mytens, who by now had received his letters of denization, was appointed 'one of our picture drawers of our Chamber in ordinarie'. Payments to Mytens for royal portraits continue until 1634, although a pass for him to return to the Low Countries was issued in September 1630 and another for his wife and children in May 1631. In 1637 he is recorded in The Hague, where he was acting as an agent for Arundel, and he died there before 1647.

Among Mytens' earliest works in England were the life-size, full-length portraits of the Earl and Countess of Arundel at Arundel House, of about 1618 (Plates 140, 142). There is still a certain stiffness about the pose of Arundel and an absence of real modelling in the features of his face, but here for the first time in English court portraiture is a sense of the weight and solidity of the sitter. What had been tentative in Van Somer's portrait of Anne of Denmark is here achieved. Arundel points with his Earl Marshal's baton to his remarkable collection of statuary, much of it brought back from his second visit to Italy in 1614, and there is a convincing recession from the ante-room in which he sits to the Sculpture Gallery beyond. Mytens' perspective, developed no doubt empirically rather than theoretically, is credible. In the same way a gallery on the ground floor of Arundel House lined with black-framed family portraits extends behind Lady Arundel.

In 1626 Charles granted a 'passe for Daniel Mitten, his Majesty's picture drawer, to goe over into the Low Countries, and remaine there for the space of six months'. This was a time of artistic renewal for Mytens: he studied recent developments in portraiture in Holland and Flanders, and the portraits he painted on his return display a new courtly elegance. They remain simple in composition, carefully detailed in their description of dress and restrained in mood, but they possess a grace absent in his earlier work. The finest of all the portraits of these years is that of the First Duke of Hamilton, painted in 1629, which has been called 'the greatest masterpiece of pre-Vandyckian portraiture in England' (Plate 141). There is some of the romanticism and much of the elegance of Van Dyck's portraits in this full-length. The Duke's costume is finely woven with silver thread and is set off against the silvery blue curtain behind him. Mytens' portraits of the King and Queen, on which he was principally engaged in the years after 1629, are for the most part less successful. A portrait of the King in Garter robes painted by Mytens in 1633 reveals the difficulty the artist had had in giving an aura of distinction to the King's short figure, long face, and heavy features. It lacks the romantic dignity of Van Dyck's portraits of the King (Plate 143), and as if in desperation, Mytens falls back on an over-elaborate description of the robes and Crown Jewels.

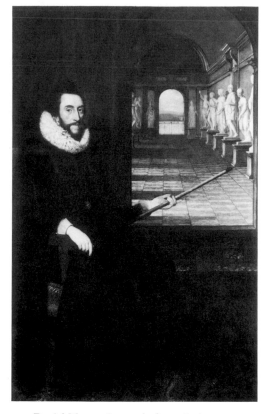

140. Daniel Mytens (1590– before 1647): *The Earl of Arundel. c.* 1618. Canvas, 207 × 127.1 cm. Arundel Castle, Sussex, Collection of the Duke of Norfolk

141. Daniel Mytens: *The First Duke of Hamilton.* 1629. Canvas, 222.2 × 135.9 cm. Signed and dated 1629. Edinburgh, Scottish National Portrait Gallery (on loan from the Duke of Hamilton).

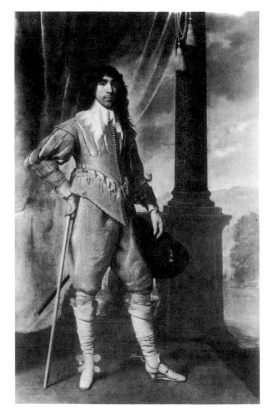

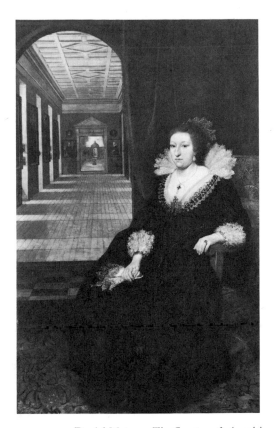

142. Daniel Mytens. *The Countess of Arundel.*
c. 1618. Canvas, 207 × 127.1 cm. Arundel
Castle, Sussex, Collection of the Duke of
Norfolk.

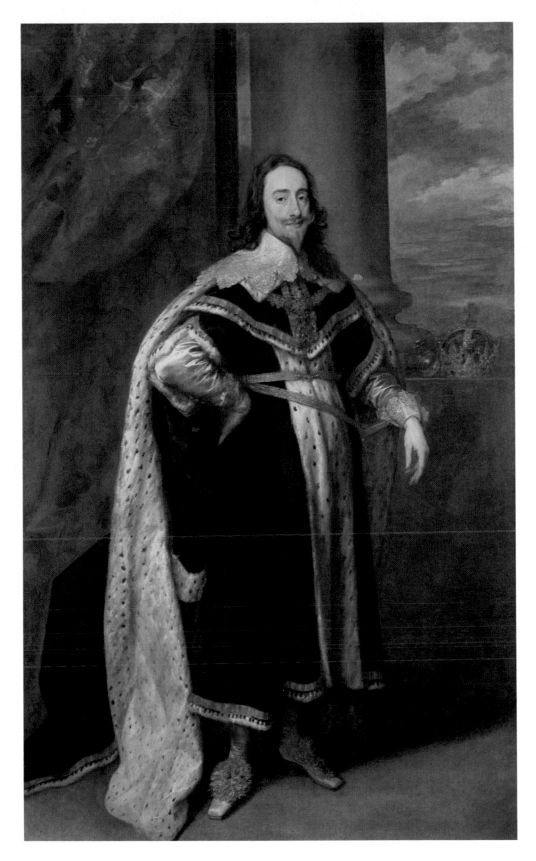

143. *Charles I in Garter Robes.* 1636. Canvas,
253.4 × 153.6 cm. Signed, Anto° van dijck
Eques Fecit. 1636. Windsor Castle, Royal
Collection.

The third important precursor of Van Dyck in England was Cornelis Johnson,
who had been born in London in 1593 of Dutch parents. Nothing is known of
his training, but it is likely to have taken place in Holland, since his earliest dated
portrait – of 1617 – shows the strong influence of Mierevelt. From then until he
left England in 1643 on the outbreak of the Civil War, Johnson painted a suc-
cession of signed and dated portraits, many of them in a head-and-shoulders
format. After his move to Holland he settled in Utrecht, where he died in 1661.
Johnson was an accomplished, if not very arresting, portraitist, who not only
fully conveyed a sense of the figure being modelled in the round but also

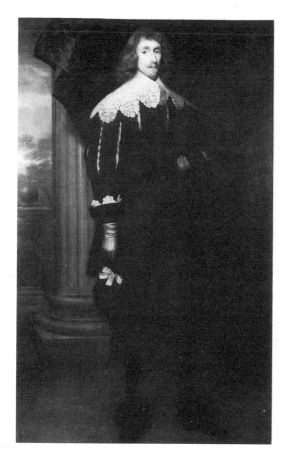

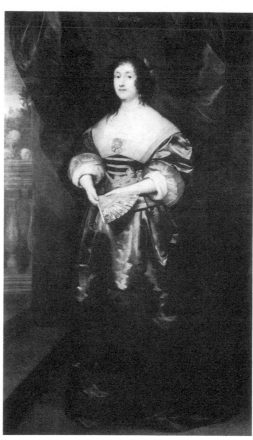

144. Cornelis Johnson. *Thomas Bruce, 1st Earl of Elgin*. 1638. Canvas, 206.4 × 127.4 cm. London. Ranger's House, Blackheath.

145. Cornelis Johnson. *Diana Cecil, Countess of Elgin*. 1638. Canvas, 206.4 × 127.4 cm. London, Ranger's House, Blackheath.

possessed a delicate sensitivity to individual character. His sitters seem largely to have been country gentry rather than courtiers. He was, however, appointed 'His Majesty's servant in the quality of picture maker' in December 1632, that is, after Van Dyck's arrival. His later works, particularly his rare full-lengths, reflect the influence of Van Dyck; for example, the portraits of Thomas, Earl of Elgin, and his Countess at the Ranger's House in Blackheath (Plates 144, 145).

Although Charles patronized both Mytens and Johnson, his unprecedented generosity to Van Dyck shows that he regarded him differently from his other portraitists. He believed – rightly – that Van Dyck was his ideal court painter. The size of Van Dyck's pension and the speed with which he was granted a knight-hood, an honour which neither Mytens nor Johnson received, are evidence of this.

One of the first members of the court with whom Van Dyck became closely acquainted after his arrival in England was Sir Kenelm Digby. Digby was a fascinating figure, with the breadth of intellectual interests that characterized the Stuart court. A pupil at Oxford of Thomas Allan, a mathematician and student of the occult, who later bequeathed his library to him, Digby travelled in France, Italy and Spain in his youth. He was in Madrid, where a relative was English ambassador, when the young Prince Charles came incognito to ask for the Infanta's hand in 1623. Subsequently he was at court, was knighted by James I, and became a close friend of the poet Ben Jonson and the statesman and historian Edward Hyde, later Earl of Clarendon. In 1627, in order to enhance his standing at court, Digby led a naval expedition to the Mediterranean; it was a privateering venture and he seized a rich Dutch prize as well as defeating a Franco-Spanish fleet. Although he was well received on his return he did not receive the hoped-for appointment as Secretary of State.

A lifelong Catholic, Digby was in the circle of Henrietta Maria, and acted as a royal agent in a number of missions to France. He was imprisoned as an ardent royalist on the authority of the House of Commons in 1642 and on his release

146. *Lady Digby on her Deathbed*. 1633. Canvas, 73 × 80.6 cm. London, Dulwich College Picture Gallery.

In a letter to his brother, dated 19 June 1633, Digby described the delivery of the painting to his house and continued: 'It is the Master peece of all the excellent ones that ever Sir Antony Vandike made, who drew her the second day after she was dead; and hath expressed with admirable art every little circumstance about her, as well as for the exact manner of her lying, as for the likeness of her face; and hath altered or added nothing about it, excepting onely a rose lying upon the hemme of the sheete, whose leaves are being pulled from the stalke in the full beauty of it, and seeming to wither apace, even when you looke upon it, is a fitt Embleme to express the state her bodie then was in...'

settled in Paris, where he published two philosophical treatises and is said to have become a friend of Descartes. He was in Rome in 1645, raising money for the Royalist cause, and again in 1647. It was on one of these visits that Digby met Bellori and provided him with information for his life of Van Dyck. According to Bellori the two men were on very close terms *per una vicendevole collegatione di genio e di benevolenza*. After the Restoration Digby returned to England and continued to act as Henrietta Maria's Chancellor. He was a founder member of the Royal Society and gathered a learned circle about him at his house in Covent Garden, among them the philosopher Thomas Hobbes. Digby died in 1665, aged 63.

In 1632 Digby commissioned from Van Dyck a family portrait of himself, his wife and their two children. Today it is known only in copies. Digby's learned interests are indicated by an armillary sphere on the table at his elbow. His wife, Venetia, died in the following year and her widower, distraught with grief, commissioned Van Dyck to paint her on her deathbed, a very unusual and deeply moving painting (Plate 146). Van Dyck, also, painted her, probably soon after her

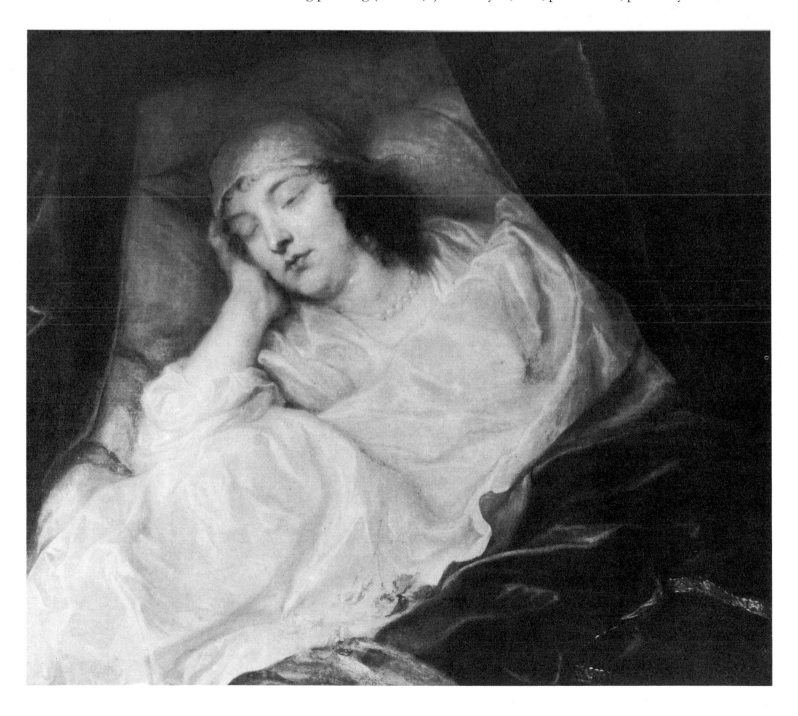

death, in the guise of Prudence (Plate 147). Allegorical portraits of this type are rare in Van Dyck's work and are so apparently alien to his literal cast of mind that the schemes for them were probably devised by the patron. Here such an explanation seems probable not only because of our knowledge of Digby's intellectual interests, but also because he is known to have given an elaborate description of the painting, presumably from memory, to Bellori: 'On a large canvas . . . his wife as Prudence, sitting in a white dress with a coloured wrap and a jewelled girdle. Under her hand are two white doves, and her other arm is encircled by a serpent. Under her feet is a plinth to which are bound, like slaves, Deceit with two faces; Anger with a furious countenance, meagre Envy with her shabby locks; Profane Love, blindfolded, his wings clipped, his bow broken, arrows scattered and torch extinguished; with other naked figures the size of life. Above is a glory of singing Angels, three of them holding the palm and wreath above the head of Prudence as a symbol of her victory and triumph over the vices, and the epigram, taken from Juvenal, *Nullum numen abest si sit Prudentia* [The prudent will not look in vain for Heaven's help].' There are slight discrepancies between this description and the several surviving versions of the painting (Bellori says that Van Dyck was so pleased with the picture that he painted a second, smaller, version). Fifteen years after he had commissioned the portrait, Digby presumably misremembered certain details. The painting had a special significance for Digby. Before her marriage Venetia Stanley, a renowned beauty, was said to have been the mistress of the Earl of Dorset. Digby had forgiven her this premarital liaison, though it continued to trouble him. Individual elements in the allegory, notably the doves and the cupid beneath her foot, while entirely appropriate to the theme of Prudence, place a special emphasis on chastity. In particular these two elements are included in the emblem of *Castità Matrimoniale* in Cesare Ripa's famous emblem book. The

147. *Lady Digby as Prudence. c.* 1633. Canvas, 215.3 × 158.4 cm. Windsor Castle, Royal Collection.
The best version of this composition is apparently the painting in the Royal Gallery in Turin. This picture may be the smaller version mentioned by Bellori.

148. *Sir Kenelm Digby with an Armillary Sphere. c.* 1633. Canvas, 153.7 × 127.6 cm. England, Private Collection.

colours used by Van Dyck in the *Lady Digby as Prudence* are particularly rich and the whole has an effect unlike his conventional portraits and closer to history paintings such as the *Rinaldo and Armida*.

Bellori also gives an account of Van Dyck's portrait of Digby 'in the dress of a philosopher with the symbol [*l'impresa*] of a broken armillary sphere' (Plates 148, 149). Digby was in mourning and the sphere is surely the one from the family portrait, as if to suggest that learning was no consolation for his loss. The portrait was used for the engraving of Digby in the *Iconography*. It bore the Horatian motto, apparently provided by Franciscus Junius, *Si fractus illabatur orbis intrepidum* [for *impavidum*] *ferient ruinae* (Horace is here describing the *iustum et tenacem propositi virum*, the just and steady-purposed man: if the heavens crack and fall, their ruins will rain down on an unbowed head). Van Dyck painted a second portrait of Digby in 1632 or 1633; it shows the courtier with a sunflower. In Thynne's *Emblems and Epigrams presented to Sir Thomas Egerton*, which had been published in 1600, the sunflower is explicitly used to symbolize the relationship between the subject and the monarch. Just as the sunflower turns to the sun for strength and sustenance, so the subject turns towards his monarch. The flower, which imitates and pays homage to its Lord the Sun, is held up for emulation and dutiful subjects are advised that they should be equally pliant in following their prince. Again, in *The Mirror of Majestie*, published in 1618, a courtier is likened to a Heliotropium, the Latin name for the sunflower, 'waiting upon the sonne of Majestie'.

The emblem is used once more by George Wither in his well-known emblem book, published in 1635. He altered the emphasis from devotion to dependence, applying it specifically to the relationship between subject and monarch. It is in this sense of dependence on the goodwill of his monarch that Digby used the sunflower when he commissioned his portrait from Van Dyck. That the idea came from Digby and not from Van Dyck is likely because the sunflower as an emblem of devotion is familiar in English emblem collections but not in contemporary Netherlandish ones, with which Van Dyck would have been more familiar. Digby

150. *Self-Portrait with a Sunflower*. 1633.
Canvas, 60 × 73 cm. Eaton Hall, Cheshire,
Collection of the Duke of Westminster.
Van Dyck points to the sunflower and
holds up the gold chain he is wearing. One
is an emblematic, and the other an actual,
expression of the King's generosity towards
him.

149. Detail of Plate 148.

was a courtier, dependent for advancement on his monarch's goodwill, and in the
early 1630s, after his return from his naval expedition, he hoped for a permanent
position at court, perhaps a Secretaryship of State. What could be more natural
than to commission a portrait which showed him in an attitude of devotion to the
King? When in 1633 Van Dyck received a gold chain with a medallion of the King
he adapted the composition devised by Digby for his own *Self-Portrait with a
Sunflower* (Plates 150, 151). The flower must possess the same significance in both
portraits – they were painted within a year of one another – and the suggestion
that it is meant also to symbolize the art of painting is therefore most unlikely.
Van Dyck shows himself here as a courtier and not as a painter. The gold chain
is a real one and not the symbolic chain in which *Pictura* is shown in Ripa's
emblem.

Digby continued to patronize Van Dyck during his years in England. Bellori

mentions that Van Dyck painted other pictures for him, among them a *Descent from the Cross*, a *St John the Baptist*, a *Magdalen*, a *Crucifixion*, and a *'Brown Lady' dressed as Paris*. It was inevitable that Van Dyck in his first years in England would become associated with the Catholic group around the Queen, in which Digby was a key figure. Digby must have been a valued guide to the political intrigues of the Stuart court as well as to its taste for sophisticated allegories, seen in their most elaborate form in the King's favourite entertainment, the masques staged by Inigo Jones.

Another member of this circle was Endymion Porter, the courtier who had bought the *Rinaldo and Armida* for the King. Porter had first served the Duke of Buckingham, and had travelled with his master and the Prince of Wales to Spain in 1623. After the Duke's death, he entered the royal service and remained close to the King, acting as his agent in picture-buying and on diplomatic missions; a

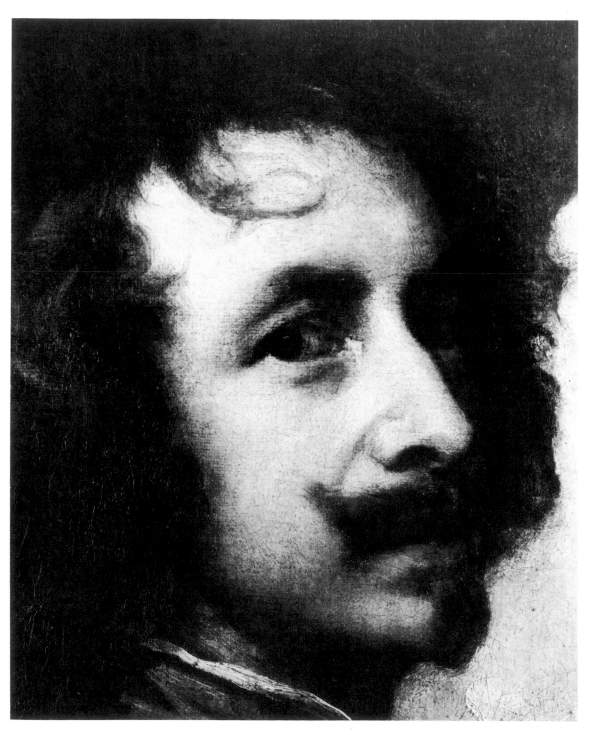

151. Detail of Plate 150.

152. *Self-Portrait with Endymion Porter*.
Canvas, 119 × 144 cm. Madrid, Prado.

contemporary wrote of him that 'tho' obscure, yet he was a great man and beloved of two kings, James I for his admirable wit and Charles I (to whom he was a servant) for his general learning, brave stile, sweet temper, great experience, travels and modern languages.' Porter was entrusted, for example, with the delicate negotiations over the payment for and shipment of Rubens' Banqueting House ceiling to London. It was natural that Van Dyck should gravitate towards such an experienced and cultivated courtier, the friend and patron of musicians, poets (notably William Davenant) and painters. The two men seem to have become particular friends and Porter was the only man whom Van Dyck included in a self-portrait, the beautiful oval-shaped canvas at the Prado (Plates 152, 153). Van Dyck glances, a little tensely, over his shoulder, while Porter, by contrast, exudes relaxed *bonhomie*. This is the Porter known for his 'sweet temper' and the warmth of his affections; the man who stands revealed in a letter from a friend, who wrote: 'My wife sends her love to you, and swears that, however much I ask

154. William Dobson: *Endymion Porter*. Canvas, 147.4 × 124.5 cm. London, Tate Gallery.

153. Detail of Plate 152.

her, she will never give you such a kiss as she did when you were drunk with Backrag [a German wine] at the Augustine Friars.'

Van Dyck also painted a group portrait of Porter, his wife and children, and single portraits of Porter and his wife. On one occasion, away from his wife, Porter wrote to her: 'I was at Aston when I had the happiness to see thy picture and that did somewhat please me, but when I found it wanted that pretty discourse which thy sweet company doth afford, I kist it with a great deal of devotion, and with many wishes for the original, there I left it.'

Porter was also painted by William Dobson, Van Dyck's unofficial successor as court painter. The portrait (Plate 154) is crammed with allusive elements which point up the essential plainness of Van Dyck's style and its lack of symbolic accessories. In the *Self-Portrait with Porter* Van Dyck portrays his companion against a background of pillar, curtain, and evening sky, elements introduced purely for decorative effect. Dobson, on the other hand, includes a bust in the background and a relief in the lower right-hand corner, and places in his sitter's

hands a flintlock rifle. The bust, with its laurel leaves and youthful appearance, represents Apollo, a reference to Porter's interest in and patronage of the arts. In the frieze two figures can be readily identified as Painting and Sculpture; the third may be Poetry. The rifle refers to Porter's love of the hunt and of the life of a country gentleman. Dobson was following the advice which Lomazzo had given in his *Treatise on Painting* (which had been translated into English in the sixteenth century): 'First you must consider the quality of the person who is the subject of the portrait and, according to that quality, give the portrait its appropriate symbol.' Van Dyck, except in a few instances, deliberately avoided the use of learned and allusive accessories of this type, aiming for a simple, uncluttered portrait which would concentrate attention on the sitter's head. It was not in his nature to employ such allusions, and he did so only if a sitter specifically requested them.

Charles and Henrietta Maria were delighted by their new court artist and sat to him very often. The Queen even attempted to bind the painter more closely to the English court by trying in 1633 to secure the services of his brother Theodoor as one of her chaplains. In August of that year she wrote to the local Vicar of his Order, requesting his presence in London.

Return to Antwerp

Theodoor did not come to London. However, in March of the following year, 1634, the two brothers were reunited in Antwerp when Anthony returned home for a visit. There were more family matters to attend to and Van Dyck also took the opportunity to buy property close to the Château of Steen, the country house which Rubens was to purchase in 1635. Van Dyck seems to have done this with a view to eventually returning to live permanently in Antwerp. He never took out letters of denization in England, as Mytens had done. However, in April 1634 he took the precaution of appointing his sister Susanna legal guardian of all his property in Antwerp while he was abroad.

From Antwerp Van Dyck was summoned to the court in Brussels. The Archduchess Isabella had died in the previous December and the entry of the new Regent of The Netherlands, Philip IV's brother, the Cardinal-Infante Ferdinand, was anticipated. Until his arrival the Spanish governor was Thomas de Savoie-Carignan, son of Charles Emmanuel of Savoy and Isabella's nephew, who had recently succeeded Aytona as general of the Spanish forces in The Netherlands. Van Dyck painted him in a superb life-size equestrian portrait (Plate 156), in full armour and holding his commander's baton in his right hand. His long-maned white horse rears and both horse and rider are outlined against imposing architecture and a cascading shot-silk curtain.

The Cardinal-Infante finally arrived in Brussels and on 4 November was officially proclaimed Governor of The Netherlands. Van Dyck made a number of portraits of him: in the scarlet robes of a Cardinal; in a painting now in the Prado (Plate 157); in armour, three-quarter length, in the Liechtenstein collection; and on horseback.

In Brussels Van Dyck found himself in great demand among members of the court circle. He painted the large group portrait of John, Count of Nassau-Siegen, his wife Ernestine de Ligne, and their sons and daughters, which is today at Firle Park in Sussex (Plate 158). Two fine preparatory drawings in black chalk with white highlights are in the British Museum; one shows the seated Count, and the other his wife with their son Johann Frans. On the reverse of the drawing of the Countess is a sketch for the portrait of the history painter Quintijn Simons which is now in the Mauritshuis (Plate 155). There is also in the British Museum a black

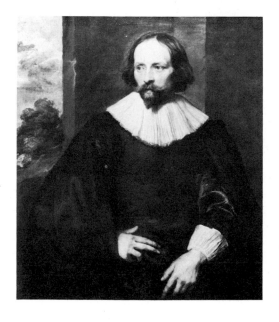

155. *Quintijn Simons*. 1634. Canvas, 98 × 84 cm. The Hague, Mauritshuis. Simons (b. 1592) was an Antwerp history painter. The portrait was engraved by Pieter de Jode the Younger for the *Iconography*.

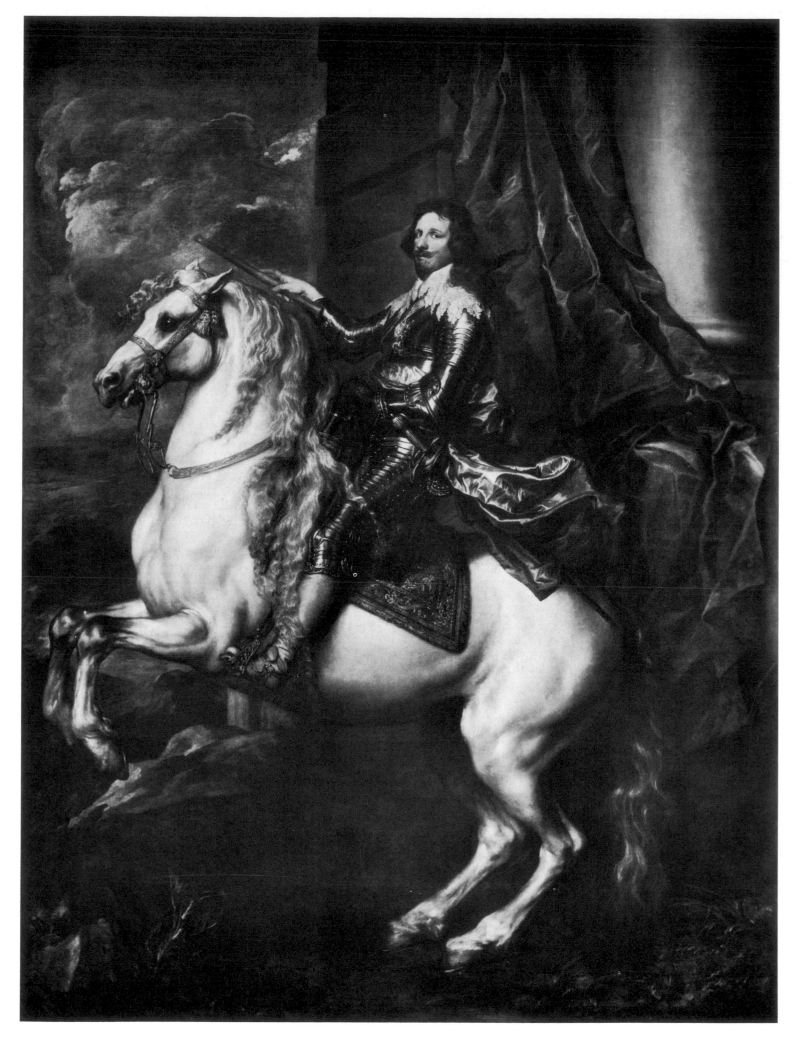

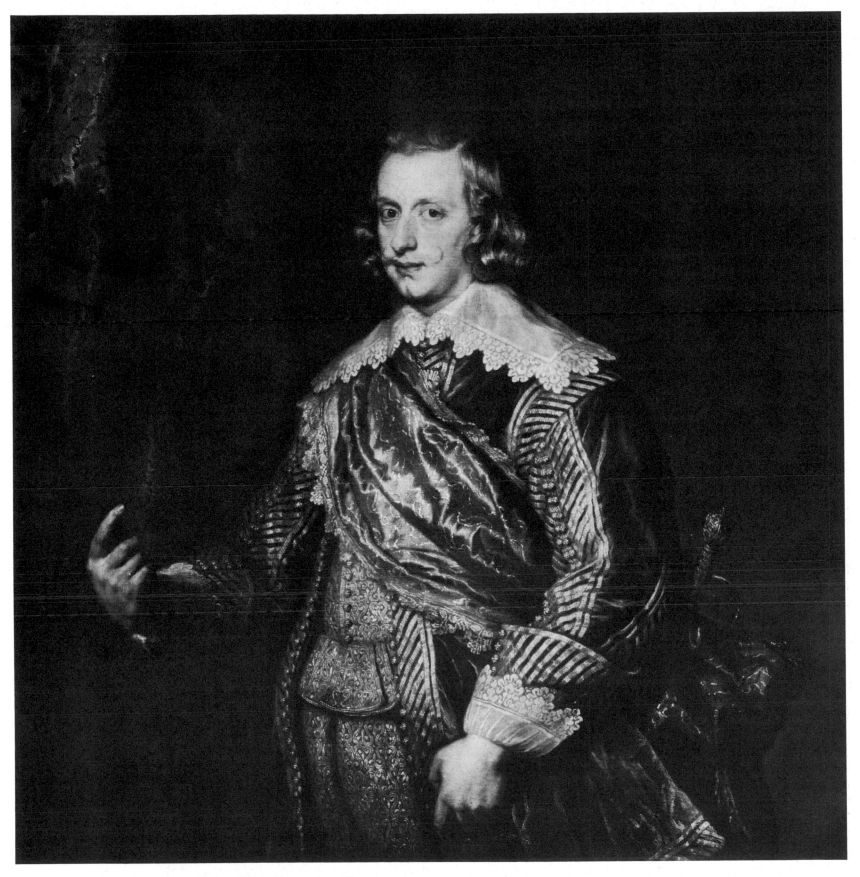

157. *Cardinal-Infante Ferdinand*. 1634. Canvas, 107 × 106 cm. Madrid, Prado.
This portrait of the victor over the Protestant armies at Nördlingen and governor of The Netherlands was painted by Van Dyck in Brussels.

156. *Thomas de Savoie-Carignan on Horseback*. 1634. Canvas, 315 × 236 cm. Turin, Galleria Sabauda.

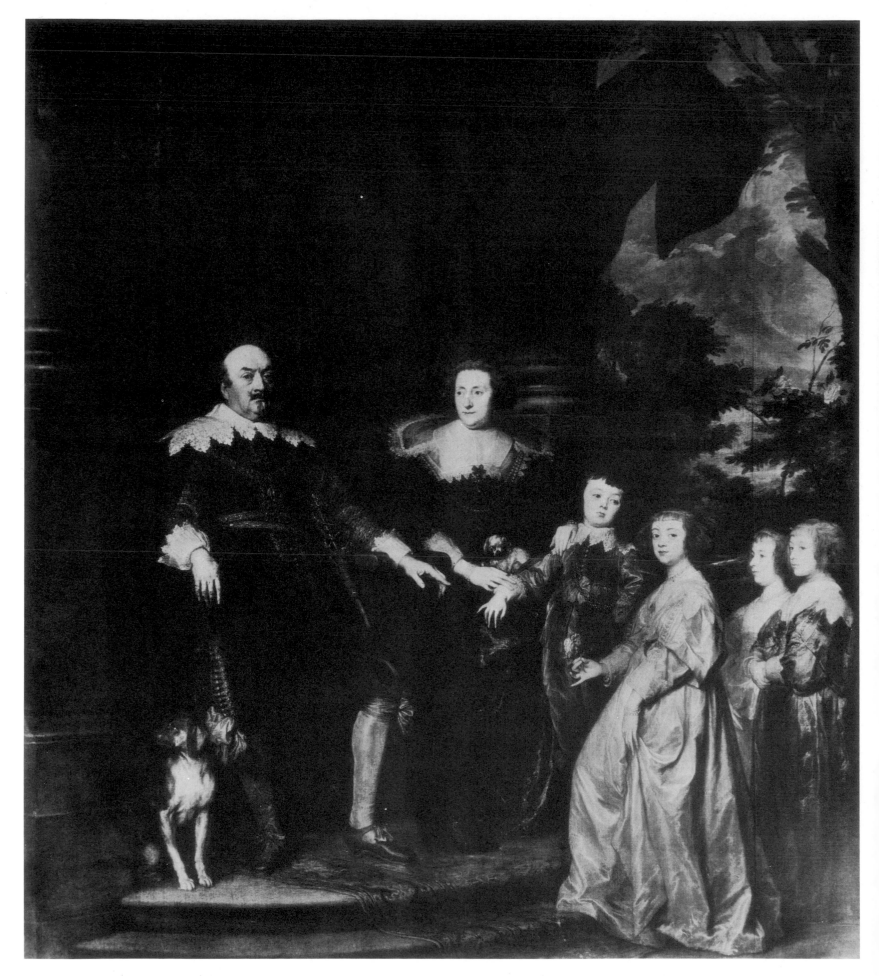

158. *John, Count of Nassau-Siegen, and his Family.* 1634. Canvas, 292.5 × 265 cm. Firle Park, Sussex, Collection of Viscount Gage.
The Count, who prominently displays his collar of the Order of the Golden Fleece, was a general in the service of the Spanish armies in The Netherlands. The lengthy inscription on the pillar at the left records that the portrait was painted in 1634.

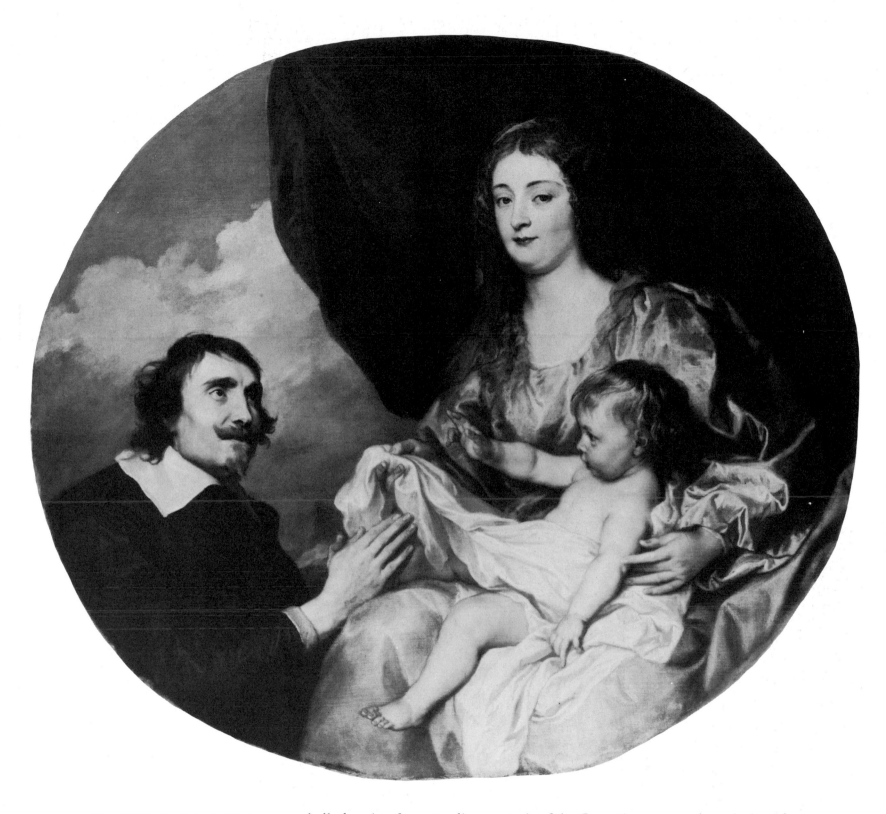

159. *The Abbé Scaglia adoring the Virgin and Child.* 1634/5. Canvas, 106.7 × 120 cm. London, National Gallery.

chalk drawing for a standing portrait of the Count in armour; the painting, done at around the same time as the group portrait, is now in the Liechtenstein collection at Vaduz.

On the reverse of the drawing of the Count in armour are two portrait studies of the Abbé Scaglia in the pose in which he is shown in *The Abbé Scaglia adoring the Virgin and Child* (Plate 159). This painting is of a group of three commissioned from Van Dyck in Brussels by Scaglia. He was an ambassador in the service of the house of Savoy during the reigns of two successive Dukes, Charles Emmanuel I and his son, Victor Amadeus. From 1614 until 1623 he had been ambassador in Rome and from 1625 until 1627 he served as ambassador in Paris. He also acted

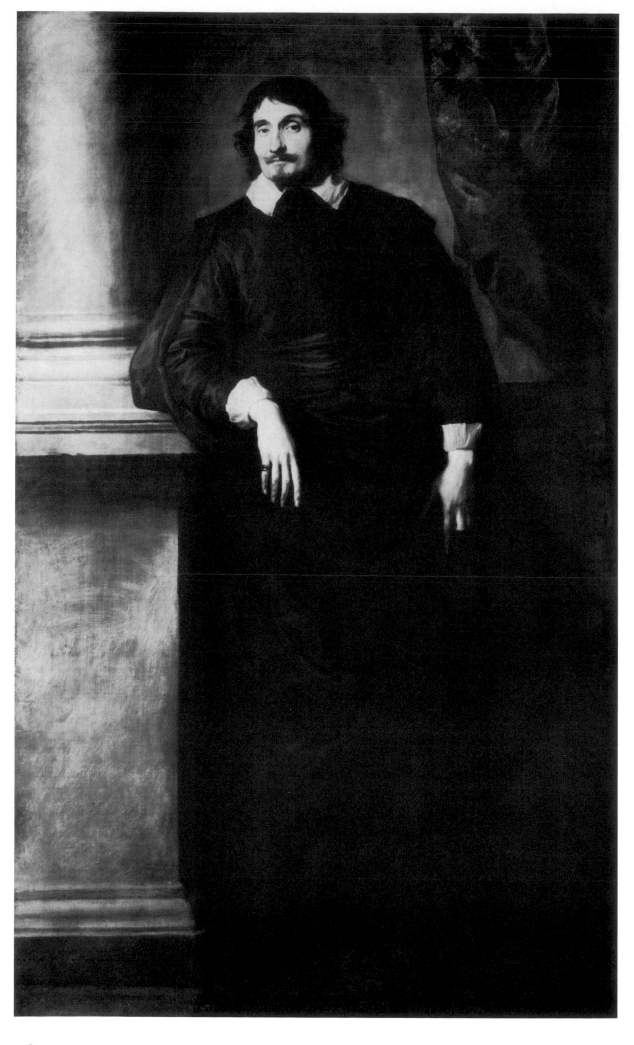

as a travelling political agent and as a trusted adviser to the Dukes. Scaglia's policy was anti-French and pro-Spanish and after the Treaty of Cherasco was concluded with the French in 1631 he found that he had been outflanked by Richelieu and was in disfavour at the court in Turin. After a short spell as ambassador in London he went into retirement in Brussels. On the proceeds of two benefices Scaglia could live in style, but even in his retirement he could not resist the lure of politics and was soon acting as adviser to Thomas of Savoy despite his estrangement from Thomas's brother, the Duke. It is against this background that the unusual painting in the National Gallery should be considered. There can be little doubt that the head of the Virgin, shown here (most uncharacteristically) as a haughty, self-possessed woman accustomed to receiving the homage of her inferiors, is intended as a recognizable portrait. Not beautiful, but striking, with her long nose and full chin, she is Christina of Savoy, the French Duchess of Victor Amadeus and Henrietta Maria's sister. Van Dyck, who may have met her when he was in Turin in 1623, would have worked from an engraving, a drawing by another artist, or even Scaglia's description. The child on her knee may be intended to represent Francis Hyacinth, her eldest son and the heir to Savoy, though it cannot be taken to be an exact portrait. The mountains which are glimpsed between Scaglia and the child may represent those of Savoy.

It is not clear why Scaglia should have chosen to flatter the Duchess in this way, but it is possible that he sent the portrait to her in an attempt to find his way back into favour with the house of Savoy. For the composition Van Dyck turned once again to his Italian Sketchbook, to a now lost painting by Titian which he had drawn. The donor's head is in the bottom left-hand corner of the picture; he is being blessed by the Christ Child, who straddles his mother's lap. On the basis of Titian's composition Van Dyck created one of the most satisfying of his mature religious works: the classic beauty of the figure group, the outstanding quality of the Abbé's portrait, and, above all, the breathtaking brilliance of the blues and pinks of the draperies combine to make it one of the most outstanding of the National Gallery's paintings by Van Dyck.

Van Dyck painted two other pictures for Scaglia at this time – a full-length portrait of him and a *Lamentation*, both of which were intended for the chapel of the Seven Dolours in the church of the monastery of the Recollects in Antwerp. The former picture (Plate 160) is one of the finest of Van Dyck's Brussels portraits. The pose is dignified, the face noble and alert. The swirl of the Abbé's cloak and his soutane of watered silk are glorious examples of Van Dyck's *bravura* treatment of drapery. The pose was originally different: in a drawing in the Institut Néerlandais in Paris the Abbé is shown seated, his left hand on a paper resting on a ledge. The *Lamentation* (Plate 161) was to hang above the altar in the chapel. The dead Christ lies in his mother's lap; she raises her eyes and hands to heaven in her grief while St John shows the wound made by a nail in one of Christ's hands to two weeping angels. It is a variation on the Lamentation theme which Van Dyck had painted a number of times during the Antwerp years. At the same time as Scaglia's *Lamentation*, he also painted the *Lamentation* now in Munich (Plate 162). The composition is very similar and a comparison brings out the special qualities of each. The Munich painting is more Titianesque, with deep rich colours (blue predominates) and loose, flowing brushstrokes. The mood is unashamedly emotional. Scaglia's picture is cooler in tone, the line firmer, the mood dramatic. Van Dyck's superlative technique and his gifts as a colourist have not detracted from the pathos of the image; they have rather served to render the harrowing scene unforgettable.

In 1639 Scaglia moved to Antwerp to be close to the monastery of the

160. *The Abbé Scaglia*. 1634/5. Canvas, 200 × 123 cm. England, Private Collection.

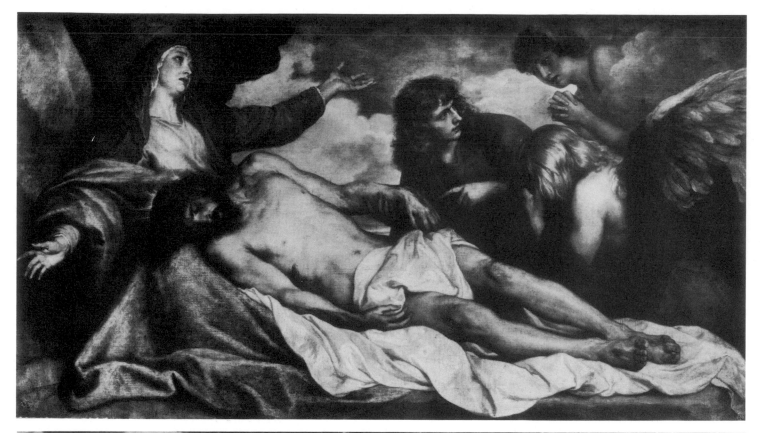

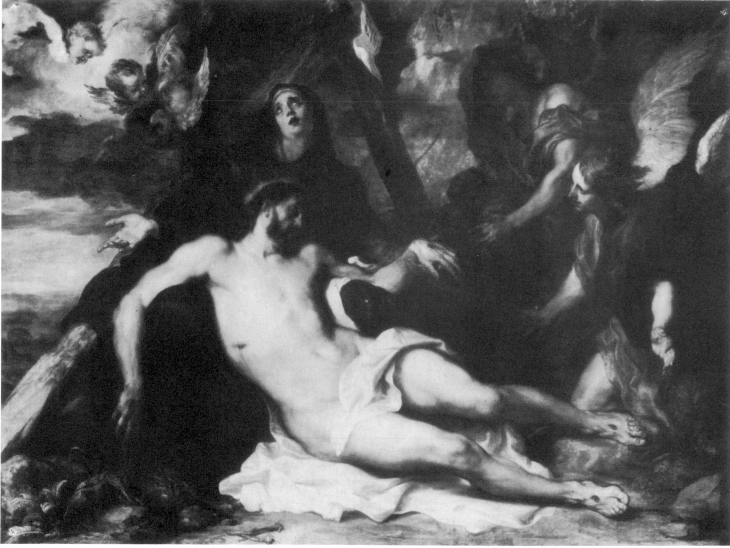

161. *The Lamentation.* 1634/5. Canvas, 115 × 208 cm. Antwerp, Museum voor Schone Kunsten.

162. *The Lamentation.* 1634. Canvas, 109 × 149 cm. Inscribed: AVDF.1634. Munich, Alte Pinakothek.

Recollects to which he had presented his own portrait and the *Lamentation*. He acted as a go-between in the negotiations with Jordaens for a series of canvases representing the story of Psyche, for the decoration of the Queen's House at Greenwich. Unfortunately the commission was never carried out. Scaglia died in 1641 and not long afterwards the Recollects sold his portrait, replacing it with a mediocre copy which today is in the Antwerp Museum.

In Brussels Van Dyck continued to receive commissions from the nobility. He painted the Duc d'Arenberg in a large equestrian portrait, which rivals that of Thomas of Savoy. It is now at Holkham Hall in Norfolk. D'Arenberg's wife, Marie, he painted in a full-length, as he did Marie Claire de Croy, Marie Marguerite de Barlemont, Comtesse d'Egmont, and other ladies of the court.

His most important commission, however, was for a life-size group portrait of the city *échevins* (aldermen) to hang in the Town Hall. The painting was destroyed in the French bombardment of Brussels in 1695, but an oil sketch for the project survives (Plate 163). This grisaille panel shows seven *échevins* grouped around an enthroned figure of Justice. It is not clear whether this represents Van Dyck's first idea for the whole composition or, as is more likely, is a sketch for the central group only. Early descriptions record that there were twenty-three *échevins* represented in all. Isaac Bullart, in his *Académie des Sciences et des Arts* (Paris, 1682), describes a trip he made to Brussels in 1675. He includes a description of Van Dyck's painting: 'A friend took me to see this great painting which is by him [Van Dyck] at the town hall. It shows the entire magistrature at that time. There are twenty-three life-size figures, arranged so well that you might imagine yourself seeing this illustrious Senate discussing and deliberating over the affairs of the Republic...' The sketch is based on a conventional composition of a type familiar from the group portraits of Holland, notably those of Frans Hals and Bartholomeus van der Helst. It was presumably painted to show to the *échevins*, and is similar in technique to the sketch made for the decorative project showing the Procession of Knights of the Garter, an abortive scheme which Van Dyck was to undertake for Charles some five years later. There are also two black chalk drawings with white highlights for the heads of two of the Brussels *échevins*.

163. *The Echevins of Brussels.* 1635. Panel, 26 × 58 cm. Paris, Ecole des Beaux-Arts. The *échevins* flank an allegorical figure of Justice enthroned.

On 18 October 1634 the Antwerp Guild of St Luke had recognized Van Dyck's pre-eminence among contemporary Flemish painters by awarding him their highest honour. He was elected dean *honoris causa* and his name was inscribed in

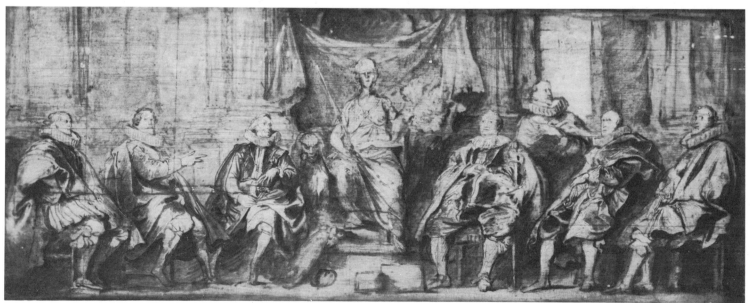

capital letters in the list of members. Only Rubens had ever before been honoured in this way, and there were to be no successors. Antwerp planned to welcome the new governor with an elaborate, solemn entry and the city fathers placed the arrangements in the hands of Rubens. He responded with an elaborate pageant which in brilliant allegorical form both praised the Cardinal-Infante and highlighted the plight of the decaying city. The town council wrote to the city of Brussels asking for a copy of Van Dyck's recent portrait of Ferdinand. From this letter we know that Van Dyck was at this time living in Brussels in a house called 'Paradise' just behind the Town Hall. He was happy to supply a replica, but he quoted so high a price that the town council of Antwerp declined, and settled for a cheaper copy of a portrait by an Italian artist.

Early in 1635 Van Dyck was in Antwerp in order to complete a large altarpiece of *The Adoration of the Shepherds* for the Church of Notre-Dame at Termonde; the commission apparently dated from November 1631. The price, exclusive of the canvas, was 500 florins. It is a traditional Italianate treatment of the scene, with Mary seated, holding the Child against a backdrop of two imposing columns. Joseph stands behind her looking upwards at a *putto*, who displays a *cartellino* bearing the words *Gloria Deo in excelsis*. The principal shepherd kneels, extending both arms in an attitude of devotion. The second, elderly, shepherd places his hand on his chest. The mood is of tender adoration, the deep colours – like the composition – having their source in Titian's religious painting. Soon after completing the painting Van Dyck returned to London, where he was to remain for the next five years in the apparently ceaseless service of the court.

Last Years in London

Although Charles I and Henrietta Maria were portrayed by numerous painters, it is in Van Dyck's portraits that they are remembered today. He fixed their images for posterity. The King and Queen constantly commissioned portraits from him, as the accounts of the royal household reveal. As early as 8 August 1632, £280 was paid for a number of paintings:

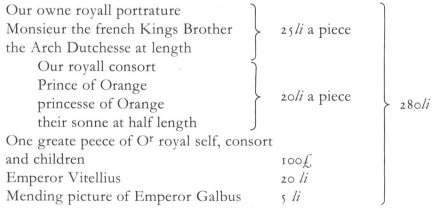

Aug. 8, viii Car. 1. Whereas Sr Anthony Vandike hath by Or Commaunde made and psented us wth divers pictures vz.

Our owne royall portrature		
Monsieur the french Kings Brother	25 *li* a piece	
the Arch Dutchesse at length		
Our royall consort		
Prince of Orange	20 *li* a piece	280 *li*
princesse of Orange		
their sonne at half length		
One greate peece of Or royal self, consort and children	100£	
Emperor Vitellius	20 *li*	
Mending picture of Emperor Galbus	5 *li*	

A number of these portraits Van Dyck no doubt brought with him to England. 'Monsieur the french King's Brother' is presumably Gaston, Duc d'Orléans, and the 'Arch Dutchesse' is Isabella. These pictures, together with the portraits of the Prince and Princess of Orange and their son, were in Van Dyck's baggage, as examples of his skill or as gifts to Charles I from the sitters. The heads of Vitellius and Galba were from the series of Roman Emperors by Titian which were in the

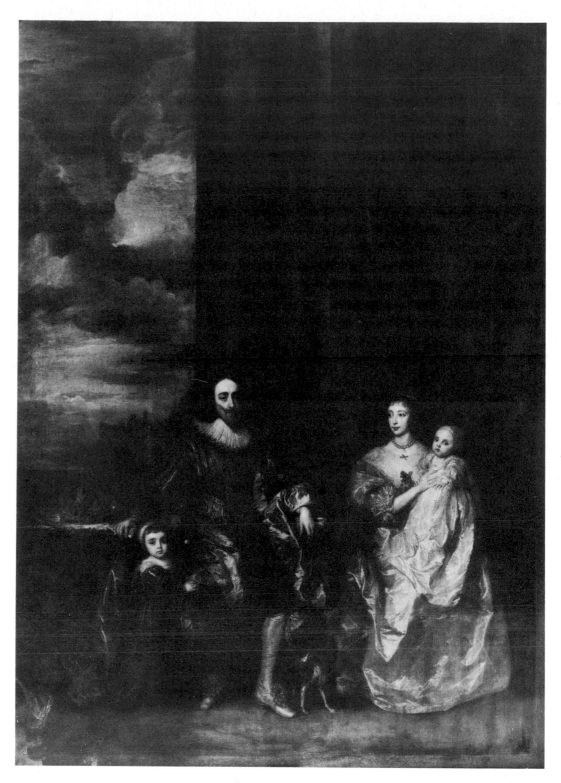

164. *Charles I and Henrietta Maria with Prince Charles and Princess Mary ('The Greate Peece')*. 1632. Canvas, 370.8 × 274.3 cm. Buckingham Palace, Royal Collection. The original painting was extended at a later date.

great collection purchased by Charles I from the Duke of Mantua. The Vitellius portrait had been damaged beyond repair during the journey by sea and Van Dyck painted a copy; that of Galba he restored. The 'greate peece' (Plate 164), painted in the few months since Van Dyck had arrived in England, is the large family portrait, now at Buckingham Palace. The King and Queen are shown seated; Prince Charles stands at his father's knee and the baby Princess Mary is held in her mother's arms. The family are set off against a typically Van Dyckian background of column and rich hanging, beyond which, on the left, is a view of Westminster. Against these sombre colours the figures of the King, in black and silver, and the Queen, in amber silk, glisten. The King looks directly out of the picture, his heavy features set, while the Queen looks across at him with a tender smile. This picture, for which there are a group of black chalk preparatory drawings, hung at the end of the Long Gallery 'toward the Orchard' at Whitehall.

In 1632, the year in which the 'greate peece' was painted, the King was thirty-two. He was then, a contemporary wrote, in 'the full flower of robust vigour natural to his time of life'. 'He is well proportioned and strong', he continued, although in fact Charles was below normal height. [Judging by his armour in the Tower of London, Charles was never more than five feet four inches tall.] 'Although more disposed to melancholy than joviality, yet his aspect, with his comeliness, is no less pleasing than grave. His actions disclose no predominance of immoderate appetites or unruly affections, indeed he is a prince full of goodness and justice.' Although he had been a sickly child, his health was good. Henrietta Maria had been only fifteen years old at the time of their marriage. Tobie Mathew, who was involved in the negotiations, reported to the Court shortly before: 'She sits on the very skirts of womanhood . . . upon my faith, she is a most sweet lovely creature . . . full of wit, and has a lovely manner in expressing it.' He was doing his best to find praiseworthy features in the gawky French princess, who was no beauty. The marriage almost foundered in its first years, but after the assassination of Buckingham the King turned to his wife for emotional support and found her eager to give it. The royal couple fell deeply in love and remained so; and the Court poets created a cult of domestic love based on their example. In Jonson's masque *Love's Triumph through Callipolis*, performed in 1630, Henrietta Maria is described as 'Pure Object of heroic love alone', and the love of the King and Queen is celebrated by the demi-chorus with the words: 'Where love is mutual, still/All things in order move./The circle of the will/Is the true sphere of love.'

In the years since she had arrived in England, the Queen's bony frame had filled out. She was still short, standing only to her husband's shoulder: her large nose and protruding teeth were softened by her fuller face, and although her best feature remained her large black eyes, she now dressed elegantly in shades of orange and blue which suited her well.

His royal patrons' continuous demands on Van Dyck can be traced in the royal accounts. On the 7 May 1633, for example, the painter was paid £444 for 'nine pictures of Or Royall self and most dearest Consort the Queene lately made by him', a tribute not only to the consistency of royal patronage, but also to the speed at which Van Dyck worked. There are further payments in the royal accounts throughout Van Dyck's years in England for the receipt of individual pictures and for his pension, which was invariably in arrears. These many royal portraits required numerous sittings; another item in the accounts records the construction of a special jetty for easy access to Van Dyck's house at Blackfriars for the benefit of his royal visitors.

The most fascinating of all these documents is a list of paintings submitted to the King by Van Dyck apparently in 1638 with prices given for each one. Some prices have been crossed out by the King himself and lower ones substituted.

<div align="center">

Memoire pour Sa Magtie le Roy

</div>

Pour mollures du veu' conte	~~27£~~	
Une teste d'un valiant poete	~~20£~~	12
Le Prince Henri	50£	
Le Roi alla ciasse	~~200£~~	100
Le Roi vestu de noir au Prince Palatin avecq sa mollure	~~34£~~	30
Le Prince Carles avecq le ducq de Jarc Princess Maria Prse Elizabeth Pr Anna	~~200£~~	100
Le Roi vestu noir au Monsr Morre avecq		

sa mollure	~~34£~~	26
Une Reyne en petite forme	20£	
Une Reyne vestu' en blu'	30£	
Une Reyne Mere	50£	
Une Reyne vestu en blanc	50£	
La Reyne pour Mons^r Barnino	~~20£~~	15
La Reyne pour Mons^r Barnino	~~20£~~	15
La Reyne pour la Reyne de Boheme	~~20£~~	15
La Reyne en petite forme	20£	
La Reyne envoye a Mons Fielding	~~30£~~	20
†Le Prince Carlos en armes pour Somerset	40£	
Le Roy alla Reyne de Boheme	~~20£~~	15
Le Roy a armes donne au Baron Wartõ	~~50£~~	40
La Reyne au di Baron	~~50£~~	40
Le Roy La Reyne le Prince Carlos au L'ambas^r Hopton	~~90£~~	75
†Une Reyne vestu en blu donne au Conte d'Ollande	60£	
†Deux demis portraits della Reyne au veu Conte	60£	
Une piece pour la maison a Green Witz	100£	
Le desein du Roy et tous les Chevaliers		

The totall of all such Pictures as his Ma^{tie} is
to paye for in his accoumpt rated by the
King and what his Ma^{tie} doth allowe of,
amounts unto five hundred twentie eight
pownde 528£

The other pictures w^{ch} the king hath marked
 wth a cross before them the Queen is to
 paye for them, and her Ma^{tie} is to rate them —

The Arrere of the Pention being five yeares
 amounts unto one thousand pounds att
 two hundred pounds p añum 1000£

More for the pictures w^{ch} S^r Arthur Hopton
 had into Spaine 0075£

The totall of all amounts unto 1603£
The pictures for the Queene 200£
Five years Pension 1000£

Endorsed Sir Anthony Vandike

Here we can not only find some of the best-known of Van Dyck's portraits of the royal family – the *Roi à la Chasse* (Louvre), the *Five Children of Charles I* (Turin), the heads of Henrietta Maria for the projected sculpted bust by Bernini – but also discover the destinations of some of his endless stream of royal portraits. A pair of the King and Queen for the Queen of Bohemia, Charles's sister Elizabeth, who was living in widowed exile in The Hague, a pair for Lord Wharton, and a portrait of the family for the king of Spain (to be presented by Sir Arthur Hopton, the ambassador to Spain). Other recipients of royal portraits included the Prince of Orange, the Prince Palatine Charles Louis, Lord Fielding (the Earl of Denbigh)

165. Detail of *Charles's Horse*. Black chalk
with white highlights. London, British
Museum.
A study for the horse in Plate 166.

and the Duke of Somerset. The painting destined for the Queen's House at
Greenwich was perhaps the superb, Titianesque *Cupid and Psyche* (which is now
at Kensington Palace), and the sketch of the King and his Knights may refer to
the oil sketch of the Garter Procession now at Belvoir Castle. The portrait of
Prince Henry is still in the Royal Collection; painted from an earlier portrait of
Charles's elder brother, it was intended for the Cross Gallery at Somerset House,
which was hung with royal portraits, for which Van Dyck also produced six
portraits of living members of the family.

The 'greate peece' had been hung by the King at the end of a long vista, the
Long Gallery at Whitehall. A second royal portrait, painted in the following year,
1633, was destined for a similar site – to fill a whole wall, in illusionistic fashion,
at the end of the long gallery at St James's Palace (Plate 166). It showed the King
on horseback, riding through a classical triumphal arch, accompanied on foot by
his riding-master, Pierre Antoine Bourdin, Seigneur de St Antoine. (Bourdin had
been sent by Henri IV of France to James I in 1603 with a gift of six horses, *des
mieux dressez, fort richement enharnachez*, for Prince Henry. He remained in the
Prince's service and was later riding-master and equerry to Charles.) The King
wears armour and supports his baton of command against his horse's saddle-
cloth. The Royal arms are displayed on the arch, whose allusion to imperial might
and classical triumphs is entirely appropriate to the picture's intended location
among the series of Roman Emperors by Giulio Romano and Titian.

The portrait of Charles on horseback is part of a sequence of magnificent life-
size equestrian portraits by Van Dyck which began in Genoa with those of Anton
Giulio Brignole-Sale and Cornelis de Wael, and continued in the magnificent
canvas of the Marquis of Aytona painted in Brussels in 1630. These paintings are
amongst the very greatest achievements of equestrian portraiture. The depiction
of horse and rider, the relationship between them, in particular the balance of a
man on the back of a walking or rearing horse, had taxed the ingenuity of the
greatest painters and sculptors. Van Dyck effortlessly surmounted such technical
problems. A black chalk drawing in the British Museum (Plate 165) shows him
examining unerringly the more difficult areas of the horse's anatomy – the head,
the folds of flesh between the front legs, the hind leg and the joint of one of the
front legs – all of which are rendered with no trace of awkwardness or hesitation

166. *Charles I on Horseback with Seigneur de St
Antoine*. 1633. Canvas, 368 × 269.9 cm.
Buckingham Palace, Royal Collection.
The painting was valued by the
Commonwealth Trustees for Sale at £150
and sold to a certain Mr Pope in 1652. In
1660 it was said to be in the possession of
Remigius van Leemput who had
unsuccessfully tried to sell it in Antwerp. It
was duly restored to the Royal Collection.

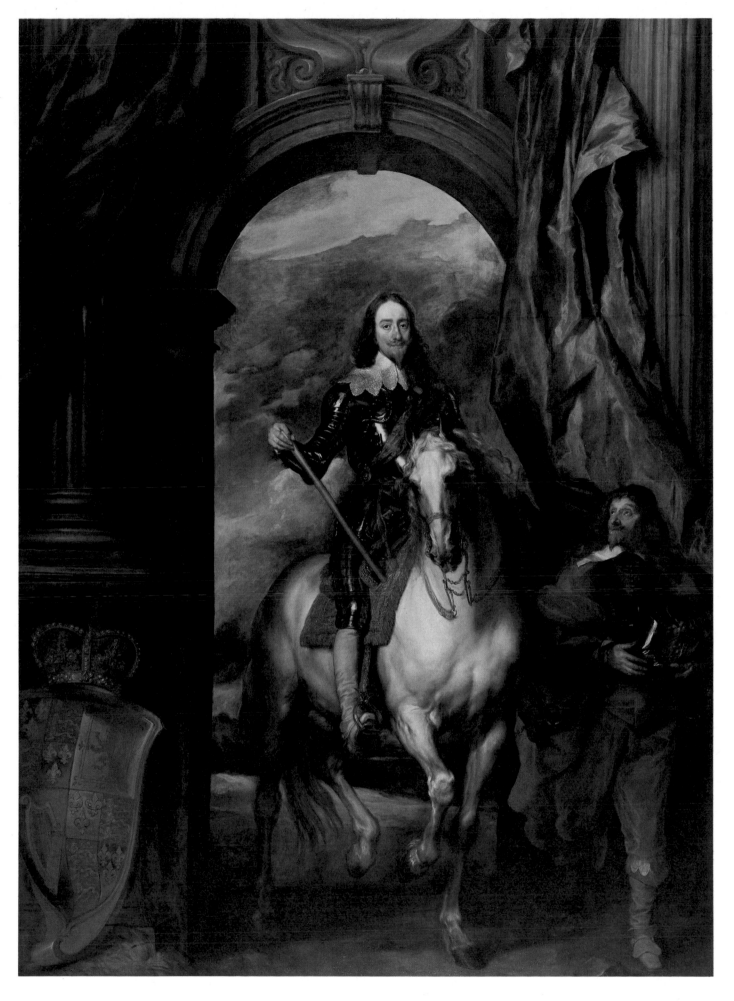

in the finished painting.

A second, very large, equestrian portrait of the King, wearing Greenwich-made armour and carrying his commander's baton (Plates 167–9), continues the theme of Charles as warrior knight. Here the King, in profile to the left, is seen in an extensive landscape beneath overhanging branches. He is mounted not on the white horse of the St James's Palace portrait but on a small-headed, yellow-brown horse with a broad, inelegant neck and long, curling mane. The King is attended by a page, who carries his helmet, and on the tree beside which the page stands is a tablet inscribed *CAROLUS REX MAGNAE BRITANIAE*, a title which his father, James VI and I, had been the first British Sovereign to enjoy. This imposing portrait was no doubt intended to provide a *coup d'oeil* at the end of a gallery. In 1639 Van der Doort recorded that it was 'at present' in the Prince's Gallery at Hampton Court, perhaps suggesting that its final destination had not yet been decided. It had probably been painted shortly before, in 1637 or 1638. At the dispersal of the royal collection under the Commonwealth the painting was bought by Balthasar Gerbier for £200, and it subsequently passed into the possession of the Elector of Bavaria. Looted from Munich by the Emperor Joseph I, it was presented by him to John, Duke of Marlborough in 1706. It hung at Blenheim Palace until sold to the National Gallery by the 8th Duke in 1885.

Both equestrian portraits – and to a lesser extent Van Dyck's other portraits of the King – are exercises in royal propaganda. They are conscious idealizations of the monarch. Emphasizing Charles's title as King of England, Scotland, Ireland, and France, the pose in the National Gallery painting deliberately echoes the famous Roman statue of the emperor Marcus Aurelius on horseback which until recently stood on the Capitol in Rome, and Titian's great equestrian portrait of Charles V, the victor of Mühlberg, which, according to Bellori, directly inspired Van Dyck's treatment. In a more local context, the poses of both horse and rider repeat those in Hubert Le Sueur's statue of the King, which now stands at the top of Whitehall; it had been commissioned originally from the French sculptor in 1630 for Lord Weston's garden at Roehampton.

In the National Gallery painting Charles wears on a gold chain around his neck a gold locket bearing the likeness of St George and the Dragon, the so-called Lesser George. St George was the patron of the Order of the Garter and the medallion identifies the King as Garter Sovereign, riding, as it were, at the head of his chivalrous knights. Charles wore his Lesser George constantly. It contained a portrait of his wife as well as an image of the Saint, and was with him on the day he died. The portrait of Charles on horseback must have held many other associations for the King and the Stuart court, not all of which Van Dyck would have recognized. In a profound sense it is a visual statement of Charles's assertion of Divine Kingship, which found written expression in his *Eikon Basilike*, published in 1649, soon after his execution.

If we compare the head of the King in the National Gallery portrait with that in the 'great peece' (Plate 164) it can be seen that Van Dyck's choice of the angle of vision in the former has the effect of softening and thereby ennobling Charles's features. The large deep-set eyes and long nose are less marked and the head possesses a dignity which is less apparent in the earlier portrait. Even contemporaries remarked on a certain air of melancholy in the King's features and later writers saw in this an aura of impending martyrdom. Yet when the equestrian portrait was painted Charles's troubles were still far off – or so at least it seemed, within the cocooned Stuart court. In 1637 he declared himself the happiest King in Christendom and the years of personal rule were a time of apparent political triumph. Melancholy cannot therefore have been intended to be the mood of the

167. Detail of Plate 169.

168. Detail of Plate 169.

portrait, though Van Dyck did mean to show the King in an attitude of contemplation, serious and abstracted, removed from mundane concerns. Dignity and nobility are the keynotes of the portrait.

In *Roi à la Chasse* (Plates 170, 171) his demeanour is quite different. He is standing, his horse held by a groom; he wears a wide-brimmed black hat, a leather doublet and high boots. One hand rests on a walking-stick; in the other he holds both his long kid gloves. This portrait belongs to a tradition of princes as huntsmen, which includes Van Somer's portrait of Charles's mother, Anne of Denmark, with her dogs, and Peake's of Prince Henry with a dead deer at his feet. Here it is the King's air of complete self-possession, his near-nonchalance, that the painter seeks to emphasize. The complete courtier (the Renaissance *Cortegiano*), elegant and relaxed, he surveys the countryside and the distant sea, entirely oblivious of the presence of the two grooms. Of all Van Dyck's portraits of the King, this is the most beautiful, with its rich colours, its exciting composition (with the King daringly placed to the left) and its absolutely assured technique. Painted in 1635, it was sent to France soon afterwards, perhaps as a gift to the Queen Mother. After being in the collections of the Marquis de Lassay and Crozat, it was purchased by Louis XV for his mistress, Madame Du Barry, who in a remarkable flight of fancy imagined herself descended from the Stuarts.

169. *Charles I on Horseback. c.* 1637. Canvas, 367 × 292.1 cm. London, National Gallery.

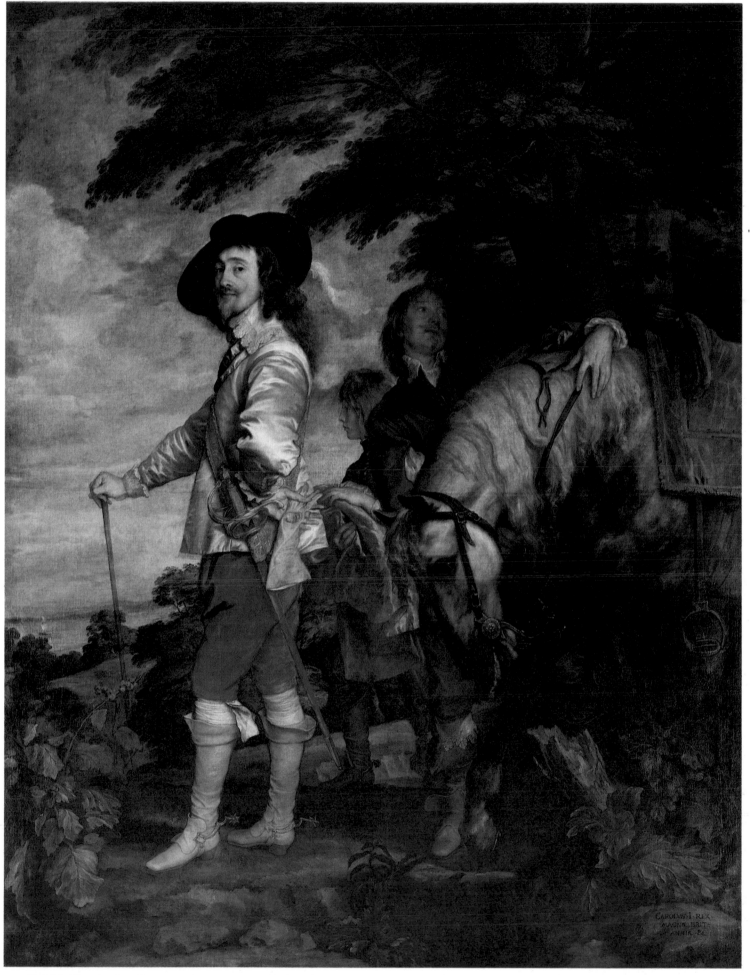

170. '*Roi à la Chasse*'. 1635. Canvas, 272 × 212 cm. Inscribed on the stone at the right: CAROLUS I REX MAGNAE BRITANNIAE and on the lower edge of the canvas A. VAN DYCK. F. Paris, Louvre.

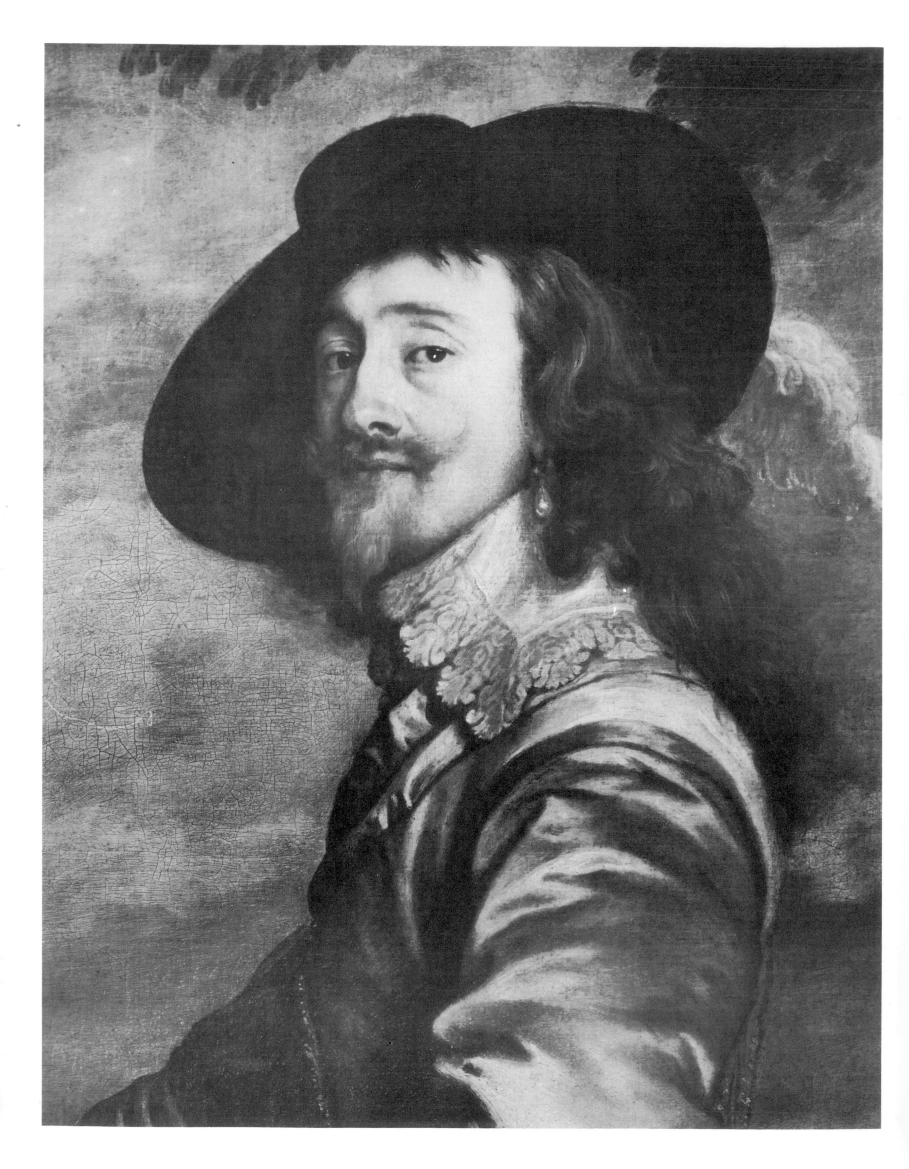

171. Detail of Plate 170.

172. *Charles I as Garter Knight*. 1632. Canvas
123 × 96.5 cm. Dresden, Gemäldegalerie.
At the top on the right is the royal
monogram CR and the date 1632.

In 1636, the year after he painted the King *à la chasse*, Van Dyck portrayed him
full-length in the robes of the Order of the Garter, a simple yet immensely
dignified image. Charles had moved the Garter festival from London (where on
St George's Day the knights, preceded by the monarch, would process down
Whitehall) to Windsor Castle. There, in St George's Chapel, Garter services were
conducted with great splendour and elaborate High Church ceremonial. Charles
set great store by the Order, which had been founded by the Tudors on the model
of the Burgundian Order of the Golden Fleece with the intention of cementing
the union between the leading nobles and the Crown; he was, in Elias Ashmole's
words, 'the greatest increaser of the Honour and Renown of this most illustrious
Order' (*The Institution, Laws and Ceremonies of the most noble Order of the Garter*,
1672). In 1626, the year after his accession, he had decreed that all knights should
wear the Garter badge – the red cross of St George – embroidered on the left side
of their cloaks. Soon afterwards he added to the cross an aureole of silver rays in
imitation of the French Order of the Holy Spirit. In a three-quarter length portrait
in Dresden (Plate 172) the King is shown proudly wearing the Lesser George on
a satin sash and displaying the Garter star on his shoulder.

Van Dyck's bust-length triple portrait of the King, known as *Charles I in Three Positions* (Plates 173, 174), was probably begun in the second half of 1635. It was to be sent to Bernini in Rome, for him to use as a model. The marble bust was to be a papal present to Queen Henrietta Maria and the commission was arranged by Pope Urban VIII at a time when hopes were entertained in the Vatican that the King might lead England back into the Catholic fold. (On leaving France after her marriage by proxy, Henrietta Maria had promised the Pope and her brother, the French King, that she would bring her children up as Catholics and act as a champion of her faith in a heretic land.) Urban's agent in London, Gregorio Panzani, reported on 13 June 1635 the King's satisfaction with the papal permission granted to Bernini to carve the bust. At this time there were other artistic contacts between London and Rome: a consignment of pictures had arrived from Rome in 1635, and Cardinal Francesco Barberini, the Pope's nephew, was involved in the commission of Guido Reni to paint a large *Bacchus and Ariadne*, probably intended for Greenwich. These transactions inevitably brought Puritan criticism: William Prynne accused the Papal Nuncio, Panzani, of trying 'to seduce

173. *Charles I in Three Positions.* 1635. Canvas, 84.5 × 99.7 cm. Windsor Castle, Royal Collection.

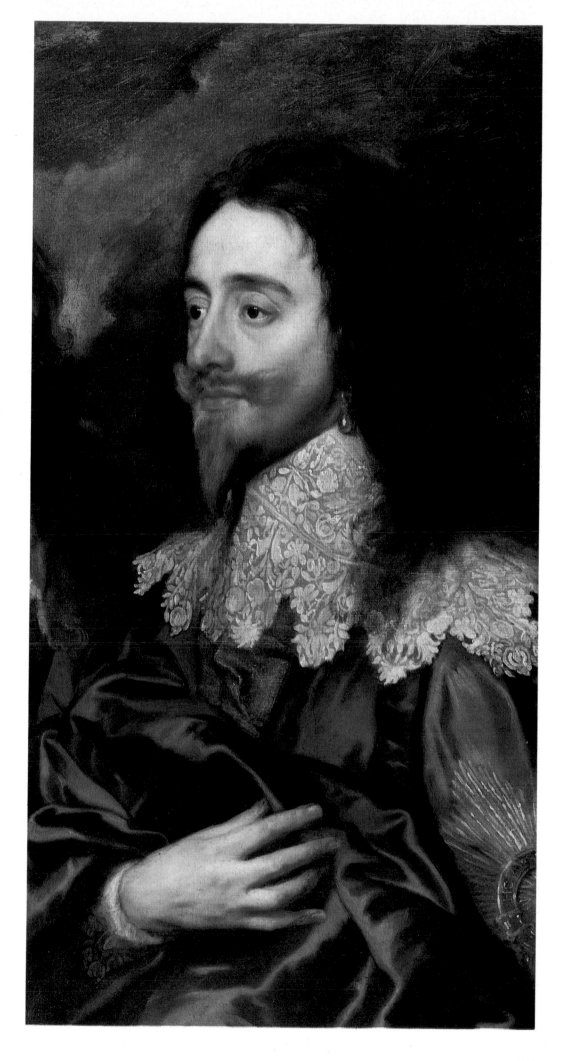

174. Detail of 173.

the King himself with Pictures, Antiquities, Images & other vanities brought from Rome'.

Van Dyck took especial care with the triple portrait, well aware that it would be carefully scrutinized by Roman artists and connoisseurs. (There can be no doubt that certain commissions interested Van Dyck more than others; in some of the English portraits, particularly towards the end of his life, there is a distinct perfunctoriness about both composition and execution.) In making a triple portrait for this unusual commission – Bernini required only the King's head – Van Dyck was probably influenced by Lorenzo Lotto's *Portrait of a Man in Three Positions*, which was hanging in Charles's collection as a Titian. Against a dark, cloud-filled sky Van Dyck shows the King in profile to the left, full-face, and in three-quarter profile to the right. He wears three different doublets, though all have the same high lace collar. On the left the King's left hand holds the satin sash from which the George hangs, and on the right his right hand supports his cloak. Here are the now familiar thick eyebrows, heavy-lidded eyes, long nose, upswept moustache, short, pointed beard and mane of chestnut hair, worn longer on the left than on the right. Charles's gaze is unfocused and contemplative, his aura one of royal grandeur. He must have been pleased with the painting: his letter of 17 March 1636 to Bernini expressed the hope that the sculptor would carve *il nostro ritratto in marmo sopra quello che in un quadro vi manderemo subito*.

Van Dyck's painting was sent to Bernini in Rome, possibly under the supervision of Thomas Baker, a royal agent who was himself later to be portrayed by Bernini. When the sculptor received it he noted, according to John Evelyn (*Numismata*, 1697), 'something of funest and unhappy, which the Countenance of that Excellent Prince foreboded'. He carved Charles's bust in the summer of 1636 and it left Rome – its dispatch arranged by Cardinal Barberini – in the following spring. It arrived at the palace at Oatlands on 17 July 1637 and was greeted rapturously 'nott only for the exquisiteness of the worke but the likenesse and nere resemblance it had to the king's countenance'. The Queen was delighted and rewarded Bernini with a diamond worth 4,000 scudi (£800). Unhappily, the bust was one of the many treasures lost in the fire at Whitehall Palace in 1698. Its appearance probably is preserved in a bust at Windsor (Plate 175), and in engravings said to be by Robert van der Voerst and drawings by Jonathan Richardson.

In gratitude for the gift of paintings which had arrived from the Vatican in 1635 and for the part he was playing in the arrangements for the Bernini bust, the Queen sent Van Dyck's portrait of her to Cardinal Barberini. It seems likely that this was the three-quarter-length portrait reproduced as Plate 176. Knowing its destination, Van Dyck took the greatest care. As he had done with the King, he softened Henrietta Maria's facial features, particularly her long nose and prominent jaw, by carefully choosing the most flattering angle for the head. He emphasized the delicacy of her complexion, framed in brown curls. Her dress is of amber watered silk with lace at the cuffs and throat; she wears pearls at her neck and around her bodice. Her hands lie cupped one upon the other just below her waist, a gesture which has been taken to refer to her pregnancy – Princess Anne was born in March 1637 – but more probably is simply intended to suggest modesty. Beside her, on a table, is her crown. The background is roughly sketched in brown on a warm, reddish ground: the paint is more heavily applied in the area of the head itself (an effect that has become more apparent with time), which may suggest that Van Dyck painted the head direct from life and subsequently reworked it on the canvas. This must have been his procedure in a number of portraits, for detailed drawings survive for only a few of them; certainly with subjects as familiar to him as the King and Queen, who also had so little time

175. After Bernini: *Charles I*. Sculpted bust. Windsor Castle, Royal Collection. The original was destroyed in the fire at Whitehall Palace in 1698. This copy may have been made by Thomas Adye from a cast.

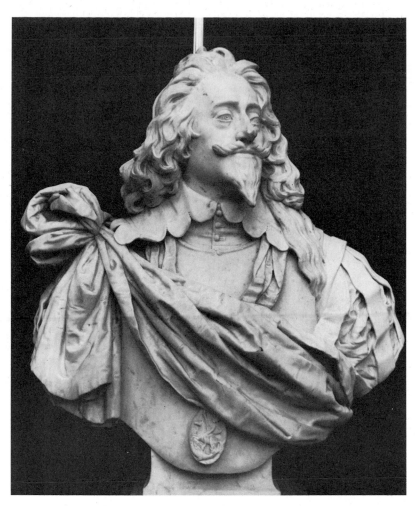

available for sittings, there would have been no need to make elaborate preparatory drawings.

When Bernini's bust of Charles arrived from Rome, the Queen was so delighted that she wished him to carve a companion bust of herself. There seems to have been a delay, however, in Van Dyck's painting the necessary portraits for Bernini to work from. She did not sit to him until late in 1637 and it was not until almost a year later (August 1638) that three separate canvases of her were ready to be sent to Rome. Her letter to Bernini commissioning a bust to be based on the portraits dates from June 1639, but in the event it seems that the paintings were never sent because, according to Baldinucci in his life of Bernini, of *le turbolenze, che poco dipoi insorsero in quel regno*. The English sculptor Nicholas Stone noted in his Diary, however, that Bernini had told him he would never do another bust based on a painting, 'even if thaire were the best picture done by the hand of Raphyell'. Two of the portraits Van Dyck painted of the Queen to guide Bernini are still in the Royal Collection. They are the left profile and the full-face; the third, the right profile, is in the Brooks Art Gallery, Memphis (Tennessee). The extent to which they soften the Queen's pronounced facial features can be judged from the disappointment experienced by Princess Sophia, the King's niece and later Electress of Hanover, when she met Henrietta Maria on her arrival in The Hague in 1641:

Les beaux portraits de Van Dyck m'avoient donné une si belle idée de toutes les dames d'angleterre, que j'étois surprise de voir la reine que je m'avois vue si belle en peinture, estre petite femme, montée sur son siège, les bras longs et secs, les épaules dissemblables et les dens comme des défenses lui sortant de la bouche; pourtant, après que je l'eus considérée, je lui trouvais les yeux très beaux, le nez bien fait, le teint admirable.

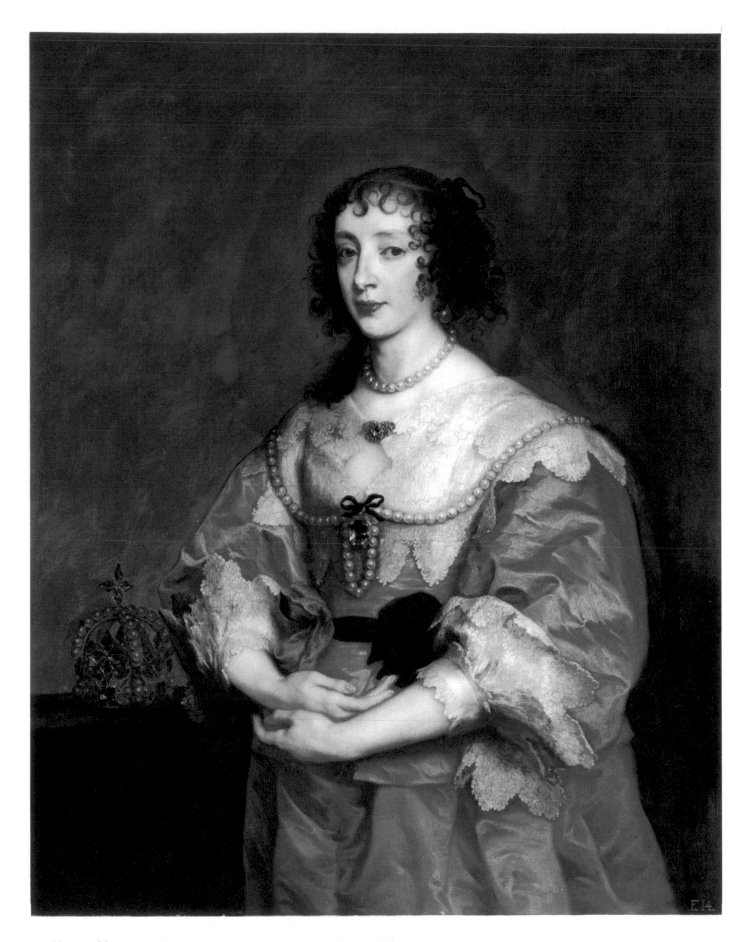

176. *Henrietta Maria*. 1635. Canvas, 105.5 × 84.2 cm. New York, Private Collection.
It was probably this portrait which the Queen sent to Cardinal Barberini in Rome to thank him for his part in arranging the carving of the King's bust by Bernini.

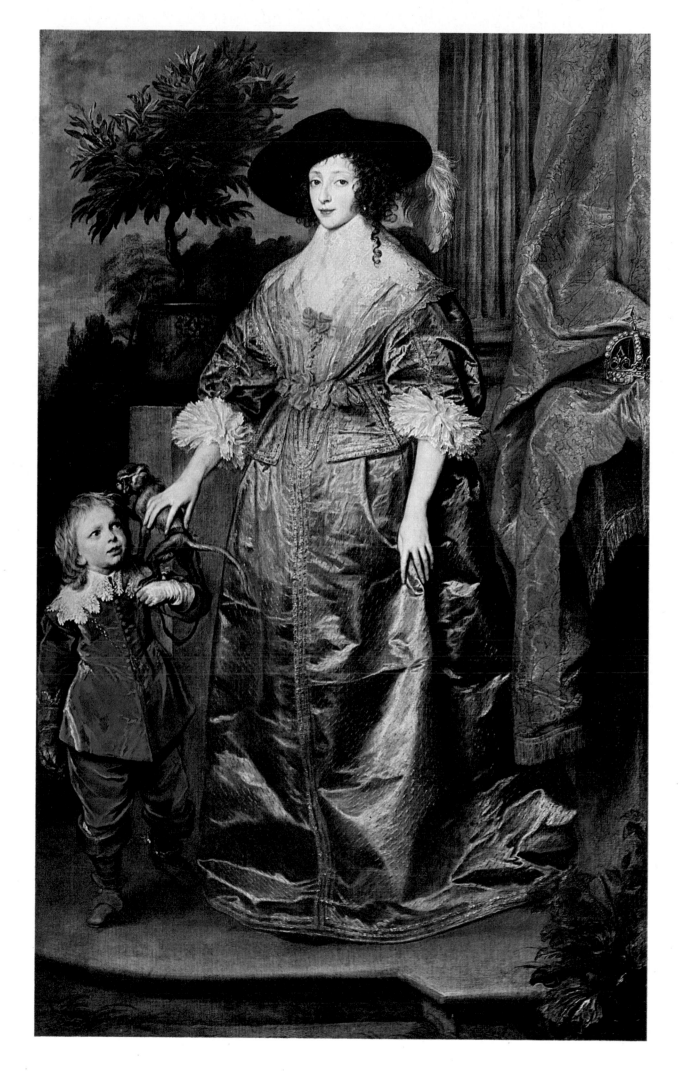

177. *Henrietta Maria, with her Dwarf Sir Jeffrey Hudson.* 1633. Canvas, 219.1 × 134.8 cm. Washington D.C., National Gallery of Art.
Hudson (1619–82) had previously been in the service of the Duchess of Buckingham. He attracted royal attention when he emerged from a pie at a dinner given by the Duchess for the King and Queen. At the age of 30 he stood about 45 inches high.

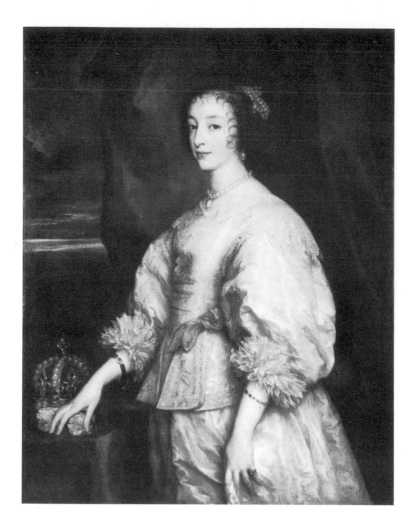

Van Dyck painted the Queen more than twenty times. Among the earliest of
these portraits, painted for the King in 1633 and given by him to Lord Wentworth
(who was later created Earl of Strafford), is the full-length now in the National
Gallery of Art, Washington (Plate 177). Standing on steps leading to a garden
with a column and a brocade curtain – on which her crown rests – on the right
and a small orange tree in a tub on her left, the Queen is dressed in blue silk with
gold braiding and lace at her cuffs and throat. She wears a wide-brimmed black
felt hat trimmed with feathers. Her right hand holds a pet monkey, which crawls
along the arm of her dwarf, Sir Jeffrey Hudson.

Two very fine three-quarter length portraits of the Queen are today at Dresden
and Windsor Castle (Plate 178). The Dresden painting shows her dressed in white
satin, clutching a handful of roses. The background is a brocaded hanging, whose
strong colours emphasize the rich simplicity of her dress. In the Windsor picture,
perhaps the first single portrait of the Queen Van Dyck painted after his arrival
in London, she rests her right hand on a table, on which her crown is placed. She
is once again in satin and lace, with pearls at her throat and in her elaborately
dressed hair.

With the exception of the 'greate peece' Van Dyck showed the King and Queen
together in only one composition, the best version being in the Archbishop's
Palace at Kremsier in Czechoslovakia. He painted it very soon after his
arrival in England in 1632. The royal couple are depicted in three-quarter length:
the Queen looks out of the painting, and Charles, gazing at her, receives a laurel
wreath from her hand while she holds the olive-branch of peace in her other hand.
It is a tender, deeply romantic image and one which is entirely in accord with the
characterizations of the royal couple presented year after year in the court mas-
ques. In Ben Jonson's *Love's Welcome*, for example, performed in 1634 at Bol-
sover, the royal couple are described as 'this excellent King and his unparalleled

Queen, who are the canons, the decretals, and whole school divinity of Love'. The concluding speech, delivered by Philalethes, addresses '... your sacred persons ... descended, one from the most peaceful [the King's father, James I], the other the most warlike [the Queen's father, Henri IV], both your pious and just progenitors; from whom, as out of peace, came strength, and out of the strong came sweetness; so in you joined by holy marriage, in the flower and ripeness of years, live the promise of a numerous succession to your sceptres, and a strength to secure your own islands, with their own ocean, but move your own palm-branches, the types of perpetual victory'.

Just after his return from The Netherlands in 1635 Van Dyck was commissioned by his royal employers to paint a group portrait of their three children (Plate 179). The painting was commissioned by the Queen and sent by her to her sister Christina, Duchess of Savoy, in exchange for portraits of Christina's children. The Queen wrote to her sister, apparently in July 1635, that the dispatch of the painting had been held up because *ma fille n'a jamais voulu avoir la pasiance de les leser achever*, and it was not until the autumn that the painting was finally sent to Turin. Prince Charles, the future Charles II, who had been born in May 1630 is on the left; his sister Mary, born in November 1631, the future bride of Prince William of Orange, stands beside him, and on the right, raised up on a step, is James, born in October 1633. Scattered at Princess Mary's feet are roses from the bush behind her. It is a masterpiece of child portraiture, each face, even that of the baby James, being sharply characterized. The expressions are caught in a moment of repose and yet there is nothing solemn about them; all three seem quite capable of mischief. A comparison with the Jacobean icons of childhood in which their father and his elder brother, Henry, were portrayed is further striking

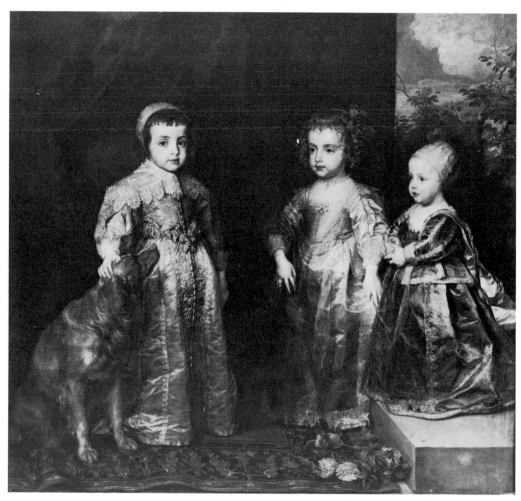

179. *Three Children of Charles I*. 1635. Canvas, 151 × 154 cm. Turin, Sabauda Gallery.
Sent by Henrietta Maria to her sister Christina, Duchess of Savoy, in exchange for a painting of Christina's children.

proof of the revolution in royal portraiture that Van Dyck and his Netherlandish predecessors had brought about.

Despite the painting's great charm, it seems that the King was not pleased with it. In November 1635 the ambassador of Savoy in London reported to the Duke that the King was *fâché contre le peintre Vandec por ne leur avoir mis leur Tablié comme on accoustume aux petit enfans*. In other words it was the relaxed informality of the group, which makes it so attractive today, that upset the King. In particular he

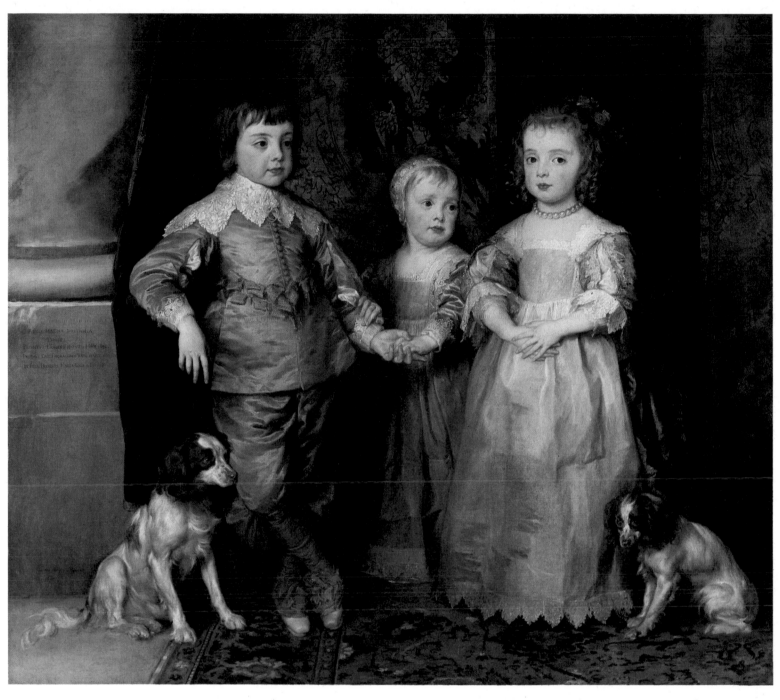

181. *Three Children of Charles I.* 1635.
Canvas, 133.4 × 151.8 cm. Windsor Castle,
Royal Collection.
Apparently painted because of the King's
dissatisfaction with Plate 179 in which he
thought the depiction of the Prince of
Wales, in his infant's coats, undignified.

180. Detail of Plate 181.

seems to have been put out because his elder son was shown still wearing his
infant's 'coats': it was usual to dress boys in skirts until they were five or six. It
may have been the King's dissatisfaction with this portrait that caused Van Dyck
to portray the children again a few months later. In the second picture (Plates 180,
181) Prince Charles wears a silk doublet and breeches and shown leaning against
the base of a massive pillar. With his left arm he supports his younger brother,
while a composed Princess Mary stands on the right. Two spaniels sit at the
children's feet. The painting is signed 'An. Van Dyck Eq.' (i.e. *Eques*, knight) and
dated 1635. Once again, using a rich brocade hanging as a backdrop, Van Dyck
manages to make individuals of the three children without solemnifying them.
Any stiffness in the group is counteracted by Prince James's action in gripping
his brother's arm and his glance towards his sister.

When, two years later, Van Dyck painted the royal children a third time, the
family had two new members – Princess Elizabeth, born in December 1635, and
Princess Anne, born in March 1637. For this group (Plate 182) he made full-

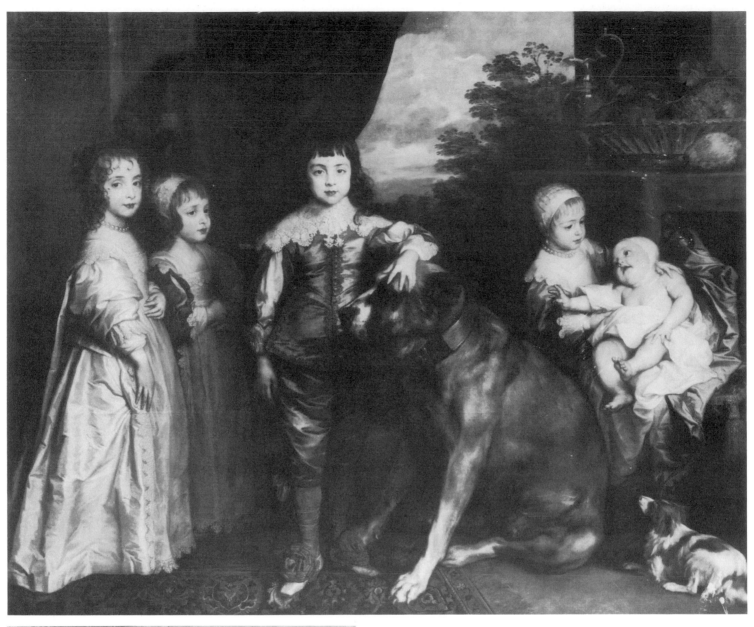

182. *Five Children of Charles I.* 1637. Canvas, 163.2 × 198.8 cm. Signed and dated: Antony van Dyck Eques fecit 1637. Windsor Castle, Royal Collection.

183. *Prince James, Duke of York.* Black chalk with white highlights, 45 × 33.4 cm. Oxford, Christ Church Art Gallery.
A study from the life for Plate 182.

length black chalk drawings of Prince Charles and of Prince James (Plate 183). He also adopted the unusual procedure of making an oil sketch of the heads of Princess Elizabeth and Princess Anne. The composition of the finished painting is far more ambitious, and the figures more rigidly disposed, than in the earlier groups. Prince Charles, his left hand resting on the head of an enormous mastiff, stands in the centre; Princess Mary and Prince James stand to his right and the two youngest princesses are on his left. A curtain is pulled aside to reveal a landscape background; on a table on the right is a silver basin filled with fruit and a matching ewer. The most striking feature of the painting is the combination of the two youngest princesses. The baby, naked but for her bonnet and a loose swaddling-cloth, reaches out toward her elder brother and is prevented from falling by Princess Elizabeth. It is a vivid detail, well observed from the life, in what is otherwise a formal group portrait. At the same time as he painted this group, Van Dyck portrayed the Prince of Wales alone, in armour, his left hand on a helmet sporting flamboyant plumes, a pistol in his right hand (Plate 184).

184. *Charles II as Prince of Wales. c.* 1637. Canvas, 153.7 × 131.4 cm. Windsor Castle, Royal Collection.

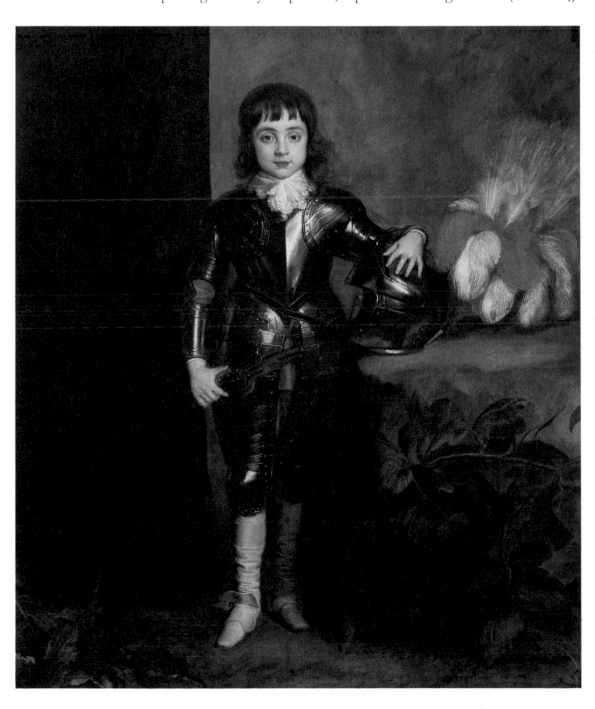

The royal family's patronage of Van Dyck did not stop at portraits. Charles already owned the *Rinaldo and Armida* and at the end of the 1630s Van Dyck painted the sole surviving mythological painting from his English period, the exquisite *Cupid and Psyche* (Plates 185–7), a picture which links Titian's *poesie* with the world of the Rococo, of Watteau and Boucher. Cupid is shown discovering the sleeping Psyche, who holds the 'box of beauty' brought to her by Proserpine at Venus's request. The story of Cupid and Psyche enjoyed a vogue at court in the 1630s. According to the neo-Platonic gloss that was applied to it, Psyche stood for Beauty and Cupid for Desire; together they represented Love in the definition given by Plato in *The Symposium* – Love is Desire aroused by Beauty. Yet Psyche was also the earthbound soul and Cupid Divine Love, and their union joined the human and the divine. It was a myth that especially suited the courtly love cult of Charles and Henrietta Maria. The Queen was particularly fond of it, and her cabinet at Greenwich was to have been decorated with canvases by Rubens and Jordaens telling the story. Scaglia acted as the royal agent in the negotiations with the Antwerp painters. Sadly, the scheme was never carried out, but it is possible that Van Dyck's painting was to be a part of it. Milton employs the myth in the conclusion of his masque *Comus*, first performed in 1634, and three years later Shackerley Marmion wrote a long poem entitled *Cupid and Psyche* and dedicated it to Charles Louis, the Prince Palatine and the King's nephew, who was visiting London. The Prince was soliciting his uncle's support in his campaign to win back the Palatinate, which had been seized from his father by the Holy Roman Emperor, and it is perhaps symptomatic of the air of political unreality

186. Detail of Plate 187.

at Charles's court that rather than the men and arms he needed, Charles Louis received an elegant neo-Platonic poem on the subject of Cupid and Psyche.

In Van Dyck's painting of *Cupid and Psyche* the technique is broad, free, and entirely assured: in this, in palette and in mood, Titian's mythological canvases for Philip II of Spain, which he had seen in Rome about fifteen year earlier, are Van Dyck's models. Here, even more than in any of his portraits, he is the direct heir of Titian. The sensuous nudes, the delicate combination of blues, greens, and pinks, the textures of silk, flesh, feather and foliage, and the balanced composition all combine to make this painting one of Van Dyck's greatest achievements. The viewer can only regret that Charles did not give him the chance to exercise his gift for history painting more often. Bellori describes other history paintings that Van Dyck made for Charles I – *The Dance of the Muses with Apollo on Parnassus*; *Apollo flaying Marsyas*; *Bacchanals*; *Venus and Adonis*; and *Nicholas Lanier as David playing the Harp before Saul* – none of which has survived. Bellori also mentions a '*Madonna col Bambino e San Giuseppe rivolti ad un ballo di Angeli in terra, mentre altri di loro suonano in aria con vedute di paesi vaghissime*'. In the early eighteenth century Vertue linked this description with a painting then in the collection of Sir Robert Walpole and now in the Hermitage, Leningrad. In fact a second version of the composition (Plate 188) includes a group of angels in the air and is therefore closer to Bellori's description than the Leningrad painting, which instead has partridges in flight. Though the model is once more Titian – and the dancing, earthbound angels strongly recall the cherubs in his *Worship of Venus* – the unbalanced composition is Van Dyck's own, as is the over-sweet treatment of the Virgin and

187. *Cupid and Psyche. c.*1638. Canvas,
199.4 × 191.8 cm. London, Kensington
Palace, Royal Collection.
One of the large collection of paintings by
Van Dyck assembled by Sir Peter Lely.

188. *The Rest on the Flight into Egypt.*
Canvas, 134 × 159 cm. Florence, Pitti Palace.

Child. In Protestant England large altarpieces were not, of course, in demand, but even in the Catholic circle centred on the Queen Van Dyck seems to have received very few religious commissions. Certain paintings, like the two superb versions of *The Flight into Egypt* (Munich and New York), could date from his London years, but were more probably painted in Antwerp.

Van Dyck apparently hankered after a large decorative commission at the end of his life, a chance to rival Rubens' Whitehall ceiling or his Luxembourg canvases of the life of Marie de Médicis. A scheme that was considered but never

189. *George and Francis Villiers.* 1635. Canvas, 137.2 × 127.7 cm. Inscribed, top right: GEORGIUS DUX BUCKINGHAMYE CUM FRATRE FRANCISCO 1635. Windsor Castle, Royal Collection.

carried out survives in an oil sketch which today is in the collection of the Duke of Rutland at Belvoir Castle (Plate 190): it shows, in Bellori's words, *la Processione de' Cavalieri ne' loro habiti*. The project, which was suggested to the King by Van Dyck's friend Sir Kenelm Digby, was for a set of four tapestries to be hung in the Palace of Whitehall, illustrating the history and ceremonial of the Order of the Garter. Van Dyck's grisaille oil sketch, painted presumably in an attempt to interest the King in the project, shows the Grand Procession of the King and his Knights to St George's Chapel at Windsor on the Feast of St George's Day. Charles is preceded by gentlemen-at-arms, the Prelate and Chancellor of the Order, the Garter King-of-Arms, the Registrar, the Black Rod, and the Knights themselves in procession. The King carries the sceptre and orb and his long train is supported by attendants. A canopy of cloth-of-gold is carried above his head. The procession is watched by spectators on a balcony: the architectural setting of classicizing columns, arches and balustrades recalls Veronese's *Family of Darius before Alexander*. Digby's proposal, however, came to nothing; it was presumably rejected on grounds of expense. After a decade of personal rule the royal exchequer was very low.

Where the royal family led, the Court naturally followed, and our image of the sophisticated, cultivated and doomed Caroline court is that created by Van Dyck. One of his earliest portrait groups of members of the Court circle is that of the widowed Duchess of Buckingham and her three children (Paris, Private Collection). She is shown in mourning for her husband, the favourite of both Charles I and his father, who had been murdered in 1628. In addition to the portrait of the Duke on the wall, she holds his miniature in her right hand; with her are her daughter Mary and her two sons, George and Francis Villiers. The whole family was very close to the King and Queen, and Charles took a special interest in the upbringing of the three children. In 1635 he commissioned from Van Dyck a double portrait of the two boys: George, the second Duke, who was to be a brilliant (and notorious) figure at the Restoration court, and Francis, who was killed near Kingston fighting for the King in 1648 (Plate 189). The two boys, then

190. Detail of *The Garter Procession. c.* 1639. Panel, 28.7 × 127.5 cm. Belvoir Castle, Collection of the Duke of Rutland. Painted on two separate panels, prepared with a chalk-based ground and joined in the centre.

191. *Mary Villiers as St Agnes*. 1637. Canvas, 186.7 × 137.2 cm. Windsor Castle, Royal Collection.
Probably painted on the occasion of Mary Villiers' second marriage to James Stuart, Duke of Lennox and Richmond, in August 1637.

seven and six years old, are shown full-length, in silk and lace, striking elegant poses against the background of a draped curtain and a glimpsed landscape. Francis glances towards his brother, who looks directly out of the painting. This picture was a favourite of Horace Walpole's ('nothing can exceed the nature, lustre and delicacy of this sweet picture') and was influential on the child portraits of several eighteenth-century English painters, among them Reynolds, Gainsborough and Zoffany.

The boys' sister, Mary Villiers, was painted a number of times by Van Dyck. Married as a child of 13 to Sir Charles Herbert, third son of the Earl of Pembroke, she was widowed a year later. Her second husband was the King's cousin and close friend, James Stuart, Duke of Lennox and Richmond. At the wedding ceremony in the Archbishop's Chapel in Lambeth she was given away by the King himself. In a painting in the Royal Collection Mary is represented as St Agnes, with her attribute, a lamb, and her martyr's palm (Plate 191). She is shown full-length, seated and dressed in white silk. St Agnes was the patroness of those about to be married and the portrait was presumably painted on the eve of her marriage to Lennox in August 1637. A delicate study of her preparatory to the portrait is in the British Museum. She was also painted by Van Dyck in blue silk, accompanied by Mrs Gibson, a dwarf who was a painter and a page at the court; and again in white silk with Lord Arran, the only son of her cousin the Duchess of Hamilton, as Cupid.

Mary Villiers' second husband was one of Van Dyck's most frequent sitters.

193. *Studies of a Greyhound*. Black chalk, with white chalk highlights, 47 × 32.8 cm. London, British Museum. Studies from the life for Lennox's greyhound in Plate 192.

192. *James Stuart, Duke of Lennox and Richmond*. Canvas, 215 × 125 cm. New York, The Metropolitan Museum of Art. Lennox is shown wearing the collar and robes of the Garter.

Van Dyck painted him in a loose-fitting white shirt and holding an apple, as Paris; in his robes, as a Garter Knight; and, especially memorably, with his hand resting on the head of a favourite greyhound (Plates 192, 193). Two of Lennox's younger brothers, Lord John and Lord Bernard Stuart, both of whom died during the Civil War, were painted in one of Van Dyck's finest portraits (Plates 194–6). The two boys possess an elegance and grace which have come to seem the quintessence of the spirit of the Stuart courtier. They both have the family characteristics of long noses and prominent jaws, and Van Dyck has given them an aristocratic grandeur and haughtiness. Both are dressed in the finest lace and softest kid leather.

194. *Lord John and Lord Bernard Stuart*. Canvas, 236 × 144 cm. Broadlands, Hampshire, Mountbatten Collection.

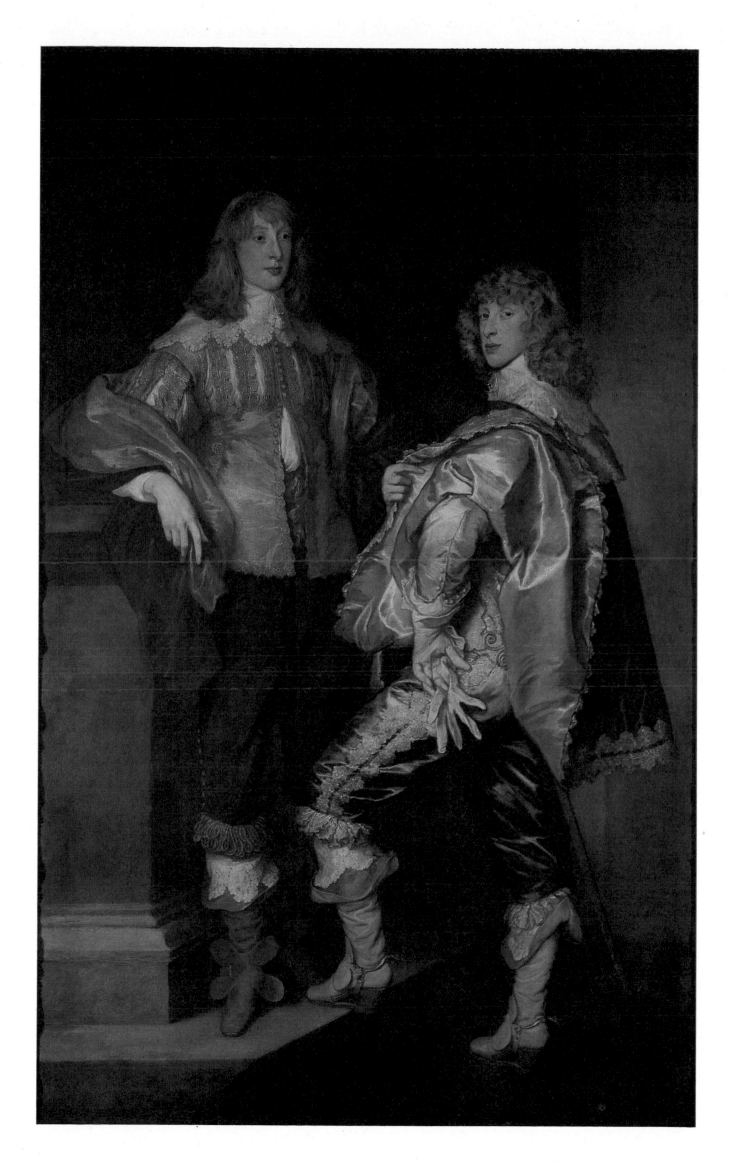

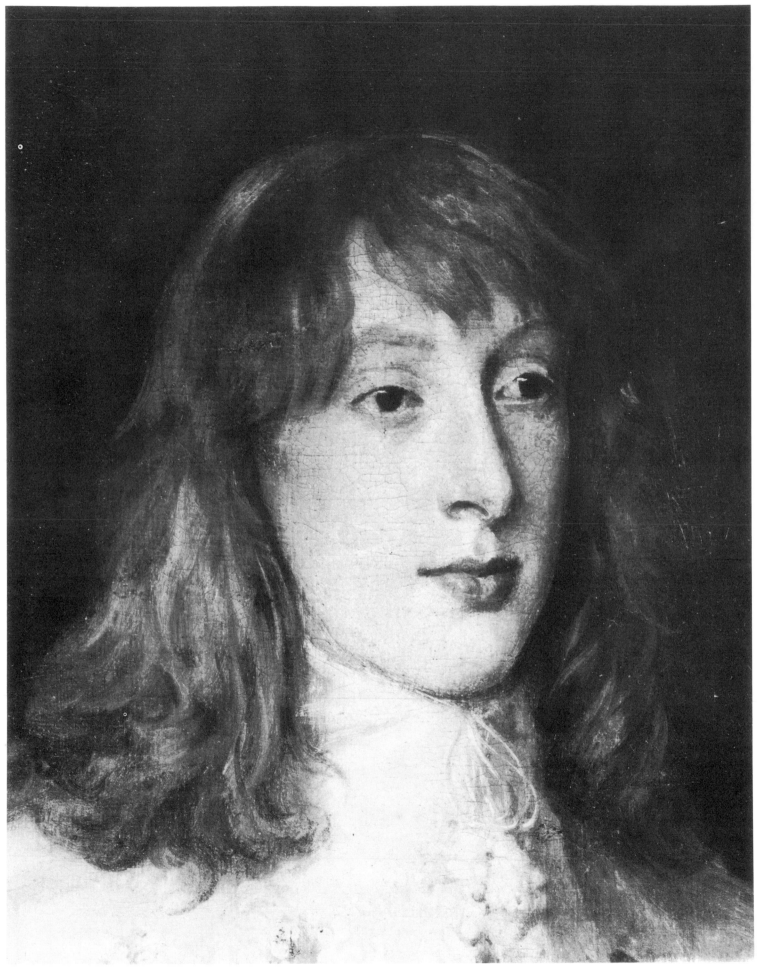

195. Detail of Plate 194.

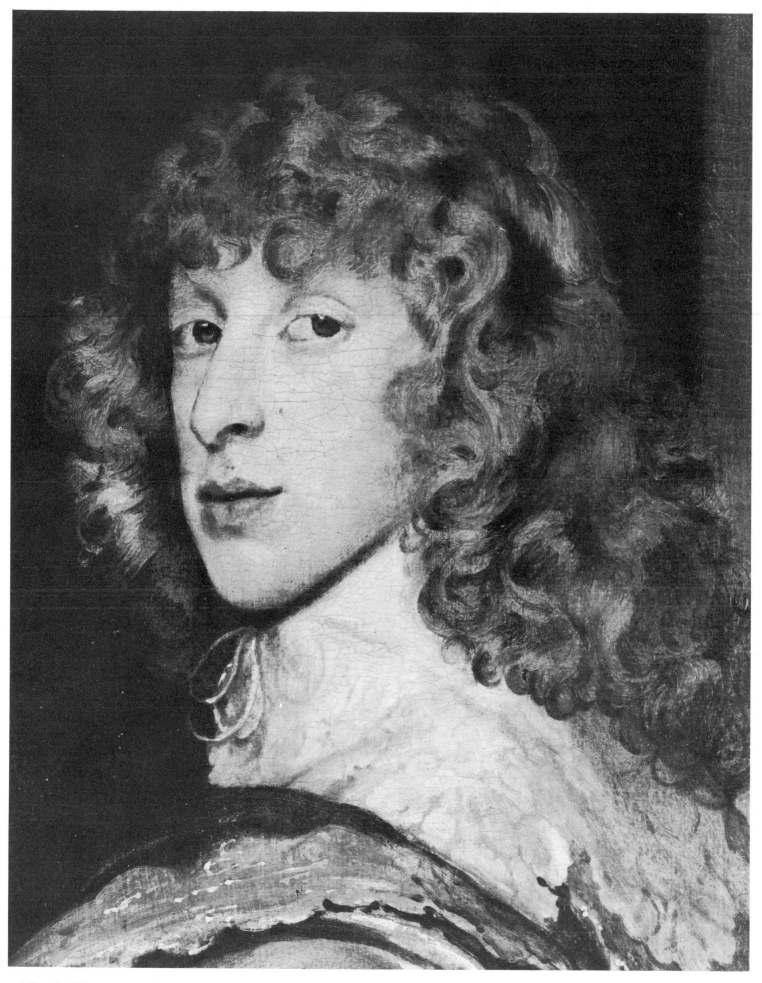

196. Detail of Plate 194.

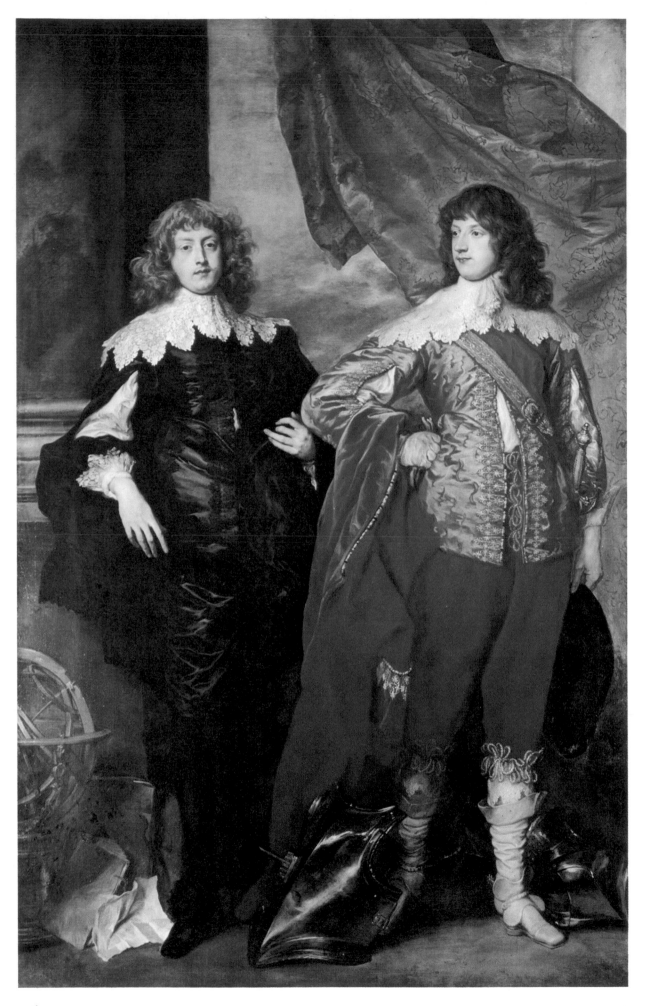

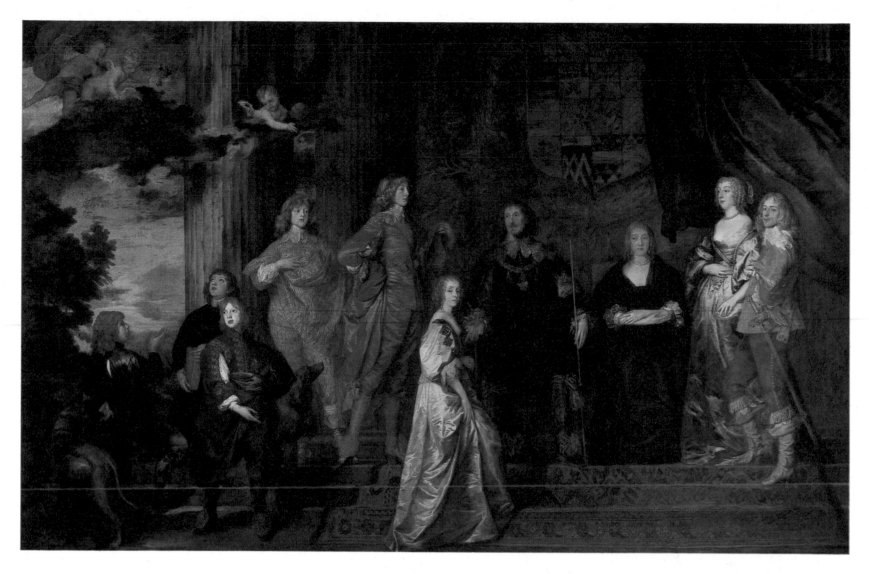

198. *Philip, 4th Earl of Pembroke, and his Family*. Canvas, 330 × 510 cm. Wilton House, Wiltshire, Collection of the Earl of Pembroke.

197. *George Digby, 2nd Earl of Bristol, and William Russell, 1st Duke of Bedford. c. 1637.* Canvas, 242.5 × 155 cm. Signed: Ant van Dyck Eques Pt. Althorp House, Northamptonshire, Collection of the Earl Spencer. The portrait was admired by the diarist John Evelyn in the house of the Countess of Bristol in the winter of 1678/9.

A third double portrait of two young men is among the most lavish of Van Dyck's English period portraits. It shows George, Lord Digby, who was later to be the 2nd Earl of Bristol, with his friend and brother-in-law William, Lord Russell, later 1st Duke of Bedford (Plates 197, 201). In contrast to the static composition of the Stuart boys' portrait, these two young men, who were students together at Magdalen College, Oxford, are brought together and at the same time individualized by pose, gesture and glance. The formal design of the portrait is similar (though on a far smaller scale) to the vast, complex family group of the Pembrokes at Wilton (Plate 198). It contrasts the temperaments of the two young men: Russell, aggressively posed and dressed in bright colours, has a breastplate and helmet at his feet to represent his martial interests, while Digby, dressed in scholar's black, is shown to be of a learned cast of mind by the inclusion of an astrolabe, books and papers. The portrait, one of the few signed by Van Dyck, was painted around 1637.

Philip, 4th Earl of Pembroke, who commissioned the large group portrait at Wilton (Plates 198–200), was one of Van Dyck's principal patrons. The antiquarian and gossip John Aubrey wrote that Pembroke 'had the most of his paintings of any one in the world'. The enormous canvas fills an entire end wall in the famous Cube Room at Wilton, though it was not intended for its present location. In 1652 it is recorded as hanging in the Earl's London residence, Durham House. The portrait shows Pembroke and his second wife Anne Clifford, daughter of the Earl of Cumberland and widow of the Duke of Dorset, enthroned

at the head of a staircase. They are seated beneath a huge shield bearing the Earl's coat of arms. The Earl wears black court dress; the Garter star is embroidered on his left sleeve, the Collar and Greater George of the Garter (a large gold jewel representing the Saint) hang from his shoulders, and he wears the Garter itself below his left knee. He holds the white staff and displays the ceremonial key of his office of Lord Chamberlain of the Royal Household. On the right, their heads outlined against the rich olive-green curtain, stand the Earl's daughter Anne Sophia and her husband Robert Dormer, 1st Earl of Caernarvon. On Pembroke's right is his son, Charles, Lord Herbert, who was to die of smallpox at the age of 16 in Florence, where he had gone to join the army of the Grand Duke of Tuscany; several steps lower, in white satin, is Herbert's wife, Lady Mary Villiers, daughter of the Duke of Buckingham. Beside Lord Herbert, in a pose reminiscent of Lord Digby in the double portrait with Russell, is Pembroke's second son, Philip, who succeeded as 5th Earl. The three youngest sons, James, William and John, are grouped together on the left. Above them *putti* borne up by clouds scatter rose petals. To give visual interest and compositional coherence to such a large group portrait presented Van Dyck with a daunting task. He turned, as he usually did, to Titian for inspiration, adapting the idea of placing the family at various levels of a flight of steps from *The Vendramin Family*, which he owned, but he draped Titian's bare marble steps with a patterned red-and-black Persian carpet. The columns, the landscape and the *putti* all have their precursors in the work of the great Venetian.

The Wilton group portrait has received a poor critical press in recent times: Cust thought it 'a conspicuous instance of the inability shown by Van Dyck in

199. Detail of Plate 198.

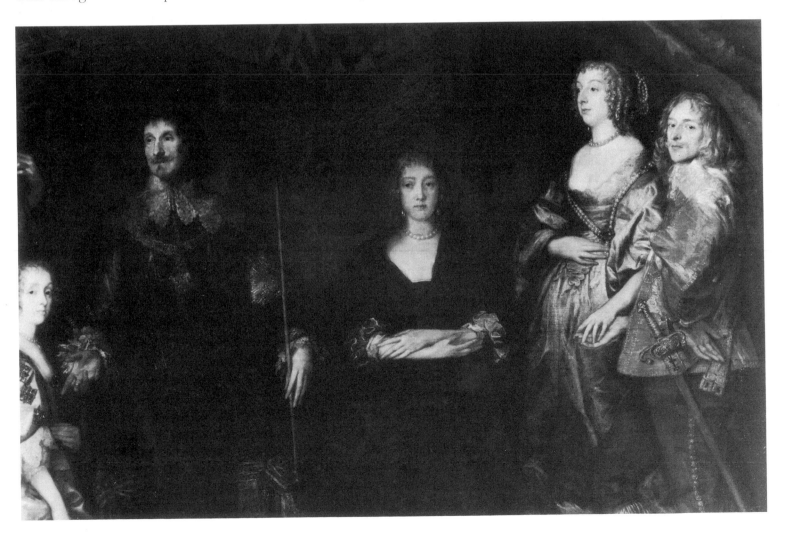

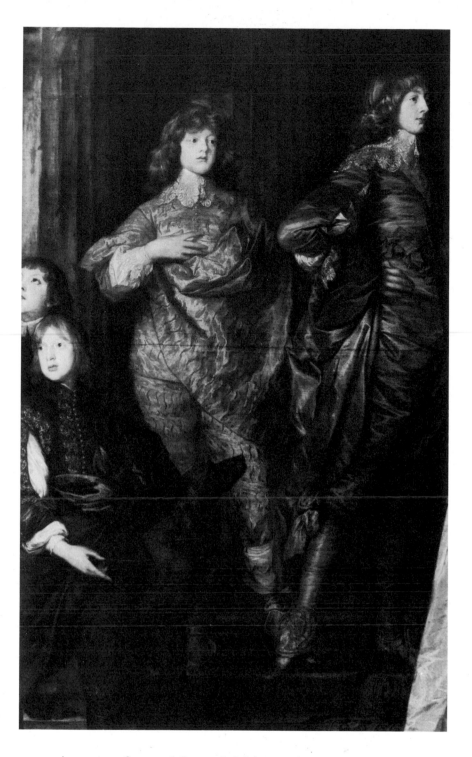

200. Detail of Plate 198.

composing a portrait group of several figures'. This may be a consequence of the
undoubtedly unattractive surface appearance of the painting, which has become
darkened by yellowing varnish and is said to be abraded by clumsy restoration.
In fact Van Dyck's disposition of the ten figures, the glances exchanged between
them and with the viewer, their gestures and poses, the contrast between the
sombre clothes of Pembroke and his wife and the rich and colourful dress of the
eldest children, all serve to create a magnificent composition which is both
monumental and yet full of eye-catching detail. Vertue records that Pembroke
gave the King the *St George* by Raphael (today in the National Gallery of Art,
Washington) and 'begd of the King to have it for a picture of the King and all
the Royal Family by Vandyke (which the King Promist him), which he designed
as a fellow to that great picture of the Pembroke family painted by Van Dyke, but
the troubles of the King coming on, and the death of Vandyke, prevented its

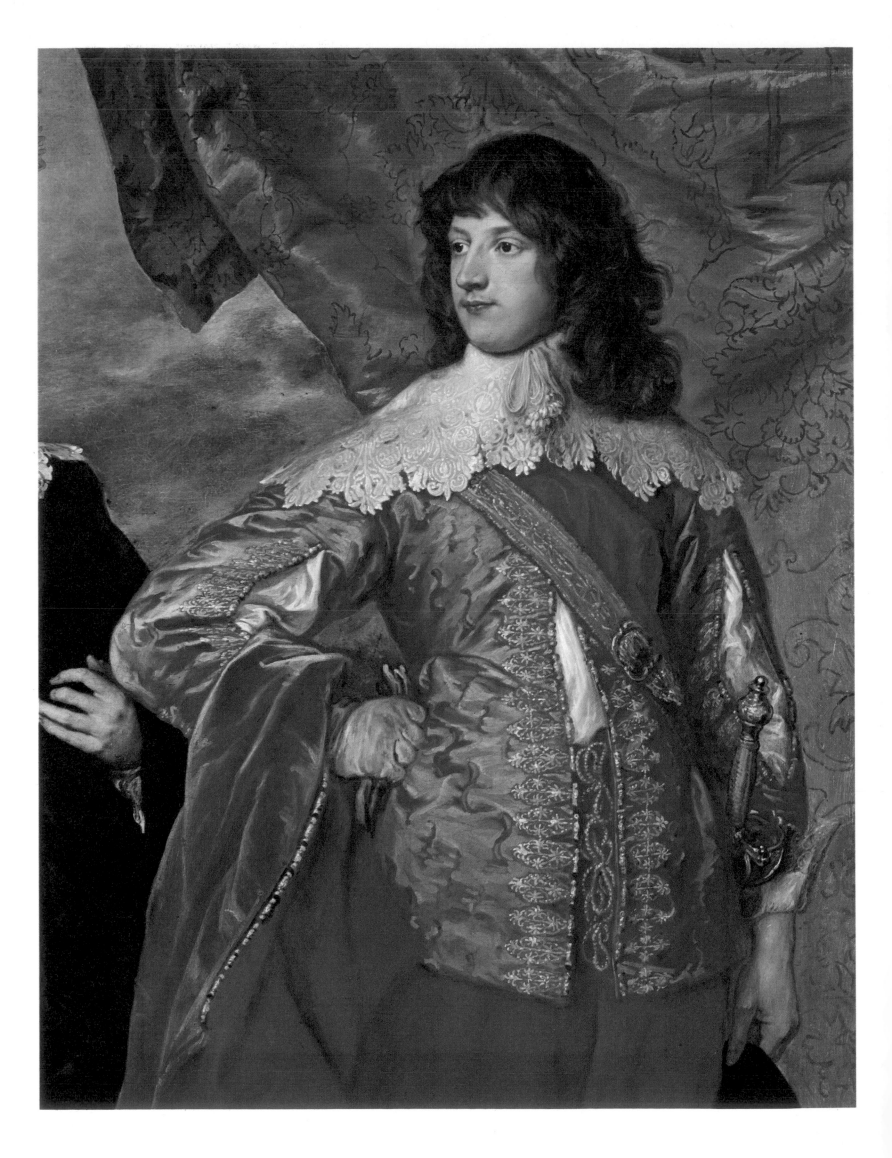

201. Detail of Plate 197.

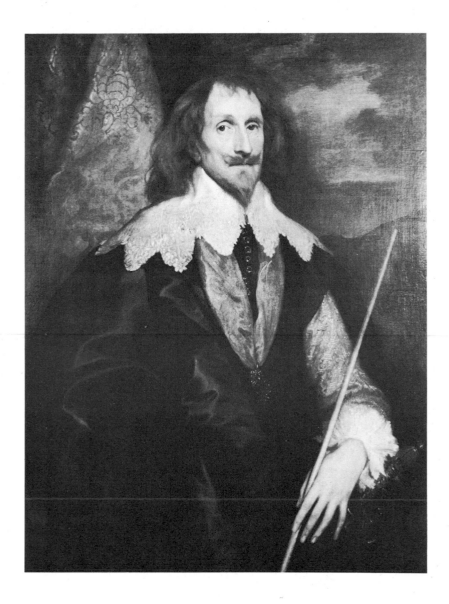

203 (Right). *Philip, 4th Earl of Pembroke*.
Canvas, 105.4 × 83.8 cm. Melbourne,
National Gallery of Victoria.
There are early copies, perhaps by Van
Dyck's assistants, at Longleat (collection of
the Marquess of Bath) and at Burghley
House (collection of the Marquess of
Exeter).

202. *Algernon Percy, 10th Earl of
Northumberland, as Lord High Admiral*.
Canvas, 212.5 × 125 cm. Alnwick Castle,
Northumberland, Collection of the Duke of
Northumberland.
Probably painted soon after
Northumberland was appointed Lord High
Admiral in 1636.

being done'. In addition to the family group, Van Dyck made several single portraits of the Earl of Pembroke (Plate 203), of his son Philip and his Countess, and of the Earl and Countess of Caernarvon.

Another senior member of Charles' court who was a regular patron, and, it seems, a particular friend of Van Dyck was Algernon Percy, 10th Earl of Northumberland. No one document reveals the remarkable position occupied by Van Dyck at the court so well as the letter Northumberland wrote to him in 1637, in which the Earl says how much he enjoys the artist's company and conversation and signs himself 'passionately your humble servant'. In a full-length portrait of the Earl, against a background of the fleet, he holds his baton of Lord High Admiral (Plate 202). He is also shown by Van Dyck in half-length, dressed in armour and resting his left hand on an anchor (Plate 204). The unusual format of the painting makes it likely that it was intended for a special position at Alnwick or at the Earl's London home, Suffolk House. In a painting at Petworth, Northumberland can be seen in a charming family group with his wife and small daughter. Also at Petworth is Van Dyck's portrait of the Earl's father, the learned Henry Percy (Plate 205), who, accused of complicity in the Gunpowder Plot, spent sixteen years in the Tower until his release in 1621 for the enormous ransom of £11,000. Henry Percy had died in 1632 and Van Dyck painted his portrait, as we know from Richard Symons' notes on the Suffolk Collection (written in 1652), 'by help of another picture'. He is shown in three-quarter length, seated and in

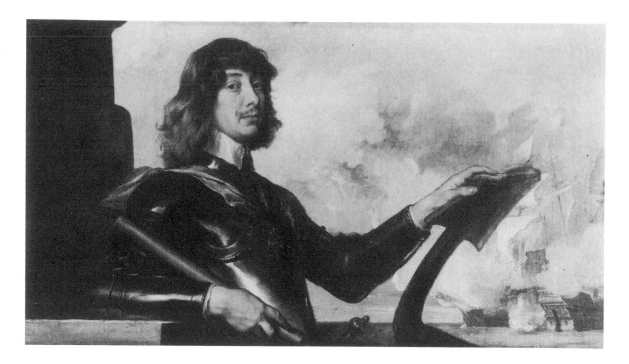

reflective pose, his head resting on his right hand. A paper lies on the table beside him.

The 10th Earl's sister, Lucy, wife of James Hay, 1st Earl of Carlisle, was a brilliant figure at the Stuart Court, wielding considerable political influence through her friendships with Strafford and Pym. She was painted by Van Dyck in a scintillating half-length portrait (Petworth). He also painted her son, the 2nd Earl of Carlisle, and her niece, Dorothy Sidney, Countess of Sunderland, the 'Sacharissa' of Edmund Waller's poems. Waller described a portrait of Sacharissa by Van Dyck, perhaps the painting now at Petworth:

> Strange! that they should not inspire
> Thy beauty only, but the fire;
> Not the form alone, and grace,
> But act and power of a face.

Philip, 4th Lord Wharton, was another prominent member of the Court. He married in 1632, at the age of 19, and this was probably the occasion for the portrait of him in Arcadian dress (Plate 207). (There is an old inscription to this effect on the painting.) Although he was later to be an enthusiastic Parliamentarian, Wharton remained close to the Royal Family throughout the 1630s. In the memorandum on page 165 a pair of portraits of the King and Queen are said to be destined for him. Wharton married for the second time in 1637; his bride was Jane, daughter and heir of Arthur Goodwin of Winchendon in Buckinghamshire. The couple lived at Winchendon House, near Aylesbury, where Wharton built a special gallery to accommodate the series of portraits of his family which he commissioned from Van Dyck in the years following his marriage (Plate 206). According to Vertue's account of the dispersal of this collection in the early eighteenth century there were 'twelve whole lengths of Vandycke and six half lengths'. He notes that eleven full-lengths were 'bought by Mr Walpole all painted between 1637 and 1640 having since the opportunity to see these pictures out of their frames at Mr Howards I lookt into them and perceive they are all right pictures, but not the most curious or finisht but done in a fine masterly manner, not studyed nor laboured many parts (especially the hand) tho' well disposed and gracefully are not determined the jewells hair trees flowers lace etc. loosely done

204. *Algernon Percy, 10th Earl of Northumberland.* Canvas, 59.3 × 134.4 cm. Alnwick Castle, Northumberland, Collection of the Duke of Northumberland. The oblong shape of the picture suggests that it was intended for a particular location, presumably to be let into panelling above a door or fireplace.

205. *Henry Percy, 9th Earl of Northumberland.* Canvas, 135 × 117.5 cm. Petworth House, Sussex, The National Trust. The Earl died in 1632, the year of Van Dyck's arrival in England, and so this portrait may well have been painted not from the life but from an intermediary portrait.

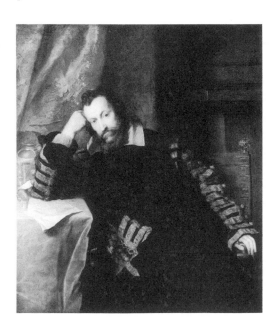

appear well at a distance'. Most of these paintings were bought from Walpole's son by Catherine the Great of Russia and today hang in the Hermitage Museum, Leningrad. One of the finest, however, the portrait of Wharton's father-in-law, Arthur Goodwin, was given by Walpole to the Duke of Devonshire and remains in the collection at Chatsworth (Plate 208). Probably painted in 1639 (according to an old inscription on the picture) it is a superb example of Van Dyck's late style. Goodwin, a country gentleman who was a close friend of John Hampden and a Parliamentarian during the Civil War, wears a sober brown and orange doublet and hose, which contrasts markedly with the brilliantly coloured and elaborately embroidered satin of the courtiers. The setting, with a single plain curtain on the left, is appropriately simple. Van Dyck has caught the determination in the handsome features of the still-vigorous Goodwin.

The world of Van Dyck's sitters was to be violently overthrown by the outbreak of the Civil War in 1642, the year after his death. Many families were divided; two brothers who found themselves on opposing sides were Robert Rich, Earl of Warwick, and Henry, Earl of Holland. Robert was painted by Van

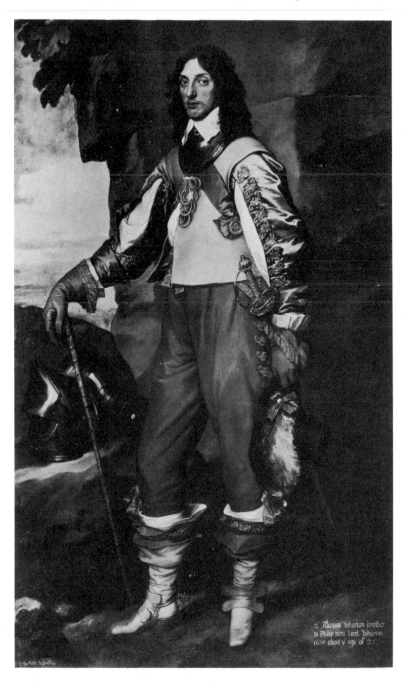

206. *Sir Thomas Wharton*. 1639. Canvas, 218 × 129 cm. Leningrad, Hermitage.

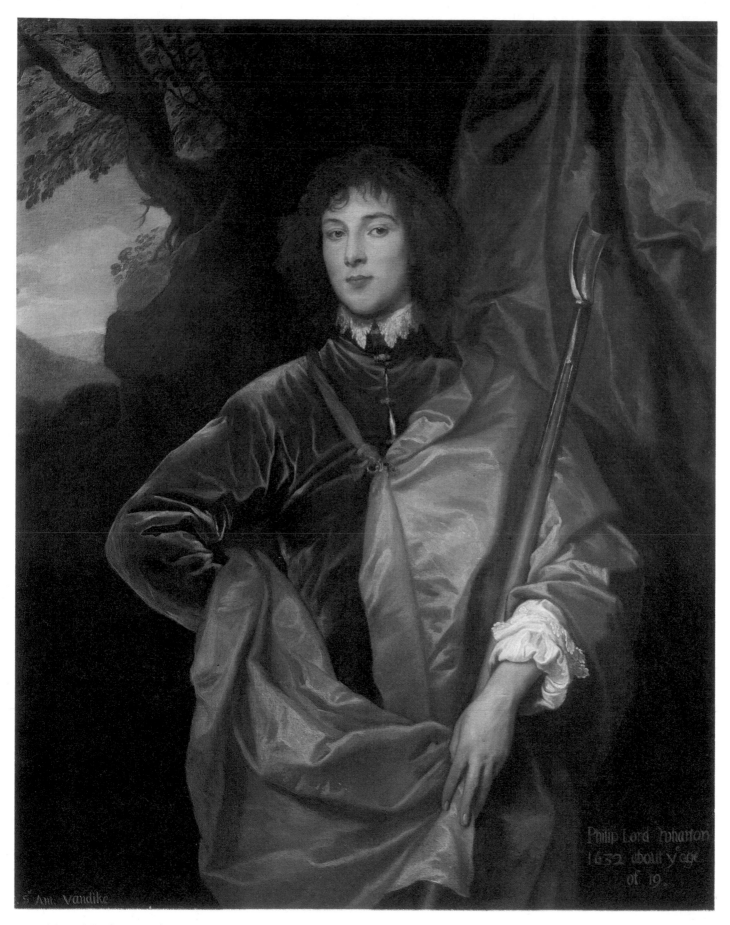

207. *Philip, 4th Lord Wharton*. 1632. Canvas, 133 × 106 cm. Inscribed: Philip Lord Wharton 1632 about yc age of 19. Washington D.C., National Gallery of Art.

208. *Arthur Goodwin*. 1639. Canvas,
220 × 130 cm. Inscribed: Arthur Goodwin
father of Jane 2ᵈ wife Philip now Lᵈ
Wharton 1639 yᵉ age of 40. Lower left, p. Sʳ
Ant: Vandike. Chatsworth House,
Derbyshire, Collection of the Duke of
Devonshire.

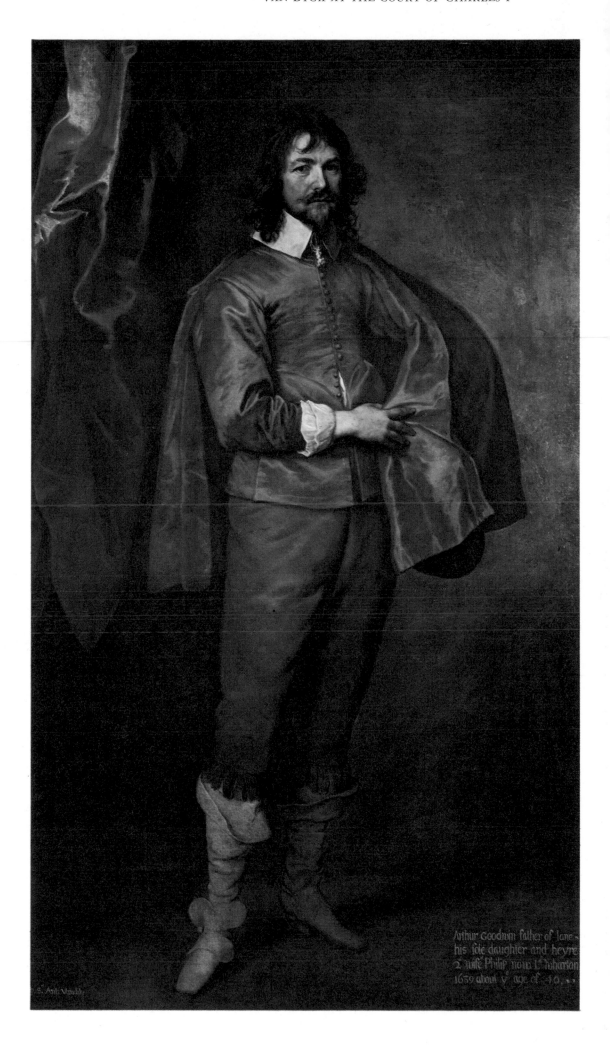

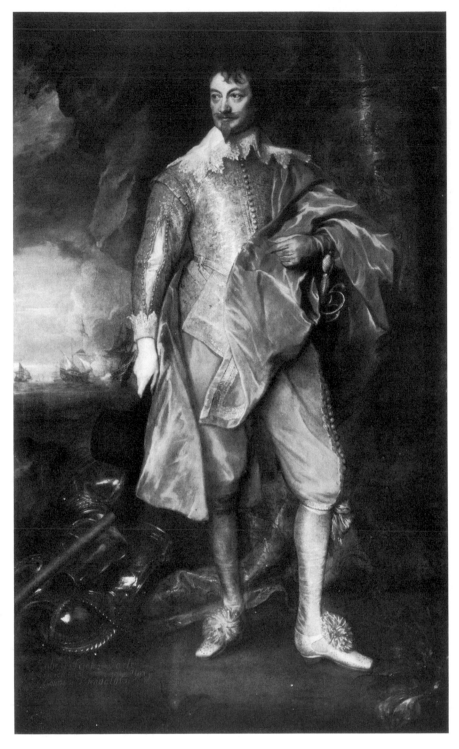

210. *James Stanley, 7th Earl of Derby, with his Wife, Charlotte de la Trémouille, and their Daughter, Catherine.* Canvas, 246.4 × 213.7 cm. New York, The Frick Collection.
A Royalist commander during the Civil War, Derby was captured and executed in 1651. His wife was responsible for the spirited defence of Latham House, the Derbys' country seat.

209. *Robert Rich, Earl of Warwick.* Canvas, 213.4 × 128.3 cm. New York, The Metropolitan Museum of Art.

Dyck in a superb full-length portrait (Plate 209). Dressed in an embroidered rose pink doublet, he stands on a seashore. Behind him is a pile of armour and in the distance a naval battle is taking place: this alludes to his voyage of 1628 in command of a small fleet to attack the Spaniards. Warwick became a dedicated Parliamentarian while his brother Henry, portrayed by Van Dyck in a full-length in the collection of the Duke of Buccleuch, remained loyal to the King and died on the scaffold in 1649 with Lord Capel and the Duke of Hamilton, both of whom had also sat to Van Dyck.

The illegitimate brother of Warwick and Holland, Mountjoy Blount, Earl of Newport, was painted by Van Dyck in full-length and also in a half-length double portrait with the leading royalist general, George, Lord Goring (Plate 211). Goring was memorably described by Clarendon in his *History of the Great Rebellion*:

'His ambition was unlimited and he was unrestrained by any respect to justice or good nature from pursuing the satisfaction thereof . . . and of all his qualifications, dissimulation was his masterpiece.' Van Dyck gives incident to this otherwise static composition by the inclusion of a page who ties Goring's sash around his waist. This motif was to be taken up some years later by Robert Walker in his portrait of Oliver Cromwell.

Another royalist who went to the scaffold was James Stanley, who was created Earl of Derby in 1642. Van Dyck portrayed him in an enchanting full-length family group with his wife Charlotte, daughter of Claude de la Trémouille, Duc de Thouars, and their daughter Catherine (Plate 210). His wife carries a posy of flowers and his daughter clasps her hands together and looks demurely at the spectator while Stanley gestures towards the background, an island set some way off the coast on which they stand. This is the Isle of Man, where he owned extensive lands and which his wife was to defend bravely on his behalf during the Civil War.

Two of the King's principal advisers in the years leading up to the outbreak of war, Thomas Wentworth, Earl of Strafford, and William Laud, Archbishop of Canterbury, both of whom died on the scaffold, were painted by Van Dyck. Strafford, whom Evelyn thought 'the wisest head in England', is shown in a magnificent double portrait with his secretary, Sir Philip Mainwaring, whose pen is poised to set down his master's words (Plate 212). The composition is taken from a painting by Sebastiano del Piombo which was in Charles I's collection. Van Dyck brought to this portrait all his years of studying the double portraits of the Renaissance, which he first drew in the Italian Sketchbook. Horace Walpole thought it his finest picture. Strafford's alert and determined expression is also seen in two full-length portraits of him in armour, which still belong to his

211. *Mountjoy Blount, 2nd Earl of Newport and George, Lord Goring, with a page.* Canvas, 126.2 × 148.7 cm. Petworth House, Sussex, The National Trust.

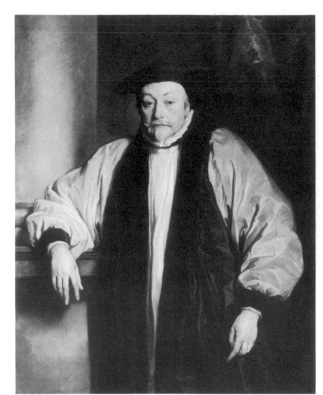

descendants, and in the superb half-length in armour (Plate 214).

The three-quarter-length portrait of Laud, now in Leningrad, bears an early inscription which dates it 'about 1638'. The formidable enemy of the Puritans wears simple clerical dress, its severe black and white set off by a red watered silk hanging on the right. A second version of the portrait in the Fitzwilliam Museum, Cambridge (Plate 213), long thought to be a studio replica, has recently been cleaned and has emerged triumphantly as an original.

Surprisingly, in view of the apparent similarity of his interests to those of the King, the Earl of Arundel never occupied the commanding position at the court of Charles I that he had held at James I's court. He remained Earl Marshal, responsible for court ceremonial, and yet there was little real warmth between him and the King. Charles refused Arundel his dearest wish, to be reinstated to the family title of Duke of Norfolk. Nevertheless, the royal painter continued to work for his earliest English patron, and in the 1630s he produced a memorable series of portraits of the Earl of Arundel and his family. According to a letter of 1635 to the Earl's agent in Rome, one portrait of him was to be sent there in the hope that Bernini would carve a bust from it, but there is no record of such a sculpture having been carried out. A large family portrait like that at Wilton was planned but never painted, though the design apparently survives in a watercolour by Philip Fruytiers; and a fine black chalk drawing for this project of the Earl, seated, wearing ermine and the Lesser George and the Garter, and holding the staff of Lord High Steward, is in the British Museum. The finest single portrait of the series is that of Arundel in armour with his grandson, Lord Maltravers (Plates 215, 217, 218), painted in about 1635. Four years later, as premier Earl, Arundel was put in command of the royal army in the ill-fated campaign against the Scots. In the event, his generalship proved disastrous: he had no experience and little stomach for war, and at the end of the same year he was unceremoniously relieved of his command so that Northumberland could be given joint responsibility for the royal forces on land and at sea.

212. *Thomas Wentworth, Earl of Strafford, and his Secretary, Sir Philip Mainwaring*. Canvas, 125 × 140 cm. Wentworth Woodhouse. The identification of Strafford's secretary comes from a seventeenth-century family inventory.

213. *Archbishop Laud. c.* 1638. Canvas, 121.6 × 97.1 cm. Cambridge, Fitzwilliam Museum.
The other autograph version of this portrait, in the Hermitage at Leningrad, carries an early inscription: William Laud Archbishop of Canterbury About 1638.

It was perhaps as a consequence of this humiliation that Arundel threw himself into the scheme for the colonization of Madagascar, which is commemorated in the so-called *Madagascar Portrait*, painted in 1639 (Plate 216). In this curious, stiff painting, the scheme for which was undoubtedly drawn up by Arundel with the help of Junius (who is present in a copy of it at Knole), the Earl and Countess are shown in three-quarter length, dressed in ermine, though he wears armour beneath. Arundel points to Madagascar on the globe. It was bizarre in the extreme for the premier Earl of England to be planning an expedition to a remote island in the Indian Ocean while trouble was brewing at home, and the scheme was eventually dropped. The Countess holds an astrolabe and compasses, instruments of navigation and most unusual attributes for a woman in a Baroque portrait, but they presumably refer to her active involvement in the adventure. The busts on the right stand for the heritage of antiquity with which Arundel associated himself and whose benefits he intended to confer on Madagascar.

214. *Thomas Wentworth, Earl of Strafford, in Armour*. Canvas, 135.9 × 109.3 cm. Petworth House, Sussex, The National Trust.

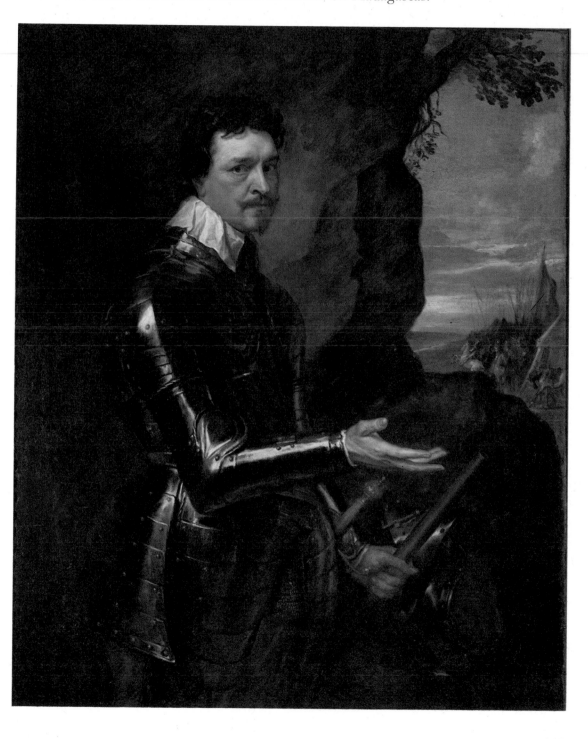

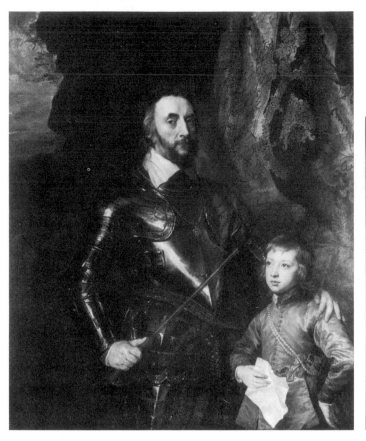

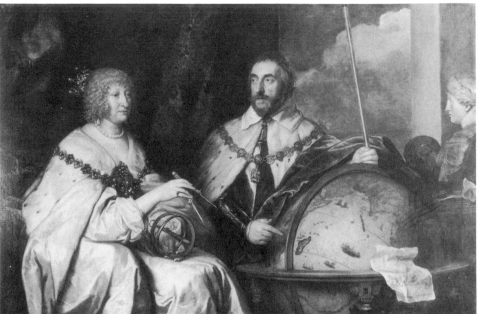

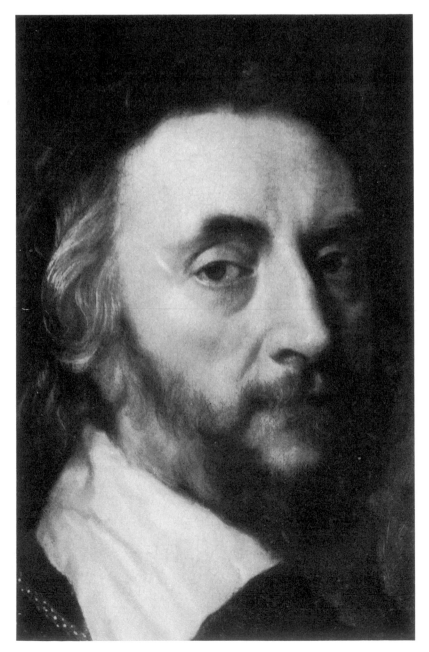

215. *Thomas Howard, Earl of Arundel, and his Grandson, Lord Maltravers. c.* 1635. Canvas, 142.5 × 120 cm. Arundel Castle, Sussex, Collection of the Duke of Norfolk.

216. *Thomas Howard, Earl of Arundel, and his Countess ('The Madagascar Portrait').* 1639. Canvas, 135 × 206.8 cm. Arundel Castle, Sussex, Collection of the Duke of Norfolk. A copy of this portrait, in the collection of Lord Sackville at Knole, includes the figure of Franciscus Junius, the Earl's Librarian.

217. Detail of Plate 215.

218. Detail of Plate 215.

219. *Thomas Hanmer.* Canvas, 105 × 92.5 cm. Weston Park, Collection of the Earl of Bradford.
A good studio replica of this portrait is in the Cleveland Museum of Art.

220 (Right). Cornelis Johnson: *Thomas Hanmer.* 1631. Canvas, 77.5 × 62.2 cm. Cardiff, National Museum of Wales.

Arundel was increasingly drawn into the developing conflict at home. In 1641 he presided as Lord High Steward over the trial of Strafford. In the following year he was asked by the King to accompany the Queen and Princess Mary to Holland, after her marriage to William of Orange. Arundel never returned, choosing exile in Antwerp. As his health failed he sought the climate of his beloved Italy, and died in Padua in 1646. His great collection of paintings was broken up over several years and disposed of in a number of sales, but the marbles and his library had a better fate (the former went to the Ashmolean Museum in Oxford and the latter to the Bodleian Library). The portraits by Van Dyck, however, were retained, and still hang at Arundel Castle in Sussex.

It is hard to find any consistency in Van Dyck's patrons among the English aristocracy as regards religious or political affiliation. When he first arrived in England he was particularly associated with the Catholic circle at court that centred on the Queen, and he continued to work for the great Catholic landed families of Northampton, Suffolk and Howard. However, his greatest single patron, the Earl of Pembroke, had pronounced Puritan sympathies and was to be one of the 'noble defectors' who sat out the Civil War in London. The Earl of Northumberland, through whose family and political connections Van Dyck received many important commissions, also had Puritan leanings and was to be another 'noble defector'. (Both men were to be important patrons of Lely.) Lord Wharton, once a favourite at court, was to fight on the Parliamentarian side. The truth seems to be that everyone at court, or even on its furthest periphery, wanted his or her portrait painted by Van Dyck, and the King imposed no restrictions on his activity as long as he found the time to complete the endless stream of royal commissions. This Catholic court painter, who in his portraits of the King was the greatest propagandist of the royalist cause, was simply the best there was, and so in constant demand. A vivid reminder of Van Dyck's eminence can be provided by a comparison between the portraits of Sir Thomas Hanmer painted by him and by Cornelis Johnson (Plates 219, 220). The latter is a competent exercise in face-painting: Hanmer's distinctive features are carefully described and

the lace painstakingly drawn. Sir Thomas, a page and later Cupbearer at court, has the air of a solid country squire. In Van Dyck's portrait, 'one of the best he ever painted' as Evelyn wrote, he is the elegant and graceful courtier. The pose in which the painter has placed his subject, hand on hip, toying with his glove, is grand and commanding. The features are the same, but Van Dyck has given them dignity and authority – so unlike Johnson's painfully literal image.

As well as the aristocrats and courtiers who thronged Whitehall Palace, Van Dyck also portrayed some of the literary figures at court. An outstanding double portrait of 1638 (it is signed and dated) shows the poet Thomas Killigrew, who was a page to the King, and a companion (Plate 222). His most successful play, a comedy called *The Parson's Wedding*, of which it has been said that its coarseness is not redeemed by any notable wit or humour, had been performed for the first time in the previous year. Killigrew is shown in mourning for his wife Cecilia Crofts, who had died on 1 January 1638. A wedding ring on a black band is tied around his wrist and the small gold and silver cross which he wears on his sleeve bears her initials interlaced. In addition, the female figures in the drawing he holds may be intended to represent his wife and her sister, Anne, Countess of Cleveland, who had died later in the same month. Killigrew's companion has been persuasively identified as his brother-in-law William, Lord Crofts, Master of Horse to James, Duke of York, and Captain of Henrietta Maria's Guards.

Sir John Suckling, a poet and dramatist at the court, was described by John Aubrey as 'the greatest gallant of his time and the greatest gamester'. In Van

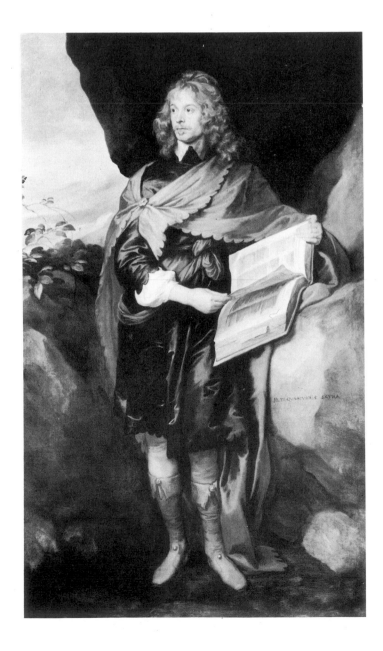

221. *Sir John Suckling. c.* 1637. Canvas, 216.5 × 130.3 cm. New York, The Frick Collection.

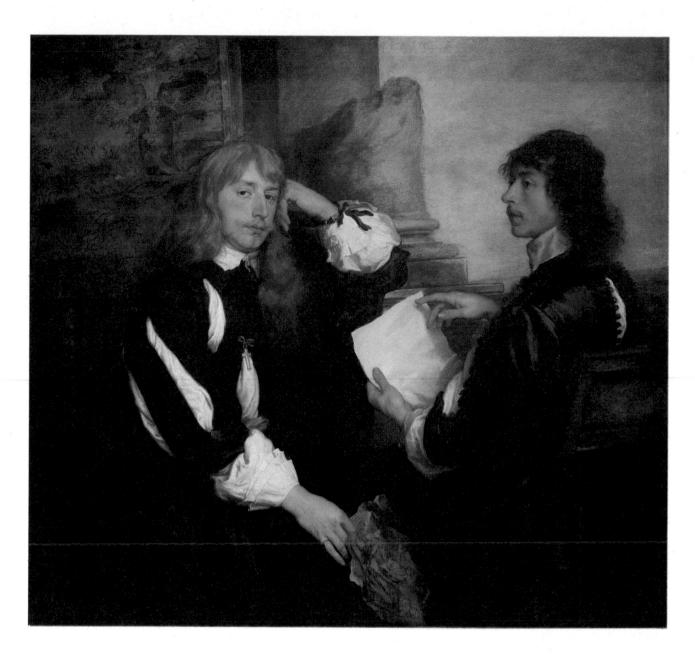

222. *Thomas Killigrew and (?) William, Lord Crofts*. 1638. Canvas, 132.7 × 143.5 cm. Signed and dated: A.van Dyck. 1638. Windsor Castle, Royal Collection.

Dyck's full-length portrait of him (Plate 221) he is shown standing in a rocky landscape; in the distance are snow-capped mountains under a sunset sky. He is wearing very unusual dress – a red mantle with a scalloped edge, fastened by a gold brooch over a blue tunic; around his waist a rose-coloured girdle; and high boots with ornamental gold buttons. He rests a large book on the rock to his left. From its pages projects a slip of paper inscribed *Shakespere*, which identifies it as the first or second folio of the *Plays*: he is turning to an opening of which the right-hand page is headed *Hamlet*. This is the first ever pictorial reference to Shakespeare and his works, and possibly the first portrait – certainly one of the first – painted in England to include an identifiable book in the vernacular (apart from the Bible and the Prayer Book) not written by the sitter. Suckling's contemporaries must have been immediately struck by the reference to Shakespeare. On the rock on which the folio rests is the motto *Ne te quaesiveris extra*. A brilliant recent analysis of the portrait has identified the motto as coming from the first satire of the Stoic satirist Persius. The phrase, meaning literally 'Do not look for yourself outside yourself', comes from a passage in which the author is arguing that poets should ignore criticism and have faith in their own inspiration. This motto is the key to the meaning of the portrait. For Suckling its implications would have been that he should ignore those who criticized him for his love of Shakespeare (Ben Jonson had reproached Shakespeare for his lack of learning and his ignorance of the ancients); he should, like Shakespeare, remain free from

servile classical imitation in his own writings; and finally, he should ignore criticisms of his work. Suckling's extravagant oriental dress and the landscape in which he stands may refer to his tragedy *Aglaura*, which he had written in 1637 and set in Persia. A scheme of this type, which includes such a wealth of personal literary references, must have been devised by Suckling and not by Van Dyck.

Van Dyck's portraits of poets and dramatists at the Stuart court may suggest that he spent time in their company, but there is no real evidence of this. He never designed a title-page, as Rubens and even Dobson did, and he was never involved in the production of the Court masques. Suckling wrote in 1637 a poem entitled 'A Session of the Poets', in which the chief wits of London – Jonson, Davenant, Falkland and Carew – assemble in a tavern to compete for Apollo's laurel wreath. Endymion Porter was one of those present, but there is no mention of Van Dyck.

De Piles tells us that Van Dyck 'was so much employ'd in drawing the portraits of the royal family, and the lords of the court, that he had no time to do any history-pieces. He did a prodigious number of portraits, about which he took great care at first; but at last he ran them over hastily and painted them very slightly'. Elsewhere in the same book the author recounts a conversation he had with the Cologne banker Everhard Jabach, whom Van Dyck painted several times (Plate 223): Van Dyck never described his method of painting in a treatise or in any of his few surviving letters, and this account of a conversation with Van Dyck is the nearest we can get to a description by him of the way in which he went about his work:

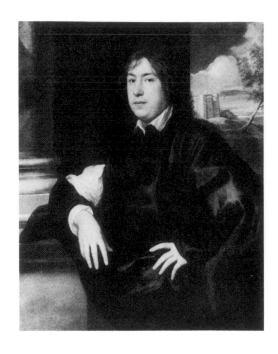

223. *Everhard Jabach*. Canvas, 113 × 91.5 cm. Leningrad, Hermitage.
Jabach, a banker from Cologne who lived in Paris, was in England in the summer of 1636 and the winter of 1637. He presumably sat to Van Dyck on one of those visits. In the background is the Ypres tower at Rye.

> Le fameux Jabach, homme connu de tout ce qu'il y a d'amateurs des beaux Arts, qui étoit des amis de Vandeik, & qui lui a fait faire trois fois son Portrait, m'a conté qu'un jour parlant à ce Peintre du peu de tems qu'il employoit à faire les Portraits, il lui répondit qu'au commencement il avoit beaucoup travaillé & peiné ses ouvrages pour sa réputation, & pour apprendre à les faire vîte dans un tems où il travailloit pour sa cuisine. Voici quelle conduite il m'a dit que Vandeik tenoit ordinairement. Ce Peintre donnoit jour & heure aux personnes qu'il devoit pindre, & ne travailloit jamais plus d'une heure par fois à chaque Portrait, soit à ébaucher, soit à finir; & son horloge l'avertissant de l'heure, il se levoit & faisoit la reverance à la personne, comme pour lui dire que ç'en étoit assez pour ce jour-là, & convenoit avec elle d'un autre jour & d'une autre heure: après quoi son valet de chambre lui venoit nettoyer son pinceau, & lui apprêter une autre palette pendant qu'il recevoit une autre personne, à qui il avoit donné heure. Il travailloit ainsi à plusieurs Portraits en un même jour d'une vitesse extraordinaire.
>
> Après avoir legerement ébauché un Portrait, il faisoit mettre la personne dans l'attitude qu'il avoit auparavant méditée, & avec du papier gris & des crayons blancs et noirs, il dessinoit en un quart d'heure sa taille & ses habits qu'il disposoit d'une manière grande, & d'un goût exquis. Il donnoit ensuite ce dessein à d'habiles gens qu'il avoit chez lui, pour le peindre d'après les habits mêmes que les personnes avoient envoyés exprès à la priere de Vandeik. Ses eleves ayant fait d'après Nature ce qu'ils pouvoient aux draperies, il repassoit legerement desus, & y mettoit en très-peu de tems, par son intelligence, l'art & la verité que nous y admirons.
>
> Pour ce qui est des mains, il avoit chez lui des personnes à ses gages de l'un & de l'autre sexe qui lui servoient de modèle.

Not everyone who sat to Van Dyck was equally pleased with the result. Cust published a series of letters in the possession of the Verney family which record

the progress of a portrait of the Countess of Sussex, who sat to Van Dyck in November 1639. 'I am glad', the Countess wrote to Ralph Verney, 'you have got home my picture, but I doubt he has made it leaner or fairer [she had earlier asked Verney, for whom the portrait was being painted, to intercede with the artist 'to make my picture leaner, for truly it was too fat'], but too rich in jewels. I am sure but it is no great matter for another age to think me richer than I was; I see you have employed one to copy it, which if you have, I must have that your father had before, which I wish could be mended in the face, for it is very ugly; I beseech you see whether that man that copies out Vandicks could not mend the face of that – if he can any way do it, I pray get him and I will pay for it; it cannot be worse than it is – and send me word what the man must have for copying the picture, if he do it well, you shall get him to do another for me; let me know I beseech you how much I am your debtor, and whether Vandicke was content with the fifty pound.' When the portrait, a full-length 'in a blue gown with perl buttons' according to an early inventory, finally arrived at Gorhambury, the Countess's house, she thought it 'very ill-favoured, [it] makes me quite out of love with myself, the face is so big and so fat that it pleases me not at all. It looks like one of the winds puffing – but truly I think it is like the original. If ever I come to London before Sr Vandike goes, I will get him to mend my picture, for though I be ill-favoured I think it makes me worse than I am.' Sadly, the portrait is lost, but the letters provide a rare and all too human contemporary reaction to a Van Dyck portrait. (They also tell us that early in 1640 Van Dyck was known to be about to leave London.)

Little is known about Van Dyck's pupils and assistants or about the organization of his studio at any period of his career. Nine hundred or so paintings by him survive, an immense number for a working life that only lasted for about twenty years. He worked quickly and with great facility from his earliest years and he employed assistants who painted drapery and backgrounds. As we have seen, there were other Flemish painters in Genoa, for example, who could have assisted Van Dyck, but few of his Italian paintings show any evidence of the participation of a second hand. Once back in Antwerp, he did establish a studio, but there is no question of its having been organized on the quasi-industrial lines of Rubens' studio. A certain Jean de Reyn, who came from Dunkirk, is said to have worked for Van Dyck in Antwerp and to have accompanied him to England. Thomas Willeboirts, Theodor Boeyermans and Pieter Thys have been described as Van Dyck's pupils in Antwerp, but as research continues on the minor artists of seventeenth century Antwerp they may well prove to have been simply among the many lesser painters who fell under his spell.

Remigius van Leemput did travel from Antwerp to London with Van Dyck and assisted him in his studio at Blackfriars. Paintings by Leemput survive which show him to have been a competent imitator of Van Dyck, and he was presumably responsible for the drapery and backgrounds in some of the English portraits. A number of these, particularly those which date from the last years of Van Dyck's life, lack the usual vivacity of Van Dyck's handling and are evidence not of his failing hand, for even in 1641 he was still painting at the top of his form (as in the double portrait of Princess Mary and her husband, William of Orange), but rather of a certain lack of interest in the endless repetition of established portrait forms and of his use of assistants who were no more than competent. Another of his assistants seems to have been Jan van Belcamp, who was to succeed Abraham van der Doort as Surveyor of the King's Pictures. There are entries in the burial register of St Anne's, Blackfriars, which refer to members of Van Dyck's household. On 14 February 1638 'Jasper Lanfrank, a Dutchman, from Sir Anth-

224. *Meadow bordered by Trees. c.* 1635.
Watercolour and body colour, 18.5 × 28 cm.
London, British Museum.

ony Vandikes' was buried there, as was 'Martin Ashent, Sir Anthony Vandike's man' in the following month, on 12 March. These men, however, were probably servants (of whom we know Van Dyck kept a considerable retinue) rather than assistants.

Van Dyck painted no landscapes but he did make a number of landscape drawings in the open air for his own pleasure. There is a view of the coast near Genoa in the Italian Sketchbook and a landscape drawing at Windsor, which is inscribed *Fuori di Genua quarto*. A view of Antwerp is dated 1632, but most of the landscape drawings date from Van Dyck's English years. There are four surviving views of the town of Rye in Sussex, a port on the south coast. On one of them, which shows the medieval houses clustering around the church of St Mary (Plate 225) Van Dyck has written *Rie del naturale li 27 d'Aug^{to} 1633*. To the left is the Ypres Tower, one of the town's oldest fortifications, a building which clearly fascinated Van Dyck, for he drew it again in some detail in two other sketches of Rye and introduced it, quite fortuitously, in the background of his painted portrait of Everhard Jabach (Plate 223). Two of his sketches of Rye seem to have been drawn from the sea, when he was aboard ship. Situated just across the Channel from Boulogne, Rye was on a much-used route to the Continent and it must have been while passing through on his way to or from Flanders that Van Dyck paused to draw the town. These drawings are the products of rare moments of relaxation in the career of a highly professional artist; they are unhurried responses to a striking view. The same instinctual reaction to the beauties of the English countryside can be seen in a number of unexpectedly simple and unaffected watercolours (Plate 224). Van Dyck also made a number of careful (and sometimes annotated) drawings of plants (Plate 226) some of which he used for the backgrounds to portraits.

Of Van Dyck's life in London there is much anecdote and little fact. 'He was a person of low stature,' De Piles wrote, 'but well proportion'd; very handsome,

225. *View of Rye.* 1633. Pen and watercolour, 20.2 × 29.4 cm. Inscribed: Rie del naturale li 27 d'Aug.to 1633 A.vand[torn]. New York, Pierpont Morgan Library.

modest and extremely obliging, and moreover a great encourager of all those of his country who excelled in any art. . . . He always went magnificently dress'd, had a numerous and gallant equipage, and kept so noble a table in his apartment, that few princes were more visited, or better serv'd'. The habits of aristocratic extravagance which he had learnt in Italy were continued in London. He was said to dabble in alchemy, an accusation also levelled, with more justification, at his friend Sir Kenelm Digby. The eighteenth-century French critic Descamps describes the Dutch painter Jan Lievens visiting Van Dyck and finding him pale and tired, bent over his stove, on which exotic concoctions bubbled. Van Dyck kept a beautiful and high-spirited mistress, Margaret Lemon, who is seen in a

226. *Sketch of Plants.* Pen and wash, 21.3 × 32.7 cm. London, British Museum. The inscription, which is in Van Dyck's hand, lists, in Flemish, the plants in the drawing.

painting in a pose that is taken from Titian's famous *Girl in a Fur Wrap* (Plate 227). She clasps a satin cloak about her bare shoulders, revealing her right breast. As early as 1654 the picture was said to be unfinished, and may have been among the canvases left in Van Dyck's studio at the time of his death. Vertue commented: 'twas wondred by some that knew him thatt having beene in Italy he would keepe a Mrs of his in his house Mris Lemon & suffer Porter [probably Endymion's brother George] to keep her company'. According to the engraver Hollar she was 'a dangerous woman' and 'a demon of jealousy who caused the most horrible scenes when ladies belonging to London society had been sitting without a chaperone to her lover for their portraits'. In one jealous rage she was said to have tried to bite Van Dyck's thumb off to prevent him from ever painting again. She is traditionally said to be the model for Psyche in *Cupid and Psyche*.

In 1639 Van Dyck married one of the Queen's ladies-in-waiting, Mary Ruthven, daughter of Patrick Ruthven, fifth son of the Earl of Gowrie. Her portrait is included in the *Iconography* and she is said to be the sitter in the delightful portrait of a young woman dressed in white satin, playing a cello.

On 30 May 1640 Rubens died and Van Dyck was invited to return to Antwerp to supervise the great workshop Rubens had set up. Philip IV of Spain was

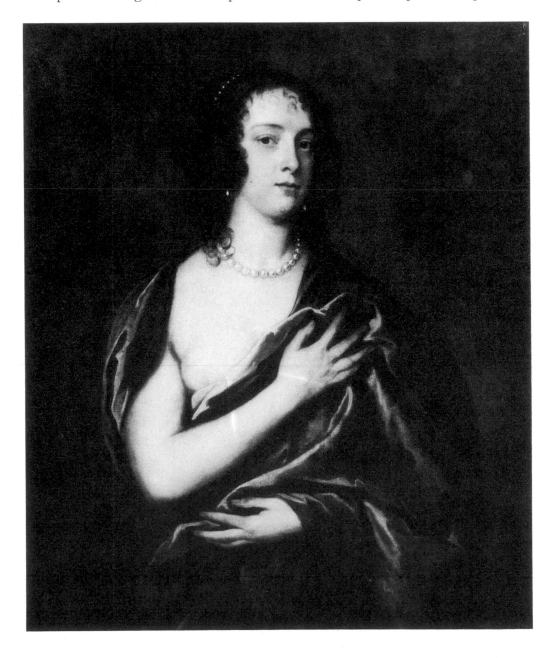

227. *Margaret Lemon*. Canvas, 93.3 × 77.8 cm. Hampton Court, Royal Collection.
This may be the painting purchased for Cardinal Mazarin in London in 1654: '*la teste de la maitresse de van Dyck, qui n'est pas achevee*'. If so, it was presumably found unfinished in the painter's studio after his death.

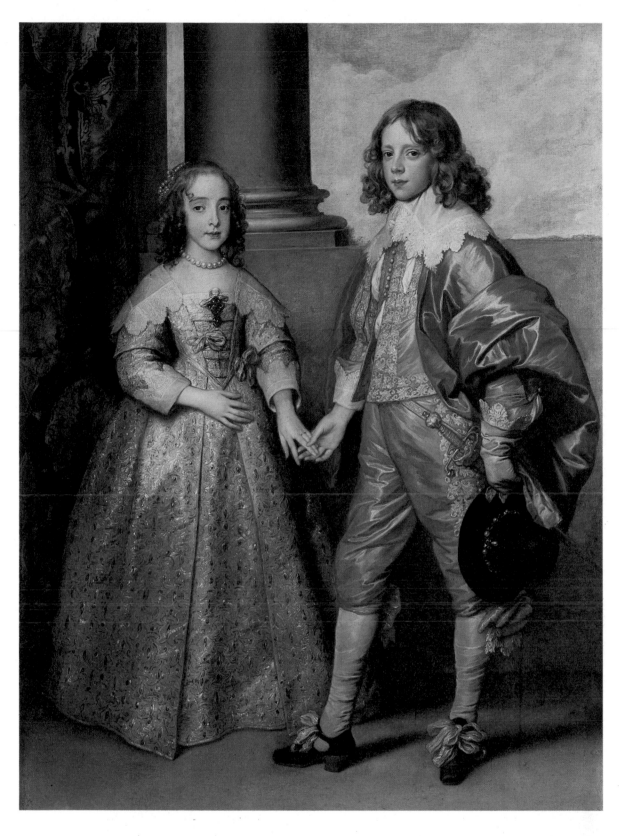

228. *Princess Mary Stuart and Prince William of Orange.* 1641. Canvas, 182.5 × 142 cm. Amsterdam, Rijksmuseum.
Painted on the occasion of their marriage on 12 May 1641.

anxious for the completion of four large-scale history paintings left unfinished at the painter's death. The King's brother, the Cardinal-Infante Ferdinand, Regent of the Netherlands, wrote to Madrid on 23 September that he would soon be speaking to Van Dyck in person and would advise the King of the outcome. The painter, he wrote, was expected in Antwerp around St Luke's Day (18 October). He would certainly, Ferdinand wrote, be preferable to all the other pupils of Rubens for the task of completing the pictures; however, he was known to be capricious (*peso tiene humor*). In response to the invitation from Antwerp, Van

Dyck had received a permit to travel. As with his permit in 1621, this came through the good offices of Arundel. In a letter of 13 September the Marquess of Hamilton wrote to Arundel: 'My nobill Lord, your Lo: will be pleased to cause send the enclosed passe to Sir Antony Wandyke, and againe I crave your Los pardone for my not sending of it souner.'

Armed with his pass, Van Dyck crossed to Antwerp, but the Cardinal-Infante's fears were realized. Ferdinand wrote to Madrid on 10 November that Van Dyck had refused to complete Rubens' paintings. Three of them were almost finished and Rubens had laid in the design of the fourth, but Van Dyck was too proud to complete another's work (*que es loco rematado*). However, Ferdinand was able to report that he had commissioned from Van Dyck a new painting of the same subject as the least finished of Rubens' four paintings. This Van Dyck had agreed to with enthusiasm. He had returned to England to supervise the removal of his household back to Antwerp. (In the event Ferdinand finally turned to Gaspar de Crayer to complete the unfinished canvases.)

In these letters from the Cardinal-Infante to his brother we learn that Van Dyck had decided to leave England and return permanently to his native Antwerp. The course of political events in England was threatening and royal payments were increasingly erratic. He had been greeted in Antwerp as the heir to Rubens, and must have felt that the moment was propitious for his return home.

Back in London, Van Dyck heard that the King of France was about to award the commission for the decoration of the principal galleries of the Louvre. This was the large-scale decorative commission for which he had been waiting. There was, too, a precedent for the French court commissioning a Flemish painter: Rubens' great series on the life of Marie de Médicis for her Luxembourg Palace. In January 1641 Van Dyck went to Paris in an attempt to secure the commission. He was back in London by May, when he painted the double portrait of the Princess Mary and William, Prince of Orange, on the occasion of their marriage, which took place on 12 May (Plate 228). He spent the summer in England and his poor health is commented upon by the Countess of Roxburghe, governess to the royal children, in a letter dated 13 August.

However, despite his being *presque toujours malade*, Van Dyck was back in Antwerp in October and was again in Paris in November, where he heard the disappointing news that the Louvre commission had gone to Nicholas Poussin and Simon Vouet. From this visit dates a letter to Monsieur de Chavigny in which he declines to paint a portrait of Cardinal Mazarin on the grounds of ill health. He still travelled in style: in the letter, he requests a passport to go back to England for *moy et cincq serviteurs, une carrosse et quatre sevaux*.

On his return to Blackfriars the painter's health gave cause for alarm. The King sent his own physician, offering him a reward of £300 if he could restore Van Dyck to health. On 1 December Lady Van Dyck gave birth to a daughter, Justiniana. Three days later Van Dyck made his will and five days after that, on 9 December 1641, he died, at the age of 42. His daughter was baptized on the same day. Two days after his death he was buried in St Paul's Cathedral, as he had directed in his will. His friend and neighbour, the King's jeweller Nicasius Roussel, was among the mourners; he noted that the place chosen for Van Dyck's interment was near the tomb of John of Gaunt in the choir of the Cathedral. Over the grave the King erected a monument to the memory of his favourite painter.

In the will drawn up five days before his death Van Dyck described himself as 'borne in Antwerp in Brabandt, weake of body yet injoyinge my sences memorie'. He asks that his body be buried 'in the Cathdrall Church of St Paul in London'. His property in Antwerp was for the most part left to his sister Susanna for the

benefit of his illegitimate daughter, Maria Theresia van Dyck. A small annuity was also to be paid to his other beguine sister, Isabella. If both Susanna and his daughter in Antwerp were to die, the property in the town was to pass to his 'lawfull daughter borne here in London on the first day of December Anno Dni One Thousand six hundred fortie and one Stilo Angliae'. His other property comprising 'moneys debts pictures & goods bonds bills & writings whatsoever left behind me in the kingdom of England with all such debts as are owinge & due unto mee by the Kings Ma^tie of England or any of the Nobility or by any other person or persons whatsoever the same shall all with that which shall be recovered thereof be equally divided betweene my wife Lady Maria Vandyke and my Daughter new borne in London aforesaid in just and equall portions'.

There is no indication as to the identity of the mother of Van Dyck's illegitimate daughter. Maria Theresia herself married soon after her father's death and her first child was born in February 1643. It seems likely, therefore, that she was born while the painter was in Italy.

Van Dyck's English estate was considerable and left his widow a prosperous woman. According to Vertue 'his widow was courted by divers of quality – at last she married one Price of Wales whose father expected much money to pay debts saying that pictures could pay no debts.' The fate of Van Dyck's own collection, which, as we know from de la Serre, included important paintings by Titian, and of the contents of his studio, is confused. After Lady Van Dyck's death in 1645 her father Patrick Ruthven addressed a petition to Parliament stating that the pictures and works of art which the painter had left in his house at Blackfriars had disappeared, some of them having been smuggled on to the Continent by a certain Richard Andrew. Ruthven requested an injunction to prevent Andrew removing any more from the house but clearly without success, for two years later he renewed his petition with further complaints.

In fact, a number of the most important paintings, including *The Vendramin Family* and the *Perseus and Andromeda* by Titian, passed via Price, who was apparently declared a bankrupt, into the possession of a certain Sir John Wittewronge, who subsequently sold them. Both those Titians went to the Duke of Northumberland.

Justiniana van Dyck, orphaned at the age of three and a half, came under the trusteeship of her aunt Susanna. She was brought up in England, presumably in her stepfather's house, and at the age of 12 was married to Sir John Baptist Stepney. The couple were in Antwerp in 1660 and there adopted Catholicism, living in Justiniana's aunt's house, *De Berg van Calverien*, in the beguinage. Justiniana gave Susanna a picture of the Crucifixion which she had painted herself and her fame as a painter spread far enough for Cornelis de Bie to include her among the important women painters in his *Het Gulden Cabinet*. The Stepneys returned to England and successfully petitioned Charles II for the continuation of the pension of £200 a year which the King's father had paid Van Dyck. Payment, however, was erratic. In 1665 Justiniana went once again to Antwerp to claim the half share of her aunt Susanna's estate which had been bequeathed to her. Justiniana was said to be dead when her own daughter, Anna Justiniana Stepney, visited Antwerp in 1690.

5 Van Dyck's Influence and Reputation

Van Dyck's influence on painting not only in England but also in Italy and The Netherlands was profound and long-lasting. When the 25-year-old Jan Lievens came to England from his native Leiden in 1632, he had already received extravagant praise from Constantijn Huygens for his small-scale, highly-finished and intensely emotional history paintings. Van Dyck swept him off his feet. Lievens entirely abandoned his previous style and adopted the Flemish painter's bold, flowing brushstrokes and rich Venetian palette (Plate 229). On his return to The Netherlands Lievens adapted Van Dyck's style to large-scale history painting. Ironically, in the Town Hall of Amsterdam Lievens was given a commission for the type of decorative project which Van Dyck hoped for but never received. The experience of many artists who came into Van Dyck's orbit was similar to that of Lievens.

As far as portrait painting is concerned, Van Dyck wholly transformed it wherever he worked: in Genoa, in Antwerp, and in London. In Genoa his portrait style was imitated by a whole generation of native painters. In Antwerp, his style was not only taken up by the local portraitists but spread throughout The Netherlands. In Amsterdam, for example, the fashionable portraits of Bartholomeus van der Helst and Govaert Flinck reveal a profound debt to Van Dyck in scale, technique, and composition. In England the revolution in portrait painting from medieval icon to modern likeness, which had been begun by Van Somer, Mytens and Johnson, was brought to a triumphant and glittering conclusion by Van Dyck. He overwhelmed all contemporary portrait painters in England, making all his predecessors seem hopelessly old-fashioned. His unofficial successor as royal portrait painter, William Dobson, modelled his style on Van Dyck's, though he was no mere imitator but possessed a robust artistic personality of his own. James Gandy was another talented follower, but the greatest was undoubtedly Sir Peter Lely (Plate 230), who assumed Van Dyck's mantle after the Restoration. Lely, who was born in Soest in Westphalia and had trained in the studio of Frans de Grebber in Haarlem, was entranced by Van Dyck. He assembled a huge collection of Van Dyck's work – paintings and drawings, including the Italian Sketchbook – to which he returned again and again for inspiration when painting his portraits of members of Charles II's court. Among the twenty-five paintings in his collection by Van Dyck, 'being his best pieces', were the *Three Eldest Children of Charles I* and the *Cupid and Psyche*, which he had bought at the sales of the Royal Collection and which he returned at the Restoration. He also owned the *Lady Elizabeth Thimbelby and Dorothy, Viscountess Andover* now in the National Gallery in London (Plate 231), the sketch for the Garter Procession, and thirty-seven grisaille oil sketches for the *Iconography*.

229. Jan Lievens (1607–74). *Self-Portrait*. *c.* 1644. Canvas, 96.2 × 77 cm. London, National Gallery.
Lievens was in London in 1632 and met Van Dyck. He was enormously impressed by him and after he settled in Antwerp (by 1635) painted portraits in a strongly Van Dyckian manner.

230. Sir Peter Lely (1618–80). *Mary Capel, later Duchess of Beaufort, and her Sister Elizabeth, Countess of Caernarvon. c.* 1658. Canvas, 130.2 × 170.2 cm. Signed with monogram, PL. New York, The Metropolitan Museum of Art.
The Capel family were Lely's most important patrons during the Commonwealth period. This double portrait was clearly based on Van Dyckian models, such as Plate 231.

231. *Lady Elizabeth Thimbelby and Dorothy, Viscountess Andover.* *c.* 1637. Canvas, 132.1 × 149.5 cm. London, National Gallery.
The sitters were daughters of the Earl Rivers. Elizabeth had married Sir John Thimbelby in 1634. Her eldest sister, Dorothy, married Charles Howard, Viscount Andover, on 10 April 1637 and the painting may have been commissioned to mark her wedding. Lady Andover's pose – receiving roses from a Cupid – is entirely appropriate to a marriage portrait. The painting was owned by Lely; it was lot 115 in the sale of his collection in 1682.

Another portrait painter bewitched by Van Dyck was Adriaen Hanneman, who had been a pupil of Anthony van Ravesteyn the Younger in The Hague. He came to London in the mid-1620s and initially adopted the manner of Johnson. Soon after Van Dyck's arrival in England, however, Hanneman began to paint in his style and after returning to The Hague (some time shortly before 1640) he did much to popularize Van Dyck's style in the Netherlands. Their paintings have been confused, for Hanneman at his best can come close to Van Dyck. A portrait of a young boy wearing a buff jerkin and a breastplate and holding a staff, in the National Gallery of Art, Washington, had long been thought to be Prince William II of Orange painted by Van Dyck. However, it has recently been persuasively argued that it is in fact a portrait of Henry, Duke of Gloucester, by Hanneman, painted in about 1653.

In addition to artists of the calibre of Carbone, Lievens, Lely, and Hanneman, Van Dyck spawned many third-rate copyists and imitators. Much of their work is still with us, but their names are lost. One that is known is Theodore Roussel, son of the royal jeweller. He had been in the studio of Johnson, who was his uncle, but subsequently made a living turning out lame imitations and copies of Van Dyck's portraits.

Sir Theodore de Mayerne, a distinguished French physician at the court of Charles I, was deeply interested in painting and painters, especially in the technical aspects of their works. In his notebooks which recount conversations with Van Dyck about varnishes, pigments and priming, he mentions (under the date July 1634), that Anne Carlisle was an assistant of Van Dyck and also notes 'M Cary, disciple of Mr van Deick'.

Another Flemish artist at the English court was the architectural painter Hendrick van Steenwyck the Younger. He painted a large perspective setting (still in the Royal Collection), in which Van Dyck was to place figures of the King and Queen, 'but', Van der Doort records, 'Sir Anthony van Dyck had no mind thereunto'.

Every British portrait painter of the period has been described as a pupil or assistant of Van Dyck, often on grounds of only the slightest similarity. George Jamesone is one; Horace Walpole went so far as to call him 'the Vandyck of Scotland'. However, now that a modern study of Jamesone has appeared, based on thorough archival research and careful stylistic analysis, we learn that he was trained in Edinburgh, is only recorded as having left Scotland once in his life, and was entirely uninfluenced by Van Dyck.

In the longer term, Van Dyck's influence on painting in Britain was immense: his manner dominated portraiture until the death of Sir Thomas Lawrence in 1830. For Jonathan Richardson the Elder, writing in the early years of the eighteenth century, 'When Van Dyck came hither he brought face-painting to us; ever since which time, that is for about fourscore years, England has excelled all the world in that great branch of the art.' For Richardson, as far as portraiture was concerned, 'next to Rafaelle, perhaps, no man has a better title to the preference than Van Dyck; no, not Titian himself, much less Rubens'; he was 'the best model for portrait-painting'. 'I confess', he wrote, 'I love to see a freedom and delicacy of hand in Painting . . .', and it was this that he found in Van Dyck, together with an ability to 'give strong indications of the mind, and illustrate what the historian says more expressly and particularly. Let a man read a character in my Lord Clarendon (and certainly never was there a better painter in that kind) he will find it improved, by seeing a picture of the same person by Van Dyck'. As an example, he takes a painting by Van Dyck in his own collection:

If a person has any peculiarities as to the set, or motion of the head, eyes and mouth (supposing it be not unbecoming) these must be taken notice of, and strongly pronounced. They are a sort of moving features, and are as much part of the man as the fixed ones: nay, sometimes they raise a low subject ... and contribute more to a surprising likeness than any thing else. Van Dyck, in a picture I have of him, has given a brisk touch upon the underlip which makes the form, and set of the mouth very particular, and doubtless was an air which Don Diego de Gusman, whose picture it is, was accustomed to give himself, which an inferior painter could not have observed, or not have dared to have pronounced, at least so strongly: but this as it gives a marvellous spirit, and smartness, undoubtedly gave a proportionable resemblance.

Richardson is one of the most perceptive of all who have written about Van Dyck; his lengthy analysis of a half-length portrait of the Countess of Exeter, which he owned and in which he considers 'in what degree the rules of Painting have been observed' and 'how far the ends of pleasure and advantage are answered' is fascinating.

As a painter himself, Richardson was particularly interested in Van Dyck's technique. Northcote records that as a young man Richardson painted the portrait of an elderly woman who had sat to Van Dyck. This 'immediately raised the curiosity of Richardson, who asked a hundred questions, many of them unimportant; however, the circumstance, which seemed to him, as a painter, to be of the most consequence in the information he gained, was this: she said she well remembered that the time she sat to Van Dyck for her portrait and saw his pictures in his gallery, they appeared to have a white and raw look in comparison with the mellow and rich hue which we now see in them, adding much to their excellence'. This is particularly interesting because both Edward Norgate and Theodore de Mayerne record that Van Dyck took particular care in preparing his varnish according to his own recipe and it may well be that the varnish darkened after it was applied.

Richardson was a competent portrait painter. A far greater painter, who admired Van Dyck equally but unfortunately wrote almost nothing about him, was Gainsborough. Gainsborough's magical technique, those 'odd scratches and marks which at a distance assume form', as Reynolds described it in his Fourteenth Discourse, was modelled on Van Dyck's; so was the sense of relaxed composure assumed by his sitters, many of whose poses are taken from Van Dyck. Indeed, in a portrait like *The Hon. Mrs Graham* (Plate 232) Gainsborough has even dressed his sitter in 'Van Dyck' dress. He has transformed Van Dyck's manner into his own pictorial language, in which the background landscape, to a far greater extent than in Van Dyck, creates the mood of the portrait as much as the magnificently painted head. 'Van Dyck' dress had been fashionable for portraits since the 1730s; 'Many women' wrote Sarah, Duchess of Marlborough, to her granddaughter in 1734, 'are now drawn in the Van Dyck manner.' Gainsborough referred to Van Dyck only once in his letters, but it was with an evident sense of identification. He was writing to David Garrick in 1766, soon after his portrait of the actor with his arm round a bust of Shakespeare had been exhibited in London and criticized in the *Public Advertiser*. 'Don't think', he wrote, 'I am in the least angry. ... There is certainly a false taste and an impudent style prevailing which if Vandyke was living would put him out of countenance.'

Gainsborough himself owned three portraits by Van Dyck. He copied the full-length of the Duke of Richmond, which used to hang at Corsham Court, and the double portrait of Lords John and Bernard Stuart, which was then in the collec-

232. Thomas Gainsborough (1727–88). *The Hon. Mrs Graham*. Canvas, 237 × 154 cm. Edinburgh, National Gallery of Scotland. The portrait was begun in 1775 and exhibited at the Royal Academy two years later.

233. Sir Joshua Reynolds (1723–92). *George John, Viscount Althorp, later 2nd Earl Spencer*. Canvas, 238.8 × 146 cm. Althorp House, Northamptonshire, Collection of the Earl Spencer.
Exhibited at the Royal Academy in 1776. The sitter wears 'Van Dyck' costume.

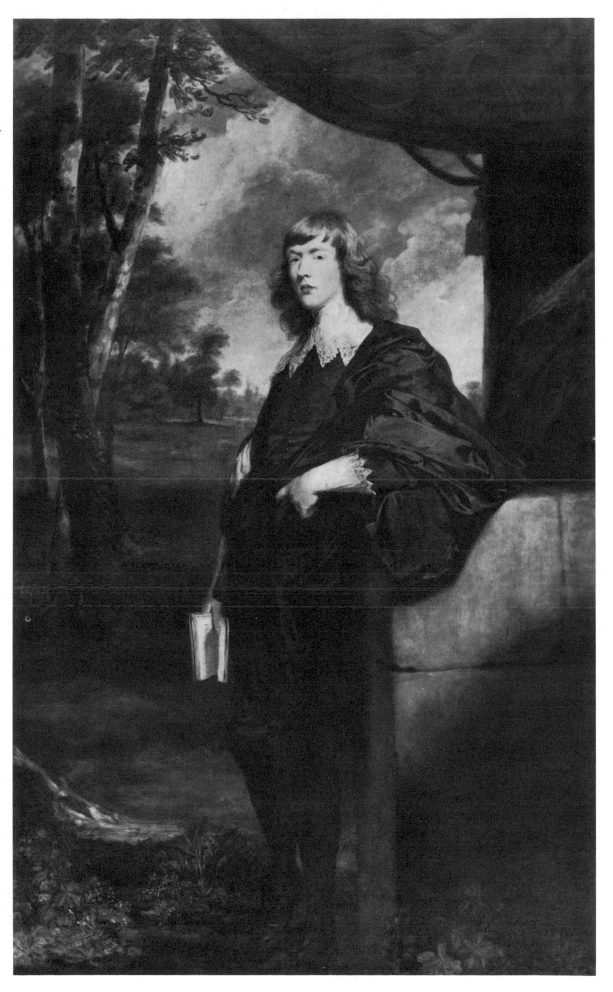

234. Sir Thomas Lawrence (1769–1830). *Queen Charlotte*. 1789. Canvas, 239.5 × 147 cm. London, National Gallery. Queen Charlotte, born Charlotte Sophia of Mecklenburg-Strelitz in 1744, married King George III in 1761. In the portrait the Queen wears a bracelet with a miniature of the King on her right wrist. In the background is a view of Eton College Chapel, which can be seen from Windsor Castle.

tion of Lord Darnley. His copy of the Stuart boys is today in the Museum of St Louis (Missouri). It shows his fascination with the superbly assured technique as well as the exquisite refinement of Van Dyck. It also lends credibility to the account of Jackson, who reported that Gainsborough's last words as he lay on his deathbed were: 'We are all going to Heaven and Vandyke is of the party.'

Reynolds, whose debt to Van Dyck was less great, but who made a number of essays in his style (for example, the portrait of the young Viscount Althorp at Althorp House, Plate 233), wrote about Van Dyck in his *Journey to Flanders and Holland*, the account of a journey he made in 1781. The portrait of Quintijn Simons (Plate 155), which he saw in The Hague, he thought 'one of the very few pictures that can be seen of Vandyck, which is in perfect preservation; and on examining it closely, it appeared to me a perfect pattern of portrait painting: every part is distinctly marked, but with the lightest hand, and without destroying the breadth of light: the colouring is perfectly true to nature, though it has not the brilliant effect of sunshine, such as is seen in Rubens' wife: it is nature seen by common day-light'. There is something bland about this praise, and, interestingly, Van Dyck's history paintings engage him more. He distinguished between Van Dyck's early and later work; of the *St Sebastian* and the *Susannah and the Elders*, which are both now in Munich, painted early on in his career, he wrote: 'He never afterwards had so brilliant a manner of colouring; it kills everything near it ... This is Vandyck's first manner, when he imitated Rubens and Titian, which supposes the sun in the room; in his pictures afterwards, he represented the effects of common day light: both were equally true to nature; but his first manner carries a superiority with it, and seizes our attention, while the pictures 'painted in his latter manner run the risk of being overlooked.' Standing in front of the *Crucifixion* at Mechelen Reynolds thought it 'one of the first pictures in the world, and [it] gives the highest idea of Vandyck's powers; it shows that he had truly a genius for history-painting, if he had not been taken off by portraits'. In the Sixth Discourse Van Dyck is named, almost dutifully rather than enthusiastically, as 'the first of portrait painters'.

If Reynolds' praise of Van Dyck's portraits seems muted, this is not the case with James Barry, who, in his sixth lecture to the Royal Academy, delivered in 1809, declared that Van Dyck's pictures, 'particularly his portraits, were evidently painted at once, with sometimes a little retouching, and they are not less remarkable for the truth, beauty, freshness of their tints, than for the spirited masterly manner of their handling or execution. I could not offer to your consideration a more apposite or illustrious example of the success of this method of finishing as you go on, than the portraits of Van Dyck. They are everywhere to be met with in this country, and you may easily convince yourselves, that his lights are brilliant, forcible, and well embodied with colour, and betray no want of that impasta which furnishes the apology for loading those parts. Indeed one should think that the very circumstance of painting on a light ground precludes the necessity of any such practice.'

The last direct heir to this English tradition of aristocratic portraiture, which had its beginnings in the work of Van Dyck, was Sir Thomas Lawrence. A man who did not theorize about his art, Lawrence paid tribute to Van Dyck, as did Gainsborough, in paint rather than in words. He shared with Van Dyck a dazzling technical facility, the sparkling surfaces of his canvases, the elegant poses and rich clothes of his sitters, and above all his belief that a portrait should be a work of the artist's imagination rather than a mere likeness. The similarities were not lost on contemporaries: at the very outset of his career Lawrence's ravishing full-length of Queen Charlotte at Windsor Castle (Plate 234), exhibited at the Royal

Academy in 1790, was said to be 'a performance of which Vandyke himself would have been proud'. Almost forty years later, years during which Lawrence had dominated portrait painting in England, the *Literary Gazette* commented on his *Caroline, Duchess of Richmond*, shown at the Academy in 1829, as 'manifestly resembling some of the portraits of Vandyke ... the result is a graceful and harmonious whole'. With Lawrence's death in 1830 the succession was broken and the great age of English portraiture was over.

Notes

References not given in full will be found in the Bibliography

p.10 For Van Balen, see I. Jost, 'Hendrick Van Balen der Ä.', *Nederlands Kunsthistorisch Jaarboek*, 14, 1963, p.83 ff.

p.12 For the court case concerning the Christ and the Apostles series, see Galesloot.
The arguments about the identification of the series of paintings showing Christ and the Apostles have recently been conveniently summarized in the Ottawa exhibition catalogue.

p.14 The Rubens bibliography is immense, although there is no one modern book that can be recommended as an introduction to his life and work. The best general book in English remains M. Rooses, *Rubens*, 2 vols., London, 1904; in German, H.G. Evers, *Rubens und sein Werk*, Brussels, 1944. For individual works or series, see the relevant volume in the *Corpus Rubenianum Ludwig Burchard*, London, 1968 – still in the course of publication.
For the most recent account of Rubens' Chiesa Nuova altarpiece, see M. Jaffé, *Rubens and Italy*, Oxford, 1977.

p.16 Sir Dudley Carleton, in M. Lee, Jr., ed., *Dudley Carleton to John Chamberlain, 1603–24: Jacobean Letters*, New Brunswick, 1972, pp.212–3.
The earliest life of Rubens is the Latin *Vita* by his nephew, Philip Rubens.

p.17 For the two altarpieces, see J.R. Martin, *The Antwerp Altarpieces*, New York, 1969.

p.22 Recently, at a symposium held at the Ringling Museum, Sarasota, in April 1982 Reinhold Baumstark argued that Rubens' own participation in the Decius Mus cartoons was considerable and that Van Dyck's participation cannot be substantiated by a study of the works themselves. For the Decius Mus series, see J. Held, *The Oil Sketches of Peter Paul Rubens*, Princeton, 1980, vol 1, p.19 ff.
For the Jesuit Church ceiling, see *Corpus Rubenianum Ludwig Burchard*: Volume 1: J.R. Martin, *The Ceiling Paintings for the Jesuit Church in Antwerp*, London, 1968.

p.25 Sperling's account is quoted by M. Rooses, *Rubens*, London, 1904, vol, 1, pp.315–16.

p.27 For a recent discussion of these drawings, see the Ottawa exhibition catalogue.
Jaffé has published a sketchbook at Chatsworth as the work of Van Dyck prior to his departure for Italy (see Bibliography). While the penwork does possess a vigour which would be expected in the young Van Dyck and the sketchbook bears the monogram AVD, the attribution has not been universally accepted and it seemed preferable to omit discussion of it from a general account of the artist's life and work.

p.43 For the X-rays of the Edinburgh *St Sebastian*, see Thompson.

p.46 *Suffer the Little Children* has recently been discussed by E. Waterhouse in a booklet published by the National Gallery of Canada in 1978.

p.52 The Fort Worth painting was exhibited (as a Van Dyck) at Ottawa in 1980 where, in the context of early paintings by Van Dyck, its true attribution became clear (at least to me).

For Arundel, see M. Hervey, *The Life, Correspondence and Collections of Thomas Howard, Earl of Arundel*, Cambridge, 1921, and G. Parry, *The Golden Age Restor'd: The Culture of the Stuart Court, 1603–42*, Manchester, 1981.

p.55 Clarendon, *History of the Rebellion*, Oxford, 1705, pp.55–6 (quoted by Parry, op. cit., p.109).

p.56 For the fragment of a frieze in the *Continence of Scipio*, see J. Harris 'The link between a Roman second-century sculptor, Van Dyck, Inigo Jones and Queen Henrietta Maria', *The Burlington Magazine*, 115, 1973, pp.526 ff.

p.61 For the manuscript life of Van Dyck, see Vaes 1924.

p.62 For the Italian Sketchbook, see Adriani. I am currently preparing a new edition of the Sketchbook, to be published by British Museum Publications Ltd.

p.73 J. Richardson the Younger, *An Account of some of the Statues, Bas-reliefs, Drawings and Pictures in Italy*, London, 1722, pp.72–3.

p.74 For the portrait of Gage, see Millar 1969.

p.82 For Van Dyck's religious paintings in Italy, see the Princeton exhibition catalogue (to which my account is heavily indebted).
For Van Dyck and Reni, see O. Kurz, 'Van Dyck and Reni', in *Miscellanea Roggen*, 1957, p.179 ff.

p.95 For Genoese painting in the years after Van Dyck's departure, see the exhibition catalogue, *Pittori Genovesi a Genova nel '600 e nel '700*, Genoa, Palazzo Bianco, 1969.

p.100 For Bellori and Soprani, see Bibliography.

p.111 The precise dating of the Langlois portrait is problematic. Although it is discussed at this point in the text, it could equally well be dated to Van Dyck's early years in England.

p.114 For the discussion of the *Vision of St Augustine*, and the first publication of the modello, see Princeton exhibition catalogue.

p.128 For Van Dyck's visits to Holland, see Van Gelder.
For Van Dyck and Tasso, see R. W. Lee, 'Van Dyck, Tasso and the Antique', *Acts of the 20th International Congress of the History of Art*, Princeton, 1963, vol 3, p.12 ff.

p.131 De la Serre's account is in P. de la Serre, *Le Voyage de Marie de Médicis en la Flandre*, Antwerp, 1632.
The inventory taken after Van Dyck's death was published by J. Müller-Rostock, 'Ein Verzeichnis von Bildern aus dem Besitz des van Dyck', *Zeitschrift für bildende Kunst*, N.F., 33, 1922, pp.22 ff.

p.134 For *The Iconography*, see Mauquoy-Hendrickx. For Vorsterman, see J. Held.

p.138 (Ed. J. Sutherland) L. Hutchinson, *Memoirs of the Life of Colonel Hutchinson*, Oxford, 1973, p.46.

p.140 For Netherlandish painters in England before Van Dyck, see Whinney and Millar and Waterhouse.

p.142 The description of Mytens' *Portrait of the Duke of Hamilton* is from Waterhouse, p.55.

p.144 For Digby, see *Dictionary of National Biography*, vol. 5, pp.965 ff.

p.147 For the sunflower, see R. Wark, 'A note on Van Dyck's Self-Portrait with a Sunflower', *The Burlington Magazine*, 98, 1956, p.52 ff.; and J. Bruyn and J. A. Emmens; 'The Sunflower Again', *The Burlington Magazine*, 99, 1957, p.96.

p.150 For Porter, see G. Huxley, *Endymion Porter*, London, 1959.

p.152 For Dobson's portrait of Porter, see W. Vaughan, *Endymion Porter and William Dobson*, Tate Gallery, London, 1970.

p.161 For the *échevins* sketch, see Paris exhibition catalogue.

p.162-5 Exchequer documents published for the first time by Carpenter.

p.164 Contemporary accounts of Charles I and Henrietta Maria quoted in P. Gregg, *Charles I*, London, 1981.

p.168 For the National Gallery portrait of Charles I on horseback, see Martin and Strong.

p.169 For the Louvre Portrait, see J. Held, 'Le Roi à la chasse', *Art Bulletin*, 1958, p.139 ff.

p.176 For the Bernini bust, see R. W. Lightbown.
John Evelyn, *Numismata*, London, 1697.

p.177 Sophia's account of Henrietta Maria can be found in her *Memoirs*, London, 1888, p.13.

p.186 My account of the vogue for the myth of Cupid and Psyche at court is taken from Parry, op. cit. pp.196-7.

p.190 For the Garter Procession sketch, see London 1972 exhibition catalogue.

p.197 For the Wilton group portrait, see Sidney, 16th Earl of Pembroke, *A Catalogue of the Paintings and Drawings in the Collection at Wilton House*, Salisbury, Wiltshire, London, 1968, p.58 ff.

p.202 Waller's poem is quoted in full by Cust, p.195.
Vertue notebooks, vol. 1, *Proceedings of the Walpole Society*, 18, 1929-30, London, 1930, pp.109-110.

p.206 Clarendon, op. cit.

p.211 The comparison of the two Hanmer portraits was made by Oliver Millar in London 1972 exhibition catalogue.

p.212 For the Portrait of Killigrew and (?) Crofts, see Millar 1963.
For the Portrait of Suckling, see Rogers.

p.214 De Piles 1744, pp.267 ff.
De Piles 1708, pp.291 ff.
Cust, p.175.

p.216 De Piles 1744 pp.419 ff.

p.217 Descamps, vol. 2., p.117.

p.220 Van Dyck's will is published in full in Carpenter and reprinted in Cust.

p.221 For the dispersal of Van Dyck's collection after his death, see my article in *RACAR*, 1982 (forthcoming).

p.222 For Lievens, see H. Schneider, *Jan Lievens*, 2nd ed. (ed. R. Ekkart), Amsterdam, 1973.
For Lely, see the catalogue, by Sir Oliver Millar, of the exhibition held at the National Portrait Gallery, London, in 1978-9.

p.224 For Hanneman, see O. ter Kuile, *Adriaen Hanneman*, Alphen aan den Rijn, 1976. (Ter Kuile made the re-attribution of the Washington portrait).

p.224 For Mayerne's notes, see M. Kirby Talley, *Portrait Painting in England: Studies in the Technical Literature before 1700*, London, 1981.
For Jamesone, see D. Thomson, *The Life and Art of George Jamesone*, Oxford, 1974.

p.225 J. Richardson the Younger, *An Essay on the Theory of Painting*, London, 1725, pp.101-2.
For Gainsborough, see E. Waterhouse, *Gainsborough*, London, 1958; Ed. M. Woodall, *The Letters of Thomas Gainsborough*, London, 1963; J. Hayes, *Thomas Gainsborough*, London, 1975.

p.229 Reynolds, *A Journey to Flanders and Holland* in *Works* (ed. E. Malone) 1797, vol. 2, p.19.
J. Barry, *Works*, London, 1809, vol. 1, p.541.

p.229-30 For Lawrence, see K. Garlick, *Sir Thomas Lawrence*, London, 1954, and the catalogue, by M. Levey, of the exhibition held at the National Portrait Gallery in 1979-80.

Bibliography

Books

G. Adriani (ed.), *Anton van Dyck, Italienisches Skizzenbuch*, Vienna, 1940 (2nd ed., Vienna, 1965).

G. P. Bellori, *Le vite de' pittori, scultori et architetti moderni*, Rome, 1672.

W. H. Carpenter, *Pictorial Notices, consisting of a Memoir of Sir Anthony Van Dyck . . .*, London, 1844.

L. Cust, *Anthony van Dyck, an Historical Study of his Life and Works*, London, 1900.

J. B. Descamps, *La vie des Peintres Flamands, allemands, et Hollandais*, 3 vols, Paris, 1753–63.

G. Glück (ed.), *Van Dyck, Des Meisters Gemälde, Klassiker der Kunst*, XIII, 2nd ed., Stuttgart-Berlin, 1931.

G. Glück, *Rubens, Van Dyck und ihr Kreis*, Vienna, 1933.

J. Guiffrey, *Antoine van Dyck: sa vie et son oeuvre*, Paris, 1882.

A. Houbraken, *De Groote Schouburgh der Nederlandsche Konstschilders en Schilderessen*, 3 vols., Amsterdam, 1718–29.

M. Jaffé, *Van Dyck's Antwerp Sketchbook*, 2 vols., London, 1966.

E. Larsen, *L'Opera Completa di Van Dyck*, 2 vols., Milan, 1980.

G. Martin, *National Gallery Catalogues: The Flemish School c.1600–c.1900*, London, 1970.

M. Mauquoy-Hendrickx, *L'Iconographie d'Antoine Van Dyck: catalogue raisonné*, Brussels, 1956.

A. L. Mayer, *Anthonis van Dyck*, Munich, 1923.

O. Millar, *The Tudor, Stuart and Early Georgian Pictures in the Collection of Her Majesty the Queen*, London, 1963.

R. de Piles, *Le Cours de Peinture par Principes*, Paris, 1708.

R. de Piles, *Abrégé de la vie des peintres*, Paris, 1715.

R. de Piles, *The Art of Painting*, London, 1744. Translated and edited by B. Buckeridge.

J. von Sandrart, *Teutsche Academie der Bau-, Bild- und Mahlerei-Künste von 1675*, ed. A. R. Peltzer, Munich, 1925.

J. Smith, *A Catalogue Raisonné of the works of the most eminent Dutch, Flemish and French painters*, Volume 3, London, 1831 (Supplement, London, 1842).

R. Soprani, *Le vite de' pittori, scultori ed architetti Genovesi e de' Forastieri che in Genova operarano*, Genoa, 1674.

R. Strong, *Charles I on Horseback*, London, 1972.

H. Vey, *Van Dyck-Studien*, Cologne, 1958.

H. Vey, *Die Zeichnungen Anton Van Dycks*, 2 vols., Brussels, 1962.

H. Walpole, *Anecdotes of Painting in England . . .*, 4 vols., London, 1765–71.

E. Waterhouse, *Painting in Britain 1530 to 1790*, 4th ed., London, 1978.

M. Whinney and O. Millar, *English Art 1625–1714*, Oxford, 1958.

Articles

L. Galesloot, 'Un procès pour une vente de tableaux attribués à Van Dyck', *Annales de l'Académie d'Archéologie de Belgique*, XXIV, 1868, pp.561 ff.

J. van Gelder, 'Anthonie van Dyck in Holland in de zeventiende eeuw'. *Bulletin des Musées Royaux des Beaux-Arts*, Brussels, 8, 1959, pp.73 ff.

J. Held, 'Rubens and Vorsterman', *Rubens and his Circle: Studies by Julius S. Held* (ed. Lowenthal, Rosand and Walsh), Princeton, 1982, pp.114 ff.

R. W. Lightbown, 'Bernini's Busts of English Patrons', *Art, the Ape of Nature: Essays in Honor of H. W. Janson* (ed. Barasch and Sandler), New York, 1981, pp.439 ff.

G. Meli, 'Documento relativo a un quadro dell' altar maggiore dell' Oratorio della Compagnia del Rosario di S. Domenico'. *Archivio Storico Siciliano*, III, 1878.

M. Menotti, 'Van Dyck a Genova' *Archivio Storico dell' Arte*, II, 1896; III, 2nd series, 1897, pp.280 ff; pp.360 ff; pp.432 ff.

O. Millar, 'Van Dyck's Continence of Scipio at Christ Church', *The Burlington Magazine*, 93, 1951, pp.125 ff.

O. Millar, 'Van Dyck and Sir Thomas Hanmer', *The Burlington Magazine*, 100, 1958, pp.249 ff.

O. Millar (ed.), 'Abraham van der Doort's Catalogue of the Collection of Charles I', *Proceedings of the Walpole Society*, 37, 1958–60, London, 1960.

O. Millar, 'Van Dyck and Thomas Killigrew', *The Burlington Magazine*, 105, 1963, pp.409 ff.

O. Millar, 'Notes on three Pictures by Van Dyck', *The Burlington Magazine*, 111, 1969, pp.414 ff.

O. Millar (ed.), 'The Inventories and Valuations of the King's Goods 1649–51', *Proceedings of the Walpole Society*, 43, 1970–72, London, 1972.

L. van Puyvelde, 'Les débuts de Van Dyck', *Revue Belge d'Archéologie et d'Histoire de l'art*, 3, 1933, pp.193 ff.

L. van Puyvelde, 'The Young Van Dyck', *The Burlington Magazine*, 79, 1941, pp.177 ff.

M. Rogers, 'The meaning of Van Dyck's Portrait of Sir John Suckling', *The Burlington Magazine*, 120, 1978, pp.741 ff.

C. Thompson, 'X-rays of a Van Dyck "St. Sebastian"', *The Burlington Magazine*, 103, 1961, pp.318 ff.

M. Vaes, 'Le séjour d'Antoine Van Dyck en Italie', *Bulletin de l'Institut Historique Belge à Rome*, 4, 1924, pp.201 ff.

M. Vaes, 'L'auteur de la biographie d'Antoine van Dyck', *Bulletin de l'Institut Historique Belge à Rome*, 7, 1927, pp.5 ff.

H. Vey, 'Anton van Dyck's Oelskizzen', *Bulletin Musées Royaux des Beaux-Arts, Brussels*, 5, 1–4, 1956, pp.168 ff.

Exhibition Catalogues (arranged chronologically)

Genoa, Palazzo dell'Accademia, *100 Opere di Van Dyck*, 1955.

Antwerp, Rubenshuis, and Rotterdam, Museum Boymans van Beuningen, ed. R.–A. d'Hulst and H. Vey, *Antoon Van Dyck, Tekeningen en Olieverfschetsen*, 1960.

London, Agnew's, *Sir Anthony van Dyck*, 1968.

London, Tate Gallery, ed. O. Millar, *The Age of Charles I*, 1972.

Paris, Grand Palais, ed. J. Foucart et al., *Le siècle de Rubens dans les collections publiques françaises*, 1977/8.

Princeton, Art Museum, ed. J. P. Martin and G. Feigenbaum, *Van Dyck as a Religious Artist*, 1979.

Ottawa, National Gallery of Canada, ed. A. McNairn, *The Young Van Dyck*, 1980.

List of Plates

Index